Luminos is the Open Access monograph publishing program from UC Press. Luminos provides a framework for preserving and reinvigorating monograph publishing for the future and increases the reach and visibility of important scholarly work. Titles published in the UC Press Luminos model are published with the same high standards for selection, peer review, production, and marketing as those in our traditional program. www.luminosoa.org

D1501057

The publisher and the University of California Press Foundation gratefully acknowledge the generous support of the Ahmanson Foundation Endowment Fund in Humanities.

Sirens of Modernity

CINEMA CULTURES IN CONTACT

Richard Abel, Giorgio Bertellini, and Matthew Solomon, Series Editors

Sirens of Modernity

World Cinema via Bombay

———

Samhita Sunya

UNIVERSITY OF CALIFORNIA PRESS

University of California Press
Oakland, California

Suggested citation: Sunya, S. *Sirens of Modernity: World Cinema via Bombay*. Oakland: University of California Press, 2022.
DOI: https://doi.org/10.1525/luminos.130

An earlier version of chapter 2 appeared as Samhita Sunya, "Moving toward Prem Nagar: An Intimate Genealogy of the 'City of Love' and the Lyrical Worlds of Hindustani Film Songs," *positions: asia critique* 25, no. 1 (February 1, 2017): 51–99. The author thanks Duke University Press journals for reprint permissions.

An earlier version of excerpts from chapter 4 appeared as "High-Fidelity Ecologies: India versus Noise Pollution in the Contemporary Public Sphere," in *Indian Sound Cultures, Indian Sound Citizenship*, edited by Laura Brueck, Jacob Smith, and Neil Verma (Ann Arbor: University of Michigan Press, 2020), 88–112. The author thanks University of Michigan Press for reprint permissions.

Library of Congress Cataloging-in-Publication Data

Names: Sunya, Samhita, 1985– author.
Title: Sirens of modernity : world cinema via Bombay / Samhita Sunya.
Other titles: Cinema cultures in contact ; 3.
Description: Oakland, California : University of California Press, [2022] | Series: Cinema cultures in contact ; 3 | Includes bibliographical references and index.
Identifiers: LCCN 2022000610 (print) | LCCN 2022000611 (ebook) | ISBN 9780520379534 (paperback) | ISBN 9780520976788 (ebook)
Subjects: LCSH: Motion pictures, Hindi—India—Mumbai—History and criticism. | Motion picture industry—India—Mumbai—History. | BISAC: PERFORMING ARTS / Film / General | PERFORMING ARTS / Film / History & Criticism
Classification: LCC PN1993.5.I8 S863 2022 (print) | LCC PN1993.5.I8 (ebook) | DDC 791.430954—dc23/eng/20220228
LC record available at https://lccn.loc.gov/2022000610
LC ebook record available at https://lccn.loc.gov/2022000611

31 30 29 28 27 26 25 24 23 22
10 9 8 7 6 5 4 3 2 1

CONTENTS

Opening Credits

"Akira Kurosawa"

A Retrospective Prologue

*akira kurosawa vittorio de sica, wyler hitchcock wajda, mizoguchi de palma,
wyler hitchcock wajda, brian de palma! akira kurosawa vittorio de sica . . .*
—CHINTU JI (RANJIT KAPOOR, 2009)

The bikini is the most important thing since the atom bomb.
—DIANA VREELAND, 1946

Can true love materialize from a transactional affair? Let me turn to a certain
Akira Kurosawa in order to broach my preoccupation with this capacious
question, one that preoccupied a set of commercial Hindi films in a postwar,
post-independence period of the long 1960s. By "Akira Kurosawa," I am referring
to a song sequence (clip 1) from the unassuming Hindi comedy *Chintu Ji* (Mister
Chintu, Ranjit Kapoor, 2009). The sequence offers a playful retrospective homage
to a historic binary that crystallized over the period in question: between the spec-
tacular audiovisual excess of the Bombay-based Hindi-language cinema on the one
hand and the canonical acclaim of an auteur-driven world cinema on the other.

The lyrics of "Akira Kurosawa" at first seem to be the gibberish of an unin-
telligible, exoticized indigenous language. The song opens upon a stereotypically
generic mise-en-scène of natives, replete with tom-toms, feathers, a teepee, and
a white captive who has been tied up before a ridiculously outfitted chieftain

Note on transliteration: I have transliterated all Hindi dialogue and lyrics in a lowercase, italicized
format. In lieu of diacritics, I have opted for phonetic English transliterations that indicate Hindi
long vowels through their doubling (e.g., *aa, ii*). In instances where certain titles (e.g., *Chintu Ji*) have
been published as romanized titles, or in instances of lyrics that include proper nouns from other
languages (e.g., Akira Kurosawa), I opt for these transliterations. The former will be evident through
their capitalization, the latter through their italicized, lowercase format. I have left diacritics in place
in a few citations, which refer to secondary sources in languages other than English that have not been
published with Romanized titles.

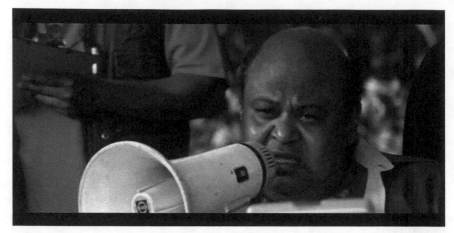

CLIP 1. "Akira Kurosawa" song sequence from *Chintu Ji* (2009).

To watch this video, scan the QR code with your mobile device or
visit DOI: https://doi.org/10.1525/luminos.130.1

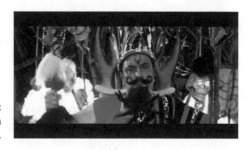

FIGURE 1. Still from *Chintu Ji* (2009):
Rishi Kapoor as a generic chieftain in
"Akira Kurosawa" song sequence.

(fig. 1). The music is percussive and upbeat, and it is joined by a twangy riff on
a synthesizer that is followed by the chieftain's rhythmic chanting of apparently
nonsensical syllables. On closer listen, they are in fact "*tarantino! vittorio! mizo-
guchi! coppola!*" A strappy leather-clad dancer gyrates before the camera against
a bevy of white backup dancers and indigenous extras, and she sultrily croons in
the voice of a playback singer: "*tarantino wilder capra, ozu bertolucci peckinpah,
fellini visconti oshima, coppola, coppola!*" (fig. 2) A litany of canonical—and largely
midcentury—world cinema auteurs' names continue as the ostensibly primitive
gibberish of the song's chorus: "*akira kurosawa vittorio de sica, wyler hitchcock
wajda, mizoguchi de palma, wyler hitchcock wajda, brian de palma! akira kurosawa
vittorio de sica . . .*"

The sequence unfolds as a parody of the item number and the pejoratively
termed "tribal" number, both of which are often categorized among the most bla-
tantly commercial forms of song-dance sequences in contemporary Hindi films.

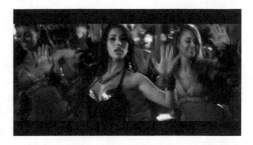

FIGURE 2. Still from *Chintu Ji* (2009):
Sophie Chaudry as generically "tribal"
dancer in "Akira Kurosawa" song sequence.

A tribal number is a production number[1] whose demeaning portrayals of indigenous people "is usually embarrassing as they frequently wear ridiculous clothes, usually fairly skimpy costumes, with Himachal hats that often look more like something one would wear to a children's party."[2] An item number is a fast-paced production number, typically featuring a cameo by an actress whose embodied sex appeal is highlighted through an eroticized focus on her dancing body and bare flesh.[3] Actor Rishi Kapoor plays himself as a film star in *Chintu Ji*, and he stars as the chieftain in the "Akira Kurosawa" song sequence, which occurs as a film shoot within the film. The star of the parodic tribal-cum-item number is dancer-actress Menaka[4] (played by actress Sophie Choudry, who lip-syncs to the voice of playback singer Anushka Manchanda). Later invoking the story of Pocahontas, the sequence spoofs the absurdity of Hollywood films' depictions of Native Americans as well.

Some accounts of the term *item number* surmise that it came from *item bomb*, as a derivation of *atom bomb*.[5] An item number is like an atom bomb inasmuch as it invokes a technologized mass spectacle of audiovisual excess. *Harper's Bazaar* fashion columnist Diana Vreeland notoriously tied the atomic age to a new age of global design with her 1946 declaration that "the bikini is the most important thing since the atom bomb."[6] The facetious aphorism stuck to Vreeland's celebrity after she jumped into the limelight as editor-in-chief of *Vogue* in the 1960s, as the explosive swimwear item remained an icon of unprecedented public displays of feminine sexuality and leisure.[7] Shortly after the end of World War II, the US had conducted nuclear tests in the Bikini Atoll, which was nothing short of an irrevocable catastrophe for the indigenous inhabitants and environments of the Marshall Islands.[8] From this namesake nuclear testing ground in the Pacific, the bikini wore an indelible imprint of the global Cold War. These twinned excesses—proliferating images of feminine sexuality and proliferating nuclear capabilities—have recurred as targets of regulation in ways that reify an uncritical acceptance of the far less spectacular non-excess against which they have been defined. That is, the display of feminine sexuality can become an object of scrutiny rather than the naturalization of heteropatriarchal structures that frame it as excess in the first place. And nuclear weapons can become an object of grave concern in ways that normalize everyday militarized infrastructures—including those of mere "tests"—against which nuclear weapons appear as an egregious excess.

In light of these stakes, *Sirens of Modernity* considers public debates over gender, excess, cinephilia, and the world via Bombay—or more specifically, via a set of Bombay films, film songs, and love lyrics over a "long" 1960s period, bookended by the 1955 Bandung Afro-Asian Conference and 1975 Indian Emergency. The film *Chintu Ji* emerged in a far more contemporary moment, following Bollywood's sweeping displacement of a realist tradition of art cinema as the default representative of Indian cinema in the world.[9] Yet, the "Akira Kurosawa" sequence—and the film as a whole—cannily cites a longer history of Hindi films' reflexivity vis-à-vis the world and world cinema. As expressed by director Ranjit Kapoor, who also wrote—or one might say compiled—the lyrics,[10] the "Akira Kurosawa" song sequence from *Chintu Ji* ultimately suggests that a polemical opposition between a realist, postwar art cinema and the excess-driven modes of popular Hindi cinema belies their historical simultaneity and overlapping aspirations. As we will see in the chapters that follow, films, film industry personnel, critics, and audiences across a range of filmmaking practices—including an array of commercial Hindi film ventures—converged in their espousal of ethical aspirations for cinema as a medium for representing, reaching, and connecting people and places who were underrepresented in the world.

The Cold War nuclear arms race fueled the development of increasingly long-distance rocket technologies, and the now-familiar opening image of *Chintu Ji* was beheld for the first time during this midcentury space age: a photograph of Earth as a planetary totality from the vantage point of outer space. As the camera ostensibly descends toward Earth, the distinct voice of actor Om Puri is audible in a cameo voice-over that introduces Hadbahedi, a fictional village in a corner of Himachal Pradesh in northern India. Immediately, a song sequence commences through a montage of establishing shots, and the lyrics describe the perfection of the idyllic village and its people. Its refrain insists that *"yahaan sab thiik hai"* (everything is okay here). But as declarations of the village's utopian character start to crack through some tentative admissions that it could benefit from basic infrastructural improvements, such as reliable electricity, the continued repetition of "everything is okay here" accrues a tinge of irony.

At its outset, *Chintu Ji* directly correlates a lack of technological prowess and media representation in the wider world to a lack of political visibility and voice. The film goes on to exaggerate and poke fun at the temperamental and selfish offscreen personalities of film stars and at their fans' faith that stars will heroically step in on their behalf—as they often do onscreen—when the state falls short, by representing the fans' collective aspirations and translating them into actionable political demands.[11] At a village meeting early in the film, one of the villagers casually remarks that if a film star had been born there, Hadbahedi would have been known and represented in the world. In response, an elderly woman steps forward and reveals that decades ago, she had served as the midwife who delivered the son of the late star Raj Kapoor, when his wife Krishna went into labor while passing

through Hadbahedi. The film's title *Chintu Ji* (Mr. Chintu) is the actual nickname of Raj Kapoor's real-life son Rishi Kapoor, a film star who plays himself as a third-generation film star in *Chintu Ji*.

The Hadbahedians' faith in Chintu Ji comes from an idealized belief that film stars, unlike politicians, are public figures whose acting is transparent, confined to the screen, and sanctioned by the patronage of their fans. In contrast, politicians are implied to be public figures who duplicitously don roles without exposing their acting as such, in order to gain votes through false pretenses that masquerade as truth. The situational comedy in *Chintu Ji* seems to arise from the audience's knowledge that Chintu Ji could not care less for the Hadbahedians, and that Chintu Ji humors them because he harbors political aspirations.[12] Yet, the film most zealously lampoons not the Hadbahedians' naivete, but Chintu Ji himself as an epitome of the ridiculously self-serving tendencies of the commercial film industry and its stars.

On the advice of his young public relations officer, Devika, Chintu Ji visits his birthplace in Hadbahedi with no other concern than amassing the villagers' votes. For this purpose, he puts on an act as a representative of the Hadbahedians' interests. Despite barely keeping his act together due to the constant eruptions of his insufferably temperamental personality, Chintu Ji nonetheless aims to deceive the Hadbahedians just long enough to win an upcoming election. In learning to eventually care for Hadbahedi despite the town's shortcomings, just as the Hadbahedians care for Chintu Ji despite his shortcomings, a reel star learns to concern himself with the interests of the real heroes: a collective of underrepresented fans. The Hadbahedians regard Chintu Ji as one of their own, despite their not-so-naïve suspicion that he is rather flawed. Playing the character of a third-generation film star who now eyes a political career, Chintu Ji does not bargain for the possibility that the cinephilic faith placed in him by the Hadbahedians would transform his relationship to them.

Crucially, Chintu Ji's own transformation occurs through a ghost of sorts from a cinematic past. The film nostalgically recalls a cinema of and for the people, epitomized for so many around the world by the tramp figures played by Chintu Ji's father, showman Raj Kapoor. An Uzbek foreign minister comes to visit Chintu Ji in Hadbahedi, and the minister mentions that Kseniya Ryabinkina, a now elderly Russian woman, wishes to visit India. Kseniya Ryabinkina had played the role of Marina in Raj Kapoor's 1970 film *Mera Naam Joker*—the very film in which Rishi Kapoor made his acting debut (figs. 3, 4, 5). The real Kseniya Ryabinkina journeyed to India from Russia to play herself in *Chintu Ji*, acting for the very first time since her role in *Mera Naam Joker* forty years earlier (fig. 6). Within the film, she reminds Chintu Ji of how inspired she was by his father, Raj Kapoor, not merely as an actor but above all as a human being. Chintu Ji's about-face happens through Kseniya's reminder of his father's legacy.

Prior to his change of heart, Chintu Ji exploits the Hadbahedians' love for him in two ways that emphasize the inseparability of popular media and representational

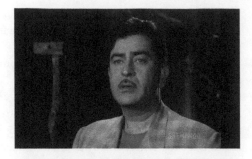

FIGURE 3. Still from *Mera Naam Joker* (1970): Raj Kapoor as Raj.

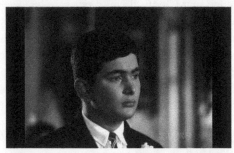

FIGURE 4. Still from *Mera Naam Joker*: Rishi Kapoor's film debut as the young Raj.

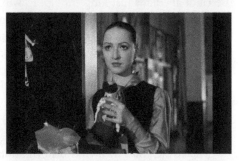

FIGURE 5. Still from *Mera Naam Joker*: Kseniya Ryabinkina as Marina.

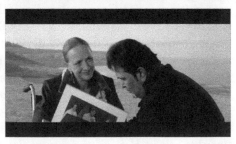

FIGURE 6. Still from *Chintu Ji* (2009): Rishi Kapoor meets Kseniya Ryabinkina, who reminisces about Raj Kapoor.

politics: covertly as an aspiring politician and overtly as a film star. Thus, the Hadbahedians—as voters and as fans—are simultaneously duped by a power-hungry representative of the state on one side and a profit-seeking representative of a media industry on the other, as they coalesce in the figure of a callously selfish film star who aspires toward electoral politics. The "Akira Kurosawa" song sequence

takes place as a production number in the middle of the film, and it is motivated by a film shoot within the film starring Chintu Ji on location in Hadbahedi. The producer within the film is especially thrilled to take advantage of the villagers, who are willing to play extras and even host and feed the cast and crew without any charge.

The comedic elements of the "Akira Kurosawa" sequence and *Chintu Ji* as a whole defamiliarize several past and present conventions of Hindi and Hollywood commercial films. Moreover, the "Akira Kurosawa" sequence playfully stages a familiar opposition between an auterist world cinema (often reductively con-flated with auteur Satyajit Ray with respect to Indian cinema)[13] and a song- and star-driven popular Hindi cinema in order to pay cinephilic homage to both. The sequence celebrates the audiovisual seductions of cinema, despite a host of for-mulaic clichés associated with its most crassly commercial forms—perhaps none more banal than that of the heterosexual marriage plot. At a climactic interlude during the number, Menaka kneels before the chieftain, cries, and points to the white captive, ostensibly requesting his release. To put a fine point on her plea, she produces a parchment drawing of figures to indicate that she is with child and that the captive is the unborn child's father. Aghast, the chieftain sighs before dramati-cally declaring, "Bonga Bonga! Satyajit Ray!" Like the titular Japanese filmmaker Akira Kurosawa, Indian filmmaker Satyajit Ray was celebrated in the West as an Asian postwar auteur. This particular gibberish—exceptional in the sequence as a spoken-masculine rather than sung-feminine utterance—is understood as an order to release the captive.

As an overtly commercial item number within the film, "Akira Kurosawa" positions the spectacular excess of feminine sexuality as the crux of both popular cinema's appeal and its divergence from the pretenses of art cinema. Alongside the conversion of master-auteur names into primitive gibberish, the rudimentary pictorial symbols on the parchment drawing extend an exaggerated (neo)colonial conceit of natives who lack intelligent language, whether spoken or written. For audiences who may not have realized that the earlier lyrics were in fact a string of auteur names, the declamatory "Satyajit Ray!" is nearly impossible to miss. After the extras comply with what is clearly an imperative to untie the white captive, all including the chieftain are shown to merrily dance together while a string of auteurs' names continue as the lyrics. Between the interlude and the conclusion of the four-minute sequence, the chieftain joins the couple's hands in an apparent blessing of their union; the couple goes off into a teepee; and they even manage to emerge posthaste with a baby in their arms.

As Menaka gyrates to a litany of world cinema auteurs' names throughout "Akira Kurosawa," the overall parodic subtext is that the eroticized, spectacular excess of the Hindi film song—here epitomized by the item number centered on feminine sex appeal—is so universally potent as to provincialize and render an entire masculine canon of world cinema as mere gibberish. But rather than

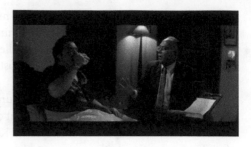

FIGURE 7. Still from *Chintu Ji* (2009): Rishi Kapoor attempts to humor a Bengali doctor's plodding readout of his screenplay.

exalting commercial cinema for its ostensible excess outright, *Chintu Ji* asks us to consider its merits *despite* its overtly profit-oriented formal strategies and exploitative labor practices. For *these* reasons, we are meant to understand the "Akira Kurosawa" sequence as absurd. And we are also meant to see that the most pretentious instances of art cinema are also absurd. An earlier scene, for example, portrays a stereotypically bookish Bengali doctor in Hadbahedi animatedly reading from a tome of a film script that he has written. Although the bedridden Chintu Ji attempts to humor the doctor's reading, the plodding, overwrought narration puts him to sleep almost immediately (fig. 7).

Slyly critiqued as most nonsensical, however, is the truism of such oppositions themselves: that Hindi cinema—even of an earlier generation—was somehow not world cinema, or that one would favor an outright dismissal of either art cinema or commercial cinema purely on the basis of their textual rather than socially embedded worlds. The oppositional setup in "Akira Kurosawa" between world cinema and commercial Hindi cinema ultimately comes undone in *Chintu Ji* around the memory of Raj Kapoor's popularity among audiences in the Soviet Union, which recalls the historical simultaneity of both cinemas' forays throughout the world. Satyajit Ray as a figure of (art) cinema in "Akira Kurosawa"—like Chintu Ji as a figure of (popular) cinema in *Chintu Ji*—is imbued with the potential of a medium that can join and shape collectivities anew through love/cinephilia. This love-as-cinephilia is posited in *Chintu Ji* as a force that transforms social relations through more equitably redistributing political power and material resources as those in power learn to become less self-serving and to genuinely care for and cede authority to their underserved constituents who seek to represent themselves.

Chintu Ji's stake is that of reclaiming a cinephilic history that does not let popular cinema off the hook in its political responsibility to its publics. The film ultimately poses a question that animates this book: In what ways was an earlier generation of world cinema and Hindi cinema more intertwined than opposed in their world-making ends, even if not always their means of exploring cinema's potential for shaping a more loving, egalitarian, collaboratively authored world in a nuclear age? More specifically, how might we seriously weigh the claim that popular Hindi cinema was uniquely disposed to shape such a world through its

very libidinal and scalar excess, as something that was commensurate with the excess of love that it could engender in turn? A mélange of films that may appear to be historical oddities—from low-budget comedies a bit like *Chintu Ji* to prestige productions, to failures, to remakes—reflexively asked this very question about cinephilia and the world over the 1960s. By attending to the historical contexts and gendered terms of the films' own arguments, I offer an answer that is worth considering, even if rarely straightforward with all its necessarily fraught qualifications.

Introduction

"Romance, Comedy, and Somewhat Jazzy Music"

In his 1977 *Experiment in Autobiography*, prolific Indian filmmaker and writer K. A. Abbas characterizes his choice to work within the Bombay industry as necessitating compromise on matters of form, for the expediency of reaching a mass audience of Indian spectators. As such, he was blindsided by the explosive success of *Awara* (*The Vagabond*, Raj Kapoor, 1951) not only within India but also abroad.[1] Abbas, who wrote *Awara's* screenplay and was known for his Left ideological alliances, led the first Indian film delegation to the Soviet Union in 1954. In recounting the trip, he reflects:

> We thought we had made a good enough film within the limits of commercial Indian cinema, offering its progressive social message (criminals are not born but are created by social injustice) rather attractively packaged in a pattern of romance, comedy, and somewhat jazzy music. It was a hit in India. But in our wildest dreams we had never expected that people steeped in the traditions of "socialist realism," who were familiar with the classics produced by such masters of realistic cinema as Eisenstein and Pudovkin, would take more than a passing interest in such a film.[2]

Abbas goes on to describe his interactions with Soviet audiences, in his attempt to understand why an avowedly—from his perspective—inferior Indian commercial film had excited Soviet audiences accustomed to the films of their own compatriots, who had masterfully inaugurated a great (rather than merely "good enough") political cinema. He is nonplussed by the irony of Russian audiences embracing Indian cinema at a time when Indian filmmakers like himself were drawing on Russian—among other European—models of political filmmaking, whether those of the avant-garde (e.g., Eisenstein and Pudovkin) or of socialist realism.

In a debate with a Soviet student, Abbas came to understand that perhaps audiences' immeasurable delight lay not so much in *Awara's* social commentary as in what Abbas had thought of as its packaging. "Instead of war," Abbas remembers

the student saying, "we want to see love on the screen, we want to see carefree happiness, we want someone to make us laugh. That's why we are crazy about *Awara*."[3] The exchange, emerging from the two parties' respective encounters with films from one another's contexts, captures diverging assumptions over what constituted *good* cinema in a postwar, post-independence Cold War period. For Abbas, an ideal cinema was—in order of priority—socially progressive, accessible to the working-class masses, and formally virtuosic.

A little more than a decade later, A. V. Meiyappan, founder of Madras-based AVM Productions film studio, strategically embraced the opposite claim: his Hindi-language films were intended to be wholly apolitical, and he was taken aback upon finding them unceremoniously caught up in a storm of protests. Purchasing a full-column advertisement in the *Times of India* to make his claim in great detail, he accused highly partisan factions of blocking Madras film producers' painstaking efforts to provide "mere entertainment" as a much-desired balm for turbulent times.[4] Meiyappan published his advertisement-cum-treatise in 1968, as political agitations had come to a head in both India and the world. Over India's second post-independence decade, searing disillusionment had pierced through any semblance of a postcolonial honeymoon. In a fractured world, India was a fractured nation whose cracks were on full display by the mid-1960s, following a humiliating defeat in a war with China, a struggling economy, the devaluation of the Indian rupee, workers' protests, and youth agitations under an increasingly authoritarian central government under Prime Minister Indira Gandhi.

At the time of Meiyappan's 1968 *Times of India* treatise, students in the South Indian Tamil-speaking state of Tamil Nadu had been protesting the North Indian imposition of Hindi as a national language, and they were targeting and shutting down screenings of Hindi films throughout the state. Meanwhile the Shiv Sena (Army of Shivaji) had sought to "reclaim" Bombay for disenfranchised, working-class native Marathi speakers. Espousing anti-migrant rhetoric against South Indians in Bombay, the Shiv Sena had attracted unemployed Marathi-speaking youth.[5] Bombay's cosmopolitan history and demographics notwithstanding, the coastal city on the Arabian Sea—and center of the Hindi film industry—was now within the state borders of Maharashtra, after the erstwhile Bombay State had split into two linguistically defined Marathi- and Gujarati-speaking states in 1960. In retaliation for the anti-Hindi protests that had blocked the exhibition of Hindi films in Tamil Nadu, Shiv Sena chief Bal Thackeray had incited the organization's *chitrapat shaakhaa* (film branch) to patrol theatres across Bombay and block screenings of not only Tamil-language films but also any Hindi films that had been produced in Tamil Nadu's capital city of Madras, the center of the Tamil-language film industry.[6]

A decade apart, Abbas's and Meiyappan's remarks unfold as reactions to unexpected encounters between their commercial films and a set of audiences beyond their respective industries' primary territories of distribution, whether internationally (in the case of Abbas) or intranationally (in the case of Meiyappan). Both

take the trouble to emphasize that commercial success has remained secondary in their endeavors, as they yoke the sheer scale of commercial cinema to an opportunity to widely disseminate social good of some kind. Abbas characterizes this social good as an explicitly ideological, progressive, political intervention, while Meiyappan characterizes it as an explicitly nonideological, apolitical one. As evidence for the absence of any self-interested motivations tied to financial gain, Meiyappan reveals that he promised all proceeds from Bombay screenings of his films to victims of the December 1967 earthquake in the city of Koyna, also in the state of Maharashtra. (Strategically, this aimed to portray Bal Thackery and the Shiv Sena as the more self-interested party, since the losses incurred by blocked screenings of Madras-produced films would ostensibly affect fellow Maharashtrian earthquake victims, rather than South Indians affiliated with the Madras film industry.)

This book takes seriously such claims, which avowed a commitment to social good through Hindi cinema's widespread popularity among audiences both within India and overseas. I neither take these claims at face value nor dismiss them outright. Instead, I trace the material histories and pressing ethical and political imperatives that demanded a reckoning with cinema's relationship to world-making over a long 1960s period. Abbas's and Meiyappan's remarks suggest a general historical trajectory of this period in an Indian national context, from a moment of optimism over India's place as a leader of the Non-Aligned Movement and Cold War–era peacekeeping to one of dimmed enthusiasm for the "Third World project"[7] and disillusionment with the Indian national project itself—much less India's potential to be any kind of world leader.[8] While this arc is not inaccurate, it is an incomplete picture in terms of the circuits and aspirations of Hindi cinema in the period between the Bandung Afro-Asian Conference in 1955 and Prime Minister Indira Gandhi's suspension of the Constitution and declaration of the Indian Emergency in 1975. Simply put, Hindi films in this period continued to enjoy and sustain immense popularity through ad hoc cross-border channels of distribution that eluded centralized control by either the state or even the Bombay industry.

Meiyappan's characterization of his films as "mere entertainment," akin to Abbas's characterization of *Awara*'s strategic packaging in "romance, comedy, and somewhat jazzy music," summons popular legacies of 1960s Hindi cinema: color, foreign locales, high romance, higher-octane jazz-and-rock-inflected music, and overtly commercial, escapist fare.[9] I revisit this period precisely to ask what "mere entertainment" might belie in terms of cinema's historical relationship to world-making. That is, how cinema mobilized collective imaginings and collective practices aimed at material transformations in the world through, rather than despite, "romance, comedy, and somewhat jazzy music." Cinema took on considerable diplomatic significance during the 1960s, amid the efflorescence of postwar art cinema, the mushrooming of film festivals, the growth of several postcolonial cinemas, and the proliferation of film initiatives that served various intelligence agencies' global Cold War interests as the US and the USSR vied for geopolitical

dominance. To fill in a more detailed picture of the broader significance accorded to cinema during this period, I turn to a set of Hindi films that entered their own arguments into a heated terrain of debate about cinema in the world.

I show, through a set of Hindi films' own reflexive engagements, that the figure of the singing dancer-actress came to embody the excess of Hindi commercial cinema: its capital excess as a commercial industry; its audiovisual excess as a music-and-spectacle-driven cinema; and its libidinal excess as a seductive cinema that was beloved by vast audiences both within the Indian subcontinent and across Eastern Europe, Central Asia, the Middle East, and the Indian Ocean world. The seemingly insatiable demand for Hindi films repeatedly bore the consternation of editorials and official reports from both within and outside India that painted the commercial song-dance films as siren-like: alarmingly noisy and nonsensical, if not dangerously seductive and utterly vulgar.

Repeatedly, Hindi films in this period rendered the figure of the singing dancer-actress as metonymic for the singing, dancing cinema. Through reflexive allegories, they defensively extolled not cinema per se but, more specifically, the love that Hindi cinema could engender en masse in the form of cinephilia. The gendered terms of these allegories posited Hindi cinema as a unique, feminine object of exchange, whose ostensibly immanent legibility and lovability across boundaries of language and nationality could bring together a world that was rent by material inequalities and national-cultural divisions. Love-as-cinephilia unfolds in the films as a thoroughly modern force and as path toward a world forged in principles of friendship, reciprocity, and collaboration in contrast to a global industrial modernity driven by self-interested, exploitative, (neo)colonial accumulations of capital. Often, this avowal of cinephilia was accompanied by a far more ambivalent stance toward the commercial film industry itself, portrayed as a less-than-ideal means to an idealized end.

I turn to a small set of films that may initially seem to be odd, atypical instances: prestige coproductions, low-budget comedies, remakes, and failures. I look at these films because they emerged from attempts to facilitate and deepen exchanges between film industries and their audiences, whether through explicitly progressive political commitments or through "mere entertainment." Together, these films reveal material histories of Hindi cinema's circulation within and beyond India, in addition to highlighting the importance of cinephilia as driver of collaboration and exchange between industries at the level of production and across audiences at the level of distribution. The homosocial character of film financing and distribution partly accounted for the films' allegorical idealization of a fraternal order in its imagination of how—and between whom—cinematic exchanges could shape the world anew.[10] Likewise, the figure of the singing dancer-actress emerged as metonymic for Hindi cinema's ostensibly immanent expressivity, legibility, and exchangeability, partly because several star actresses—particularly dancer-actresses—were well known for working across multiple languages and commercial industries within India.[11]

By closely scrutinizing the gendered terms—and gendered hierarchies of labor—of these films' own arguments about Hindi cinema in the world, I offer an account that looks with fresh eyes at world cinema, cinephilia, and the global 1960s via Bombay. Popular legacies of the global 1960s bring to mind a cocktail of political turbulence, paranoia, pleasure, and protest: "hippie" and countercultural youth rebellions, antiwar demonstrations, radical anticolonial struggles, the specter of nuclear annihilation, women's movements, civil rights mobilizations, liberal drug use, free love, jet-setters, and rock and roll.[12] I focus on Bombay (cinema) as a "nodal point"[13] of the global 1960s in order to consider what both love and cinema meant for shaping a world order that palpably hung in the air as a question during this Cold War period. I join other recent scholars that have turned to the Global South in order to reconsider Cold War–era histories in the everyday through perspectives, cultural practices, and locations beyond state-level diplomacy and beyond a focus on the superpowers of the US and USSR.[14]

The world as a biophysical, planetary totality was first revealed to the human eye in 1946, when the first images of Earth were taken from a US rocket launched from New Mexico. Theorizing world-making in an earlier historical period, Ayesha Ramachandran offers a poignant analysis of how in the absence of such ocular evidence, the world was rendered as a totality—that is, how cartographers, philosophers, and poets in early modern Europe conceived of the world as a whole and brought it into being on paper during an age of European maritime exploration and imperial expansion.[15] In following this particular strand of imagining the world, Ramachandran tracks a shift from a cosmological ordering in which the world referred to a totality of God's creation to a conception of the world as a discrete planetary entity shaped by man. Because the world could not be apprehended by the eye as a totality, Ramachandran insightfully underscores the role of the human imagination in rendering the world as a conceptual and material whole.

At the outset of the Cold War, the world as a totality was for the first time rendered both visible as an object of photography and vulnerable as an object—or what Rey Chow refers to as a target—of human-inflicted (nuclear) catastrophe.[16] The nuclear arms race and the space race produced technologies of unprecedented scale and spectacle, from the distances that rockets could go to the destruction that atom bombs could inflict. As such, ambitions of world-making from a variety of locations recruited a commensurate marshaling of technologies of scale. In this context, cinema operated as a potent vehicle for the exercise of soft power—in the case of, for instance, the global distribution of Hollywood films as well as the US Information Agency's public diplomacy films, technologies, and educational initiatives that aimed to win "hearts and minds" worldwide.[17]

Whether on the part of governments, industries, nonstate agencies, or individuals, perceptions of cinema as a potent medium of both influence and cosmopolitan engagement with the world at large was hardly without precedent.[18]

Instead, what changed in the postwar moment was the intensity of the stakes in which cinema was caught up, particularly as war-torn Europe and atom-bombed Japan faced the ascendance of the US as a superpower in the world.[19] The development of postwar European art cinema, the state-supported emergence of film festivals and delegations, and the proliferation of journals dedicated to film criticism formed the institutional foundations of world cinema, which in this period largely connoted an art cinema of social uplift that placed a premium on the visionary acumen of the director-auteur. In Europe, these initiatives were in no small part a response to the unprecedented geopolitical dominance of the US.[20]

Institutions of postwar European art cinema and criticism have had a foundational imprint on film studies as a scholarly discipline and on the historiography of cinema in contexts outside Europe.[21] This is evident in the canonization of certain films and filmmakers as belonging to the terrain of world cinema while others remained outside this domain. Despite *Awara*'s immense popularity across audiences both within India and overseas, for example, it was Bengali filmmaker Satyajit Ray's neorealist film *Pather Panchali* (Song of the little road, 1955) that yielded breathless, repeated praise for finally "put[ting] Indian cinema on the world map," following the film's acclaim in the West at a plethora of international film festivals.[22] Abbas, in his autobiography, articulates the axiom that "criminals are not born but are created by social injustice" as the key lesson he embedded in his screenplay for *Awara*. This message could just as easily describe the vaunted postwar Italian neorealist classic *The Bicycle Thieves* (Vittorio De Sica, 1948), which preceded *Awara* by only three years and famously inspired Ray's *Pather Panchali*.[23]

Awara and *Pather Panchali* (or for that matter, *The Bicycle Thieves*) may seem to be antipodes in terms of commercial versus art cinema or melodrama versus realism. Yet, as Neepa Majumdar has pointed out, the reduction of Indian art cinema to Ray, Ray to *Pather Panchali*, and Ray/*Pather Panchali* to the antithesis of commercial Indian cinema obscures the range and porosity of practices that constituted Indian art cinema and its commercial "others."[24] Among *Pather Panchali*'s varied legacies is its embrace of "anticommercial imperatives."[25] Despite Ray's own writings that decried the loose narratives and melodramatic proclivities of commercial Indian cinema, *Pather Panchali* did in fact draw on techniques of visual storytelling and melodrama from mainstream commercial Indian cinemas—namely, "the transfer of inner psychological and moral realities onto externalized icons . . . whose meaning is immediately legible."[26] In this manner, Indian filmmakers and critics working across a variety of practices were omnivorous in the influences that they engaged, debated, and drew into their own practices. This is evident in the careers of several filmmakers who in this period worked across multiple formal idioms, industries, languages, and scales of production: from experimental films to star-studded ensemble films, from song-dance films to songless films, from children's films to farcical comedies, and from state-sponsored films to commercial productions across language industries within India.[27] Such versatile

filmmakers included both Ray and Abbas, as well as Ritwik Ghatak, Hrishikesh Mukherjee, and Bimal Roy, among others.[28]

Continuities across the emergent Indian art cinema and commercial cinema over the 1960s notwithstanding, several commercial Indian films took great pains to reflexively dramatize and defend themselves as art and as not only grounded, but even as uniquely equipped to address pressing social issues in the world.[29] Several circumstances account for this defensive positioning, including the ongoing self-consciousness of being an other of not only Hollywood cinema but also of a properly modern, authentic Indian (art) cinema.[30] By the 1960s, the category of world cinema was well established through an auteurist discourse of art cinema and its attendant institutional networks of film festivals in and beyond postwar Europe.[31] In India, officials, filmmakers, activists, and audiences engaged with the category of art cinema and with developmentalist aspirations to modernize Indian cinema through a range of institutions that were established in this period.

In addition to the earlier establishment of the Films Division in 1948, which produced state-sponsored documentaries, the government inaugurated the first International Film Festival of India in 1952, the National Film Awards in 1954, the Film and Television Institute of India in 1960, the Film Finance Corporation in 1960, and the India Motion Picture Export Corporation in 1963, which, along with the Film Finance Corporation, was subsumed under the National Film Development Corporation created in 1975. Simultaneously, the Federation of Film Societies of India was established in 1959, as the film society movement took root across multiple centers nationwide. The term *film appreciation* captured the pedagogical side of these projects, which sought to refine Indian audiences' discerning capacities when it came to cinema, such that neither audiences nor filmmakers would be stuck in their holding pattern of what many regarded as an insufficiently modern—yet crudely tenacious—popular film form.[32] This is what Abbas had self-consciously described as "the limits of commercial cinema."

Alongside the proliferation of institutions of film culture in this pre-television period came the advent of color stock. The advent of color in Indian cinema brought a 1960s "postcard imagination" of consumption and leisure to the screen, with several big-budget Hindi films featuring an array of picturesque locales across and beyond the subcontinent.[33] Even as Hindi films of the 1960s oozed with the exuberance of color and romance, film production across India experienced tremendous volatility and precarity due to an economic crisis that culminated in the devaluation of the Indian rupee, rising costs of production tied to tariffs and expenses for importing color stock, and a standoff between film producers and distributors, as well as a number of political agitations—including the anti-Hindi protests that shut down screenings of Hindi films in Tamil Nadu and the retaliatory shutdowns of Madras-produced Hindi films in Bombay. Although the state had been investing in institutions of film culture, the Bombay industry was not among its primary beneficiaries.[34]

The state's developmentalist discourse contributed to a wider polemic that pitted a yet-to-be-realized state-sponsored, middle-class Indian cinema against mainstream commercial cinema. The middlebrow Indian new wave that emerged from the 1950s art cinema known as "parallel cinema" was defined by its difference from commercial cinema, even when in practice, there was constant movement and overlap between the two. The corollary middlebrow discourse of film appreciation veered toward colonial, need-based theories of reception, which held patronizing assumptions about certain segments of the population (e.g., girls, women, rural communities, the urban poor) being especially prone to acting on base instincts, against their better judgement.[35] Where mainstream commercial cinema had purportedly taken advantage of the masses by tailoring itself to these baser instincts, film appreciation proposed civilizational training by which the masses would learn to resist and overcome an inferior cinema's cheap seductions.

As Hindi films themselves engaged with this polemic over a period of intense volatility, I show how some films offered counterarguments premised upon the deification of love as an ethical horizon. Rather than a sign of backwardness, libidinal excess was defended as a marker of true love, which was in turn put forward as a thoroughly modern ideal. Often, this argument surfaced through compulsive, melodramatic disaggregations of love from lust, truth from artifice, friendship from exploitation, inner substance from superficial beauty, and music from noise.[36] All of the latter—lust, artifice, exploitation, superficial beauty, and noise—constituted the very terms with which the Hindi film industry was frequently denigrated as a debased hotbed of immoral excess. The films' defensive counterargument was that Hindi cinema could produce a libidinal excess of love that was qualitatively and quantitatively unmatched, in the iteration of cinephilia. After all, excess was the mark of an embodied truth in matters of love, and love-as-cinephilia could be experienced and distributed on a scale that could rise to the occasion of drawing together a fractured nation and world.

In tracking the persistence of love as an argument about excess and cinephilia over the 1960s, I build on Arti Wani's insightful study of love in Hindi cinema of the previous decade.[37] Wani's analysis proceeds from two keen observations. Firstly, despite the prominence of romantic love in Indian cinema, focused scholarly attention on love as a specific phenomenon in Hindi cinema has been relatively scant. Secondly, as also noted by literary scholar Francesca Orsini in a longer cultural history of love in South Asia, Wani points to the outsized prevalence of romantic love and free-choice romantic couplings in a textual domain (of mass entertainment, in the case of popular cinema) in contrast to its far more muted embrace in the domain of everyday practice.[38]

Wani suggests that in the case of Hindi cinema, caste may be the central present absence historically, as a ubiquitous subtext and structure that was seldom

represented in explicit terms.[39] She surmises that caste may have been the primary material context that drove romantic love's overwhelming presence and celebration onscreen as a fantasy of modernity, while being withheld as a lived experience for many in terms of everyday practice.[40] Caste, as a structure of accumulation that rationalizes inequality through shape-shifting ritualized and secularized practices of touching/not touching, has depended upon vigilant control over women's sexuality for its social reproduction.[41] Thus, on the one hand, free-choice romantic love carries the radical potential for going against the mandates of socially prescribed practices that have demarcated caste boundaries through the regulation and control of sexuality. On the other hand, however, images of romantic love in Indian popular cultures have privileged upper-caste Hindu middle-class conjugality as an unmarked ideal, which unfolds as an ostensibly progressive, secular, modern practice of free choice.[42]

Navaneetha Mokkil presciently notes that "the possibilities of being publicly recognized as a desiring and desirable subject and the ease with which an individual can be projected as an icon of romance and agency is coterminous with caste privilege. The structure of caste grants greater autonomy, mobility, and desirability to certain sections of the population."[43] Many have argued that the "woman question" of Indian modernity is thus inseparable from the "caste question" in colonial and national discourses that constructed upper-caste Hindu womanhood as the inviolate "inner" essence of national identity.[44] This dominant national discourse, which placed "the woman as the emerging figure of modernity in need of containment,"[45] put immense pressure on narratives of Hindi films. The dominant post-independence form of the social frequently labored to rhetorically neutralize—most often, through narratives of middle-class, upper-caste conjugality—one of the most palpable hallmarks of the Bombay industry's excess: the spectacularly public, sensual presence of the star actress.[46]

Ideological critiques of mainstream cinemas' privileging of a "male gaze" have been an important contribution of feminist film theory and Marxist apparatus theory.[47] Critiques of this influential work are also important in rightly noting the privileging of binary gender difference over other kinds of difference in theories of spectatorial identification.[48] While much of 1970s feminist film theory took a position of deep suspicion toward spectatorial pleasure vis-à-vis mainstream (particularly Hollywood) cinema, subsequent feminist critiques of this work have offered important considerations of spectatorial pleasure as potentially—though never automatically—liberatory.[49] Additional rejoinders have noted that even if a cinematic apparatus ideologically constructs dominant spectatorial positions of identification (e.g., that of the "male gaze"), the spectator themselves may or may not occupy these positions in a predictable manner.[50] I take Hamid Naficy's reflections over third-world film spectatorship and ideological "haggling" as a particularly instructive model, which accounts for spectatorial agency without denying the ideological power of images.[51] Seemingly oddball Hindi films that emerged

from cross-industry ventures over the 1960s offer a chance to examine a range of contemporaneous ideological pressures, especially as these pressures were shaken up through the acts of translations that ensued from the involvement of multiple industries, intended audiences, and idioms of cinema.

In the 1957 India-USSR coproduction *Pardesi* (Foreigner; aka *Journey beyond Three Seas*, K. A. Abbas and Vasili Pronin), for example, uncharacteristically explicit invocations of caste are juxtaposed with the more commonplace representation of feudal structures of class, as grounds for "homosocialist" solidarities between the toiling Russian peasant and the Indian Dalit against their feudal and upper-caste brahminical oppressors. In a string of Madras-produced Hindi remakes of Tamil comedies, the romantic couple often comes off as an exaggerated caricature, if not a comedic cliché that spoofs and sidelines their centrality. In the 1972 India-Iran coproduction *Subah-O-Sham* (From dawn to dusk)/ *Homa-ye Sa'adat* (Bird of happiness), Tapi Chanakya, 1972), the predominantly Muslim characters are depicted as ultramodern, and their Muslimness remains largely unmarked and inconspicuous.[52] This was unique in that it went against contemporaneous tendencies of Hindi cinema toward either tokenistic representations of Muslims as side characters along binaries of "good" versus "bad" Muslims or nostalgic "Muslim socials" set in bygone eras, such as *Mughal-e-Azam* (*The Great Mughal*, K. Asif, 1960) and *Pakeezah* (*The Pure One*, Kamal Amrohi, 1972).[53] Across these instances, love is theorized as a libidinal excess that is thoroughly modern, yet vociferously distanced from the excess of capital gained through extraction and exploitation. I pull this out as a reflexive argument about popular cinema and cinephilia, as it sought to distinguished the authenticity, social value, and moral value of cinephilia from the financially motivated constraints of the industry.

This theorization of the value of popular Hindi cinema privileged the sincerity and scale of pleasure afforded by a consensual, dynamic relationship between the seductive cinematic object and a spectator who is *willingly and knowingly* seduced by its artifice, beyond and despite the transactional, monetized terms of their encounter. This is an especially important counterclaim because it addressed a far more agential viewing subject than the one imagined either by contemporaneous developmentalist projects of film appreciation or by Hindi films' representational tendencies to idealize specific kinds of subjects. This more agential addressee was also one of two minds, as the defensiveness of the films' arguments about cinema suggests polarities of a spectator who is at once deeply cinephilic and deeply cinephobic. Cinephilia, here, is proposed as that "something" that is embodied and authentic in its vitality and critical awareness. It is posited as an excess that is inadvertently produced by a commercial industry, yet crucially escapes its commoditization.

Excess as a term denotes a range of interventions across both cinema studies and studies of sexuality, and it has been conceptually significant to South

Asian (cinema) studies in particular. I retain multiple valences of excess as a set of historical and disciplinary debates over cinematic form, idealized bodies, and hierarchies of value. This is in keeping with feminist commitments to vigilance against the naturalization of social hierarchies—including those of but not limited to gender—lest they appear uncontested and ahistorical. Kristin Thompson's well-known formalist definition of cinematic excess is premised on the narrative unity of classical (i.e., Hollywood) cinema.[54] Stating that excess tends to elude analysis, she defines excess as that which is unmotivated and thereby counter-narrative and counter-unity. However, this formalist definition does not account for the ways in which excess, as well as notions of classicism, are historically contingent on regimes of power and (aesthetic) value. Masha Salazkina's historiography of Sergei Eisenstein's unfinished film ¡Que viva México! is an example of a formalist approach to cinematic excess that emphasizes the inextricability of excess from dominant institutions of power, as she takes up Raymond Bellour's notion of a "textual unconscious" to consider elements that escape both systematization into economies of meaning and inclusion into easy or definitive historiographies.[55]

Linda Williams's theorization of excess is among the most methodologically pertinent to analyses of popular Indian cinemas. She focuses on "body genres" of horror, pornography, and women's melodramas that are often regarded as gratuitous vis-à-vis the "classical realist style of narrative cinema."[56] She links the ostensible excess of body genres to the spectacular onscreen feminine body's centrality in the production of spectatorial sensations and to the wider assumption that spectators' bodies automatically mimic the involuntary sensations being represented onscreen—such as fright, sexual arousal, or pain/weeping. In surmising that gendered, bodily associations account for these genres' low cultural status, she urges caution in uncritically assuming either what spectators' bodies do, how they are gendered, and how they experience pleasure, or that these genres are indeed "excessive" and gratuitous. Excess in this sense must be understood through the dominant historical contexts that frame its status as such, in opposition to what remains unmarked as purported "non-excess."

For scholars of popular Indian cinema, excess has been a key term for presenting historical and theoretical debates over both film form and public displays of feminine sexuality. Rather than a face-value descriptor, excess points to dialectics of value, seeing, and sensing in Neepa Majumdar's history of gender and stardom, for example, as well as in Arti Wani's analysis of love in 1950s Hindi cinema and Usha Iyer's study of dancer-actresses.[57] Melodrama appears as excess in relation to realism; formal elements like song sequences appear as excess in relation to narrative structures of classical cinema; and spectacles of performing women appear as excess in relation to idealized upper-caste middle-class Hindu women whose sexuality is confined to the private space of conjugality.[58] The latter concern overlaps with Durba Mitra's recent work on sexuality and the social sciences in modern India, which she frames as a historiography of excess. Excess, in her account, is

indelibly linked to the archival excess of deviant women in social scientific knowledge produced by colonial and Bengali men, whose obsessive production of all Indian women as potential prostitutes carried the authority of social scientific fact.[59]

While Mitra's account is not concerned with cinema, it nonetheless lends crucial historical context to administrators' preoccupations with deviant women from colonial through post-independence periods. Similar preoccupations have centrally structured discourses and taxonomies of excess in relation to specific star bodies and popular cinema on the part of detractors as well as defenders.[60] Excess is invoked as similarly attached to marginalized bodies in Navaneetha Mokkil's much more contemporary analysis of sexual subjects and sexual figures—namely, the sex worker and the lesbian—in the southwestern Indian state of Kerala.[61] Another valence for excess emerges in Ashish Rajadhyaksha's theorization of the ontology of celluloid cinema itself, proposed as a dialectic between excess and containment.[62] In his theorization, containment invokes the material structure of both the film frame and the movie theatre, while excess points to "how cinematic exchanges trigger off something that can spill over into extra-textual and other social spaces."[63]

Whether in reference to aesthetic forms or to bodies, excess tends to belie hierarchies of difference that are structured by what is privileged as *non*-excess: as unmarked. As this privileged center is contested, so, too, are notions of excess. In the case of film form, excess has historically invoked women's genres and "low" body genres,[64] as well as elements perceived to be in excess of formal and aesthetic ideals that are ostensibly authentic.[65] While often tied to ideals of Hollywood classicism, the privileging of formal unity further crystallized through an influential postwar European discourse of world cinema, which denoted an auteur-helmed, realist cinema in the postwar period.[66] Contemporaneous accounts of Bombay films' overseas reception, however, show that boundaries between excess and realism—the latter understood as grounded in a material context that may or may not align with modes of realist aesthetics—to be contingent and contested rather than fixed.[67] The cross-industry productions I examine entered their own arguments perceptively and reflexively into this terrain of debate.

In considering Hindi cinema in the world of world cinema over the 1960s, I trace a historical and theoretical tension between three kinds of excess: the excess of bodily difference, the excess of form, and the excess of capitalism. All three privilege a universal, modern subject against whom excess is defined: he is unmarked by the bodily excess of race, gender, caste, and class; he is constituted as the individualized subject of realist perspectival relations; and he is a rational, productive agent of choice within an efficiently industrialized economic order. I look at how a number of Bombay films reflexively and simultaneously grappled with these interrelated excesses in the post-independence, Cold War period—that is, the libidinal excess of (especially feminine) star bodies, the formal excess of spectacle-driven

audiovisual forms, and the capitalist excess of profit-oriented mass production and consumption, over a period still marked by nominal commitments to ideals of Nehruvian socialism as well as Gandhian austerity. By lyrically extolling cinephilia—rather than cinema—as their product, these productions sought to actively theorize and argue their own role in the world.

I join Sarah Keller, among others, in seizing cinephilia as an opportunity to think more expansively, beyond its origin points, about love for cinema through manifold histories and practices.[68] In her poignant, wide-ranging history of cinephilia, she notes the term's emergence in 1920s France and later resurgence in the postwar period as "French cinephiles' efforts to reclaim the cinema (even popular cinema) for art . . . focused its amorous attention on cinema's expressive, image-oriented (rather than literary) abilities, its unique purview, and its untapped potential . . . wrought for the most part by professional critics and filmmakers rather than by laypersons."[69] While she surmises that high-low culture distinctions between the cinephile and fan have perhaps lain in their respective specializations in cinema versus stars, she acknowledges that this distinction is often untenable.[70]

Much work on cinephilia has maintained an emphasis on writing as a primary form of the cinephile's amorous expression.[71] This can exclude important phenomena like Hindi film songs, which have been primary interfaces for participatory, cinephilic engagements that are irreducible to star adulation alone. My account marshals love lyrics in a longer history of South Asian oral cultures and in Hindi cinema as an undertheorized element that has much to contribute to histories and theories of cinephilia. This is an especially important consideration in contexts where oral practices like poetry and song have been an important vernacular site of knowledge production, especially for those who were excluded from opportunities to read and write.[72] Onscreen romance unfolds in several moments as tongue-in-cheek paeans to love-as-cinephilia, in defense of the spectators' affections and screen objects' solicitations despite the circumstances of an explicitly transactional affair involving an industrially produced commodity. How, why, and where these ekphrastic arguments arose over the 1960s—that is, rhetorical details and claims about cinema within a set of films—sustains my inquiry, as it occasions a textual and material history of cinema and cinephilia in the context of Hindi films' highly mobile, prolific circulation both domestically and overseas.

Sirens of Modernity is structured in two parts. In part 1—"Establishing Shots: World Cinema in Tongues," I move from the category of world cinema to the lyrical trope of the "City of Love." I juxtapose the claim that songs drove Hindi films' immanent widespread legibility among less educated audiences in the world (chapter 1) with a genealogy of song lyrics that demonstrates the significance of lyrics and songs as key interfaces for collective, critical reflections propelled by cinephilia (chapter 2). In part 2—"Star-Crossed Overtures: Cinephilia in Excess,"

I look at a set of cross-industry productions over the long 1960s, including India-USSR and India-Malaya coproductions (chapter 3), a set of Madras-produced Hindi remakes of Tamil comedies (chapter 4), and an India-Iran coproduction (chapter 5).

Throughout the book, I turn to press sources, trade journal reports, parliamentary proceedings, memoirs, and archival ephemera that shed light on material histories of Hindi films' prolific circulation both within India and overseas. I read these sources critically as anecdotal fragments,[73] alongside films, song sequences, and song lyrics that offer reflexive, allegorical commentaries on their (gendered) contexts of collaboration and aspirations of worldmaking through cinephilia. My emphasis on networked histories complements the insights of a recent collection of essays edited by Monika Mehta and Madhuja Mukherjee, which compellingly makes the case that cross-industry circuits are a rule rather than an exception in the history of Indian cinema, if not the history of cinema more broadly.[74] It is as a specialist of Hindi cinema that I am approaching a particular set of cross-industry productions over the long 1960s. Debates over cinema's role in the world—and the world's role in cinema—raged across manifold locations as well as languages in this period. I hope to capture some sense of these debates' vociferousness by reading a set of Hindi films as enthusiastic and argumentative participants.

Chapter 1, "Problems of Translation: World Cinema as Distribution History," offers an overview of how the category of world cinema gained traction during a crisis of distribution in postwar Europe. Through a review of historical and scholarly work on cinematic translation, I emphasize language translation as one aspect—but not always an essential or primary one—of distribution over the 1960s. Hindi films' overseas circulation in this period invited contradictory claims in Anglophone press accounts: on the one hand, film songs were noted as propelling Hindi films' circulation regardless of dubbing or subtitling; on the other hand, film songs were identified as the roadblock that hindered the films' comprehensibility, particularly in the West. Explanations for this contradiction tended to reproduce (neo)colonial, racialized, classist theories of reception, which naturalized cinematic forms of ostensible excess to audiences and places perceived as backward. Such explanations assumed that musical films were immanently legible through the body and thus crude. I consider other explanations that might account for Hindi films' overseas popularity in this period: from the films' cheap availability through ad hoc and informal distribution channels, to their tendency to narrate interior conflicts through their external visualization,[75] to their musical expressivity. These elements constituted not an underdeveloped cinematic language but a vernacular whose narrative and sensorial modes of expression surely invited contemplation as well as sensorial pleasure.

Chapter 2, "Moving toward the 'City of Love': Hindustani Lyrical Genealogies," observes that while Hindi song lyrics were not always translated, they reveal witty, ekphrastic participation in post-independence debates over the Bombay-based

cinema's questionable legitimacy as a national form. I contextualize these debates in a 1930s prehistory of the anti-colonial All-India Progressive Writer's Association, many of whose members worked as lyricists and writers in the Bombay industry.[76] I show that film song lyrics in the early talkie period drew on premodern genres and tropes of love poetry—such as *prem nagar* ("City of Love")—to defend cinematic forms of alleged artifice. Romantic song lyrics reflexively pointed up the noisy exuberance of romantic love—as a horizon of universality and intimacy, beyond language—that the urban machine of popular cinema could manufacture for the world en masse, in the modern incarnation of cinephilia. Premodern lyrical antecedents of the cinematic "City of Love" offer a comparative historical perspective on the potential as well as limits of cinephilia, regarding love as an ethical praxis for translating critical reflection into collective action toward radically egalitarian forms of sociality.

Chapter 3, "Homosocialist Coproductions: *Pardesi* (1957) contra *Singapore* (1960)," focuses on the elaborate 1957 Indo-Soviet coproduction *Pardesi*, the first of a handful of high-profile, star-studded coproductions via the Bombay industry over the long 1960s. In each of the transnational prestige productions examined in the book, the endeavors of coproduction are reflexively rendered in melodramatic registers within the films, wherein the figure of the singing dancer-actress becomes metonymic for Hindi song-dance films that had been circulating among contemporaneous audiences—both diasporic and non-diasporic—through multiple second- and third-world contexts. Within a dialogic arena of debate over both world cinema and cinema in the world, I note *Pardesi*'s implicitly gendered casting of Hindi cinema as a feminine token of exchange, embodied by the singing dancer-actress whose charms are defensively extolled in service of "films for friendship," in codirector Abbas's words.[77] To the latter end, *Pardesi* melodramatically and reflexively divorces its own coproduction from profit-driven strategies of cofinancing, instead embracing both coproduction and the formal idioms of popular Hindi cinema as means of forging embodied homosocial(ist) bonds between audiences of the world against the backdrop of the Cold War. I end by juxtaposing the ambition of *Pardesi* with that of the Indo-Malay coproduction *Singapore* (1960) in order to emphasize the two contemporaneous coproductions' distinct ambitions and overlapping contexts of production and distribution.

Chapter 4, "Comedic Crossovers and Madras Money-Spinners: *Padosan*'s (1968) Audiovisual Apparatus," continues chapter 3's exploration of cross-industry productions through an account of commercial remakes of films across languages and industries within India. In a parallel to the discourse of world cinema in Europe, a 1960s discourse of world cinema in India was partly motivated by an especially acute crisis of revenue loss in the Madras industry. Thus, the advocacy of world cinema on the part of Indian industry affiliates was simultaneously an advocacy for collaboration, support, and exchange across commercial language industries and their respective audiences within India. This context gave rise to

a set of Hindi remakes of highly reflexive 1960s Madras studio comedies, which critics decried as "money spinners" for their comedic excess.

Comic superstar Mehmood was a preeminent attraction in several Madras-produced Hindi comedies. His stardom—and histories of Hindi film comedy generally—remain virtually absent in scholarly accounts of Hindi cinema. Unraveling the manner in which Mehmood's home production, the 1968 hit comedy *Padosan* (Girl next door) is structured around a mise en abyme of the window as cinematic apparatus within the film, I pull out the film's own arguments about cinema, authorship, and form in defense of material practices of playback recording and histories of nonprofessional, amateur labor alongside classically and professionally trained film workers in the Bombay industry. I contextualize my reading of *Padosan* in histories of Indian cinema of the 1960s—a decade in which the "parallel" Indian art cinema established its foothold—to underscore the window as a key stand-in for cinema upon a threshold of modern sexuality, epitomized by the urban problem of noise and related legal debates over noise regulation. Interweaving a comparative analysis of noise, sexuality, and the apparatus of the window in the 1970 parallel film *Dastak*, I emphasize *Padosan*'s polemical meta-commentary upon the belovedness of the Bombay industry's cacophonous, vulgar seductions.

Chapter 5, "Foreign Exchanges: Transregional Trafficking through *Subah-O-Sham* (1972)," connects practices of production across commercial industries within India to the instance of the 1972 India-Iran coproduction *Subah-O-Sham*. The film's Telugu director Tapi Chanakya had by then remade the hit Telugu comedy *Ramudu Bheemudu* (1964) as Madras-produced hits in both Tamil and Hindi with *Enga Veettu Pillai* (1965) and *Ram Aur Shyam* (1967). The film's heroine is a trafficked singer-dancer from India living in Iran, played by Indian film star Waheeda Rehman, whose film debut had in fact been as a dancer in Tapi Chanakya's 1955 Telugu film *Rojulu Marayi*. I connect the meta-cinematic registers of *Subah-O-Sham* to a material history of third world celluloid smuggling networks. Through archival documents and press sources, I trace the Indian state's contemporaneous attempts to crack down on a film smuggling scheme by which "blue films," or exploitation films, were being clandestinely imported from the Middle East as the cheap celluloid waste that constituted a raw material for manufacturing plastic bangles, which were exported in large quantities for valuable foreign exchange.

I highlight the resonances between *Subah-O-Sham*'s reflexive defense of the trafficking of Indian films in the Middle East and the contemporaneous scandal of celluloid bangles. Laden with overtones of unconstrained feminine sexuality, celluloid bangles were a colorful, modern alternative to the married woman's much more audible glass bangles. In both cases, forms of audiovisual artifice—blue films that appear as mere waste headed for the bangle factory; colorful celluloid bangles that are decorative but do not chime—enable material circuits that exceed boundaries of the licit and sanctioned. To acknowledge and defend the

promiscuous excess of both cinema and modernity, *Subah-O-Sham*, I show, reflex-
ively renders the Hindi song-dance film in the incarnation of an irresistible femi-
nine catalyst toward a post-national future forged in an ethos of fraternity.

Centering cinephilia as both a practice and a vibrant ekphrastic discourse
through Hindi films allows me to put pressure on historiographies and theories
of cinephilia that siphon off engagements with the popular, particularly when the
latter is star-centered. *Ekphrasis* generally refers to a rhetorical device: a verbal
description of a visual object. W. J. T. Mitchell parses ekphrasis as a method of
contemplating the relationship between the verbal and visual, of the symbolic
(language) and iconic (image).[78] Across several periods, Hindi commercial films
have vividly described cinema.[79] This underscores not only a separateness between
the "thing" and its description (even if the description is occurring within a film)
but also the status of such description as an explicitly rhetorical strategy. Mitchell
further notes that "insofar as art history is a verbal representation of visual repre-
sentation, it is an elevation of ekphrasis to a disciplinary principle."[80] I embrace this
as a reminder that academic disciplines constitute merely one site of knowledge
production, along a continuum of energetic critical engagements with cultural
forms. It is in this spirt that I engage Hindi films' own ekphrastic claims about
cinema in the world.[81]

Establishing Shots

World Cinema in Tongues

Problems of Translation

World Cinema as Distribution History

Geoffrey Nowell-Smith's editorial introduction to *The Oxford History of World Cinema* opens with a quote from Paul Rotha, a British filmmaker who was also a prolific and influential film critic and historian: "The cinema, wrote the documentarist Paul Rotha in the 1930s, 'is the great unresolved equation between art and industry.'"[1] Among Rotha's publications were two volumes titled *The Film Till Now: A History of the Cinema* and *Movie Parade: A Pictorial Survey of the Cinema*, first published in 1930 and 1936, respectively. When they came out in subsequent postwar editions, their subtitles featured a curious alteration: the first was reprinted in 1949 as *The Film Till Now: A History of World Cinema*, and the second in 1950 as *Movie Parade: A Pictorial Survey of World Cinema*.

Across film scholarship and pedagogy, the term *world cinema* appears in a variety of iterations: a descriptor contrasted to national cinema; a catchall "foreign" film or survey-course category; and a vehicle for exploring canonicity, transnational genealogies of form, and transnational histories of circulation.[2] This chapter examines an institutional genealogy of world cinema as a particular history of world cinema that emerged in postwar Europe from the problems and possibilities of distribution in translation. I look more closely at why commercial Indian films, despite their prolific circulation overseas, were often excluded from any serious consideration as world cinema. Transnational Anglophone discussions of commercial Indian cinema often diagnosed the films' dependence on songs as an index of the cinema's underdevelopment and incoherence. That is, the films did not translate well. Paradoxically, songs were also identified as the element that drove Indian films' overseas circulation regardless of language translation. That is, the song-filled films were immanently comprehensible and required no translation.

World cinema's postwar cachet as a category on the one hand and the prolific overseas circulation of Hindi films on the other invite conceptual and his-

torical reconsiderations of film distribution as an issue of translation. This also sets the stage for a 1960s period in which institutions of cinema proliferated as a response to crises in both global Cold War contexts and Indian national contexts. Twentieth-century Europe has been a key site for analyzing histories of media distribution in a multilingual context. Accounts of world cinema have much to gain, however, from considering the contemporaneity of not only Hindi films' prolific circulation among worldwide audiences but also tensions over their circulation and even dominance across robustly multilingual contexts both within and outside India.

Film festivals and European art cinemas mushroomed as various new waves rippled across the globe in the postwar decades amid larger geopolitical shifts, all of which were registered by the slight, yet nonetheless crucial editorial shift in Rotha's titles—that is, in the shift from "the cinema" to "world cinema."[3] Yet, in the 755 pages of *The Film Till Now: A History of World Cinema*, only three pages, under a section titled "Films from Other Countries," deal with cinemas outside Europe and North America.[4] Rotha and co-author Roger Manvell open their preface to the 1950 edition of *Movie Parade* by noting that "since the first appearance of this book in 1936, the cinema has added to its world audience and hence to its social influence."[5] The previous edition's preface, meanwhile, observes that "in almost every country in the world, there have been made thousands of films."

Between 1936 and 1950, the two editions' characterization of the relationship between cinema and the world changed not in any significant consideration of films from contexts outside Europe and the US but from the earlier acknowledgment of the universality of film *production* around the world to an emphasis on the expansion of an *international audience* for cinema and hence, its "social influence" throughout the world.[6] The second edition's suggestions of a new world order and of a moving-image medium that had "added to its world audience and hence to its social influence" highlight links between the aftermath of the Second World War; the proliferation of newly independent, formerly colonized nations; and the Cold War division of the globe into first, second, and third worlds in the shadow of the US's increasingly interventionist, militaristic positions throughout the world.

In earlier periods, US films had enjoyed substantial popularity in European markets, first in the 1910s and again after World War I.[7] After World War II, however, US film companies' dominance in Europe was unprecedented.[8] In turn, as Mark Betz notes:

> A certain kind of film culture was fostered in the first three postwar decades (and reached its apogee in European art cinema of the 1960s) that has shaped our understanding of cinema ever since. For during this decade the idea that filmmaking was a personal form of artistic expression combined with the *international film marketing* of European films in ways that distinguished the latter as more than mere commercial entertainments—and in ways that have indelibly stamped both the history of the cinema and the practices of Anglo-American academic film studies.[9]

Betz further underscores the specificity of this moment in the fact that since the development of synchronous sound, language translation had come to occupy a central role in film distribution. World cinema, as it emerged in postwar Europe, was fundamentally a project of a new kind of cinema that was premised on distribution in translation. European national-popular cinemas, meanwhile, tended toward continuity rather than rupture with prewar film narratives, forms, and themes.[10] Here, too, however, language remained a crucial boundary that marked each popular cinema's identity and postwar success in their drive toward nationalization in the face of Americanization.[11]

Scholarly treatments of cinematic language translation have tended to focus on one or both of two moments in the history of cinema: the coming of sound in the late 1920s and the postwar decades that saw the rise of European art/auteur cinema and the manner in which it was "internationally market[ed]" to audiences of different language backgrounds.[12] The international marketing of European films occurred alongside—and to a large degree in response to—US film companies' postwar dominance of European markets, which reprised their earlier climb during the late-1920s moment of cinema's transition to synchronous sound. Histories of cinematic language translation have been overwhelmingly plotted along the axes of firstly, Anglophone Hollywood's ventures into non-Anglophone markets and secondly, the polyglot space of European cinemas.

In a section of *Cinema Babel* titled "Babel—the Sequel," Markus Nornes chronicles the myriad debates and strategies through which producers, distributors, and audiences negotiated acute, high-stakes questions of cinema and translation, spawned by the coming of the talkie in the late 1920s.[13] In Nornes's account, as in those by Antje Ascheid, Martine Danan, Kristin Thompson, and Mark Betz, the heavyweight in the ring was Hollywood, whose producers and distributors had everything to gain (or lose) by successfully surmounting (or failing to surmount) the languages barriers that had sprung up with the talkie, as dialogue had suddenly became a core component of cinema's appeal.[14]

In this moment of "Babel—the Sequel," early Hollywood-led translation strategies included internationally distributing talkies in silent versions; inserting translations of dialogue sequences throughout a talkie in the form of dense intertitles; producing multiple-language versions (MLVs) of films that were shot two or more times in multiple languages, either with the same or different sets of actors; and employing the Dunning process of using matte backgrounds against which to shoot actors from different parts of the world for producing versions in several languages.[15] Nornes notes that in Japan *benshi*, or storyteller-performers whose narration had been integral to silent-era films, initially attempted to do the same with imported talkies—whether by narrating in place of the (muted) soundtrack, narrating simultaneously over audible dialogue in another language, or having the

projectionist stop and resume the film at multiple points so that the *benshi*'s narra-tion-translation could be intermittently squeezed in. Another translation strategy attempted in Japan was placing an extra screen next to the main screen and using a magic lantern to project translations as side titles. This strategy endured for some years in China, although the above processes were ultimately discarded for being unwieldy in terms of production costs, for being poorly received by audiences, or for a combination thereof.[16]

Distribution strategies of dubbing and subtitling arrived as the most viable solutions for the language-translation issues that plagued what Nornes terms "Babel—the Sequel." Far from being a universal problem for cinema, however, the difficulty of neutralizing language barriers was welcomed as a boon by several postcolonial, third-world, and smaller-scale enterprises, that finally had a com-petitive edge over Hollywood and other major producers by being readily poised to make films in local languages.[17] In these cases, audiences' familiarity with a film's language was a critical selling point, even if its production values were much lower.[18] This competitive edge did not always outlast the efforts of larger indus-tries. In each national and regional context, issues of cinematic translation at these key moments—during the years following the late-1920s transition to sound and during the aftermath of World War II that marked the independence of several formerly colonized nations—played out through a combination of related factors that included state policies, language regionalisms and language nationalisms, and political economies of production and distribution.

Martine Danan treats dubbing versus subtitling as a question of national preference, depending on state policy and on the mode of translation to which a particular national audience is most accustomed. She, too, locates the axis of Hollywood-European cinema as a primary context for entering the issue of cin-ematic translation. She highlights the technological capital involved in the talkie transition, noting that "when sound film started to become popular around 1930, American companies had a monopoly on the recording equipment and, for a few years, tried to prevent European countries from competing with them."[19] Ulti-mately, Danan concludes:

> Dubbing is an attempt to hide the foreign nature of a film by creating the illusion that actors are speaking the viewer's language. Dubbed movies become, in a way, local productions. . . . Subtitling corresponds to a weaker system in which a nationalistic film rhetoric and language policy are promoted equally. Suppressing or accepting the foreign nature of imported films is a key to understanding how a country perceives itself in relation to others, and how it views the importance of its own culture and language.[20]

While Antje Ascheid, too, argues that the foreignness of dubbed films is mitigated by the sense that the actors are speaking a target audience's own language, her emphasis in comparing dubbed versus subtitled films shifts from Danan's primary

concern with differences in state-driven cultural policies to a concern with differ-
ences in the effects of subtitling versus dubbing, as experienced by spectators.[21]
Ascheid argues that while a sense of the "original text" being translated pervades
subtitled films, dubbed films appear as originals. However, two related issues chal-
lenge this assertion—the first having to do with race, which Nornes raises briefly,
and the second having to do with the history of realism and national identity in
European art cinema, which Betz treats at length.

Ascheid, for example, mentions that a montage of clips from several well-
known Hollywood films were edited for an Academy Awards ceremony with the
intent to amuse audiences. What was meant to (and did) amuse US audiences was
that "every star that appeared onscreen, from Fred Astaire to John Wayne, from
Bette Davis to Meryl Streep, had been dubbed into French, Italian, German, and
so on."[22] Ascheid observes that this sequence was hardly as amusing to many Euro-
pean audiences, for whom the altered voices were actually the most familiar and
natural ones for the stars, whom they would have encountered precisely through
such dubbed versions of their films. Ascheid writes, "It was somewhat bewildering
to witness the Hollywood greats laughing at John Wayne's voice, his German voice,
a voice most Germans would identify as more authentically belonging to him than
his original one."[23]

Like Danan's argument that "dubbing is an attempt to hide the foreign nature
of a film by creating the illusion that actors are speaking the viewer's language,"
Ascheid's argument that dubbed films appear as originals holds true for the
instances that she raises.[24] Indeed, the suspension of disbelief over the fluent
French or German or Italian being spoken by characters in the American West,
for example, could have certainly been motivated by the genre itself—that is, the
fact that Hollywood westerns had been circulating in dubbed French, Italian, and
German versions to which their respective audiences were accustomed.[25] How-
ever, another crucial factor contributing to the naturalization of dubbed voices in
these instances may have been the visual proximity of Anglo-American actors and
actresses to their European counterparts. In this vein, Nornes observes that the
characters in dubbed films from, say, Asia or Africa, would have been marked as
both visually *and* aurally—racially *and* linguistically—foreign to Euro-American
audiences.[26]

In 1957, an article appeared in *Variety* magazine, which carried the heading "India
Latest Foreign Land to Badly 'Misunderstand' U.S. Film Economics."[27] The article,
printed as a response to an editorial in an Indian trade journal, deplored the edito-
rial's criticism of the unidirectionality of Hollywood's relationship to Indian film
industries and lack of interest in a two-way exchange in which the US would import
Indian films with equal regularity.[28] The *Variety* article offers up its defense: out-
siders to the US were having trouble comprehending such a thing as the exercise

of individual choice, and it was solely this exercise of individual choice on the part of audiences that determined what films were being exhibited in the US. In India, however, the low quality of "mostly song-and-dance" indigenous films, a lack of alternative film offerings, and a lack of educational opportunities had forced "the educated Indian" to turn to the UK and the US not just for films but frequently for higher education as well.[29]

The article establishes this as the crucial difference between such an educated Indian and his US counterpart, who had no need to turn elsewhere for either education or films. An American viewer, after all, had a plethora of "quality screen material" coming his way not only from Hollywood but also from Europe "where pix are backgrounded against a milieu that is at least familiar."[30] Cultural unfamiliarity, however, was not wholly insurmountable, the article assuredly proclaims, as "a few Oriental films, mostly from Japan, have clicked in selected spots, providing that offbeat and quality that are a definite attraction."[31] The *Variety* article, too, assumes Hollywood-European cinema as the privileged axis for the foreign exchange of "quality screen material"—world cinema, as it were—with a few Japanese films thrown in for a sprinkling of novelty.

Just a year earlier, in 1956, the American Academy of Motion Picture Arts and Sciences had inaugurated a merit award for best foreign-language film.[32] The emergence of this category highlights the institutional value accorded to the aural experience of an unfamiliar tongue as a standard for high-quality, award-worthy films from "elsewhere." The implied expectation is that films nominated for this award would feature subtitles rather than being dubbed. Regarding subtitled versus dubbed films, Ascheid contends that "the subtitled version contains a number of reflective elements which hold a much larger potential to break cinematic identification, the suspension of disbelief and a continuous experience of unruptured pleasure."[33] This assertion, however, rests upon counterexamples of dubbed films whose *aural* properties—including, of course, the language(s) of audible dialogue—are successfully naturalized to the films' *visual* properties. Thus, "cinematic identification, the suspension of belief and continuous experience of unruptured pleasure" may indeed remain intact in—to return to Ascheid's own example—dubbed German versions of US westerns, which German audiences may have beheld as German rather than foreign films.[34] Yet, as noted earlier, had it been a case of German speech emanating from the mouths of Japanese actors in a German-dubbed version of a Japanese film, the effect on German audiences may have taken a markedly different turn.

Key factors, then, in determining the effects of subtitling and dubbing are the specificities of a given film as well as the specificities of its production and circulation contexts, including the makeup of its various audiences and their prevailing assumptions about the ideal forms and functions of cinema. Often, the kinds of films that are subtitled would never be accepted by their target audiences in dubbed versions and vice versa. While Ascheid highlights the potential of subtitled films

to underscore their very foreignness and break identification through the viewers' constant awareness that their understanding of the film is being mediated through translations supplied as subtitles, the long-standing association of subtitles with neorealist, art/auteur, ethnographic, and documentary films potentially contributes to the opposite effect as well, in presenting such films as seamlessly authentic records of their foreign contexts through the preservation of an ostensibly organic wholeness of the bodies onscreen and the voices that belong to them.

"One of the unwritten rules of art cinema culture," Betz observes, "is not simply a preference but the exigency for the subtitled print."[35] Betz acknowledges that an oft-invoked explanation for this exigency is that, as Bordwell and Thompson put it, "dubbing simply destroys part of the film."[36] Bordwell and Thompson's assertion assumes that a film is a singular object rather than, in fact, hundreds of celluloid copies that are altered as a rule rather than exception: whether through slight modifications, such as a projectionist's changeover marks, or more drastic ones, such as dubbing.[37] For Betz, the misapprehension of dubbing's supposed destructiveness is most evident in the large number of Italo-French coproductions made during the postwar decades in which there was no recording of any live sound at all—in other words, no original sound that would have been destroyed by dubbing. In such instances, all dialogue was post-synced and each film was released in either Italian or French and then subtitled in other languages. Betz takes a historical route to offer an explanation, and his final analysis is keen. He highlights the critical importance of the auteur in maintaining the singular national identity of European art films that resorted to coproduction as a strategy of cofinancing:

> When confronted with the evidence of multi-national investment in an art film, authorship picks up the slack. . . . The name of the auteur above the title anchors the European art film to its nation in a way that the same name above an English title does not. Art film coproductions among European nations, with no American investment, thus continue not to be recognized as such (i.e., as coproductions) because the inscription of national language at the level of the soundtrack and of national character in the person of the director combine to form an almost inviolable bond— a bond that is broken, I would argue, only by the travesty of the dubbed print.[38]

Dubbing was not merely a travesty but approached the horrific and grotesque in writings by Antonin Artaud and Jorge Luis Borges.[39] Mikhail Yampolsky and Larry P. Joseph show that both Artaud and Borges invoked the horror of dubbing in their descriptions of a voice being dislodged from one body and supplanted into an alien body whose voice had been rent.[40] The dubbed body, in these descriptions, was the cinematic body taken to its extreme. It was a body whose wholeness was paradoxically rendered by the very thing most alien to it: the voice that entered from without, devouring the body's own voice while being itself devoured and incorporated into a body that it animated in turn, giving illusory coherence to the resultant hallucinatory chimera.[41]

FIGURE 8. Still from *The Bicycle Thieves*
(1948): Antonio ekes out a living by
hanging up film posters.

The intensity of this characterization reveals anxieties over cinema's propensities toward technologized productions of wholeness that were anything but. Above all, post-Enlightenment notions of the human—like that of being individuated by one's body and voice—could become loosened and no longer remain inviolate. Borges and Artaud had written their respective pieces just after the arrival of synchronous sound. Their writings captured an anxiety that intensified in postwar Europe, as European art cinema derived considerable impetus from a crisis of unmoored identity. European filmmakers not only witnessed US geopolitical dominance but also saw Hollywood films as grossly untethered from their realities. Hence, in Vittorio De Sica's 1949 Italian neorealist classic *The Bicycle Thieves*, Antonio's desperation is memorably underscored by the fact that his livelihood— and that of his family—depends upon the meager earnings that he gets from pedaling a bicycle around Rome and hanging up film posters of Rita Hayworth. In the posters that we see, she epitomizes a Hollywood star who basks in the glamour of a world that could not be further from the bleakness of the one at hand, both within and outside the film (fig. 8).[42]

With the economic benefits of shared costs driving a number of European coproductions in the postwar decades, the Artaudian/Borgesian voice-body problem foreshadowed a national language–national body problem in postwar Europe. Reconstruction presented a crisis in Europe, as transnational diplomacy and collaboration seemed especially urgent in the aftermath of World War II's horrors. At the same time, participation in a world federation seemed to come at the cost of acquiescing to a (first-)world order that had American interests at its helm, following the US's dropping of atom bombs on Hiroshima and Nagasaki. World cinema was a project of dealing with this crisis through an emphatic insistence on mutual exchanges of a certain kind of film—a product that was aurally and visually anchored in its national point of origin, at the same time that it was ordained in its very creation with an imperative to travel forthwith. By thus locating the emergence of European art cinema, its oft-cited commitments to an auterist realism, and the manner in which various problems of cinematic translation were

negotiated in the postwar period, my aim is to consider how the category of world cinema weighed on contemporaneous contexts—and historiographies therein—well beyond Europe.

Practices of cinematic translation in other locations offer contrapuntal histories to those charted thus far. These "other" histories of cinema and translation remain wholly embedded in the world of world cinema, even if the latter category did not always recognize them as such. The late-1920s and early-1930s upheavals over issues of cinema and language translation have engaged scholars in the question of how (primarily Hollywood and European colonial) film industries and distributors negotiated the bottlenecks of language engendered by the talkie. This context of experimentation eventually led to the postwar prevalence of subtitling or—far less desirable in spaces of art cinema—dubbing practices, as the most viable solutions for enabling Hollywood's penetration of non-Anglophone markets as well as the international distribution of European art cinema. Other trajectories of inquiry, however, open up from passing notes in Nornes's account that deal with possibilities of translation for song-dance-filled films. These were the very types of films that the 1957 *Variety* response had dismissed as unsuitable for even "the educated Indian," much less for discerning audiences in the rest of the world.

Accounts of Hindi films' overseas circulation frequently ascribe talismanic qualities to the film song as that which enabled Hindi films to travel "starting in the 1930s and peaking around the 1960s."[43] It was indeed the coming of synchronous sound by the 1930s that allowed songs to be embedded in and circulate with a film. For cinema, then, the coming of sound was not necessarily a global descent into "Babel—The Sequel" in that synchronous sound seemed to also allow for the possibility of a kind of Esperanto through songs. For decades, songs were rarely translated, even when Hindi films were dubbed or subtitled. But to what extent was a film with songs more immanently legible than a film without songs?

Nornes mentions a report by Warner First National that was drawn up in 1931, which observed that "in Java they were projecting [foreign] films with no translation. . . . However, only the ones with more music than dialogue were making money." The observation that musical films could be comprehended without linguistic translation emphasizes an apparently unique mobility across and irrespective of language barriers.[44] Yet, elements of song and dance were precisely what the 1957 *Variety* piece had singled out as roadblocks, irrevocably hampering the quality of Indian films and their comprehensibility among US audiences. The about-face that has happened since the late 1980s, with song-dance sequences being celebrated among audiences in the US and the UK as an outstanding feature sustaining the popularity of Bollywood, is frequently narrated as a process of Hindi cinema's *becoming* transnational over the last three decades. An example of such pronouncements refers to the "'unmoored quality' of the [Bollywood]

film/song in the film's narrative . . . as the 'most transnational' part of the film, attested to by its increasing popularity in mainstream U.S. consumer culture."[45]

Behind such pronouncements lies an equation of the US with the transnational, in addition to a characterization of film songs as exceptionally mobile and effortlessly legible. Since the 1930s, Hindi (and also other South Asian–language) popular films have enjoyed prolific circulation throughout not only the Indian Ocean regions of East Africa, the Persian Gulf, and Southeast Asia but also Fiji, the Caribbean, Central Asia, West Asia, North Africa, Eastern Europe, and East Asia. Yet, these circuits encompassing both diasporic and nondiasporic audiences remained largely outside the orbit of Indian cinema's arrival and consecration on the hallowed ground of world cinema. The latter was largely a project of postwar European art cinema where, as Betz notes, the auteur was established as the linchpin for the identity of a film, as an audiovisual, linguistic-geographical, and always subtitled artifact of its national origin. The world of world cinema, in other words, was an arena of inter-*national* exchange in which certain unwritten rules not only were in place but also had congealed through the crises of a handful nations that had designated themselves and their own aesthetic, ideological, and pressing socioeconomic priorities as the center of, respectively, the world and world cinema.

The power of this origin point of world cinema lies in its frequent effacement, despite the weight that it has exerted on the history and historiography of cinema. For example, several histories of Indian cinema with respect to the world have remained elusive, while a limited narrative of Indian cinema with respect to world cinema has remained more visible:

> Before Bollywood went global, India had internationally respected film makers like Satyajit Ray, whose first Bangla film, *Pather Panchali*, released in 1955, put India on the global cinema map, winning international critical acclaim and running for more than seven months in New York, a new record for foreign films released in the United States. Known internationally as a master craftsman whose deep humanism and attention to detail set the standard for serious cinema, Ray was presented with the Legion d'honneur by the French president in 1990 and, in 1992, was awarded an Oscar for Lifetime Achievement in film, the only Indian to be thus honored.[46]

The outsized celebration and canonization of Ray and *Pather Panchali* has often come at the cost of sidelining Ray's versatility and larger oeuvre, as well as the heterogeneity of Indian cinema across art, commercial, and avant-garde practices.[47] If Ray's neorealist classic *Pather Panchali* "put India on the global cinema [i.e., world cinema] map," then the question that arises is, what is the nature of this map? And what other maps might be lying around?[48]

Ray's *Pather Panchali* was welcomed in 1955 as a milestone, ostensibly awaited by the "educated Indian" and his European and US counterparts who had been hardpressed for "quality screen material" from a corner of the world that was notorious for churning out its particular brand of song-dance films. This arrival heralded

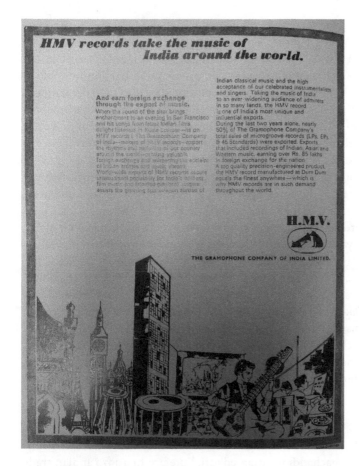

the anointing of not only Ray as an auteur of world cinema but also of sitarist Ravi Shankar as an ambassador for Indian music. Shankar's exquisite instrumental score for *Pather Panchali* carried the pedigree of a by-then-state-supported classical form of North Indian music, which unfolded as an appropriate complement to the visually pristine humanist realism of Ray's subtitled masterpiece.[49] A popular Gramophone Company of India magazine advertisement in the 1960s and 1970s carried the headline "HMV Records Take the Music of India Around the World," and it proclaimed: "When the sound of the sitar brings enchantment to an evening in San Francisco and hit songs from latest Indian films delight listeners in Kuala Lumpur—its on HMV records!"[50] (fig. 9).

Much is obscured, however, by such binaries of high culture–low culture and first world–third world that opposed Indian classical music to film songs, even *if* it was true that listeners in San Francisco preferred sitar music, while listeners in Kuala Lumpur preferred film music. The popularity of Shankar and Indian

classical music among the 1960s US counterculture followed Shankar's initial visibility through Cold War–era projects of cultural diplomacy. Like filmmaker K. A. Abbas, Shankar had participated in an Indian cultural delegation's visit to the Soviet Union in 1954.[51] The very next year, violinist Yehudi Menuhin was able to bring Shankar to the US for an Indian festival sponsored by the Ford Foundation.[52] Shankar's popularity grew among the US counterculture movement that emerged in the wake of youth-led protests against the Vietnam War, and Shankar moved in the same circles as celebrated psychedelic rock musicians—most famously, George Harrison and the rest of the Beatles.[53]

The spirit of "world music" collaborations through psychedelic rock was not altogether dissimilar from the contemporaneous eclecticism of Indian film music, especially with debutant Hindi film music director R. D. Burman marking a generational shift toward an upbeat, percussive intensity that was in step with global music cultures and youth cultures of the 1960s.[54] Shankar himself had previously collaborated with Abbas to compose the songs for Abbas's *Dharti Ke Lal* (*Children of the Earth*, 1946), a social realist film that had some exposure in the Soviet Union.[55] Ray, too, was not averse to songs in films. His lighthearted musical fantasy *Goopy Gyne Bagha Byne* (Goopy the singer and Bagha the drummer, 1969) was and is among his most popular, acclaimed, and commercially successful films, although it was much less visible than *Pather Panchali* in the West. Film songs, on the one hand, and Indian cinema's (non)visibility in the West, on the other, remained gravely interrelated concerns for several Indian filmmakers and critics over the 1960s.

"Next to Japan, India is the second largest film producer in the world," proclaims editor-critic T. M. Ramachandran in an editorial preface to a 1970 Indian trade journal's special issue on Indian cinema.[56] He closes his preface with the pronouncement that "the encouragement of Government and hard work of domestic industry will enable India to occupy a prominent position in the world film map, given better international understanding and appreciation."[57] The discrepancy between India's output as the "second largest film producer in the world" and its failure to occupy a "prominent position on the world film map" is quickly established as a problem of Indian films' underexposure and lack of acclaim in the West. Ramachandran also turns a developmentalist discourse of "film appreciation" onto audiences in the West when he notes that the problem is not so much Indian films' own lack, but rather the lack of "international understanding and appreciation" on the part of Western audiences. The special issue compiled contributions from several renowned film personalities of the time, including writer-director-journalist K. A. Abbas; directors V. Shantaram, Mrinal Sen, and B. R. Chopra; and Hindi film star-director Dev Anand.[58] Abbas, whose article opens the issue, professes that "cinema can be the means of creating international understanding between

diverse peoples divided by culture and ideology."[59] As the article continues, Abbas also urges an open-mindedness toward Indian films on the part of audiences in the West:

> Let the West learn to appreciate the distinctive features of Indian films—yes, even their inordinate length and their slow-moving plots—as we in India try to understand and appreciate the new and sometimes (to our sensibilities) complex and even shocking film-making of the West![60]

Abbas goes on:

> The Indian films, it is sometimes complained, are over-long. . . . That the pace of the Indian film is slow, is another complaint often heard from the occidental picture-goers. . . .
>
> Then there is the road-block of songs in Indian films. I was the first to produce a Hindi film without songs, but I have no patience with the snobbish view point that decries Indian films because they depend upon songs—and, it is argued, that robs them of their realism!
>
> Art is not necessarily representation of reality. Sometimes, it is suspension of disbelief.[61]

Abbas's characterization of songs as a "road-block" in Indian cinema's quest for a "prominent position on the world film map" implies that the only foreseeable route to such prominence was through the West and through realism. Even though several articles in the issue mention the popularity of Indian films in other parts of the world, the issue is overwhelmed by concerns over garnering critical acclaim in the West as a way of rectifying the fact that, as another contributor laments, "Indian cinema still remains—to use an expression employed by a congregation of leading luminaries of film art assembled at the Venice Film Festival in 1964—'an unknown territory.'"[62]

Film critic Amita Malik's contribution juxtaposes "a modest, small-budget, black and white film by Satyajit Ray" and the kind of films "made for peanut-munching, loudly whistling and charmingly escapist audiences [who] . . . have just devoured with relish the latest starlets from Bombay or Madras."[63] Malik breathlessly continues:

> It is this typical film which constitutes the folk art aspect of Indian cinema. For pop art is pop art anywhere and the Bombay film song, now known all over the world, is as much a part of modern life as the Rolling Stones. There is a faithful listener to All India Radio in Japan, who recently sent a unique fan letter to AIR in Delhi. He asked them to make sure that they played Indian film songs at a particular time in the evening because he confessed, he could not go to sleep without them. There are said to be stampedes across the border into Afghanistan from Pakistan every time a consignment of new Long Playing Records of Indian film songs arrives. And when the Afghans find their stocks running low, they send across to Iran, where Indian film songs are equally popular, for more.

This is the popular Indian cinema, as devotedly loved in neighboring Asian and African countries as at home.[64]

Malik's description is reproduced in the prose of *John Kenneth Galbraith Introduces India*, a nonfiction guidebook published in 1974. Galbraith was an economist who had served as the US ambassador to India under President John F. Kennedy before he became president of the American Economic Association in 1972. The guidebook explains:

> The 1950s saw the establishment of what the rest of the world rather vaguely calls the "typical Indian film." This is a marathon, which Indian audiences treat very much like a picnic, a day's outing with the family, complete with packed lunches, babies wailing in the auditorium, and an audience which includes wives of industrialists in their newest imported nylon saris to college students, illiterate domestic servants, peasants who cannot read the credit titles, and taxi drivers who are happy to miss a day's earnings to witness a personal appearance by a popular star.
>
> The typical film plot has something for everybody, since it is, in effect, a tragi-comical-musical-historical-sociological-dance-drama which audiences in developing countries in Asia and Africa devour wholesale, and quite often without subtitles or dubbing, *so strong is it visually*, and so familiar the dialogue *in any Eastern language*. The overseas fan mail of All-India Radio runs into thousands of requests for film songs. One listener in Tokyo confessed that he could not sleep at night unless he heard an Indian film song before going to bed.[65]

The guidebook's description of "devouring" as the mode of spectatorship for a "typical Indian film" highlights its lowest-common-denominator appeal that encompassed people implied to be the most primitive of spectators: "illiterate domestic servants" as well as "peasants who cannot read the credit titles."[66] Malik's initial description is more sympathetic, as she situates herself as an insider in declaring Indian popular cinema to be "as devotedly loved in neighboring Asian and African countries as at home."[67] In this account, love comes to denote a "devouring," passionate cinephilia that precedes either rationality or language, which is further corroborated by insistent anecdotes of song-starved audiences stampeding across national borders for LPs, not to mention the twice-cited man in Tokyo whose nightly sleep came only if coaxed by the melody of an Indian film song. Recalling Dimitris Eleftheriotis and Dina Iordanova's call for a method of historiography that ensues from the anecdotal, how does one read such hyperbolic accounts of stampedes across the borders of Pakistan-Afghanistan-Iran or of the man in Tokyo? Even if inadvertently, these claims reproduce racialized (neo) colonial theories of spectatorship in naturalizing the immanent legibility and audiovisual excess of Indian films to interchangeable "Eastern" languages that are instinctively comprehensible to Eastern bodies and to racially marked Afro-Asian spectators' primitive urges brought on by sleep, hunger, and infatuations stoked by "starlets."

Editor T. M. Ramachandran specifically addresses Indian films in non-European countries in another section of the 1970 "Accent on Indian Cinema" special issue. The third subheading in the article, following brief sections titled "Traditional Markets" and "Import Policy Abroad," concerns itself with the need for dubbing. Interwoven in Ramachandran's call for dubbing initiatives as a matter of official film policy is a call for "coproductions and closer collaboration . . . for the mutual benefit of India and the areas in the traditional markets."[68] While dubbing is posited as a means of systematizing and scaling up earnings in "traditional markets" where Indian films were readily distributed, coproduction is posited as a means of developing a more meaningful economic and diplomatic exchange by which the state would stand to also benefit. Ramachandran's reference to "traditional markets" foregrounds the fact that by 1970, Indian films had established a regular presence among audiences in regions that he goes on to enumerate and discuss: Southeast Asia, Africa, the Middle East, and the Soviet Union. The call for infrastructural support through dubbing technologies and for state support through coproduction incentives emphasizes the general lack of both and the question of how, and if, Indian films circulating in the above-mentioned regions were being formally translated.

In pursuing these trails of distribution and the extent to which dubbing and subtitling were being implemented, fragmentary references point to the role of overseas hubs in the wider distribution of Indian films. *Indian Film*, a 1974 publication by the National Film Archive of India, laments that "it is a sad thought that our films exported to U.S.A. and Canada have still to be subtitled in Beirut for lack of proper facilities at home."[69] As late as 1980, a section of the *Report of the Working Group on National Film Policy* also notes, "Except for one working subtitling machine available in Bombay, there are no subtitling facilities available in India, despite the simplicity of technology."[70] As I have detailed elsewhere, in cases of Indian films being dubbed and subtitled over the postwar decades, these processes were taking place largely outside India, most often through the efforts of independent distributors and studios in the Middle East.[71]

Dimitris Eleftheriotis corroborates the role of independent distributors in his account of the "spontaneous" presence and popularity of Indian films in Greece through the 1950s and 1960s: "The suggestion that minor independent distributors spearheaded the importation of Indian films is not only supported by the study of the publicity material but it also makes sense in the context of international distribution practices at the time."[72] Eleftheriotis further notes that because songs were the key attraction of Indian films for audiences in Greece, the "onerous task of subtitling," which often depended on acquiring and working from versions with English subtitles, was greatly alleviated. He adds, however, that a significant portion of the films' audiences "were illiterate or semi-literate anyway."[73] This issue of literacy, interestingly, does not arise as a significant factor in much of the historical

and theoretical work dealing with questions of cinema and translation, which again points to the ways in which postwar histories of film circulation and world cinema have tended to be confined to a rather specific axis of Hollywood and European art cinema.

Turning to other axes of cinematic translation not only reveals a range of translation practices in other locations but also invites reconsiderations of how one analyzes their histories and effects. Ahmet Gürata's reception history of the Hindi film *Awara* (Raj Kapoor, 1951) in Turkey, for example, observes that while dubbing was important to the film's success, dubbing did not localize the film to the extent that its Indian identity was overwritten. Gürata concludes that *Awara*'s success in Turkey emerged from a specific combination of the film's high production and marketing values, its exhibition in venues associated with Hollywood films, and its reception as a film that was at once foreign in its milieu *and* familiar in its (dubbed) tongue. The film struck a chord as a sophisticated, modern, yet Eastern exemplar for Turkish cinema and Turkish audiences' own modernizing aspirations, which critics zealously debated in the wake of *Awara*'s release.[74] Gürata's analysis, like that of Betz, captures a range of material contingencies that accounted for both the application and reception of cinematic translation processes.

Over the 1960s, Indian state agencies eyed dubbing as a cutting-edge technology for its potential to modernize and reassert state control over Indian films' overseas distribution and earnings. In 1963, for example, the Indian Department of Commercial Intelligence and Statistics published a report that called for dubbing and re-editing in order to better regulate the quality of Indian films circulating in Iran:

> The process of dubbing foreign films in Persian has been undertaken successfully . . . and Iranian cinema goers have shown great admiration for dubbed films. . . . Dubbing has become one of the major factors in popularising and ensuring good return for foreign films. Almost all the foreign films are first dubbed in Persian either in Iran or in foreign countries before being exhibited in Iran. . . . Some of the Iranian studios are well equipped with implements for the purpose of dubbing, which is done in an efficient manner.
>
> It has generally been observed that Indian films are usually lengthy as compared to other foreign films. In order to make it short, the film is cut at several places. . . . It has been suggested that Indian films should be specially edited for Iran as to maintain the continuity of the theme. Visitors have found that all the Indian films are generally alike in theme and action. Besides, third-rate films are imported at cheap prices and exhibited in the Iranian market. These create a bad name for Indian films.
>
> There is a considerable scope for exporting to Iran quality Indian films with novelty of theme and action. In recent years some Indian films such as AWARA, BOOT POLISH, SHRI 420, MOTHER INDIA, JIS DESH ME GANGA BAHATI HAI have proved successful. The visits of top ranking film actors and actresses and good stories may prove to be box office successes, if steps are also taken for dubbing these films. It has been suggested that Indian film festivals might be held at Tehran and other centres with the collaboration of picture houses and importers. The best Indian films

have to be screened at first-rate halls during these festivals. Such festivals initiated in the past by other countries proved effective. The distribution of Indian films has also to be entrusted to well-established firms for screening at first-class halls.[75]

The examples of "quality films" referred to here are the very song-dance-filled Hindi films that are entirely dismissed in other sources—whether Rotha and Manvell's world cinema compendiums or the *Variety* editorial. Here, quality films with "good stories" are instead set against "third-rate [Indian] films [that] are imported at cheap prices and exhibited in the Iranian market."[76]

At the time of the report's publication, commercial Indian films were readily circulating—and sometimes being translated—in Iran, albeit through independent distributors who, from the Indian state agency's perspective, had little investment in maintaining the country's reputation, as evidenced by the supposedly poor-quality films being sold to Iranian exhibitors. The overseas distribution and exhibition of mainstream commercial Indian films thus emerges as intertwined with lesser-known operations of making and trading B and C films. The report's suggestions that Indian films and leading industry figures would benefit from their films' active participation in overseas film festivals and exhibition in "first-rate halls" is held as a priority alongside box-office success in Iran. These priorities, as per the report's findings, would crucially hinge on state control through yet-to-be-developed domestic facilities for dubbing.[77]

This Indian government report seems to diverge from contemporaneous Anglophone discourses of world cinema and foreign-language films, since the latter tended to dismiss both dubbed films and Indian song-dance films as little more than trivial entertainments. Yet, the Indian government report's embrace of dubbing and of song-dance films as "quality films" remains similarly premised on deriving a given film's quality from assumptions about its audiences vis-à-vis nationalist constructions of ideal spectators. Dubbed films and Indian song-dance-filled films did not belong to an auteurist category of world cinema because this category naturalized the authenticity of a film to not only its auteur-derived nationality and unity (in name and tongue) but also its presumed cosmopolitan, modern spectator. While the Indian government report does not eschew either dubbed films or song-dance-filled films, it also naturalizes "quality films" to a similarly modern, bourgeois spectator who is the implied desirable patron of "first-rate" cinema halls in Iran.

In 1963, the same year as the report's publication, the Indian government established the India Motion Picture Export Corporation (IMPEC). IMPEC sought to nationalize overseas distribution, and the above report's call for dubbing is in line with IMPEC's own—ultimately failed—attempts to streamline the revenue and reputational benefits of Indian films being exported. The report spotlights dubbing precisely as a means toward such statist centralization of infrastructural—and thereby economic—aspects of film distribution, ostensibly on behalf of Indian film industries as well. It further recommends editing shorter Iran-specific versions

of the films for similar reasons of control, citing distributors in Iran taking their own liberties to cut shorter versions of Indian films as they saw fit. In some cases, Iranian exhibitors may have cut out portions of Indian films in order to accommodate the added running time from another modification that constituted yet another practice of translation: the periodic insertion of Persian intertitles with summary-translations, which narrators sometimes read aloud.[78]

The Indian government report's call for dubbing is minimally—if at all—actually about the language translation, since Indian films were readily circulating in Iran, among other places, with or without the application of a range of translation practices, from dubbing to subtitling to intertitling. The report is instructive for underscoring the aspirations attached to cinematic translation as an "open-sesame" for scaling and availing massive economic, cultural, and political benefits of film distribution across national and linguistic borders. A variety of stakeholders—state institutions, critics, filmmakers, industry personnel, and audiences—were centrally concerned not only with what kinds of films were being translated by what methods but also with what kinds of spectators could be reached in the process.

The frequent idealization of a certain kind of cosmopolitan, modern spectator was premised upon post-Enlightenment theories of human development, which naturalized specific kinds of films to the needs of specific kinds of audiences.[79] Such racialized, (neo)colonial hierarchies presumed that some audiences contemplated good films in translation through their faculties of the mind, while other audiences merely devoured poor-quality films, whose translations were largely incidental to the films' satisfaction of primal, bodily urges. At stake here is the assumption that films were effortlessly intelligible and consumable *because* they circulated among "lesser" audiences—whether those who occupied third-rate cinema halls in Iran or those "peanut-munching, loudly whistling and charmingly escapist audiences [who] . . . devoured with relish the latest starlets from Bombay or Madras."[80] Tautologically, backward audiences and vulgar films made—and were made for—each other. In several accounts, it is through varying degrees of this logic that some, if not all, Indian song-dance films were immanently legible to certain spectators, while they remained utterly incomprehensible to more educated spectators, whose intellectual needs could not be met by such "third-rate" fare.

We must certainly eschew any "logic" that drew on hierarchies of human difference to naturalize the intelligibility of films to various spectators' cognitive-developmental proclivities. We must also look elsewhere to consider the historical question of what accounted for Indian song-dance films' intelligibility and their prolific overseas circulation that peaked in the 1960s. We can consider, for example, the visual, gestural, poetic, and musical modes of expressivity that constituted specialized cinematic languages through considerable creative labor, and we can entertain the possibility that audiences engaged actively and critically with these modes of expressivity.[81] In some instances, Bombay (and other song-dance) films

offered not only a far more economical alternative to Hollywood films,[82] but also political alternatives to competing modernities and world-making aspirations from first-world, second-world, and third-world locations.[83]

In the next chapter, I turn to a genealogy of Hindi film song lyrics over three decades of sound cinema, between the 1930s and 1960s. I read song lyrics as a primary site of poetic ekphrasis in heated anticolonial and postcolonial debates over aesthetics, progressive social movements, and the role of modern literature and cinema therein. In celebrating love as an embodied excess of both cinema and modernity, some film song lyrics in the post-independence period began to argue a theory of the human that could be activated rather than compromised by technologized artifice. Here, the invocation of love allows for the possibility of a cinephilic practice that is at once contemplative, critical, impassioned, and embodied—at once thoughtful and "devouring." To some, like Borges and Artaud, the dubbed cinematic body was horrific because it appeared deceptively human through the artifice of a technologized chimera.[84] But what of a technologized chimera that proclaimed its own artifice in order to transform a willingly seduced spectator's very sense of the human? Not in the experience of wholeness but in the experience of being beside oneself—that is, in the possibility of delight through utter disorientation?

2

Moving toward the "City of Love"

Hindustani Lyrical Genealogies

In 1997, science professor Ashraf Aziz narrated an extended personal memoir as a Hindi-language talk radio feature for Voice of America (VOA), broadcast out of Washington, DC. The memoir proceeded through his reflections over the circulation of gramophone records of Hindustani[1] film songs among South Asians in East Africa, descended from those whom the British transported to East Africa as bonded laborers to serve their war efforts during World Wars I and II. In 2011, the Hindi literary journal *Jalsa* (Fête) published a transcript of the radio feature under the title "*sigret sinemaa sahgal aur sharaab*" (Cigarettes, cinema, Saigal, and spirits) in a special issue dedicated to the theme of exile.

An epigraph for Aziz's memoir refers to D. N. Madhok's lyrics for a song from the film *Saiyan* (M. Sadiq, 1951): "*vo raat din vo shaam kii guzrii huii kahaaniyaan, jo tere ghar mein chhod diin pyaar kii sab nishaaniyaan*" (The little bygone stories of that day and night, that evening—which left behind all those little traces of love in your house).[2] The memoir begins, "Without literature, there is no life in history," and then proceeds as, essentially, a subaltern narrative preoccupied not with the exploits of any emperors or kings but with the memories of a community of "ordinary people."[3] The author emphasizes that he himself is neither a historian nor a litterateur but a member of such a community who has recollected and recorded a history of film songs in the form of a personal memoir.

Aziz then narrates the World War contexts in which his grandparents and parents left and returned to British India and again departed for East Africa as bonded laborers who served British war efforts during World Wars I and II. He writes, "The traces of those Hindustani people [bonded laborers and soldiers] who were martyred in the first war are apparent in both directions of the rail lines that run between Tanga and Moshi."[4] The word that Aziz uses for "traces," *nishaan*, is the same word that appears in the lyrical epigraph. In this manner, the memoir

continually invokes Hindustani poetic motifs of separation, longing, and remembrance. It emphasizes the importance of music and poetry as resources for a community whose recent history was shaped by—albeit irreducible to—labor exploitation and displacement. For this community, Aziz's memoir attests, the images and affects of Hindustani film songs came to invoke not only specific diegetic sequences from films but also their own lives and experiences in which the songs had an intimate, everyday presence as both a source of pleasure and a language of contemplation.

Recalling his childhood in Tanga, in present-day Tanzania, Aziz expresses incredulity that he has no recollection of "the blasts in which Hiroshima and Nagasaki were reduced to cinders and the course of history irrevocably altered." He vividly remembers, however, that sometime between 1946 and 1947, his elder brother brought home a gramophone and some 78 rpm records of a Hindustani film songs from Mombasa. By overlaying cataclysmic geopolitical events with deeply personal ones, Aziz joins multiple scales of history through acts of reading and remembering Hindustani film songs. While the ethereality of the songs seduced Aziz's youthful attentions and managed to eclipse even the catastrophe of two nuclear genocides, this very ethereality of Hindi film songs also spurs Aziz's lyrical and deeply critical reflections over his own relative privilege in that moment and in others, as a diasporic South Asian who came of age in East Africa.

The dawn of a postwar nuclear age comes full circle in Aziz's eventual immigration to the United States in the 1960s, at a time when Cold War policies sought to woo third world professionals to the US for higher education.[5] Voice of America, where Aziz's memoir was initially broadcast as a Hindi radio feature for the fiftieth anniversary of India's independence, was itself established during World War II and continued through the Cold War as an arm of US cultural diplomacy in the world. The memoir's multiple narrative and extra-narrative contexts of migration, media circulation, translation, and publication highlight the significance of aural/oral technologies and transmissions in twentieth-century experiences of war, cinema, and the everyday. Aziz recalls:

> In our town, Hindustani film music first set foot in our house. In the milky moonlight upon the verandah, the first film song that I ever heard was Noorjehan's song from *Village Girl*, "I am seated, propped upon the sustenance of your memory."[6]

The poetic trope of an ineffable feminine beloved personifies an *audio*visual media object in motion by whom the viewer-listener is irrevocably and intimately transformed. Aziz's personification of Hindustani film music as entering his family's home on an enchanted, moonlit night is itself a romantic image that invokes two motifs that have proliferated through older folk genres as well as courtly genres of Hindustani poetry and that have in turn become mainstays of Hindustani film lyrics: the motif of a new bride stepping into her husband's home as the night of

their union has fallen and the motif of a woman going stealthily into her lover's home by night under the cover of darkness. The latter motif again recalls the lyrics in the epigraph, sung from the perspective of a woman who is bereft, but for her memories of such a tryst: "The little bygone stories of that day and night, that evening—which left behind all those little traces of love in your house." A feminine figure's act of crossing the threshold to enter an unknown home in both motifs allegorically invokes the risk and anticipation of border-crossing journeys, with their possibilities of immense pleasure as well as pain.

Romantic tropes in film songs—like *prem nagar* (City of Love), the figure of the feminine beloved and the tryst that is as fleeting a night as it is enduring a memory for the bereft, anguished lover—can become loosened from singular referents, authors, and at times even genders, through the promiscuity of their circulation through the worlds of innumerable lyrics and films. These tropes have repeatedly surfaced across an array of diegetic situations through the composite labor of lyricists who wrote them into their film lyrics; playback singers and musicians who rendered their melodies; and actors, actresses, and hundreds of technicians who gave them their embodied onscreen expression. Rather than working solely as clichés or stock images, they can offer themselves up as open-ended metaphors within a public domain of poetic resources, available as raw materials for narrating memories and desires, for archiving histories and envisioning futures.[7] Contemplative cinephilic engagements with film songs and lyrics, such as Aziz's memoir, connect the profoundly public presence of these lyrical modes of expression to their circulation in spaces that are much more intimate and personal.

In this chapter, I focus on the specific Hindustani lyrical trope of *prem nagar* (City of Love). I look at songs whose lyrics invoke *prem nagar*, a trope derived from folk songs and poetry attributed to ascetic and mystic *sant* (saint-singer) poets—namely, Kabir (fifteenth century) and Bulleh Shah (eighteenth century). The City of Love is a choice destination referred to by more than fifty film songs from just as many films between 1934 and the early 2000s, whose lyrics were penned by more than twenty different lyricists working in the Hindi film industry between these years.[8] Moving from its folk and literary antecedents through its cinematic iterations, I show that referents for *prem nagar* in film songs ensue from generalized experiences of transit to and within the modern-industrial city on the one hand and from the possibilities of romantic love in urban spaces on the other and that the experience of popular cinema becomes inextricable from both.[9] In other words, as Hindustani film songs incorporated the premodern lyrical trope of *prem nagar*, this trope—the City of Love—became reconfigured as an ekphrastic epithet for the romantic pleasure-spaces of motion pictures and their associated milieu of urban life. Those in search of the modern City of Love (and I will show that *prem nagar* enters cinema as an ephemeral, mirage-like destination for seekers who remain in perpetual transit) are lyrically addressed as a collective of cinephiles, who are willfully entranced by the repetitious, rapturous songs—the seductive artifices and utopian dreams—of Hindi popular cinema.[10]

In contrast to film song sequences and film music, film lyrics have only occasionally constituted a primary site of analysis for media scholars, music historians, musicologists, cultural anthropologists, or literary scholars of South Asia.[11] Often dismissed for being an inconsequential string of hackneyed clichés[12] or nostalgically recalled as being meaningful in one or another bygone era, film song lyrics have occupied a somewhat paradoxical status vis-à-vis South Asian popular cinemas both historically and in scholarly accounts. The coming of sound in the colonial studio era of the 1930s inaugurated new categories of workers, such as music director, lyricist, and dialogue writer.[13] One the one hand, one could convincingly argue that film song lyrics were irrelevant in many instances, particularly when audiences had little to no knowledge of a given film's language. On the other hand, in addition to their primacy in production workflows, printed song booklets constituted a prolific form of film publicity since the very advent of the talkie. In this manner, song lyrics circulated as oral and written texts that have constituted an important interface for reception outside the space of the theatre.[14]

The work of the lyricist—many of whom also had or aspired toward reputations as writers and poets outside the film industry—thus vacillates between being of utmost primacy to being superfluous to commercial film production, meaning-making, and reception. Even when the National Film Awards instated all-India awards for artists and technicians in 1967, the lyricist remained absent from the eight award categories (best actor, actress, color cinematography, black-and-white cinematography, direction, music direction, playback singing, and screenplay). When an award for best lyricist finally emerged at the National Film Awards in 1970 (alongside a new category for best child actor/actress and separate categories for male and female playback singers), it was quite unlike the rest of the awards for artists and technicians in its specificity: "Lyric-writer of the best film song on national integration."[15] The seemingly bizarre specificity of such an award category reveals the post-independence state's preoccupation with mobilizing cinema's potential for the project of national integration and its recognition of the potential ideological impact of film song *lyrics* by virtue of the catchiness and repeatability of film songs.

Following India's independence in 1947, national integration was a strategy touted by the first prime minister, Jawaharlal Nehru, for promoting and ushering in a sense of national belonging for a populace that was highly stratified by divisions of gender, caste, class, language, religion, and ethnicity.[16] By the 1950s, several lyricists were popularly known, highly regarded, and celebrated *as* film lyricists, despite the fact that the initial version of the award category for film song lyrics acknowledged their potential to merely serve nationalist sentiments rather than having any creative or artistic merit beyond this narrow parameter. While some popular as well as scholarly accounts consider the 1950s and 1960s as constituting a golden age of Hindi film songs,[17] others lament the 1960s for abandoning the previous decade's progressive ethos in favor of songs that were overly preoccupied with romance and composed for highly escapist color films.[18] To what extent, however, did the

progressive potential of cinema reside in the content of specific films or lyrics versus the broader fervor of public engagement with cinema across both decades?[19]

A genealogy of *prem nagar* as a lyrical trope specific to film songs that became reflexively tied to modern, affective spaces of cinematic encounters affords an opportunity to consider a longer history of film song lyrics' ekphrastic claims about cinema. With increasing frequency in the 1950s, *prem nagar* reflexively invoked not only the space of the onscreen romantic couple but also the spectator's affections for cinema. The sincerity on both sides of this latter affair, lyrical arguments held, could transcend the transactional and extractive conditions of their encounter. While one could cynically—and not incorrectly—regard these arguments as self-serving justifications on the part of the film industry as a profit-oriented enterprise, the compulsive repetition of such arguments reveals a wider historical anxiety over the commoditization of human feelings: that is, the sense that even love—as a sacral object of modernity—would be rendered inauthentic, as a marketplace commodity. Love-as-cinephilia is thus lyrically articulated as faith in the potential for commercial cinema to engender love as an embodied truth, despite its extractive and even fraudulent means.

Since the 1997 publication of *The Cinematic City*, an anthology edited by David Clarke, a plethora of film scholarship has analyzed links between city-space and cinema-space as mutually constitutive representational as well as lived spaces.[20] This body of work has investigated the ways in which "the cinema" and "the city" have not only shaped and been shaped by one another but also precipitated ways of seeing, being, and moving that have been fundamental to the experience of twentieth-century modernity.[21] Theories of visual culture and architecture have supplied critical disciplinary perspectives within analyses of the cinematic city, premised upon the irrefutable omnipresence of reproducible moving images alongside the rise of modern cities, both of which have affected the very parameters of experiencing and negotiating the space of the world in and after the twentieth century.[22] The cinematic city has delineated a historical and theoretical context for not only investigating modern subjectivity (e.g., "ways of seeing") but also querying contemporary political life.[23] For the city and the cinema remain historically bound to processes of industrialization and to the crystallization of the masses—a collective variously identified as workers, voters, or audience members—who form a primary unit of (re)public societies in the era of cities and citizens that succeeded the earlier reign of kings and kingdoms. In short, the spatial and social dimensions of both the cinema and the city have formed crucial axes for the organization of modern life.

Contributions to cinematic city scholarship have come from a variety of disciplines including—once again—architecture and visual culture studies, in addition to urban planning, art history, and sociology. A genealogy of Hindi cinema's lyrical

city of *prem nagar* highlights the specificity of cinema, as an audiovisual form and technological formation whose status was audibly and visibly caught between that of an expressive art and an industrial commodity. The trope of *prem nagar* moved out from a domain of sung poetry attributed to premodern, pre-colonial saint-mystics and into the modern space of Hindustani film songs. The emergence of this latter-day cinematic City of Love directs our attention to the movements of popular music in constituting the *audio*visual spaces of modernity, public as well as intimate.

In her critique of "the attractions of the cinematic city" for scholars, Charlotte Brunsdon points to the lure of the cinematic city as a space that promises inter-disciplinarity, translocality, and theory. She argues that the shape that this scholar-ship has taken often fulfills these promises through juxtaposing several essays that are concerned with different contexts and that arise out of different disciplines, rather than through sustained reflections and syntheses of either the relationship between *a* specific cinematic city and *the* cinematic city as a theoretical term or the disciplinary perspectives that have contributed to this work. Brunsdon argues that the cinematic city emerges in a post-celluloid moment of the neoliberalizing university, "repositioning [cinema] within a 'high culture' paradigm at a histori-cal moment at which its threat and energy as a mass cultural urban entertain-ment is conclusively spent."[24] As evidence of this repositioning, Brunsdon argues that "adding attention to the cinema signifies interdisciplinary endeavor for more established disciplines, yet the reverse is not true. . . . The film studies scholar who cites poetry is seen as merely pretentious."[25] What *prem nagar* as *a* cinematic city associated with popular Hindi cinema contributes to an understanding of *the* cinematic city occurs by virtue of its historical location at the interstices of poetry, literature, music, and film in a much longer genealogy of South Asian lyrical and popular practices. This genealogy—and that of *prem nagar*—carries profound eth-ical investments in vernacular oral practices as modes of knowledge production that have critiqued violently inegalitarian social formations.

The body of hagiographic and scholarly writing on the Hindavi poetry of Kabir, an oppressed-caste, fifteenth-century weaver who lived near present-day Benares, is immense.[26] Kabir has been embraced as a political, literary, and even god figure in contemporary Dalit (formerly "untouchable") and anti-caste movements. Milind Wakankar has asked what it means to think through "prehistory" as the silences in contemporary accounts of the past, with respect to the present political contexts in which Kabir, a historical figure, has been rewritten for different ends—both hegemonic and subaltern—as either a Hindu mystic in the devotional tradition of *bhakti*, a Muslim Sufi, a Dalit leader, or even a Dalit god.[27] Wakankar argues that the singularity of this prehistory, as the concrete experience of structural violence to which Kabir bears witness in his poetry, necessarily becomes abstracted and

mystified in the identity-based politics of civil society that have congealed around Kabir. His life and poetry have since been deified, glorified, and romanticized in the face of what Wakankar refers to as the unbearable weight that a prehistory of scripturally sanctioned, upper-caste brahminical violence continues to exert upon the present.[28]

In the poetry attributed to Kabir, *prem nagar* emerges as a miraculous space that is inhabited in the real time of the poet rather than as one that is imagined. The specificities of *prem nagar* remain vague, although Kabir affirms in his verses that these specificities are necessarily esoteric. For Kabir, given the concerns of his oeuvre, *prem nagar* is where caste exploitation and brahminical (upper-caste Hindu) orthodoxy, as well as animosities between religious communities, come to the fore and simultaneously come undone in his ecstatic communion with the Other, achieved through the mystic's (sung) testimony that bears witness to the irreducible, concrete experience of both pain (violence) and God (love). Kabir's *prem nagar* lies in an intellectual history of anti-caste utopias that vehemently rejected the violently enforced inequalities of their respective presents.[29] Addressed by Kabir to "my friend"—none other than his own heart—the verses below are not celebratory in their tone but highly mournful and disillusioned in the face of their addressee's inability to overcome ignorance and inactivity, a prerequisite to the discovery of "the secrets of this city of love":

> O my heart! You have not known all the secrets of this city of love:
> In ignorance you came, and in ignorance you return.
> O my friend, what have you done with this life?
> You have taken on your head the burden heavy with stones, and who is to lighten it
> for you?
> Your Friend stands on the other shore, but you never think in your mind how you
> may meet Him:
> The boat is broken, and yet you sit ever upon the bank;
> and thus you are beaten to no purpose by the waves.
> The servant Kabir asks you to consider:
> Who is there that shall befriend you at the last?
> You are alone, you have no companion:
> You will suffer the consequences of your own deeds.[30]

In an analysis of the poetry of another South Asian saint, the eighteenth-century Punjabi poet Bulleh Shah, Denis Matringe looks at the various devotional and poetic genealogies that Bulleh Shah's verses draw upon. As an example of the fused Krsnaite bhakti and Sufi elements in Bulleh Shah's poetry, Matringe offers the following verses, which open with a mention of *prem nagar* followed by a description that is far more buoyant than that of Kabir's invocation of the same:

> In the city of love, everything is upside down
> Reddened eyes become happy,
> The 'self' gets caught in a net.
> Once my self was caught you killed it.[31]

These lines celebrate the glory of the self's annihilation in the Beloved, the ecstasy of which is rendered as the infinitely joyous experience of *prem nagar* in an immanent world of the present, where the *sant* resides and where "everything is upside down." For Punjabi mystic Bulleh Shah,[32] too, as for Kabir, *prem nagar* is experienced in the here and now, as a place where "everything is upside down" and where "now I am lost," having annihilated the Self into the Beloved:

> Now I am lost in the City of Love
> I am searching for myself
> Finding neither mind, nor hands, nor feet
> Having shed my Self
> I found self awareness
> Bulleh Shah! The Beloved resides in both worlds
> There is none but this.[33]

In these early poetic instances as well as some of the more contemporary cinematic ones, the ecstasy of *prem nagar* affirms faith in the possibility of overturning the real-world violence of the interrelated orthodoxies of religious dogma and structural inequalities of caste. Kabir's poetry, however, suggests that faith itself is not enough. A melancholy cynicism as to how and to what extent faith can precipitate any change ("The boat is broken, and *yet you sit* ever upon the bank")[34] arises out of a critical and reflexive practice (Kabir speaks to himself/his own heart: "Your Friend stands on the other shore, but you never *think in your mind* how you may meet Him").[35] For Kabir, this deeply critical mode of questioning must necessarily be taken up in order to know *prem nagar* and arrive at its "secrets." Furthermore, both Kabir and Bulleh Shah testify to finding and dwelling in *prem nagar* only by embracing the fragmentation—if not the annihilation—of the individuated Self.

The unsentimental social critiques advanced by Kabir—among other *sant* poets—carry a trenchant politics that challenges sentimentalized Indian nationalist legacies that have placed Kabir within a larger fold of Hindu bhakti and more narrowly construe *prem* as a decontextualized devotional love.[36] While a popular claim about bhakti is that it was a radically egalitarian, vernacular Hindu devotional movement that critiqued brahminical monopolies on material and spiritual accumulation, some scholars have characterized the bhakti movement and its afterlives as far more ambivalent, at best, regarding matters of caste and social equality.[37] They point, firstly, to the fact that the written hagiographies of even oppressed-caste bhakti saints remained a significantly brahminical—and eventually nationalist—vocation.[38] And secondly, to the fact that there is little evidence of bhakti effecting large-scale transformations toward the eradication of caste, in spite of the ubiquity of its textual and ritual presence across the subcontinent in multiple vernacular and popular forms, both oral and written.[39]

Modern anti-caste movements thus insist on the importance of figures like Kabir in ongoing struggles to translate radically egalitarian ethical visions into large-scale material transformations of the social.[40] If *prem nagar* is the abode of

Kabir's singular, intimate experience of Love/God, a corollary, as I will show, is that the cinematic *prem nagar* becomes an abode of love—in the incarnation of cinephilia—that can inspire belief in the possibility of moving toward the imagined, utopian worlds of which cinema seductively and suggestively sings. Taking a cue from Kabir's question, this chapter asks how, and to what extent, such cinephilia might induce active, material transformations through an ethical insistence on both individual reflection and collective action against oppressively inegalitarian forms of modernity.

By the turn of the twentieth century, Kabir's mainstreaming as a literary figure—and as a representative literary figure, even—of the Indian subcontinent is evident in India Society, London's publication of *One Hundred Poems of Kabir* in 1914, translated into English by Indian writer Rabindranath Tagore the very year after Tagore won the Nobel Prize in Literature.[41] *One Hundred Poems of Kabir* was reprinted in 1917 by Macmillan, London as well as Macmillan, New York, with the latter edition carrying the alternative title *Songs of Kabir*.[42] The apparent interchangeability of "poems" and "songs" is firstly indicative of the (after)life of Kabir's poems both as oral texts that have circulated in the form of song and as written texts that have circulated as literature. Secondly, this interchangeability is also indicative of a wider field of popular *sant* poetry that has been a legacy of the Indian subcontinent's medieval history, wherein the act of repetition through participatory singing has enacted the poetry's strong investments in experience as an immanent form of knowledge. In its most critical instances, this vernacular poetry condemned brahminical knowledge production and Sanskritic scriptural orthodoxy as thoroughly exploitative, rather than spiritual, endeavors.[43]

From the very inception of the Bombay-produced talkie, with Aredeshir Irani's *Alam Ara* (*The Light of the World*) in 1931, diegetic songs became a staple of popular cinema in India. Cheaply produced song booklets were published independently and sold alongside a film's release; they often had a color, poster-style title image of the film on the cover and contained a plot summary, followed by the printed lyrics for each of the film's songs. The pages were sometimes interspersed with advertisements and poster images previewing other films. Hindi film song booklets were often bi- or trilingual, with translations of the plot summary and transcriptions of the song lyrics rendered in Devanagari, Nastaliq, and/or Roman typefaces. While it is possible that the song booklets may have been collectible items—especially for their covers—and purchased by audiences irrespective of literacy, the English translations of plot summaries, Roman text, and bi- and trilingual transcriptions of song lyrics were intended for a filmgoing audience that was construed as urban, literate, highly cosmopolitan, and desirous of singing along.[44]

Via song lyrics, the trope of *prem nagar* was rewritten into the space of cinema in this early studio era of the talkie, amid the convergences of older and newer

popular participatory practices of sung poetry, the presence of literary activ-
ists in the film industry, and the anti-colonial–nationalist and progressive-leftist
movements that were under way at the time. Lyricists in this moment (1) were no
exception in often having migrated from elsewhere and ultimately finding work in
the Bombay-based film industry, (2) were frequently either Hindi or much more
frequently Urdu writers and poets in their own right,[45] (3) were therefore highly
attentive to details of language, (4) would have been cognizant of the genealogies
of *sant* poetry from which *prem nagar* emerged, and (5) tended to be involved with
progressive, anti-colonial movements, given that the more conservative writers
would not have involved themselves—and their reputations as purists—with the
likes of the film industry.[46]

In the first two decades of the talkie, Hindustani film songs drew upon a rep-
ertoire of folk songs as well as musical genres that had been codified into classi-
cal and semiclassical forms. In this sense, it is hardly surprising or noteworthy in
itself that *prem nagar* moved from a domain of popular musical and lyrical prac-
tices into the arena of cinema. What is more intriguing is a sweepstakes departure
that takes place all at once, as the modern form and context of cinema razed and
rewrote the temporal and spatial relationships scaffolding the space of *prem nagar*
as it had emerged in *sant* poetry. Differences notwithstanding, the *prem nagar* of
both Kabir and Bulleh Shah is a place that is inhabited by the poet in the real time
of a miraculous present. The self is put forward by as the major obstacle standing
in the way, whether in its lack of perceptual acuity or failure to embrace a tren-
chant rejection of the world in the case of Kabir, or in its failure to obliterate and
lose itself to the ecstasy of Love/God in the case of Bulleh Shah.

In contrast to the eternal here and now of *prem nagar* as it unfolds in *sant*
poetry, the cinematic City of Love is catapulted onto a horizon that lies perpetu-
ally ahead. In 1934, three different lyricists wrote *prem nagar* into the cinema. In
addition to a song from *The Mill* (dir. Mohan Bhavnani) that opens with the line
"prem nagar kii raaha kathin hai sambhal sambhal kar chalaa karo" (The path to
the City of Love is difficult, go carefully), two other film songs from the year 1934
open with references to the City of Love (see table 1): the well-known *"prem nagar
mein banaauungii ghar main"* (I will build a house in the City of Love), rendered
by singer-actor K. L. Saigal in a duet with Uma Shashi for the film *Chandidas*, and
"prem nagar kii or naiyaa khivayen hain, prem ke saagar mein" (In the direction of
the City of Love are boat and oarsmen, in the Sea of Love), a lesser-known song
from the lesser-known film *Chalta Purza*. In all three instances, *prem nagar* is con-
figured as a destination that lies spatially and temporally ahead—as a place toward
which one must proceed carefully, as a place in which a house will be built one day,
as a place in whose direction a boat and oarsmen are poised to row toward.

This City of Love materializes in these instances as a cinematic city in being tied
to an apparatus of mechanized movement whose emergence was historically inter-
twined with forms of mass transit for people both migrating to and moving within

TABLE 1. References to *prem nagar* (City of Love) in Hindi film songs

SONG	FILM	YEAR	DIRECTOR	SINGERS	LYRICIST	MUSIC DIRECTOR
"*prem nagar kii or naiyaa khivaiye hain prem ke saagar men*" (In the direction of the City of Love are boat and oarsman in the sea of love)	*Chalta Purza* aka *The Invincible*	1934	R. N. Vaidya	"Moti - Shiraz (Vijay Singh)"	Dina Nath Madhok	Damodar Sharma
"*prem nagar men banaaaungii ghar main*" (I will build a house in the City of Love)	*Chandidas*	1934	Nitin Bose	K. L. Saigal, Uma Sashi	Agha Hashra Kashmiri	R. C. Boral
"*prem nagar kii raaha kathin hai sambhal sambhal kar chalaa karo*" (The route to the City of Love is difficult, go carefully)	*The Mill* aka *Mazdoor*	1934	Mohan Dayaram Bhavnani	Tarabai	Premchand	B. S. Hoogan
"*prem nagariyaa vaale raaha bataa de, panchrang chunariyaa vaale mukhdaa dikhaa de*" (Dweller of the Township of Love, tell me the route, o wearer of the many-hued raiment, show your face)	*Shri Satya-naaraayan*	1935	Drupad Rai		Radheshyam Kathavachak	Somnath Patpat
"*sakhii chal bas prem nagar men, prem nagar ati sundar bastii*" (Dear companion, come dwell in the City of Love – the City of Love is such a beautiful township)	*Jungle Queen* aka *Jungle Ki Rani*	1936	Nandalal Jaswantlal			Anna Sahab Maainkar, H. C. Baalii
"*prem nagar ke biich mein chalii nain talvaar . . . raadhaa tuu aur main kanhaiyaa*" (Daggers of eyes flashed in the middle of the City of Love . . . You are Radha, myself, Kanhaiya)	*Nishaan-e-Jung*	1937	Abdul Rah-man Kabuli			
"*prem nagar kii prem pujaarin prem diip pragataay*" (The priestess of the City of Love lights the lamp of love)	*Talwar ka Dhani*	1938	Dhirubhai Desai	Urmila Gupta	Pandit Gouri Shankar Lal "Akhtar"	Kikubhai Yagnik
"*prem nagar ke raajaa aao dil kii lagii bujhaao*" (Come, king of the City of Love, assuage the desires of the heart)	*Toofan Express*	1938	Chunilal Parekh	Jaal Merchant, Raajkumari	Chunilal Parkeh	Baldev Naik

Song lyric	Film	Year	Director	Singer/Actress	Lyricist	Music Director
"premii prem nagar men jaayein" (Lovers shall go to the City of Love)	Aadmi (Hindi) aka Manoos (Marathi) aka Life's for Living	1939	V. Shantaram	Shanta Hublikar, Shahu Modak	Munshi Aziz	Master Krishnarao
"prem nagar men prem pujaarii piyaa darshan ko aate hain prem kii mithii baaton se . . ." (In the City of Love are the priests of Love seeking out the vision of the Beloved, upon sweet words of love . . .)	Actress Kyon Bani	1939	G. R. Sethi			Ram Gopal Pande
"prem nagar kii phulvaarii men sundar phool khile sajnii" (In the garden of the City of Love blossom beautiful flowers, my dear)	Aandhi aka The Tempest aka The Storm	1940	Dinesh Ranjan Das	Picturized on Kumari Manjari (character Ila)	Aarzoo, Rashid Gorakhpuri, Pandit Nautiyaal; for this song: Aarzoo	Krishna Chandra Dey; asst: H. P. Rai, Pranab Dey
"mast havaaen prem nagar men aaj sandesaa laaii hain, soye huye hriday . . ." (The heady breeze of the City of Love has today brought news, the sleeping heart . . .)	Haar Jeet aka Abhinetri	1940	Amar Mullick		Aarzoo, Kedaar Sharma	R. C. Boral, asst: Haripad Chatterjee
"main prem nagar kii raanii, suno merii priit kahaanii, madh se miithaa meraa pyaar" (I am the queen of the City of Love, listen to my tale of love, my love sweeter than honey)	Nirali Duniya aka Trust Your Wife	1940	V. M. Vyas		Ahsaan Rizvi	Mushtaaq Husain; asst: L. Hussain
*"aaye re, pii kii nagariyaa se aaye re, saajan ke nainaa se nainaa milaaye re . . ." (Having come, having come from the Township of the Beloved, the lover's eyes have met with another's)	Prem Nagar	1940	Mohan Dayaram Bhavnani	Sharda (gramophone recording); Vimala Kumari (film)	Dina Nath Madhok	Naushad Ali
*"saajan aao aao aao, man kii nagariyaa basaao" (Come, come, come, darling, dwell within the Township of the Heart)	Rupa	1946	Azir	Rajkumari	Rammurti Chaturvedi	Govind Ram

TABLE 1. (*Continued*)

SONG	FILM	YEAR	DIRECTOR	SINGERS	LYRICIST	MUSIC DIRECTOR
"*prem nagar kii or chale hain prem ke do matvaale*" (Two intoxicated with love are headed in the direction of the City of Love)	*Manjhdaar* aka "Lost in Mid-Stream"	1947	Sohrab M. Modi	Khurshiid, Surendra	Shams Lakhnavi	Ghulam Haidar, Gyan Dutt, Anil Biswas; for this song: Gyan Dutt
"*prem nagar men basnevaalo, apnii jiit pe hansne vaalo, priit hansaaye priit rulaaye, priit milaaye, priit hii saath chhudaaye, hansmukh phuulo ye mat bhuulo*" (O dweller of the City of Love, O you who rejoices in your own victory, love draws laughter, love draws tears, love joins together, at the same time love rends apart, O smiling blossom, do not forget this.)	*Barsaat*	1949	Raj Kapoor	Lata Mangeshkar	Iqbal "Hasrat" Jaipuri, Shailendra, Ramesh Shastri, Jalaal Malihabadi; for this song: Hasrat	Shankar-Jaikishen
**"*mujhe priit nagariyaa jaanaa hai, koii hai jo rastaa batalaa de*" (I want to go to the Township of Love, is there anyone who can guide me and tell me the way?)	*Ek Nazar*	1951	O. P. Dutta	Lata Mangeshkar, Mohammed Rafi	Rajendra Krishan	Sachin Dev Burman
**"*mere dil kii nagariyaa men aanaa, na aa ke jaana balam pardesiyaa*" (Come to my Township of the Heart, don't leave from here my beloved stranger)	*Madhosh*	1951	J. B. H. Wadia	Lata Mangeshkar	Raja Mehdi Ali Khan	Madan Mohan
**"*o ruup nagar ke saudaagar o rang rangiile jaaduugar*" (O merchant from the City of Beauty, O colorful magician)	*Sazaa*	1951	Fali Mistry	Pramodini Desai, Lata Mangeshkar	Rajendra Krishan	S. D. Burman
**"*armaanon kii nagariyaa ujad gayii*" (The Township of Desires has been lain to waste)	*Tamasha*	1952	Phani Ma-jumdar	Lata Mangeshakar	Bharat Vyas	Manna Dey
**"*sapnon kii nagariyaa haaii*" (The Township of Dreams, Oh)	*Raj Ratan*	1953	Hiren Bose	Asha Bhosle	Bharat Vyas	Neenu Majumdar
**"*chalii pii ke nagar ab kaahe kaa dar*" (I left for the City of the Beloved, why is there any reason to be afraid now?)	*Mirza Ghalib*	1954	Sohrab Modi	Shamshad Begum	Shakeel Badayuni	Ghulam Mohammed

Song	Year	Film	Director	Singer	Lyricist	Music Director
*"sun rii sakhii mohe sajanaa bulaaye, mohe jaanaa hai pii kii nagariyaa" (O listen, my companion, my dear summoned me, I must go to the Township of the Beloved)	1954	*Nagin*	Nandlal Jaswantlal, I. S. Johar	Lata Mangeshkar	Rajendra Krishan	Hemant Kumar
*"o bedardii jaane ke na kar bahaane, is man kii nagariyaa se jaao to jaame" (O callousness, make no excuses to leave! If you leave this Township of the Heart, who knows?)	1956	*Lalkaar*	Nanubhai Vakil	Mahendra Kapoor, Sabita Banerjee	Madhur	Sanmukh Babu
"prem nagar se jogii aayaa, aayaa badal ke sakhii rii bhesh" (A mystic came from the City of Love, he came, my friend, having altered his garb)	1958	*Miss Punjab Mail*	N. Vakil	Asha Bhonsle	Kaifi Azmi	B. N. Bali
***"tuu ruup kii nagarii kaa raajaa, main pyaar galii kii raanii" (You are the king of the Township of Beauty, I am the Queen of the Lane of Love)	1959	*Jagga Daku*	Chandrakant	Manna Dey, Geeta Dutt	B. D. Mishra	S. N. Tripathi
"are pataa note karo, ho pataa note karo hamaaraa, hamse aa milnaa dubaaraa, prem nagar men prem sadak ke sabse uunche maale par hai, kholii number gyaaraah, pataa note karo" (Hey, note the address, o! note my address, come meet me again, in the City of Love it is on the highest floor of a place on the Road of Love, room number eleven's open, note the address!)	1959	*Zara Bachke*	Nisar Ahmed Ansari	Mohammed Rafi	Raja Mehdi Ali Khan	Shaukat Dehlvi Nashad
"o madam o madam coma coma coma . . . tum thiik hii kahtii ho madam, main paagal huun, main paagal huun, main paagal huun . . . " (O madam, o madam, come, come, come . . . You are right, I am crazy, I am crazy!)	1960	*Girlfriend*	Satyen Bose	Kishore Kumar	Sahir Ludhianvi	Hemant Kumar
"hoye prem nagar men banaauungii ghar main" (Oh! I will build a house in the City of Love)						

TABLE 1. (Continued)

SONG	FILM	YEAR	DIRECTOR	SINGERS	LYRICIST	MUSIC DIRECTOR
"tuu prem nagar kaa saadhu chalaa kar jaaduu meraa dil luut liyaa, oye meraa dil luut liyaa" – **"tuu ruup nagar kii ranii badii mastaanii meraa dil luut liyaa, haaii "meraa dil luut liyaa" (You, a saint from the City of Love, cast a spell upon me and looted my heart, oh you looted my heart – You, a seductive queen from the City of Beauty looted my heart, oh you looted my heart)	Masoom	1960	Satyen Bose	Mohammed Rafi, Sudha Malhotra	Raja Mehdi Ali	Robin Bannerjee
"ik but banaaaungaa teraa aur puujaa karuungaa" (I will make an idol of you to which I will pay my obeisance)	Asli Naqli	1962	Hrishikesh Mukherjee	Mohammed Rafi	Shailendra, Hasrat Jaipuri; for this song: Hasrat	Shankar-Jaikishen
"ruup kii chaandii pyaar kaa sonaa prem nagar se laake, terii sundar chhabii banegii donon chiiz milaake" (Having brought the silver of beauty, the gold of love from the City of Love – combined, your beautiful countenance will be formed)						
*"farishton kii nagarii men main aa gayaa huuṅ, main aa gayaa huuṅ" (I have returned from the Township of Angels, I have come)	Hamari Yaad Aayegi	1962	Kedar Sharma	Mukesh	Kedar Sharma	Snehal Bhatkar
*"chalii aaj gorii piyaa kii nagariyaa, mangiyaa men sinduur odhe chunariyaa" (Today the fair one has gone to the Township of the Beloved, forehead bedecked by vermillion, wrapped in a stole)	Godaan	1963	Trilok Jetley	Lata Mangeshkar	Anjaan	Ravi Shankar
***"ruup dhaar kar ruup nagar se aayii sundar naarii" (Carrying herself with poise, a beautiful lady has come from the City of Beauty)	Flying Man aka Havaaii Insaan	1965	Pradip Nayyar		Khaavar Zamaan; for this song: Soz Haidri	Naushad
*"main ne pyaar kaa nagar basaayaa o nagar basaayaa" (I settled the City of Passion, oh the city I settled)	Rustom-e-Hind	1965	Kedar Kapoor	Shamshad Begum	Qamar Jalalabadi	Hansraj Behl

Song	Film	Year	Director	Singer	Lyricist	Music Director
*"jaao re jogii tum jaao re, ye hai premiyon kii nagarii, yahaan prem hii hai puujaa" (Go, O go, enraptured mystic, this is the Township of Lovers, here Love itself is worship)	Amrapalli	1966	Lekh Tandon	Lata Mangeshkar	Hasrat Jaipuri, B.A. Kamal, Shailendra; for this song: Shailendra	Shankar-Jaikishen, Saraswati Devi
*"kaun rokegaa ab pyaar kaa rastaa, main to pii kii nagariyaa jaane lagii, aaj baithe-bithaaye ye kyaa ho gayaa, dil kii har baat aankhon men aane lagii" (Who will stop me now in the along the road of love, I for one have begun the journey to the Township of the Beloved, today whilst seated what was happened? Each desire of the heart has come before my eyes)	Ek Kali Muskai	1968	Vasant Joglekar	Lata Mangeshkar	Rajendra Krishan	Madan Mohan
"la la la, tum pyaar se dekho, ham pyaar se dekhein . . ." (La la la, you shall behold with love, I shall behold with love . . .)	Sapnon Ka Saudagar	1968	Mahesh Kaul	Sharda, Mukesh, Saathi	Hasrat Jaipuri, Shailendra, S. H. Bihari; for this song: Shailendra	Shankar-Jaikishen
"nagarii javaan armaanon kii ye prem nagar hai, har dil uchhal rahaa hai mohabbat kaa asar hai" (The Township of Youthful Desires, this is the City of Love, that every heart is jumping is the effect of love)						
*"piyaa kii nagariyaa sajke gorii jaaye re, naihar kii yaad dil se bisraaye re piyaa kii nagariyaa sajke" (Having bedecked herself, the fair one shall go to the Township of the Beloved, from within her heart memories of a childhood home shall disperse, O to the Township of the Beloved, having bedecked herself . . .)"	Pujarin	1969	Dhirubhai Desai	Mohammed Rafi	Madan Bharati	Naryan Dutt
"main ek raajaa huun tuu ek raanii hai, prem nagar kii ye ek sundar prem kahaanii hai" (I am a king, you, a queen, this is a beautiful love story of the City of Love)	Upahaar	1971	Sudhendhu Roy	Mohammed Rafi	Anand Bakshi	Lakshmikant-Pyarelal, asst: Shashikant, Gorakh

TABLE 1. (Continued)

SONG	FILM	YEAR	DIRECTOR	SINGERS	LYRICIST	MUSIC DIRECTOR
"aao tumhen main pyaar sikhaa duun – sikhlaa do na – prem nagar kii dagar dikhaa duun – dikhlaa do na" (Come, I shall teach you the ways of love – Teach me, won't you – I shall show you the way to the City of Love – Show me, won't you)	Upaasna	1971	Mohan	Mohammed Rafi, Lata Mangeshkar	Indeevar	Kalyanji-Anandji
"jaaduugarnii aayii prem nagariyaa se, dil se dil milaa ke" (A sorceress has come from the Township of Love, conspiring to join hearts)	Bijli	1972	Ram Kumar (Bohra)	Asha Bhosle	Asad Bhopaali	Usha Khanna; asst: Parte, Sardaar
"o taangevaale, chal prem nagar jaayegaa, bataʼaao taangevaale – oye kii gal hai kudiye" / (O horsecart driver, shall we go to the City of Love? – O what is it, girl?)	Jeet	1972	A. Subba Rao	Lata Mangesh-kar, Mohammed Rafi	Anand Bakshi	Lakshmikant-Pyarelal; asst: Shashikant, Gorakh
*"luute koii man kaa nagar ban ke meraa saathii – kaun hai vo, apano men kabhii aisaa kahiin hotaa hai, ye to badaa dhokhaa hai" (Becoming my mate, someone looted the City of the Heart – Who is this one? Among one's own how can this occur, this is indeed a huge fraud)	Abhimaan	1973	Hrishikesh Mukherjee	Lata Mangeshkar, Manhar Udhas	Majrooh Sultanpuri	S. D. Burman
"kiskaa mahal hai kiskaa ye ghar hai, lagtaa hai ye koii sapnaa o sajnaa, prem nagar hai ye apnaa o ratnaa" (Whose mansion is this, who's home is this, it feels like it is some dream oh darling - is this my own City of Love, my precious one)	Prem Nagar	1974	K. S. Prakash Rao	Lata Mangeshkar, Kishore Kumar	Anand Bakshi	S. D. Burman; asst: Mira Deb Burman, Anil, Arun, Maruti Rao
"prem nagar kaa rahne vaalaa thaa ek sundar raajaa, ruup nagar kii rahne vaalii thii ek sundar raanii" (He who dwelt in the City of Love was a beautiful king, she who dwelt in the City of Beauty was a beautiful queen)	Suhani Raat	1974	Vijay Mohan Gupta	(For film: Shailesh Mukherjee, Mina Kumar, Rekha Gupta, Durga Borkar)	F. M. Qaisar	Ram Ganguly; asst: Ramlal, Kamal Ganguly

Lyrics	Film	Year	Director	Singers	Lyricist	Music
"*main raajaa tuu raanii – tuu raajaa main raanii – main prem nagar kaa raajaa tuu ruup nagar kii raanii*" (I am the king, you, the queen – You are the King, I, the queen – I am the king of the City of Love, you are the queen of the City of Beauty)	*Dildaar*	1977	K. Bapaiah	Kishore Kumar, Asha Bhosle	Anand Bakshi	Lakshmikant-Pyarelal
"my name is anthony gonsalves, main duniyaa men akelaa huun, dil bhii hai khaali ghar bhii hai khaalii, ismen rahegii koii qismat vaalii, haaii jise merii yaad aaye jab chaahe chalii aaye, ruup nagar prem galii kholii nambar chaar sau biis" (My name is Anthony Gonsalves, I am alone in the world, my heart is vacant, and my house, too, is vacant, in it will some fortunate lady live, oh, the one who thinks of me shall come over whenever desired, to the open room number 420 on the Street of Love in the City of Beauty!)	*Amar Akbar Anthony*	1977	Manmohan Desai	Amitabh Bacchhan, Kishore Kumar	Anand Bakshi	Lakshmikant-Pyarelal
"*o mere prem nagar ke raajaa ab to aa aa re ik dukhiyaaran ke dvaar . . . aa jaa re*" (O king of the City of Love, come, come now to the door of a wretched one, o come)	*Karva Chauth*	1980	Ramlal Hans	Usha Mangesh-kar	Pradip	C. Arjun
"*aajaa mere paas aajaa, ruup nagar kii main raanii, prem nagar kaa tuu raajaa ho raaaja*" (Come, come to me, I am the queen of the City of Beauty, you are the king of the City of Love, o king o king)	*Ham Donon*	1985	B. S. Glad	Anuradha Paudwal	Anand Bakshi	R. D. Burman
"*o dholaa dhol manjiraa baaje re*" (O the drum, the cymbals, resound)	*Joshilaay*	1989	Sibte Hassan Rizvi	Asha Bhosle, Suresh Wadkar	Javed Akhtar	R. D. Burman
"*prem nagar kaa jogii huun main thaam le meraa haath*" (I am an enraptured mystic of the City of Love, grasp my hand)						

TABLE 1. (*Continued*)

SONG	FILM	YEAR	DIRECTOR	SINGERS	LYRICIST	MUSIC DIRECTOR
"*main prem nagar kaa raajaa*" (I am the king of the City of Love)	*Pyar Hua Badnaam*	1992	Vicky Sharma	Asha Bhosle, Shabeer Kumar	Sameer	Anand Milind
"*prem nagar men rahnevaalo ho, apnii dhun mein bahnevaalo ho, kuchh to jaano o diivaano*" (O dwellers of the City of Love, those floating in their own tunes – know this, o enraptured ones)	*Radha Ka Sangam*	1992	Kirti Kumar	Anuradha Paudwal, Sukhwinder Singh	Hasrat Jaipuri	Anu Malik
"ruup nagar kii raanii huun mujhe haath na lagaanaa re babu" (I am the queen of the City of Beauty, sir, do not touch me)	*Kartavya*	1995	Raj Kanwar	Poornima	Rani Malik	Dilip Sen, Sameer Sen
"o hamsafar dil ke nagar, sapne chalo ham sajaayein" (O my traveling companion, o my City of the Heart, dreams we shall follow)	*Fareb*	1996	Vikram Bhatt	Alka Yagnik, Kumar Sanu	Neeraj	Jatin-Lalit
"*baajre ke khet mein*" (In the millet fields)	*Benaam*	1999	T. L. V. Prasad	Jaspinder Narul	Anwar Sagar	Bappi Lahiri
"*o yuun lagataa hai prem nagar se ye kauvaa hai aaya, muaa kaalaa kauvaa aayaa*" (It seems that this black crow has come from the City of Love, damned black crow's come)						
"*ishq binaa kyaa marna yaaro, ishq bina kyaa jiinaa*" (What is dying, without love, what is living, without love?)	*Taal*	1999	Subhash Ghai	Anuradha Sriram, Sujatha, Sonu Nigam, A. R. Rahman	Anand Bakshi	A. R. Rahman
"*ishq hai kyaa ye kisko pataa, ye ishq hai kya sab ko pataa, ye prem nagar anjaan dagar, saajan kaa ghar kaa kisko khabar, chhotii sii umar ye lambaa safar . . . ye dard hai yaa dardon kii davaa, ye koii sanam yaa aap khudaa*" (What is love? Who knows? At the same time, everyone knows what love is, the City of Love lies down an unfamiliar path, who knows anything of the Beloved's house? A short life, a long journey . . . Is this pain or balm? Is this some sweetheart, or God Himself?")						

Lyrics	Film	Year	Director	Singers	Lyricist	Music
"prem jaal men phas gayii main to, prem taal pe nach padii main to, prem nagar men ho gayii merii shaam" (I got caught in the net of Love, I was obliged to dance to the beat of Love – in City of Love I was finished)	Jis Desh Men Ganga Rehta Hai	2000	Mahesh Manjrekar	Sukhwinder Singh, Anuradha Sriram	Dev Kohli, Praveen Bhardwaj	Anand Raj Anand
"o re chorii" (O, maiden) "sun sun le sajan janam janam ham prem nagar ke baasii" (Listen my darling, lifetime after lifetime let us remain dwellers of the City of Love)	Lagaan	2001	Ashutosh Gowarikar	Udit Narayan, Alka Yagnik, Vasundhara Das	Javed Akhtar	A. R. Rahman
"baajre ke khet men" (In the millet fields) "o yuun lagataa hai prem nagar se ye kauvaa hai aaya, muaa kaalaa kauvaa aayaa" (It seems that this black crow has come from the City of Love, damned black crow's come)	Reshma Aur Sultan	2002	S. Kumar			Abhi-Raj
"prem nagariyaa kii tum bhii dagariyaa chalo" (You, too, come along the path to the City of Love)	Chalte Chalte	2003	Aziz Mirza	Udit Narayan, Alka Yagnik	Javed Akhtar	Jatin-Lalit, Aadesh Shrivastava

* Lyrics include "sister cities" to prem nagar (City of Love).
** Lyrics include ruup nagar (City of Beauty).

urban spaces to earn their livelihoods.[47] Upon being subsumed into cinema, the trope of *prem nagar* unfolds within the industrial cinema space of the modern city, which is associated not only with an intensified experience of perpetual locomotion through migration or transit alongside the movement of (audiovisual) images but also with an experience of perpetual movement toward the egalitarian promises of a utopian modernity that is imagined—in contrast to a space that materializes in the present as a miracle through the *sant's* rejection of the world at hand—and therefore always deferred. The (post)colonial condition of Indian modernity compounded and complicated this deferral through its multiple temporalities in vacillating between desires to move toward Western ideas of nationhood, progress, and development on the one hand and to return to an idealized, premodern, pre-colonial antiquity that was often but a contemporary narrative that effaced its own modernity in the guise of tradition on the other.[48]

The film song, however, was an arena in which claims to so-called tradition were often null and voided by its very form. By its associations with the cinema, the film song became so deeply tied to technologies of recording and reproduction that critics often positioned film music as the modern antithesis to the so-called traditions of Indian music, both folk and classical.[49] The latter, in contrast, circulated as culturally authentic, embodied expressions even when they, too, came to circulate in recorded forms.[50] I highlight the status of the film song as a quintessentially modern form in order to account for the fact that *prem nagar*, despite originating within a premodern space of ostensible tradition, became synonymous with the modern space of cinema so quickly after it first surfaced in film song lyrics during the mid-1930s.

In gesturing toward a utopian horizon ahead, *prem nagar's* appearance in film songs could have easily been a masked reference to independence during the 1930s and 1940s. "The use of Hindi lyrics as a means of articulating a progressive sentiment was, not surprisingly, intertwined with the freedom struggle," note Ali Husain Mir and Raza Mir, while simultaneously noting the scrupulousness of the British censor board in banning any such songs.[51] A trope that was associated with *sant* poetry, *prem nagar* could be deployed in the pre-independence moment of the talkie with a degree of ambiguity as a means of subverting the iron fists of film censor boards that had been set up by the British colonial government. By singing of a vaguely utopian future, these film songs could escape the censors' scrutiny and go on to become anthems in the struggle for freedom from the oppression of colonial rule, among other social movements such as workers' rights movements. These themes were taken up in the 1934 film *The Mill*, one of the earliest instances of a film containing a song whose lyrics invoke *prem nagar*. The lyricist for *The Mill's* songs was none other than Munshi Premchand, the pen name of author Dhanpat Ray Shrivastava, who some have characterized as "the single most important figure in the development of a mature narrative style in both Hindi and Urdu."[52]

Although Premchand has been a central figure in the scholarship as well as pedagogy of modern Hindi and Urdu literature, Premchand's brief—and failed—foray into the Bombay-based film industry has been of relatively minimal academic interest. *The Mill*, also known as *Mazdoor* (Worker), was adapted from Premchand's writings, and the author himself was hired to write dialogue for the film.[53] Premchand's own brief narrative of his time in the film industry as gleaned from letters that he wrote from Bombay, as well as from the retellings of that time by his biographers on the basis of these letters, conclude that the film industry was no place for a writer like Premchand, who wished to portray and critique pressing social issues of exploitation through his creative work. However, as labor historian Sabyasachi Bhattacharya astutely points out, this narrative of Premchand's stint in the film industry is belied by a cursory historical investigation into *The Mill* and the reasons for its failure.[54] Bhattacharya suggests that Premchand's disenchantment with the film industry was, more than anything else, a consequence of his dire financial straits when the film failed to rake in revenue in addition to the fact that his health was failing at the time, rather than, despite what Premchand writes in his letters, because popular cinema's aesthetics and entertainment values compromised its social relevance.[55]

For although elements of romance and melodrama were apparently part of *The Mill* and not to Premchand's taste, these aesthetics were not inherently at odds with the film's investments in critiquing the reality of labor exploitation and validating the cause of worker's movements through its plot. Bhattacharya points out that the film failed because it was banned by colonial officials and Indian businessmen who sat on film censor boards in various provinces of British India and had vested interests in the textile business.[56] These men saw the film as being highly incendiary at a time when relationships between mill owners and labor unions were especially volatile, having erupted in a series of strikes that had wracked the productivity of mills in cities that included Bombay and Ahmedabad.[57] By virtue of being banned, then, *The Mill* certainly had succeeded in hitting close to home. The cover of a song booklet that was published in Bombay wears this badge of success with pride, in all caps: "M. BHAVNANI PRESENTS THE ORIGINAL VERSION OF THE FILM THAT WAS BANNED."[58]

The year 1936 would be Premchand's last. He had left the film industry, and his health and financial situation had deteriorated considerably by this time. Among the legacies of his final days was a speech he delivered at the first meeting that convened the All-India Progressive Writers Association (AIPWA) in Lucknow, for which he accepted an invitation to give the presidential address.[59] By this moment, Premchand had become disillusioned not only with the film industry, but also, as Carlo Coppola notes,

> with the Gandhian approach to the questions of India's independence from Britain, the plight of the Indian masses, and the role of the writer in society, and [he] looked

to a more forceful, aggressive political, social, and literary activism to attain these various problems. . . . Among the organizers of the progressive movement Premchand found both young writers in need of assistance from an older, established author, and political thinking of a distinctively leftist cast.[60]

In an admittedly polemical gesture, Coppola suggests that the ailing Premchand's address to the first AIPWA meeting, titled "The Purpose of Literature," may have been either ghostwritten or gleaned from Akhtar Husain Raipuri, whose article "*adab aur zindagii*" (Literature and life) had been published in the Hyderabad-based literary journal *Urdu* just the previous year.[61] Raipuri's article had had created quite a stir, and Coppola notes that it bears many similarities to Premchand's presidential address to the AIPWA.[62] Both Premchand's address and Raipuri's published essay delineate their criticisms of Indian literature to date and go on to uphold the project of a modern Indian literary movement that would direct its concerns toward the plight of the masses, elevate social consciousness, and effect changes for the betterment and empowerment of those who suffered oppression.

Whether ghostwritten, plagiarized, or not, Premchand's address does indeed overlap with concerns in Raipuri's essay and in turn, with concerns that had become major points of discussion among Urdu writers of the time. At one moment in his address, Premchand indicts earlier practices of Indian literature—namely, the output of poets under courtly patronage for their indulgence, in contending that "the ideal of love satisfied lust and that of beauty contented the eyes."[63] "True" literature, for Premchand, cultivated critical acumen and tastes:

> That literature which does not rouse our good taste . . . which does not awaken our love for the beautiful, which does not produce in us resolution and the determination to achieve victory over difficulties, that literature is useless today. . . . [Literature] tries to awaken this love of beauty in man. . . . [The writer's] esthetic sense becomes so refined that whatever is ugly, ignoble, and devoid of human qualities becomes intolerable to him. He attacks this with the full force of words and feelings at his command. . . . Society is his court and he submits his plea to this country and deems his efforts successful if it arouses a sense of the esthetic and a sense of justice.[64]

In the above passage, Premchand identifies the purpose of literature (which, he contends, is progressive by its very nature if it is indeed "true" literature) as its ability to awaken a "love of beauty in man" and thereby arouse a "sense of the esthetic and a sense of justice." Prior to this portion of the address, Premchand notes that the emergence of modern literature as a secular form paved the way for the pursuit of such ideals, possessing the power to finally steamroll over the narratives by which religion in feudal societies—that is, obeisance to a cosmic order that rationalized inequality—held power over people.

Both Premchand and Raipuri note that the production of literature in India, until the modern era, was dominated by two classes of people: poets under courtly patronage on the one hand and mystic-ascetics on the other. While Raipuri reserves

his most scathing critiques for the former, he is highly dismissive of Kabir as a poet who is representative of the latter, for embracing death-in-life in "lament[ing] the impermanence of life and the helplessness of man."[65] Such an indictment entirely disavows Kabir's historicity, as death-in-life was also an uncompromising rejection of the caste hierarchies that had brutally condemned so many. By regarding Kabir as a writer who exhibited poor taste in his literary choices, Raipuri displaces the historical and interceding hagiographical contexts that are imbricated in Kabir's poetry and isolates the poet as "an individual of enormous power and charisma . . . [and] as the figure of a feisty individuality."[66]

It this conception of the author as "an individual of enormous power and charisma [and] of a feisty individuality" that Premchand and Raipuri both take for granted. By exalting the author as the primary agent of progressive thought, whose genius is attested to by the author's ability to convince the masses of the merit of his progressive thinking, a rather patronizing stance toward these masses emerges in its foreclosure of any possibility of active participation, aside from that of acquiescence. In Premchand's address, this stance is especially evident when his discussion of the "purpose of literature" quickly gives way to a self-aggrandizing characterization of the author: "[Literature] tries to awaken this love of beauty in man. . . . [The writer's] esthetic sense becomes so refined . . . [and he] deems his efforts successful if it arouses a sense of the esthetic and a sense of justice."[67]

Revisiting the letters that Premchand sent to the younger Hindi writer Jainendra Kumar from Bombay, it becomes apparent that the film industry's apparent disinterest in Premchand's eminence as an author was what seems to have left him most disenchanted. Writing about his experience with *The Mill*, Premchand opens a letter to Kumar:

> I knew you won't like "Mazdoor." Though mine, it is not mine. A romance is on its way, even that is not mine. Very little of me has gone into it. The same with "Mazdoor." In a film, the director is all in all. A writer may be a nabab of his world but to the director he is a bonded slave, without any say. Only through submission can he survive in this celluloid world."[68]

In his letters, Premchand does indict the film industry for capitulating to powerful producers and for thriving on vulgar public tastes for cheap entertainment, although he admits that "even the directors are dissatisfied."[69] However, the primary source of Premchand's dissatisfaction with the film industry, which he addresses at the outset of another letter that he wrote to Kumar from Bombay as well, seems to be his fall from his status as a "nabab" to that of a "slave" upon leaving his home in the world of letters and entering the foreign territory of cinema. "Very little of me has gone into" the finished product, Premchand writes with disappointment, expressing his frustration over the fact that his own writerly contributions were overrun by other concerns on the part of producers and directors in the hierarchical space of the studio.[70]

Yet, what popular cinema could potentially give the public, even through entertainment, was exactly what Premchand identifies as the mode of critique that lies at the heart of his own conception of a modern [progressive] Indian literary movement. This purpose was not necessarily to offer a realist reflection of the present but rather to usher in a "love of beauty," or a desire for the utopian promises of modernity that would sustain the constant mobilization of a large collective through its infinite deferral, as it would always remain ahead of the far more disappointingly less-than-ideal present, particularly for those who were most vulnerable to exploitation. Conceived thus, the radically egalitarian, anti-authoritarian promise of literature—as well as cinema, among other forms—resides not in the liberal subjectivity of either the author or the reader-viewer-listener as an individual but in a field of energetic, collective engagements that constitute a world of radical possibilities through critical acts of reading, as elaborated by J. Daniel Elam.[71]

A feminist commitment that Elam advances in his consideration of foundational anti-colonial Indian intellectuals' conceptions of reading is that the critical potential of reading privileges neither mastery nor efficacy nor applicability. In other words, these intellectuals' writings point to the "inconsequential" pleasures of reading as opening up anti-authoritarian, anti-colonial, "impossible" forms of a world imagined by a reading collective who would hope against hope. The radically egalitarian promise of such reading would ensue from disburdening the act of reading from of having to satisfy either masculine ideals of mastery and productivity or related pragmatic concerns over applicability that would necessarily capitulate to hegemonic, structural limits of the "possible." Necessarily illiberal in its ethical horizons that eschewed the primacy of the Western, post-Enlightenment self, the modernity advanced by such reading practices is not altogether unlike the lyrical conception of knowledge attributed to figures like Kabir and Bulleh Shah, who similarly rejected both the preservation of the ego and the orthodoxy of authoritative (brahminical) mastery for being self-serving pursuits that were ethically abhorrent.

In Premchand's AIPWA address, the font of a text's creative and political energies are concentrated in the genius of the individual author. The heterogeneous form of Hindi popular cinema, however, destabilized the status of any single author or authority significantly enough to have allowed for the collective participation of audiences, particularly around the infinite catchiness, repeatability, and open-ended poetics of its songs.[72] In his AIPWA address, Premchand criticizes the excessive love of older courtly genres of Indian poetry at the same time that he upholds love as the essence of a progressive ethics of modern literature. The pursuit of love and beauty as ideals thus unfolds as a slippery slope between justice and indulgence—or, as noted by theorists of both love and cinema, between radically egalitarian sociopolitical formations through the politicization of aesthetics and those that are utterly fascistic through the aestheticization of politics.[73] This

slippery slope comes to the fore in post-independence iterations of *prem nagar*, as the City of Love becomes an increasingly reflexive reference to the romantic, sensual space of popular film/songs and begins to field various arguments around popular cinema and its bids for entry into arenas of "authentic" national culture.

In her analysis of V. Shantaram's 1939 film *Aadmi*, Sangita Gopal points to the film's stake in establishing a realist aesthetic for Indian cinema amid the growing nationalist movement toward independence.[74] Gopal discusses a scene in the film that lays out this investment as the film's hero and heroine, a policeman named Moti (Shahu Modak) and prostitute named Kesar (Shanta Hublikar), stumble upon an outdoor film shoot. A song sequence is being shot, which makes fun of romantic duets as well as the kinds of films that were made by the Bombay Talkies studio. In addition, a parody of the song *"prem nagar men banaauungii ghar main"* ("I will build a house in the City of Love") from the 1934 film *Chandidas* ensues, with Kesar and Moti singing and acting out their own version of a romantic duet in the song sequence *"premii prem nagar men jaayein"* ("Lovers shall go to the City of Love"), which "pushes to absurd limits the romantic idealism proffered by love songs . . . [as] they sing of 'prem ki chulha, prem ki roti, prem ki chutney'—stove, bread, and chutney made of love."[75]

Gopal concludes that "by aligning the artifice of the product with the inauthenticity of the producers, Shantaram makes a case for an indigenous—and therefore more nationalist—aesthetics."[76] The sequence from *Aadmi* pejoratively equates the City of Love to a cinema of artifice whose exemplary feature is its indulgence in the cloying excesses of romance, especially through the romantic song sequences that are its cheapest trick. In the next few years leading up to the subcontinent's independence in 1947 and in the decade of the 1950s that was to follow, *prem nagar* remained a staple among other stock images that made regular appearances in romantic songs.[77] As a uniquely spatial motif that could refer to not only the city in its modern sense but also expressions of romantic love that had by then become inextricable from the idioms of popular cinema, *prem nagar*, a trope that had previously been closely tied to *sant* poetry, was increasingly synced to the diegetic and spectatorial spaces of popular cinema and the repeatable, romantic songs that marked them as such.

Shantaram's desire for a realist aesthetic at the heart of a purportedly more authentic Indian cinema and his concomitant critique of a cinema that indulged in the artifice of romantic excess was a nationalist desire that snowballed through the 1950s on the part of a much wider constituency.[78] In the 1950s, "sister cities" to *prem nagar* proliferated through film song lyrics, registering a shift that imbued the City of Love with increasingly romantic, fanciful, and intimate connotations by association: *pii(yaa) kii nagar* (City of the Beloved), *man kaa nagar* (City of the Heart/Desires), *priit nagar* (City of Affection), *dil kaa nagar* (City of the Heart),

sapnon kaa nagar (City of Dreams), *farishton kaa nagar* (City of Angels), and *ruup nagar* (City of Beauty) (table 1; see rows marked with asterisks).[79] The trope seems to have completely pried itself from its roots in *sant* poetry, moving from the mid-1930s moment when cinematic references to *prem nagar* implied experiences of transit and deferral that were formally and historically embedded in the medium of the cinema and its constitutive city-spaces of industrial modernity through the 1950s when *prem nagar* became a township affiliated with a series of sister cities of Affection, Dreams, and so on.

However, a song from the 1958 film *Miss Punjab Mail* (N. Vakil), which was scripted by celebrated Urdu poet and AIPWA member Kaifi Azmi, recuperates an association between *prem nagar* and *sant* poetry through an explicit reference to the figure of the mystic. It begins, *"prem nagar se jogii aayaa, aayaa badal ke sakhii rii bhesh"* (A mystic came from the City of Love, he came, my friend, having altered his garb). While the film is no longer extant, an archived script fills in the diegetic context for this song: "Heroine is dreaming, singing and dancing on the moon with two girl friends."[80] Presumably, the heroine is a young girl who is either awaiting an initial romantic experience or awaiting a lover for whom she pines, as she sings of a fraudulent "mystic" from the City of Love who, having altered his countenance, was able to seduce her. While she chides this figure through the song lyrics as *chanchal* (capricious), the tone of the lyrics and the context of the song suggest that the sequence is flirtatious and upbeat overall.[81]

Two years later, a song (table 2) was recorded for the album of film *Masoom* ("Innocent," Satyen Bose, 1960), whose refrain similarly recuperates the figure of the mystic in its reference to the City of Love: *"tuu prem nagar kaa saadhu chalaa kar jaaduu meraa dil luut liyaa, oye meraa dil luut liyaa"* (You, a saint from the City of Love, cast a spell upon me and looted my heart, oh you looted my heart). Artifice is characterized as a pleasurable mode of seduction, defending the space of *prem nagar* and the wily, irresistible charms of, respectively, the mystic and saint who disguise themselves as celibate ascetics but are in fact masters of illusion, magic, and seduction, and who hail from the City of Love. Throughout the rest of the song from *Masoom*, the masculine and feminine voices alternate in a dialogue of verses that are not only replete with explicit references to other films and to the processes of going out to watch movies (buying a ticket, finding that a particular film was sold out, etc.) but are also each set to the tune of well-known, more-or-less contemporaneous film songs (see table 2). The lyrics of each verse parody the original songs that are referenced melodically, but this time, in contrast the sequence from *Aadmi*, the parody upholds rather than debunks the use of artifice, epitomized by stylized performance and romance.

What is apparent in a song like *"tuu prem nagar kaa saadhu"* is that the authority, or the meaning, of the text is relegated to the audience. Its sense as an argument for the pleasures of cinema is scaffolded by its reflexive pastiche that becomes robust

Hindi Lyrics	English Translation
f – tuu prem nagar kaa saadhu chalaa kar	f – You, a saint from the City of Love, cast
jaaduu meraa dil luut liyaa	a spell upon me and looted my heart,
oye meraa dil luut liya	oh you looted my heart!
m – tuu ruup nagar kii raanii badii	m – You, a queen from the City of Beauty,
mastaanii meraa dil luut liyaa	overjoyed, looted my heart,
haaii meraa dil luut liyaa	oh you looted my heart!
m – ham dekhan ko gayaa thaa	m – I had gone to see
chaltii kaa naam gaadii	*Chalti Ka Naam Gaadi*[1]
jab tikat na milaa to	Since I didn't find a ticket
ham dekh aayaa anaarii	I watched *Anaarii*[2] and came!
f – sab kuchh tum ne dekhaa	f – You have seen everything?[3]
na dekhii hunterwali	You haven't seen *Hunterwali*[4]
hunterwali se mister	The men (taking a cue) from *Hunterwali*
karte hain akhii-chaalii	Flirt/make eyes at you!
m – sab kuchh ham ne dekhaa	m – I have seen everything
na dekhii hunterwalii	I haven't seen *Hunterwali*!
f – tuu prem nagar kaa saadhu . . .	f – You, a saint from the City of Love . . .
m – tuu ruup nagar kii raanii . . .	m – You, a queen from the City of Beauty . . .
f – o tere baap kaa makaan saiyaan	f – O, your father's house, darling[5]
badaa aaliishaan	is rather luxurious
puchhe mere abbaa jaan hai	Ask my dear father
kiraayaa kitnaa	How much rent is!
m – leke puuraa khaandaan	m – Bring your whole family,
aajaa ban ke mehmaan	come as my guest
main na puchhuun merii jaan	I won't ask, my love,
tuu ne khaayaa kitnaa	How much you ate!
m – pyaar ke sholon men tere	m – In the flames of your love[6]
main jaluungaa ek din	I will one day burn
chhod ke duniyaa jahannum	Leaving the world, to Hell
ko chaluungaa ek din	I shall go one day
chhod ke duniyaa jahannum	Leaving the world, to Hell
ko chaluungaa ek din	I shall go one day!
f – tumhaare sang,	f – Along with you,[7]
tumhaare sang	Along with you
main bhii chaluungii piyaa jaise	I, too, will come just like
patang piichhe dor	A string tethered to a kite
haan re piyaa jaise	Yes, o my love, like
patang piichhe dor	A string tethered to a kite!

TABLE 2. (*Continued*)

Hindi Lyrics	English Translation
m – chaand chhupaa aur kutte bhaunke	m – The moon silent and the dogs[8] barking,
raat gazab kii aayii	The wondrous night arrived
soch samajh ke milne aanaa	Calculating carefully, come to meet me
dekh na le hamsaayii	Don't let the lady next door see you,
o dekh na le hamsaayii	O don't let the lady next door see you!
f – uunche uunche bangale kii	f – The tall, tall bungalow's[9]
divaare saiyaan phaand ke	walls, my darling, I'll jump over
jii phaand ke	Yes, jump over and
main aauungii	I will come
tere liye taangen apnii tod ke	Breaking my legs, for you
main aauungi	I will come
tere liye taangen apnii tod ke	Breaking my legs, for you!
m – hai hai!	m – Whoo, whoo!

f = feminine voice

m = masculine voice

[1.] *Chalti Ka Naam Gaadi* (That which moves is called a car, Satyen Bose, 1958); "super-hit" earlier film by the director of *Masoom*.

[2.] *Anaarii* (Novice, Raj Kapoor, 1958); "super-hit" film that swept several Filmfare awards that year.

[3.] Melody and lyrics: parodic citation of *sab kuchh hamne siikhaa* (I have learnt everything), a song from *Anaari*.

[4.] *Hunterwali* (Lady of the whip); title of both a 1959 film and a famous 1930s stunt film.

[5.] Melody: parodic citation of *tere dil kaa makaan* (The house of your heart), a song from *Do Ustad* (Tara Harish, 1959).
Original lyrics:
f – *o tere dil kaa makaan, saiyaan* / O, the house of your heart, darling
badaa aaliishaan / is rather luxurious
bolo bolo merii jaan hai / tell, tell my love
kiraayaa kitnaa / how much the rent is
m – *khaalii dil kaa makaan* / to the empty house of the heart
banke aajaa mehmaan / come as a guest
ye na puchho merii jaan / do not ask, my love,
hai kiraayaa kitnaa / how much the rent is.

[6.] Melody: parodic citation of a song from *Sohni Mahiwal* (Raja Nawathe, 1958).
Original lyrics:
aaj galiyon men terii / Today in your lane
aayaa hai diivaanaa teraa / has one crazy for you arrived
dil men lekar gham teraa / having taken your sorrow in his heart,
hothon pe afsaanaa teraa / your story upon his lips
aaj galiyon men terii / today in your lane
aayaa hai divaanaa teraa / has one crazy for you arrived.

[7.] Melody: parodic citation of a song from *Sohni Mahiwal* (Raja Nawathe, 1958).
Original lyrics: The same. The joke is that as a response, the feminine voice is saying that she will be happy to follow her lover to Hell "just like a string tethered to a kite."

TABLE 2. (*Continued*)

8. Melody: parodic citation of a song from *Sohni Mahiwal* (Raja Nawathe, 1958).
 Original lyrics:
 chaand chhupaa aur taaren dube / The moon hidden and the stars submerged,
 raat gazab kii aayii / the wondrous night arrived
 husn chalaa hai ishq se milne / Beauty has left to meet Love
 zulm kii badlii chhaayii / the spell of tyranny clouded
 ho raat gazab kii aayii / o the wondrous night arrived.

9. Melody: parodic citation of a song from *Nagin* (Nandlal Jaswantlal, 1954).
 Original lyrics:
 unchii unchii duniyaa kii divaaren / The tall, tall walls of this world
 saiyaan thodke / my darling, I'll break
 jii thodke / yes, break
 main aauungii / and I will come
 tere liye saaraa jag chhodke / leaving behind the whole world.

with meaning only when the audience can contribute their cinephilic expertise. Furthermore, the song's slightly altered repetition and recombination of a number of other film songs is merely an exaggerated instance of what is more or less typical. Hindustani film songs not only refer to one another and/or recombine and repeat stock phrases and images continuously but also in this way become both templates as well as reflections of participatory practices among audiences, who take pleasure in repeating, referencing, and creatively recombining songs from films. At its best, this amounts to a collective cinephilic practice of critical reading.

While "*tuu prem nagar kaa saadhu*" appears on the record album and in song booklets for *Masoom*, the song stands out as extraordinarily ludic against the film's narrative, which is about three orphaned siblings who are left homeless and must fend for themselves on the streets of Bombay. A developmentalist commitment to social justice on the part of the filmmakers concludes the prose summary-introduction that precedes the printed lyrics in the song booklet:

> In our own humble way, we have in MASOOM attempted to focus attention to this vital social problem. MASOOM tells the story of three lovable children orphaned by the sudden and untimely death of their father, and whilst presenting this story of three innocents in an unkind world, we are drawn to Pandit Jawaharlal Nehru's words—"It is the birthright of every child to have education, love and affection, proper clothing and opportunities to progress in life."[82]

Although writer Ruby Sen won a Filmfare Award at the time for Best Story, the film's narrative has not carried forward a legacy. In fact, the extremely well-known children's song "*naanii terii mornii ko mor le gaye*" (Granny, the peacocks have made off with your peahen) actually comes from the film *Masoom*, although the film as a whole—materially, in any recorded format and discursively, as a cultural memory of its generation—has all but fallen into oblivion. The song "*naanii terii mornii ko mor le gaye*" was penned by Shailendra, a beloved lyricist associated with actor Raj Kapoor and known as a poet of the people.[83] When I came across one

extant positive celluloid print of *Masoom* at the National Film Archive of India (NFAI), the exciting discovery of such an interesting song sequence—how was a song like "*tuu prem nagar kaa saadhu*" picturized?—seemed imminent.[84] Yet, the song neither appears in the film nor is it referred to anywhere in the archived script on file at the NFAI. The song's appearance in the latter might have indicated that the song was intended to have been shot but was never actually filmed, or it was filmed and later excised. Was the song recorded for another film originally and then added as a bonus to *Masoom*'s album? Was it recorded as a whimsical, romantic song to appeal to people who may not have purchased the album without such a track?

Another explanation arises out of *Masoom*'s historical context. The film emerged at a time when the Indian state had established institutions to support an alternative, properly modern cinema, and some saw Hindi cinema in this period as having "turned its back to the political and social scene and started churning out romantic films."[85] The song "*tuu prem nagar kaa saadhu*" makes an argument for the merits of popular cinema around its belovedness, in spite of and even because of its tricks of stylized artifice. This ekphrastic argument complements *Masoom*'s publicity materials, which position the Bombay cinema as an all-India public's alternative representative vis-à-vis the state. In the summary-introduction of *Masoom*'s song booklet, the filmmakers put forward their support of a developmentalist program of intervention that might ease the plight of orphans. The film proffers to instill through its story a widespread sense of compassion for such orphans, in whose lives the public will then have a stake. The prose turns to a declaration by India's first prime minister Jawaharlal Nehru that "it is the birthright of every child to have education, love and affection, proper clothing and opportunities to progress in life."[86] This citation affirms the Nehruvian state's developmentalist program at the same time that it critiques it as a failed promise, due to its conspicuous unfulfillment.

Popular cinema steps in here, exhibiting itself as both an ally in a nationalist program of development and a critic that voices social issues affecting a public constituency that remains underserved by the state. It is to make such an argument for popular cinema—synonymous with love as both romance and cinephilia—that "*tuu prem nagar kaa saadhu*" is thoroughly a part of *Masoom*, even when it isn't. On the one hand, we can analyze the progressive textual aspirations in a film like *Masoom* (e.g., its narrative, its publicity), but on the other hand, these meanings are rendered unstable by the extent to which such a film's various parts—lyrics, songs, specific dialogues—could circulate more or less on their own, and unpredictably so. The transformative potential of cinephilia is perhaps apprehended only by taking these various texts seriously and critically and holding together their contradictions: that is, to neither dismiss a song like "*naanii terii mornii*" as merely "silly," nor to take reflexive celebrations of popular cinema's romantic pleasures at face value, nor to dismiss the same outright, nor to assume the vacuity

of lyrics and lyrical tropes—or even films, for that matter—that seem utterly banal and formulaic. The pressure for cinema to be productive of social good for the nation and world in this period precipitated films' active engagement with questions that remain of pressing importance to any commercial media that interfaces with its publics on a large scale: What constitutes social good? Does pleasure itself constitute a social good? How so, for whom, and by what means?

Ekphrastic, lyrical paeans to love were one way of articulating the truth of pleasure at the heart (pun intended?) of popular cinema, as a response to charges of exploiting audiences with cheap tricks of romance and frauds of unreality and artifice. In both the song from *Miss Punjab Mail* and the song from *Masoom* whose refrains invoke *prem nagar*, performative modes of seduction through the artifice of disguises and spells—the charms of cinema—are affirmed as participatory, consensual forms of romance, pleasure, and even social justice. The one who is seduced by the saint-mystic is neither *really* caught off guard by the artifice nor an unwilling party to the seduction by any means. The song from *Masoom* explicitly links the seductions of artifice to the pleasures of popular cinema through a plethora of melodic and lyrical references to other film titles and film songs. The presence of the figure of the saint-mystic as well as the trope of *prem nagar* hearken back to a genealogy of popular practices of song, nodding in the direction of the *sant* poetry from whence the trope of *prem nagar* emerged.

However, given the structure of the songs and their lyrical associations of the saint-mystic and *prem nagar* not with asceticism and spirituality but with the trickery of both romance and cinema, it is clear that by the 1960s, the City of Love, despite its genealogical affinities with *sant* poetry, had become explicitly tied to the modern context and form of popular film/songs. The City of Love here argued that it could offer the public *itself*—as a space for "inconsequential" pleasures inhabited and created through public participation and as a jurisdiction of a fantastic artifice that keeps in motion those who have willingly submitted themselves to its charms in pursuit of a utopian future that the real-time of the present continues to withhold.

Among the sister cities to *prem nagar* that spring up in song lyrics in the post-independence decade is *ruup nagar*, the City of Beauty (table 1; see songs marked by double asterisks). Within the diegesis of the film *Sazaa* (Fali Mistry, 1951), a band of folk singers performs a song that begins, "*o ruup nagar ke saudaagar o rang rangiile jaaduugar*" (O merchant from the City of Beauty, O colorful magician). In this song, *ruup nagar*, like *prem nagar* by this time, is characterized as a space of illusion and magic and furthermore, as a bazaar-like marketplace of merchant-magicians and street singers. As *prem nagar* and its sister cities are reflexively rendered as the space of cinema, this characterization of *ruup nagar* is one that underscores the industry of cinema as a commercial enterprise aligned with

peddlers of attractions—magicians and merchants—milling about the bazaar, the open-air market of city streets. One recalls that the duet from *Masoom* opens with a playful accusation in a feminine voice: "*tuu prem nagar kaa saadhu chalaa kar jaaduu meraa dil luut liyaa*" (You, a saint from the City of Love, cast a spell upon me and looted my heart). To this, the masculine voice responds in the next line: "*tuu ruup nagar kii ranii badii mastaanii meraa dil luut liyaa, haaii meraa dil luut liyaa*" (You, a seductive queen from the City of Beauty looted my heart, oh you looted my heart).

Having first entered film song lyrics in the 1930s from *sant* poetry that had been transmitted through participatory practices of song, *prem nagar* was increasingly coupled with *ruup nagar* in particular as the domain of an alluring feminine figure akin to the Beloved: the bewitchingly beautiful, unattainable object of courtly genres of classical Hindustani poetry. This split between a masculine City of Love and feminine City of Beauty falls along hierarchical binaries reinforced by the dyad of gendered voices in romantic duets: masculine and feminine, active and passive, depth and surface, substance and appearance, public and private, subject and object. In a lyrical genealogy of *prem nagar*, this splitting emerged at a juncture that saw the dominance of the social—what Prasad refers to as the feudal family romance—whose nationalist-ideological core revolved around the cinematic construction of the middle-class, upper-caste, heterosexual Hindu couple, in tandem with the prominence of the romantic duet.[87] But as poetic tropes that had by then become clichés of cinematic romance, the lyrical deployments of *prem nagar* also carry a more transgressive force that goes against the grain of idealized, heterosexual Hindu monogamy.

In a well-known episode of the Hindu epic of the Ramayana, the abduction of the deity Rama's idealized goddess-wife Sita occurs through the demon-king Ravana's employment of subterfuge. Versions of the Ramayana have been central to violently patriarchal assertions of Hindu nationalism and brahminical modernity, which have insisted in unambiguously absolute terms upon Rama's martial virtue, his consort Sita's chastity as a devotedly married woman, and Ravana's demonic villainy.[88] At a pivotal moment of the epic, Ravana disguises himself as an ascetic in order to beguile Sita into crossing the *lakshmana rekhaa*, a protective spatial boundary demarcated by her brother-in-law Lakshmana, within which her honor as the married consort of the deity Rama would remain impervious to any potential for violation. With the figure of the wily mystic-lover invoking this myth of the lustful Ravana disguised as an ascetic, the lyrical defense of (cinematic) artifice hinges on an allegorical assertion that the feminine Beloved is not merely an passive victim but in fact a resolutely willing party to the seduction at hand. In such a defensive assertion of consensually transgressive pleasure epitomized by the ostensible excess of nonconjugal, nonreproductive feminine sexuality, the spectator is addressed as shrewdly role-playing in their suspension of disbelief—in gleefully crossing a *lakshmana rekhaa* with their eyes wide open and in having their hearts willingly "looted," whether by love or by beauty, on- or offscreen.

The publicness of popular cinema—the space of the theatre that assembles the masses as a collective—has been a fixture of film theory, especially within Indian film studies' emphasis on the pivotal historical role that cinema has played in mediating the public's postcolonial transitions into political society as the domain of the rights-bearing citizen of the modern nation-state.[89] In the case of South Asian popular cinemas, the public's encounter with cinema-as-modernity in the public space of the theatre was deeply interlaced with cinema's presence in much more intimate spaces. With (and even without) the technology of the radio and gramophone, cinema entered the home in the oral/aural forms of film song melodies and lyrics and in printed forms like song booklets, which, despite circulating autonomously, were constitutive of cinema as a technological and aesthetic formation whose mediation of social worlds was not limited to the space of either the theatre or the screen.

The question of spectatorship and cinephilia becomes a key stake for revisiting claims about the degeneracy of Hindi cinema over a period of the long 1960s. As often as some have celebrated this period as part of a post-independence golden age that began in the previous decade, others have decried the 1960s for a range of cloying excesses, none more egregious than the facile escapism of romping, romancing couples. Naseeruddin Shah, a renowned thespian associated with the middlebrow Indian new wave, famously blamed Hindi film star Rajesh Khanna for the industry's decline that began in the 1960s and accelerated through the early 1970s. Shah remarked in 2016 that mainstream Hindi cinema had yet to recover from the damage inflicted by this period: "The quality of script, acting, music and lyrics deteriorated. Colour came in. You could make a heroine wear a purple dress and hero a red shirt, go to Kashmir and make a movie. You didn't need a story. This trend continued and I certainly think Mr. Khanna had something to do with it because he was a God in those days."[90] Such sentiments situate the value of Hindi film/songs in the aesthetic unity of their stories and the quality of authorial content. Such an emphasis on the aesthetic and authorial unity of content echoes Premchand's AIPWA address, which situates the project of progressive thought in the individual genius of authors who can incite and mobilize the public through the charisma of their ideas, whether in terms of the films' narratives (films concerned with social and political issues versus romantic films) or song lyrics (progressive lyrics versus politically vacuous lyrics).

This chapter's pursuit of *prem nagar*, an open metaphor for a space whose content has been colored in by the contexts through which it has traveled and whose poetic and cinematic genealogies imbue it with a social history of vernacular forms of sung poetry and love lyrics, points to an alternate formation of the progressive that ensues out of participatory cinephilic engagements. Such poetic forms can become available within a collective domain of the popular in ways that exceed their alignments with dominant capitalist as well as statist imperatives, fueling the creative energies of spectators like Ashraf Aziz, who in turn contribute as additional authors of movements toward an egalitarian world that is debated

and forged—rather than merely consumed—by "the masses," in its multiplicity of memories, histories, and desires. The ensuing chapters continue to explore reflexive engagements with love-as-cinephilia over the long 1960s through a set of productions that sought to cross various thresholds: of national borders, linguistically demarcated publics, and, perhaps most crucially, the rational and possible.

Star-Crossed Overtures

Cinephilia in Excess

Homosocialist Coproductions

Pardesi *(1957) contra* Singapore *(1960)*

Following the resounding success of *Awara* (Raj Kapoor, 1951) among Soviet audiences, screenwriter K. A. Abbas led a film delegation to the USSR in 1954. A founding member of the Indian Peoples Theatre Association (IPTA) affiliated with the Communist Party of India, Abbas was a prolific journalist and writer who saw cinema as an ideal medium for raising the masses' consciousness toward progressive social causes. In 1955, India had declared its adherence to the Non-Aligned Movement, whose principles of Cold War neutrality were drafted at the Bandung Afro-Asian Conference in Indonesia that year.[1] The Soviet Union "gave a full-throated endorsement, roaring in support of the anticolonial claims of the attendees," and for the next decade, diplomatic relations remained warm between the Indian socialist democratic government under its first prime minister Jawaharlal Nehru and the Soviet Union under Nikita Khrushchev.[2]

Shortly after the Indian film delegation's visit to the Soviet Union, plans began for a coproduction between Abbas's company Naya Sansar (New World) and the Moscow-based Mosfilm Studio. A three-year-long process culminated in a film released in two languages: a Hindi-dubbed version titled *Pardesi* (Foreigner) and a Russian-dubbed version titled *Khozhdenie Za Tri Morya* (*Journey beyond Three Seas*), released in 1957 and 1958, respectively. Abbas's recollections of the coproduction appear in a chapter of his autobiography titled "Three-Legged Race." The chapter's titular metaphor evocatively captures the challenges that ensued from the coproduction's commitments to a deeply collaborative transnational venture, involving two directors, two cinematographers, two music director-composers, and two editors, as well as production on location in both the Soviet Union and India.[3] Among the difficulties that came up for Abbas was the matter of contributing his portion of funds to the joint venture. In the Bombay industry, a typical method of financing films was to mortgage the negative to private investors upon

its completion. But in this case, the negative of *Pardesi/Khozhdenie* was in Moscow. Although the coproduction was a private (rather than state-backed) endeavor on the Indian side, Indian Prime Minister Jawaharlal Nehru intervened on Abbas's behalf in light of the perceived diplomatic significance of the endeavor.[4] Abbas ended up getting a loan—typically unavailable for filmmaking, since cinema was not officially recognized by the government as an industry—from Finance Minister T. T. Krishnamachari.

Distribution rights were negotiated at the very outset of the coproduction. Abbas explains that "India and the 'Indian overseas' (where substantial numbers of Indian settlers are and where the Indian version could be exploited) were to be with us; while the Soviet Union, and the rest of the Western world would be exploited by Sovexportfilm on a fifty-fifty basis."[5] While a shorter, 101-minute Hindi version is currently available in a poorer-quality black-and-white subtitled DVD edition (along with shorter unsubtitled Hindi versions), no digitized color version of the Hindi film is readily available.[6] A 1999 Ruscico DVD release, intended for distribution outside the former Soviet Union, is the best-quality release among available versions, barring any well-preserved archival prints. The 143-minute Ruscico DVD features a high-resolution, wide-screen color version of the film over two discs that include several DVD extras and language options. This is perhaps the version that is closest to a 151-minute version of the film, which was edited down to an "overseas reduced length" of 122 minutes and submitted by India as an entry to the 1958 Cannes Film Festival, where it was selected for that year's competition and honored among "Five Outstanding Pictures of the World."[7] To a major institution of world cinema like Cannes, *Pardesi/Khozhdenie* was eligible for consideration only through its official categorization and submission under a single country of origin, despite the fact that the film's collaborative process was in many ways antithetical to this imperative.

The language options offered by the Ruscico DVD are solely European languages: Russian, English, and French DVD menus; Russian audio; Russian audio with either English or French voice-over translations; and subtitles in English, French, Spanish, Italian, and German. The absence of any Hindi-language option whatsoever is not surprising, in light of the film's distribution rights having been divided at the outset of the coproduction. At the same time, the absence of this option points to the extent to which *Pardesi/Khozhdenie*, in being so emphatically invested in its own coproduction as a political project of Indo-Soviet cinematic collaboration and exchange, goes against the grain of the most visible (and audible) institutional and market divisions that often map onto area-studies territorial blocs. The endurance of such blocs of distribution is apparent through the menu of European language options offered by the Ruscico DVD, at a remove of four decades from the time of the film's release.

In this chapter, I detail the extent to which *Pardesi/Khozhdenie* was steeped in its endeavor as a coproduction, as the film's diegetic world and production

contexts thoroughly infused one another across variations in the film's multiple extant versions. Toward the end of this chapter, I contrast the material and diegetic contexts of *Pardesi/Khozhdenie* with those of *Singapore* (Shakti Samanta, 1960), a Hindi-language Indo-Malay coproduction. While *Singapore's* production was more overtly commercial, both coproductions mobilized the diegetic figure of the singing dancer-actress—and the stardom of the dancer-actress Padmini in particular—as a distinctly Indian feature that could contend with issues of multilingual distribution. Through a juxtaposition of *Pardesi/Khozhdenie* and *Singapore*, I emphasize material-historical and diegetic motifs of the singing dancer-actress as a uniquely mobile figure across industries within India and between Indian and overseas industries through a handful of transnational prestige coproductions over the long 1960s.

The importance of the figure of the singing dancer-actress in this period and of the kind of cinephilia that she figured in turn were indispensable to the ambitions of multiple cross-industry productions that proceeded via the Bombay industry. Diegetic sequences across seemingly oddball productions over the 1960s conflated the singing dancer-actress with the audiovisual excess of Hindi cinema in order not only to spotlight the stardom of dancer-actresses but also to make ekphrastic arguments about Hindi cinema's comprehensibility to audiences across languages and its world-making capacities therein.[8] In the films that I examine in part 2, the libidinal excess of love-as-cinephilia is reflexively posited as a well-matched adversary to a range of exploitative excesses that have tended to organize the world: colonialism, casteism, classism, racism, authoritarianism, and sexual violence.

Among the blind spots in these theorizations of love-as-cinephilia, however, is that they rhetorically defend the figure of the singing dancer-actress as metonymic for Hindi cinema's unique capacity to (re)productively engender an overwhelmingly homosocial modernity, based on principles of friendship and exchange. In the case of cross-industry productions, this idealized homosocial world not only reflected the status of film (co)financing as a hierarchically masculine affair but also advanced a heteropatriarchal—and ultimately limited—theorization of love and pleasure. Such ekphrastic claims often contradicted other formal and narrative elements that betrayed far more robust possibilities for cinephilia and spectatorial pleasure. The top YouTube comment for a Hindi version of *Pardesi/Khozhdenie*, for example, is from a user who goes by a Russian woman's name and fondly recalls: "That was my fav movie when I was a child :) I simply got sticked to the screen when I have seen fabulous Padmini dancing in a temple. . . . 'This is Lakshmi, she's a dancer. She can speak with her dance gestures'—that was something like out of this world to me."[9] This top comment not only registers the tremendous impact of dancer-actress Padmini's relatively brief cameo but also underscores the extent to which that sequence was perhaps far more memorable than the extended scenes of masculine bonding, which comprise the film's narrative-ideological core and take up the majority of its screentime.

Pardesi/Khozhdenie not only elevates a mythos of origin for its contemporaneous contexts of Indo-Soviet friendship but also advances a series of arguments about popular cinema's formal capacities for world-making in a reflexively "homosocialist" manifesto for its own coproduction. The film adapts the classical Russian literary text of a memoir by Afanasy Nikitin, a fifteenth-century Tver merchant "who opened, in 1466–1472, a trade route from Europe to India."[10] Repeated melodramatic disaggregations of friendship from both romance and commerce declaim the coproduction's own endeavor as being wholly motivated by friendship and not by self-interest. *Pardesi/Khozhdenie* was produced during the period of the Soviet Thaw, following the death of Joseph Stalin. This period ushered in the circulation of Hindi films among Soviet moviegoers, as well as a healthy sense of socialist goodwill between India and the Soviet Union.[11] Especially popular among Soviet audiences were Hindi films featuring actor-director Raj Kapoor, known for his tramp characters in films such as *Awara* and *Shree 420* (Mr. 420; 1955), whose screenplays were in fact written by none other than Abbas.[12] In this context, *Pardesi/Khozhdenie*'s project emerges as the establishment of a genesis story of Indo-Soviet camaraderie and homosocialist solidarities through Russian literary-historical figure Afanasy Nikitin.

A prestige coproduction that realized its ambitions of scale in a rather literal sense, *Pardesi/Khozhdenie* was shot in SovColor and SovScope.[13] The color photography and wide-screen aspect ratio enable several panoramic vistas, painted as well as photographic, which highlight and juxtapose Soviet and Indian landscapes and monuments throughout the film. In its wide-screen versions, the symmetry of a painted title image establishes the duality of the film's twin national contexts of production through several details, with the left and right sides mirroring one another in their layout, as dramatic orchestral music scored by Boris Tchaikovsky presents the feature as a coproduction of Naya Sansar and Mosfilm Studios (fig. 10). On either side, block text rests in the foreground at the bottom of the screen, displaying the names of the two studios in front of statues of paired men and women workers who are frozen in the athleticism of agrarian and manual labor. These statues of workers are painted atop blocks, and the figures stand tall with their chins raised and their faces angled, their gazes converging at a central point upon a horizon that extends into and above the position of the audience below. The statues rise into a continuous sky that is bright behind them, gradually darkening toward the top corners and edges to effectively spotlight the figures against a breaking dawn. Diagonally behind the figures are monuments on either side, in the bottom corners of the frame and appearing to be at some distance in the background. The tapered, domed peaks of a temple on the left complement the squared lines of a cathedral on the right, and while the monuments are distinctive and visible, the statues of the working-class pairs occupy an indisputable

FIGURE 10. Still
from *Khozhdenie*
Zi Tri Morya (1958):
Title credit.

position of prominence. Subsequent credits continue to emphasize the meticulously symmetrical nature of the film's coproduction, through multiple layers of collaboration between cast and crew from both India and the Soviet Union.

In the opening title image, as well as in at least two subsequent moments, the film explicitly envisions the transnational participation of both men and women workers in its progressive-socialist world-making endeavors. This world-making endeavor, however, is narrated through a hierarchal opposition between a primary masculine domain of work and friendship in the space of the world and a secondary feminine domain of romance and love in the space of the home. On the one hand, the film does acknowledge the revolutionary potential of love when it crosses thresholds imposed by the heteropatriarchal "organization" of the world along lines of class, caste, race, and nationality. On the other hand, *Pardesi/Khozhdenie* ultimately exalts the heroic selflessness of masculine characters who renounce their personal libidinal desires in the interest of socially oriented matters of work, duty, and friendship. The film thus forwards a limited Gandhian logic of austerity, which fails to see that heteropatriarchal injunctions against love and sexual desire across thresholds of difference have been central, rather than peripheral, to the reproduction of highly exploitative hierarchies of race, caste, and class.[14]

Codirector Abbas highlights *Pardesi/Khozhdenie* commitments to "genuine coproduction" in a 1969 article titled "Films for Friendship," which opens an issue of the Indian trade journal *Film World* dedicated to Soviet cinema. Abbas states:

> The production "Pardesi" was launched only in 1956 with the two directors (K. A. Abbas and V. I. Pronin) jointly calling "Camera." That continued to be the basis of our joint work—two directors, two cameramen, two sound recordists, two art directors, and a mixed Indo-Soviet cast led by Nargis and Oleg Strizhenov. In that sense, it remains to date the only genuine co-production between an Indian and a foreign producer.[15]

While *Pardesi/Khozhdenie* was in competition as a nominee for the prestigious Palme d'Or at the Cannes Film Festival in 1958, Abbas does not wear this accolade at all, instead locating the achievement of the film entirely in the fact that "it remains to date the only genuine co-production between and Indian and a foreign producer."[16] Among the most visible manifestations of the film's status

as a joint production are its leads, as the film features a transnational love story between Soviet actor Oleg Strizhenov as the hero-traveler Afanasy Nikitin and Indian actress Nargis as an Indian village woman named Champa.[17] However, the romance between Afanasy and Champa occurs as a monsoon-season interlude that remains star-crossed. Instead, it is the friendship between Afanasy and Sakharam, played by Indian actor Balraj Sahni, that endures as the most robust outcome of Afanasy's travels to India—as a homosocialist allegory, in turn, for the coproduction itself.

Following the title credits, we see Oleg Strizhenov as Afanasy, weakened and haggard upon returning "from the end of the world." Weary from his travels, Afanasy seeks refuge in a church. He sits alone in a dim, candlelit cell, and as he removes a figurine of an Indian woman from his tattered bag, the strains of an Indian *aalaap*, or free-form introductory passage of notes, float up in a woman's voice.[18] This very melody becomes a leitmotif for the as-yet-unseen Champa as well as India, and Afanasy gingerly holds the figurine and gazes upon it for a moment, before removing a journal from his bag and opening it up. The rest of the film proceeds as a flashback that is motivated by Afanasy's continuation of his writings, as he prays, in a voice-over, for strength to share what he has seen. The fifteenth-century literary-historical text of Nikitin's memoir is in this way written into the film. The audiovisualization of the text is framed as a journey of remembering and writing along with Afanasy, as he plunges into his memories to retrace the footsteps of his journey to India.

The flashback begins in the same way as the film's opening scene—with a younger Afanasy having grown weak from his most recent travels and in dire need of rest. However, at this earlier moment in his life, before he has traveled to "the end of the world," he has made it back to his home from a shorter trip to Lithuania[19] with nothing left in his pockets due to having been robbed by multiple bands of thieves on his return journey. His mother and sisters, as well as a young woman whom his mother hopes will soon be married to Afanasy, are as glad to see him as they are anguished by his insatiable wanderlust, which has brought about his poor health and penury. To their dismay, Afanasy's friend and fellow trader Mikhail persuades Afanasy to go to Moscow even before he has fully recovered, in order to seek the prince's patronage for further travel and trade. Although Afanasy is a merchant by trade, the outset of the film shows neither his pockets nor his health to be any measure of his heroic legacy. This parallels *Pardesi/Khozhdenie*'s ambitions as prestige coproduction, which avowedly subordinated any commercial ambitions to the deepening of transnational collaboration, friendship, and camaraderie through cinema.[20]

When Afanasy and Mikhail arrive at the prince's court to find a patron for their travel and trade, the prince refers to the "world" as a domain of resources for Russia, as well as a space for expanding and enhancing Russia's renown. "We don't travel enough around the world, merchants," the prince proclaims, adding

that many Russians, alas, do not even know of the existence of other lands. In the Russian version, the prince states that a man from Lithuania had recently been telling the court about a fantastic land called India, where a short-tempered monkey-king rules people who have heads of dogs—sometimes two—and tails. Afanasy, through Mikhail, voices doubt over the facticity of the Lithuanian man's testimony, having heard otherwise from Persian traders. He avers, "People in India are just like other people. Only they have dark faces." Through Afanasy's response, the film advances the importance of firsthand encounters with the world as correctives to false accounts that stand in for truthful knowledge about foreign people and places.

The prince character's advocacy of endeavors to curb Russia's isolation and enhance the country's renown resonated with the climate of the contemporaneous long 1960s Soviet contexts of *Pardesi/Khozhdenie*'s production.[21] The film, furthermore, underscores histories of mercantile trade across Eurasian kingdoms, locating Persia as a key intermediary between Western and Eastern regions of the continent—a legacy whose contemporaneous cinematic resonances lay in the crucial, yet under-analyzed role of independent distributors in the Middle East in facilitating the transnational circulation of films across the continent. The film's depiction of a long history of Russian-Persian-Indian friendship worked to emphasize Soviet claims to a Central Asian region that was notoriously polarized between antagonistic political factions and Cold War blocs at the time.[22] The palace scene concludes with a frontal medium close-up of the prince as he dramatically turns toward the audience and pronounces an imperative that Russian merchants go forth and trade throughout the world.

Marking Afanasy and Mikhail's departure by boat, a nondiegetic folk song that is an ode to the (home)land of the Volga River commences over wide still shots of painted landscapes that transition through match cuts to wide photographic pans of the river—ostensibly the Volga—as it snakes through lush green landscapes (fig. 11). The camera eventually alights on Afanasy and Mikhail, who are on a boat with a jolly band of Tver merchants. Afanasy goads Yevsey Ivanovich, an older merchant portrayed as a merry drunk, to regale the men with his fantastic accounts of two-headed ocean dwellers and people who wear feathers in their hair and rings in their noses. Such explicitly imaginative characterizations of fantastic foreign lands give way to Ivanovich's utopian declaration that "we will outshine the Moscow merchants!" His declaration marks out a distinction between the endeavors of the traders and those of the seat of power. The endeavors of the traders align with those of the filmmakers, whose ambitions are independent and potentially subversive of—even if crucially supported by—the official desires of their respective states.

Cutting from the court to Afanasy's home, the film juxtaposes the prince's declaration with the reaction of Afanasy's mother, who instead demands that Afanasy stay at home. At the very outset of the film, the space of the home emerges as a

FIGURE 11. Still from *Khozhdenie Zi Tri Morya* (1958): Painted panorama of Russian landscape.

Farewell, thee, wealthy land of Russia,

feminine, domestic space for a static family life that Afanasy's mother wants her son to settle into, in contrast to the dynamic allure of travel amid the fraternities of princely rulers, ambassadors, and traders. In the opening moments of the film, as Afanasy begins the writings that frame his flashback, he wonders in a voice-over whether his desire to see the world caused not only his physical but also his spiritual undoing, precipitating a fall from godliness through the temptation of a wanderlust that lands him in the lap of the devil, as his mother believes. This ambivalence over the moral value of wanting to *see* the world through travel and trade is continually raised, in order to emphasize the sincerity of Afanasy's wanderlust not as an end in itself but as a means of world-making through the forging of progressive-socialist solidarities across national, linguistic, and cultural boundaries.

Afanasy's continual invocation of this question and his insistence that his motivations are noble ventriloquize the ethical aims and claims of a cinematic undertaking's resource-intensive scales of production. Afanasy insists in the opening voice-over, as well as in subsequent intermittent voice-overs, that he has benefitted very little financially and that he has been compelled by a sincere desire to not only see but also record and share his firsthand account of the various people and places of the world he has encountered through his arduous travels that have severely compromised his health. In this manner, Afanasy becomes aligned with the project of the filmmakers, who were sandwiched between state imperatives to enhance their nation's prestige by making world-class artistic films on the one hand and the demands of their respective mass publics at home who clamored for hit films that would offer their filmmakers the satisfaction of box office success on the other. Driven neither by the vanity of acclaim nor by the greed of economic gain, Afanasy's motivations for travelling as an independent merchant are expressed in terms of his desire to humbly share his experiences of the world and to advance relationships of cultural exchange and understanding. The possibilities and limits of such Cold War–era cultural diplomacy through channels of the popular—or in Abbas's words, "films for friendship"—unfold through the film's diegetic explorations of travel, trade, romance, and friendship across national, linguistic, and ethnic borders.

Through a series of repetitions and oppositions, *Pardesi/Khozhdenie* proposes the nature and value of true friendship as a mode of world-making. Early on, Afanasy finds himself alone after his dear friend Mikhail dramatically falls dead while they are proceeding by foot across the deserts of Central Asia. A lonely Afanasy finds and joins a caravan, and as the caravan is making its way through the desert, another lone man calls out and runs toward it. He introduces himself as Miguel Rivera, a Portuguese merchant en route to India. Miguel, whose name is but an Iberian variation of Afanasy's dearly departed Mikhail, asks if he may join them, and an overjoyed Afanasy steps forward, shakes Miguel's hand, and says aloud, "It seems God Himself is sending me a companion." The warmth that Afanasy extends to Miguel, such as when Afanasy offers Miguel his coat on a cold night, dramatizes the treachery of Miguel's imminent betrayal under the cover of darkness. Miguel stealthily pickpockets Afanasy, bursts the caravan's water supply, steals a horse, and runs away while the caravan sleeps.

The characterization of Miguel as a Portuguese merchant is a key that unlocks an important allegorical register of the film. Afanasy, Mikhail, and eventually Sakharam, Hasan-bek, and Lakshmi are emblems of sincere commitments to transnational exchanges of friendship on the one hand, in contrast to Miguel as an emblem of colonial greed on the other. The subtext for this juxtaposition is the well-known history of Portuguese explorer Vasco da Gama leading the first European expedition that successfully reached India by sea. In fact, the Russian title of the film *Khozhdenie Za Tri Moray (Journey beyond Three Seas)* is referred to when Afanasy tenderly wraps Miguel in his coat and urges him to take heart and not get discouraged by the arduousness of the journey. At the beginning of this sequence, Afanasy is writing in his journal, and Miguel asks him, "What is it you're whispering and writing all the time?" To this, Afanasy responds, "I want to tell people about what they've never seen." Not only does Afanasy reestablish his motives for traveling to a place as distant as India, but also his motives are contrasted to Miguel's far more avaricious and self-interested designs. Shortly thereafter, the brotherly Afanasy assures Miguel, "It's only about six days more, and then across the sea to India," which narrates a shared fifteenth-century Russian and Portuguese history of reaching India by sea for the first time. This shared history, however, is shown to fork in its radically differing causes and effects, with a Russian commitment to friendship and mutual understanding splitting itself off from a Western European legacy of colonial plunder and exploitation.

Discovering Miguel's betrayal, Afanasy resolves to catch him, and the first of two objects his mother had given him—an heirloom necklace—comes in handy, as he offers it to an elder of the caravan in exchange for a horse. Recalling that Miguel had talked of going to India via Hormuz, Afanasy rides off in the same direction. Unbeknownst to Afanasy, Miguel is on the same ship that Afanasy ends up boarding, which sets off from Hormuz for India. Miguel hides himself in a dark corner

of the ship, and the orchestral score emphasizes a sense of foreboding. He is eventually discovered by Afanasy, and a dramatic nighttime scuffle ensues as Afanasy chases Miguel from the hold to the deck, while the ship rocks through a raging storm. Providential justice is meted out as waves wash over the deck and swallow up Miguel, sparing Afanasy as well as leaving his hands bloodless. The moment Miguel vanishes into a dark, tumultuous sea, the ominous orchestral score that is intertwined with sounds of crashing waves brightens into a triumphant major key.

Once again, Afanasy is left without a companion. Soon after the ship reaches India, the lone Afanasy comes across a man whom he had just encountered as a performer in the midst of an open-air marketplace. Afanasy is terse, feeling slighted that the Indian man, Sakharam, had refused to accept his coins when taking up a collection from the audience. Sakharam, whose Sanskritic name means "friend of God," responds that he was testing Afanasy to see if he had a conscience and is gladdened to see that Afanasy took offense. "You're new here and I wanted to get to know you better," Sakharam explains, confessing that he was vetting Afanasy as a potential friend rather than regarding him as a patron and source of economic gain, again invoking the ethical ambitions of the coproduction. When Afanasy finds out from Sakharam that the governor, Asad Khan, has taken his horse, Afanasy's character is once again put to the test when he seeks out the governor. When Asad Khan invites Afanasy to work for him in return for his horse, Afanasy adamantly refuses to betray his loyalties to his own prince and homeland. Afanasy's integrity as a friend to India is thus established as being contingent on his loyalty to his own people, and it is in this sense that the coproduction's logic of friendship is built upon a specific allegory of bonds between ostensibly (modernizing) Russian and Indian values, rather than through an allegory that locates this encounter within a universalizing, liberal cosmopolitanism.

Friendship and understanding between people of different nations—that is, that which underlies the film's own endeavor of coproduction—is established as a politically progressive means to a more egalitarian world. Dismayed when the governor won't return his horse, Afanasy returns and shares his woes with Sakharam as they sit beside a fire at night. Sakharam says to Afanasy, "If people treat other people the way they want to be treated . . . the world will change." The soft lighting and the gentle nondiegetic flute melodies maintain an effect of peace overall, rather than one of despair. Sakharam reaches over Afanasy to cover him with a blanket, just as Afanasy had previously done for Miguel. However, while Miguel had treacherously betrayed Afanasy, Sakharam is shown to reciprocate where Miguel did not, juxtaposing Miguel as a figure of colonial plunder with both Sakharam's and Afanasy's selfless commitments to mutual exchange.

Sakharam advises Afanasy to throw himself in front of an ambassador who will be visiting shortly and complain about Governor Asad Khan in order to get his horse back. Knowing that he will be risking his life by standing in front of the ambassador in an act that may be mistaken as impudent, Afanasy does as Sakharam

CLIP 2. Afanasy and Sakharam come across the dancer Lakshmi in *Khozh-denie Zi Tri Morya* (1958).

To watch this video, scan the QR code with your mobile device or visit DOI: https://doi.org/10.1525/luminos.130.2

suggests. To Afanasy's delight, the ambassador is none other than Hasan-bek, the Persian ambassador from Shirvan whom he had met and befriended while sailing down the Volga River. Their friendship saves Afanasy from any punishment, and moreover, Asad Khan grows meek in front of Hasan-bek and agrees to return Afanasy's horse. The diplomatic importance of friendship and the significance of Central Asia as a strategic intermediary between the two ends of the continent are reestablished through Hasan-bek's reappearance in India, after having initially come across Afanasy at the very outset of his journey down the Volga River. Through its invocation of Shirvan, a region of then-Soviet Azerbaijan, in this climactic moment, the film paints a panoramic, homosocialist geography of friendship across Eurasia via Afanasy, Hasan-bek, and Sakharam.

One evening, as Sakharam and Afanasy are taking a stroll through an ancient monument and confiding in one another about their respective heartbreaks, they come across a court dancer who happens to be practicing inside an ancient temple. The dancer, played by dancer-actress Padmini, proceeds to dance as Sakharam whispers to Afanasy, "She can speak through the gestures of her dance. . . . Listen to what she's saying" (clip 2). The sequence cuts between the dancer's performance and the rapt faces of Afanasy and Sakharam, as Sakharam interprets aloud the meaning of her gestures, which are directed towards Afanasy: "If you're our friend, and I can see that is so, my heart and my house are always open for you" (fig. 12). While Sakharam remarks that the dancer's gestures are immanently legible to

FIGURE 12. Still
from *Khozhdenie Zi
Tri Morya* (1958):
Padmini as temple
dancer Lakshmi.

anyone who listens, he somewhat paradoxically ends up interpreting their mean-
ings to Afanasy within the scene. In this sequence, Padmini becomes metonymic
for the song-dance forms of Hindi cinema. The film reflexively explains, extols, and
defends the unique legibility of song-dance forms across boundaries of language,
while also insisting that an unfamiliar viewer must learn how to view and listen
to—that is, how to read—such expressive cinematic forms that do not depend
(only) on speech.

The dancer Lakshmi, we learn, has fallen in love with Afanasy. By reciprocat-
ing in a solely platonic fashion, however, Afanasy shows himself to once again
renounce any self-interest, remain in full control of his libidinal desires, and sub-
ordinate the ephemeral feminine pleasures of romance to the far more enduring
masculine legacies of duty and friendship. This gendered hierarchy of ethics, as
we will see, surfaces repeatedly and reflexively throughout the film. By exalting
genuine friendship above the excesses of both commerce and romance, the film
rhetorically subordinates its formal excesses of romance, song-dance sequences,
and panoramic vistas, as well as its capital excesses of scale, to a project of "genu-
ine coproduction" that is firmly anchored in homosocialist principles of two-way
exchange and friendship.

In the sequence of Afanasy's departure from India, Sakharam sings in the voice
of Manna Dey "*phir milenge jaane waale yaar do svidaniya*" (We'll meet again,
friend, we'll meet again) in both Hindi ("*phir milenge*") and Russian ("*do svi-
daniya*"). The sequence cuts back and forth between Sakharam among a crowd on
the shore and Afanasy on the ship, as they face one other in the moment of their
parting. Common to Soviet dubbing practices, a voice-over narration in Afanasy's
voice resumes over the song, translating its message as "You're withdrawing from
my eyes, but not from my heart. And if tomorrow we're no more, others will come
in our place." As Afanasy's ship sails away, the song comes to an end with a per-
cussive cadence, after which the voices of an a capella chorus ascend in a coda, as
the crowds along the Indian shore sing a prolonged, repeated "*do svidaniya*" in
Russian (We'll meet again) before their voices fade out with a fade to black.

Through this bilingual moment in the film that triumphantly repeats the
phrase "we'll meet again," the coproduction places itself in arc that both narrates

and fulfills a fifteenth-century promise of exchange between India and Russia. The scene addresses its two target audiences simultaneously and enfolds the Russian and Hindi versions of the film into a single project, whereby the dual dubbed versions of the film occur as the means of fulfilling the coproduction's spirit of collaboration and mutual exchange, allegorized by Afanasy's own project of building a world through homosocialist commitments to friendship. The film locates the value of cinema, as a technology of *seeing*, in its ability to bring distant cultures face to face. *Pardesi/Khozhdenie*, furthermore, reflexively extols its "genuine" coproduction as an ethical mode of seeing-as-transformation through a symmetrical exchange that outlasts the finite duration and ephemeral visual pleasures of the film: "You're withdrawing from my eyes, but not from my heart. And if tomorrow we're no more, others will come in our place."

The final scene of the Russian wide-screen version features an orchestral score that accompanies a pan of a landscape that is recognizable as the vista of Russia shown at the film's outset. The worn and haggard Afanasy, having reached his homeland, kneels and crosses himself as he fondly says aloud, "My dear Russia." Afanasy falls prone as he embraces the ground, while the music rises in triumphant chords that accompany a crane shot leading into a panoramic view that pans left, presenting the Volga River once again, through lush green trees before dissolving into a painted title image of Afanasy's book, quill, and inkwell. White block text appears, proclaiming "The End," followed by the final fade to black. There is no need to return to the dimly lit room in the church, which had motivated the film as a flashback occurring in tandem with Afanasy's completion of the memoir. For the intended purpose of his writings as professed throughout his voice-overs was to share the legacy of the trials and tribulations and, most importantly, the friendships that unfolded over the course of his "journey beyond three seas." This task, as the film's work that is presented as Afanasy's life's work, becomes complete with the moment of Afanasy's return to Russia. *Pardesi/ Khozhdenie* thus narrates and simultaneously situates itself as a direct inheritor of a fifteenth-century legacy of friendship and exchange initiated by the historical figure of Afanasy Nikitin.

Early in the film, as Afanasy and a group of fellow Tver merchants set out along the Volga River, the men grow apprehensive, fearing that an approaching boat may be a group of Tatars. It turns out, however, that the boat is Hasan-bek's, a friendly Persian ambassador from Shirvan. In the only instance of completely untranslated dialogue (i.e., neither subtitled nor dubbed in the languages of the target audiences), Afanasy is able to display his facility in Persian, again marking out the historical centrality—both geographically and economically—of the erstwhile Persia along trade routes between eastern and western regions of the Eurasian continent. "It's so nice to hear the language of my home country," Hasan-bek expresses

to Afanasy—a sentiment that also holds traction with the fact that the *Pardesi/ Khozhdenie*'s primary dialogue-translation strategy was dubbing, with all characters speaking Hindi in one set of versions and all characters speaking Russian in another set of versions, except for this brief moment of Persian dialogue.

Neither the ability of the Indian characters to speak Russian in the Russian version nor the ability of the Russian characters to speak Hindi in the Hindi version is motivated by any details of plot that might, for example, have shown the characters' language acquisition to be gradual, along a learning curve induced by a sustained encounter with a character of a foreign tongue. While the visibility of race and ethnicity can interrupt the naturalization of the dubbed language to the faces that appear to be speaking, the desire for a specific kind of realist coherence crucially precedes the question of this naturalization. Markus Nornes notes, for example, that in response to Fox Studios' first release of a Japanese dubbed film (*The Man Who Came Back* [Raoul Walsh, 1931]), a Japanese critic stated that "if you sit down and think about it, the idea is incredibly absurd. Foreigners, Farrell and Gaynor, speaking Japanese. First you have to get rid of that unnaturalness. It's only tolerable because it's that kind of melodrama."[23]

Melodrama, as a mode of externalizing interior conflicts through aural, visual, and narrative oppositions, can decenter or preempt desires for naturalism,[24] making dubbing "tolerable" despite its visibly and racially marked "unnaturalness." In the case of *Pardesi/Khozhdenie*, the dubbing is tolerable not only because of the melodramatic proclivities of its frontal and gestural acting styles, painted tableaus, and plot twists of coincidence and serendipity that were familiar to audiences of both Soviet and Indian cinemas, but also because of the melodrama of the film's reflexivity. The film constantly underscores the fact of its coproduction and sets itself up as a film whose narrative explicitly thematizes and announces its extra-narrative project of traversing national and linguistic boundaries in order to offer up a vision of a shared Indo-Soviet past, present, and future. Afanasy—like such a project itself—is an epitome of the film's determination in the face of myriad difficulties. Upon being asked by Hasan-bek how he will manage to get to India without knowing the route, Afanasy's response is framed by a frontal medium close-up in which he declares that the challenges of language and translation, among others, are hardly insurmountable: "What it takes is aspiration, and he who has a tongue will find his way!"

Visually externalizing the emotional contours of the plot, the high points of Afanasy's journey are pictured in bright and often sunlit sequences, while dimly lit scenes mark out his troubled times and moments of despair—often in cramped, indoor spaces. While the brightness of daylight illuminates the Tver merchants' pleasant encounter with Persian travelers, a painted panorama marks nightfall, and the ensuing, far less friendly encounter is shrouded in darkness. The earlier allusion to Tatars ends up prophetic, foretelling the fate of the boat at their hands. The Tatars are depicted as aggressive, ruthless pirates who plunder the ship

FIGURE 13. Still
from *Khozhdenie
Zi Tri Morya* (1958):
Wide shot of
Central Asian desert
landscape.

by night and kill several of the Tver merchants in course of their bloody raid. Scholar Vadim Rudakov places such representations of Tatars as bloodthirsty barbarians among "the worst traditions of the old Soviet films." In response to a more recent controversy that arose around the persistence of such representations, Wahit Imamov notes that such portrayals of the predominantly Muslim Turko-Mongol Tatars are historically "part of the Kremlin's determination to use culture to promote Russia's image as a Slavic, Christian nation."[25] While *Pardesi/ Khozhdenie* forwards progressive commitments to upending social ills that stem from race, class, and caste hierarchies, religious orthodoxies, and imperial greed, its progressive vision is limited by the blind spots of homogenizing representations that define and visualize Russia and India along majoritarian-nationalist lines of race, religion, and language at the expense of their myriad alternatives. Following the Tatar's raid, Afanasy and Mikhail continue by foot, motivating wide shots of Central Asian landscapes that are at once constitutive of and marginal to a Russia-centric Soviet visual geography.

Abbas recalls that "in cinemascope and colour the scenes of India we had shot and the scenes of Central Asian deserts which they had shot in the Soviet Union looked really grand" (fig. 13).[26] In several sequences, the film reflexively celebrates its non-realist performative, gestural, and pictorial excesses not as modes that take liberties with the truth of its literary-historical source material but as modes that deepen the authenticity of an affective experience that immerses the spectator as a participant in the coproduction's mediations of friendship and exchange through cross-cultural cinematic encounters with the world. One evening, for example, Indian actress Nargis's character of the village girl Champa observes Afanasy as he writes in his journal, and she asks what he is recording in his book. The two of them are alone, and Afanasy responds that he has been chronicling everything in the course of his journey, including his voyage by ship, the incident in which he was robbed by Miguel, and his encounter with a girl "with the eyes of fire." Her eyes downcast, Champa recognizes that Afanasy is referring to her, and she suggests that he not write about this girl he speaks of, should his writings come to harm her reputation. Afanasy, without a second thought, abides by Champa's request and begins to blacken out a section of his writings. It is through this scene

that an ellipsis in the literary text of Nikitin's memoir is imagined, through which romance, as a quintessential element of popular cinema, gets stirred into the cinematic adaptation.

On the film's lukewarm reception in India, Abbas recalls that an audience member remarked, "Why didn't they make Afasani Nikitin into an Indian who loves a Russian girl? That would have been really appealing."[27] To this, Abbas responded, "That wouldn't be true."[28] *Pardesi/Khozhdenie* thus remained committed to the historicity of its adaptation-in-translation through the very possibilities of melodrama and popular cinema. To this end, the film frames Afanasy's journey as a flashback, includes intermittent narrations in Afanasy's voice to remind the audience that they are witnessing what he has recorded as a document of his journey, and imagines a redacted portion of the original text to justify the inclusion of a love story. The commensurability between excesses of detail and scale, on the one hand, and commitments to a deeply historical narrative of Indo-Russian friendship, on the other, continued through the Moscow-based Geographical Society's publication of an elaborately and colorfully illustrated, hardbound, trilingual print edition of Nikitin's memoir in 1960.[29] Featuring abridged versions of Nikitin's memoir printed with visually intricate, embossed flourishes in Russian, English, and Hindi, the volume includes a facsimile insert of an original handwritten manuscript in addition to glossy card inserts illustrating Nikitin's travels (figs. 14, 15, 16). The inserts are styled as colorful Persian miniature paintings, invoking Orientalist legacies of highly popular, richly illustrated European-language editions of *The Thousand and One Nights*.[30]

The communal pleasures of color, imagination, exaggeration, exotic vistas, and gestural modes of expression are apparent not only in the sequence of Sakharam and Afanasy's encounter with Lakshmi but also in several other sequences that take place in India and reflexively invoke performance- and song-dance-based expressive modes of Indian cinema. In one memorable sequence, for example, Champa dresses in Afanasy's coat, jacket, and hat to regale a group of her girlfriends with tales of his adventures. She dramatically reenacts his ship voyage through her exaggerated bodily gestures and vocal inflections, replete with scenes of fighting sea monsters and resisting the wiles of fairies along the way. Her admiration for Afanasy is apparent as she characterizes him as bravely fighting off the sea monsters and steadfastly resisting the temptations of the fairies. The scene is humorous, and Champa's act is not entirely false in the qualities that it bestows upon Afanasy. She paints him through an intentionally stylized virtuoso performance, which is beheld as such by her thoroughly and willingly captivated diegetic audience.

When land is first sighted from Afanasy's India-bound ship, the *aalaap* leitmotif floats up for the first time since the film's beginning, and the mise-en-scene brightens, visually reflecting the lithe spirits of the passengers aboard the ship. Through

FIGURE 14. Hindi and English title page of a trilingual edition of Afanasy Nikitin's *Voyage beyond the Three Seas* (1960).

the *aalaap*, India is first heard as a woman's voice rather than seen, and the camera focuses on the mesmerized faces of Afanasy and other passengers. They are transfixed as they gaze upon the land that is ostensibly in front of them and sigh, "India" (fig. 17). A cut reveals the object of their gaze to be a panoramic vista of silhouettes against a brightening dawn, as Hindu chants fill out an emotional moment for Afanasy, who gazes upon the land and utters, "I've been dreaming of you for so long." Another cut reveals a slightly closer—and brighter—panoramic view of (mostly) men performing morning ablutions in the sea, and the chorus of chanting and singing is suddenly anchored in the diegesis of their ritual observances (fig. 18). The earlier prominent orchestral score now yields to the sounds of Indian folk songs and folk instruments—bamboo flutes, plucked lutes—that accompany a series of additional panoramic vistas, as the landscape is captured as an aurally and visually delightful complement to the earlier vistas of Russia.

Lead actor Strizhenov recalls various aspects of the production over the course of playing the role of Afanasy Nikitin in an interview included as a special feature of the 1999 Ruscico DVD of *Khozhdenie* intended for distribution outside the

FIGURE 15. First page of Hindi section of a trilingual edition of Afanasy Nikitin's *Voyage beyond the Three Seas* (1960).

FIGURE 16. One of seven Persian-miniature-style card-insert illustrations in a trilingual edition of Afanasy Nikitini's *Voyage beyond the Three Seas* (1960): "An Indian noble plays host to Afanasy Nikitin."

former USSR. Strizhenov fondly reminisces about the coproduction despite the fact that it was often intensely grueling not only because the entire cast and crew had to travel to, from, and within the Soviet Union and India, but also because Strizhenov had little respite from the shooting schedules because he appeared in virtually every scene. He nostalgically recalls the scene in which the ship from

FIGURE 17. Still from *Khozhdenie Zi Tri Morya* (1958): Afanasy's ship reaches India.

FIGURE 18. Still from *Khozhdenie Zi Tri Morya* (1958): Wide shot of fishermen, among other vistas upon Afanasy's arrival in India.

Hormuz makes landfall in India as the most memorable moment of production—for, according to Strizhenov, the people of the coast were simply going about their daily routines of offering morning prayers, fishing, and so on. Whether or not the scene was the authentic ethnographic record that Strizhenov describes, the manner in which he recalls this particular moment is strikingly similar to the way in which his character, Afanasy, beholds the scene within the film: India materializes as a long-awaited feminine object of desire. In such instances, the endeavor of the coproduction remains so tightly bound to its thematic and narrative energies that they become indistinguishable.

In its cinematic adaptation of Nikitin's memoir, *Pardesi/Khozhdenie* allows the audience to experience Afanasy's arrival in India as an audiovisual turning point: all of a sudden, the mise-en-scène looks and sounds markedly different. The camera lingers in place for a thirty-second wide shot that captures an encounter between Afanasy's horse and an elephant after Afanasy has alighted from the ship amid audible melodies of Indian folk instruments. A lengthy sequence then follows Afanasy as he slowly walks through a bazaar, which further paints the initial encounter between Afanasy and India through the newness of the sights *and* sounds he beholds. A crane shot brings into view a man on a dais below, performing right in the midst of the bustling open-air bazaar. The character is Sakharam, and he sings a folk song in the voice of playback singer Manna Dey that opens with references to the Ramayana and eventually lands in a chorus that beckons the participation of the onlookers as the camera is lowered and additional singers join in: *"ye hindustaan hai pyaare, hamaarii jaan hai pyaare"* / "This is Hindustan, my dear—this is our love, my dear."

FIGURE 19. Still from *Pardesi* (1957):
Sakharam's puppet show in the bazaar.

The song is neither dubbed nor subtitled in extant versions, and its importance is far less in its lyrical content—the "welcome to Hindustan" chorus is, after all, redundant—than in its form and its positioning vis-à-vis the audiences that are both within and outside the diegesis. The fact that the song commences in the midst of a busy open-air market dovetails with both codirector K. A. Abbas and actor Balraj Sahni's involvement with the Indian People's Theatre Association (IPTA), a Left cultural organization and affiliate of the Communist Party of India, which espoused a commitment to art directed toward the empowerment of the masses.[31] There is no diegetic motivation whatsoever for the crane shot that initially positions the audience above the dais, as if looking down from the elite balcony seats of a theatre. In the Hindi version of the film, there is even a cut to a close-up of an onstage puppet theatre that *becomes* the big screen for a moment, with Sakharam appearing to sing "playback" for the puppets (fig. 19). However, as soon as the chorus commences and the crowds start to join in, the camera brings the audience to occupy a ground-level position amongst the crowd, reveling in the pleasures of a peoples' participatory art form—that is, popular cinema—that aims, through its songs, to cut across the class and caste positions of its audiences and bring them together in a public space.

The well-documented influence of IPTA on the Hindi popular film industry reveals itself across several 1950s films of Raj Kapoor, among others, in which the small man is frequently shown traipsing through the streets of Bombay and singing to the crowds (and film audiences) about his aspirations in the big city.[32] The quintessential example of such sequences is comedic actor Johnny Walker's oft-remembered *"ye hai bambaii merii jaan"* (This is Bombay, my love) from the 1956 film *C.I.D.* (Raj Khosla), whose chorus is actually quite similar in its lyrics to Sakharam's *"ye hindustaan hai pyaare"* (This is Hindustan, my dear.)[33] While an explicit reference to modern-industrial city spaces is not within the historical purview of *Pardesi/Khozhdenie* as a period film, *Pardesi/Khozhdenie*'s contemporaneous contexts are nonetheless implicitly present. Johnny Walker's *"ye hai bombay merii jaan"* (This is Bombay, my love) is iterated in Balraj Sahni's

"*ye hindustaan hai pyaare*" (This is Hindustan, my dear) as an invitation for the audience to publicly participate in an art form that opens itself out to all. As the song ends, multiple shots capture the diversity of its audience members. When Sakharam holds out his upturned drum for coins and teases individual audience members, their heterogeneity is underscored through their appearance as well as the ways in which Sakharam addresses them—the audience includes old and young, Hindu and Muslim, men and women, and those wearing tattered clothes alongside a brahmin priest, a money lender, and Afanasy.

Pardesi/Khozhdenie posits cross-cultural (cinematic) encounters with an outside world as utopian opportunities to critique and reimagine the hierarchical social structures of one's local contexts. When the crowd at the bazaar performance begins to disperse, Afanasy witnesses a woman wailing in distress over her daughter Champa, who has suffered a snakebite. The ensuing episode advances a critique of the rigidity of the upper-caste, brahmin, priestly class that does so little to help Champa while Afanasy, a stranger, is much more sympathetic in offering his assistance. Reprising Ivanovich's earlier declaration aboard the ship that "we will outshine the Moscow merchants!" it is through contact with outsiders that entrenched hierarchies of one's own society are called into question. Afanasy follows the woman and sees her husband furiously ringing a temple bell, although the priest who comes to meet him stoically responds that the head priest is unavailable to help.

Her face out of view, Champa lies unconscious at the very bottom of the frame as a crowd gathers around her parents and bears witness to their desperation. At this moment Afanasy resorts to the second object that his mother had bequeathed to him, and he asks Champa's parents if he may offer a snakebite antidote that he carries with him. Champa continues to largely remain out of the frame as Afanasy administers the ointment, building suspense over the predictable romance to come. It is only after Afanasy walks away that the camera slyly grants an intimate view of Champa's face, as her mother holds and gently turns her head toward the camera. A bamboo flute resumes the lilting melody of the *aalaap* leitmotif while the audience is invited to gaze upon her face, just as they had gazed upon India, for the first time. The bright melody and luminous lighting leaves little doubt that Champa will surely awaken.

The coproduced *Pardesi/Khozhdenie* advances the transnational class solidarity of men and women workers—including, of course, the joining together of film industry workers—as a foundation for Indo-Soviet friendship. This solidarity is explicitly put forward in the language of caste in Afanasy's response to Champa's father when the men sit down to eat and Champa's father tells Afanasy, "You know, we usually don't eat with people of other castes. But you are quite another matter. We consider you one of us." To this, Afanasy responds, "But we do belong to the same caste. . . . My father was a ploughman, too." He invokes unities of both friendship and occupational caste-as-class that surmount their apparent differences,

CLIP 3. *"rim jhim rim jhim barse paanii re"* song sequence from *Khozhdenie Zi Tri Morya* (1958).

To watch this video, scan the QR code with your mobile device or visit DOI: https://doi.org/10.1525/luminos.130.3

expressing solidarity and pride in agrarian and manual labor. This moment hearkens back to the painted title that elevates the importance of collaboration between men and women workers in the world, across nationalities and religions.

A romantic folk song sequence, *"rim jhim barse paanii aaj more aanganaa"* ("Rim jhim" go the water droplets today as they splash upon my courtyard"), features Champa singing in the voice of playback singer Meena Kapoor through a striking montage that spotlights various tasks and crafts of manual labor (clip 3). Against the backdrop of a sustained downpour, Champa, Afanasy, and the other villagers are collectively engaged in wielding a plow, pounding grain, spinning pottery, weaving rope, grinding flour, and spinning thread. The audiovisual choreography of the sequence celebrates the rhythmic movements and sounds of men and women workers and their implements as the villagers join in for the chorus while they spin, pull, pound, and grind away.

Pardesi/Khozhdenie is structured in two parts around the expectation of an intermission, and part 2 of the wide-screen versions opens with a title sequence of credits that is similar to the sequence that opens part 1, only that part 2's credits are superimposed over panoramic views of Indian landscapes and sounds of Indian folk melodies, which counterbalance the Russian landscapes and orchestral music that open part 1. Following part 2's opening credits, a sequence of intertitles recaps

the happenings of part 1. From there, the plot resumes with a shot of a slow fall down along an intricately sculpted tower of a Hindu temple, accompanied by the audible sounds of singing and chanting. As the camera descends, a festive procession comes into view, and Afanasy, who is walking by, begins to follow the procession into the temple. He is angrily shooed away at the entrance by a group of brahmin priests who allege that he, a foreigner, will defile the temple.

Suddenly, the sonorous voice of a lone singer is heard, and the entire crowd turns to see Sakharam standing to the side of the temple, as he begins to sing in the voice of playback singer Manna Dey, "*raam kahaan, tujh men raam mujh men, sab men raam samaayaa, sabse kar le pyaar jagat men koii nahiin hai paraayaa re*" (Where is God? God is in you, God is in me, God dwells in all, Love all in the world, no one is a 'pariah').[34] As the song goes on, Afanasy recalls the event in a voice-over narration that translates the song's Gandhian critiques of caste hierarchies[35] into racialized terms: "God is not in a church, or in a mosque, He's in your heart, you silly. Open it up and you will see His reflection both in white and Black people. If God gets offended when a man of another faith comes to his temple, then he is not God. Priests divide people into castes, while all men are brothers."

Sakharam's song moves the crowd to the extent that they boldly usher Afanasy into the temple at the behest of the priests who slink back into a corner, while Sakharam continues to persuasively sing. Vernacular performance—in the form of Sakharam's song—is framed as a progressive force that overturns the authority of the brahmin priests through collective action in the name of a God/love that is immanently accessible to all, regardless of caste, race, religion, or nationality. At the entrance of the temple, the vast crowds below join in and resume the chorus as they together chant, sing, chime, drum, clap, and dance while Afanasy is escorted into the temple. The scene fades to black and then cuts to a wide shot of the temple after the crowds have dispersed, with the tiny figures of Afanasy and Sakharam conversing in a corner. Afanasy is explaining that he left Champa without even saying goodbye, with little alternative left. "Today the doors of this temple did open for me," he says, "but there're still so many obstacles in the world that separate people." Sakharam confesses that he understands Afanasy's predicament, telling Afanasy that he himself had fallen in love with a woman of another caste, and because they couldn't be together "according to our country's laws," she swallowed poison to end her life.

An issue rarely mentioned in explicit terms in Hindi films of the period, the diegetic context of explaining an aspect of Indian society to a foreigner motivates a direct acknowledgment of taboos on love across caste boundaries as an important yet daunting site of struggle. Yet, as they wander about the structure of the ancient temple and reflect upon their woes, Sakharam tells Afanasy that he believes that the ephemerality of happiness and love is far outlived by one's deeds. He points to the stone temple as an example, and as they walk through it for some time, the sequence affords several touristic views of the temple's interior structure and

FIGURE 20. Still from *Khozhdenie Zi Tri Morya* (1958): Afanasy and Sakharam discuss life, love, and work.

sculptures (fig. 20). The pair surmises that the artists surely suffered the heartaches of various loves and took them to their graves, while they bequeathed to the world the fruits of their labors that have stood the test of time. Art and work are exalted in a shared masculine homosocial space of enduring legacies, while heartache is normalized as a shared inevitability and, along with romantic love, relegated to an ephemeral feminine domain of private emotions that are nonetheless valuable for their libidinal energies that can be nobly diverted into one's work.

Incorporating a spectrum of anticolonial, third world, and leftist thought, from Gandhian ideals to socialist commitments to workers' struggles, *Pardesi/Khozhdenie* tellingly falls prey to the shortcomings of political visions that have tended to separate matters of the world from matters of love through gendered hierarchies of value that are contingent on assumptions of scale. Sakharam points to the stone temple as material evidence for the durability and timelessness of artists' work, in contrast to the evanescence of those very artists' heartbreaks, which surely propelled the expressiveness of their art. Even as *Pardesi/Khozhdenie* explicitly critiques brahminical practices of exclusion and the role of temples in producing boundaries between "brothers," it fails to fully indict the regulation of sexuality as a central, rather than peripheral, aspect of caste practices' social reproduction and endurance. The conversation between Sakharam and Afanasy sentimentalizes heartbreak and romanticizes the renunciation of prohibited love as experiences that improve the quality of one's (art)work and its potential to impact masses of people. The pursuit of prohibited love, in contrast, is construed as a far more individualistic and indulgent affair. Reflexively, the film forwards an argument about itself, as it leaves aside its romantic plot in order to prioritize its world-making endeavor of Indo-Soviet friendship.

Afanasy is ultimately successful in his work. He meets the sultan, who finds that Afanasy is a sincere representative of his prince and homeland, worthy of receiving an official decree to take to his prince so that trade may indeed commence between India and Russia in the spirit of friendship. The sultan is played by actor Prithviraj Kapoor, the father of actor Raj Kapoor and quintessential onscreen patriarch of Hindi cinema known for his thunderous, booming voice. Following the accomplishment of the major aim of his journey, Afanasy wanders about,

eventually returning to the coastal village that he "knew well." The film juxtaposes Afanasy's fulfilled task—a destiny decreed by divine providence as well as various benevolent patriarchs-cum-patrons—with his unfulfilled love, as he thinks about Champa and arrives at her house. He goes near a window to look in, and Champa is shown cradling an infant as she hums a lullaby. Keeping himself hidden in the way that Champa had done when he had left her house, Afanasy leaves his whole purse upon the windowsill, as an anonymous donation to her family. Yet again, the film avows the ethical steadfastness of Afanasy's endeavor—and that of the coproduction—through a rhetorical renunciation of both romantic and commercial gains, construed as excesses of ephemeral pleasure that are subordinated to the transcendence of enduring brotherhood.

While making his way toward the shore, Afanasy comes across Sakharam, who has fallen ill. Sakharam recalls their earlier conversations, surmising that the problems of the world are so overwhelming that any attempt to battle them can seem utterly futile. Sakharam refers to the histories of several conquerors who came to India and greedily looted the land, again juxtaposing Afanasy's sincere commitment to establishing links of friendship between India and Russia with the selfish intentions of (implicitly) colonial merchants. This, Sakharam's remarks suggest, offers hope of a world that could be otherwise—possibly even a world where their respective loves would not end up in heartbreak. Afanasy assures Sakharam, in a confirmation of their socialist, anticolonial camaraderie, "I'm going to tell the Russians, my countrymen, about the good people of India. That they hate the injustice just like us."

After a fade to black, a brief low-angle shot shows Sakharam holding out his upturned drum while coins come flying in, which dissolves into the moment of parting between Afanasy and Sakharam. The proximity of the scenes implies that Sakharam, knowing Afanasy to be penniless, raises and donates his own collection to Afanasy so that he may journey back to his much-longed-for homeland of Russia. In these latter scenes of Afanasy's return to the coastal village, the greed-driven injustices of colonial histories are contrasted to redistributive gestures that are motivated by the sincerity of transnational friendship and love, with Afanasy leaving all of his earnings for Champa's family on the one hand, and Sakharam giving all that he has to Afanasy on the other, in order to enable Afanasy's return trip that will carry forward a legacy friendship between the two lands.

Pardesi/Khozhdenie's exaltation of friendship unfolds through its opposition of idealized platonic homosocial love to both romantic fulfillment and commercial success. Aside from the heterosexual presumption of this opposition's denial of any possibility of sexual desire between men, feminine figures like India, Champa, and Lakshmi (whose name invokes the Hindu goddess of wealth) appear as siren-like temptations—even if naively so, on their part—that offer opportunities for both erotic pleasure and material gain. Afanasy resists these temptations at every turn, in his duty-bound commitment to the greater purpose of his mission and

loyalty to his homeland. Ironically, however, the film entirely depends on the spectacular presence of these ostensible excesses to have any legs. The film, in other words, could have rather easily done without its heavy-handed doses of homosocialist bonding. But without its high production values, its transnational vistas, its "love themes," its stars, and Padmini's dancing, *Pardesi/Khozhdenie* attempt to move large swathes of its dual audiences would have been unlikely to stand even a chance.

A rare lighthearted moment of humor alludes to love as a force that goes against the status quo, as Afanasy seeks out the sultan in order to initiate a Russia-India trade agreement that is to be his life's legacy. Afanasy approaches a letter-writer for his services, in hopes of introducing himself to the sultan. The scribe says that he charges one rupee for a letter to one's parents, two for a letter to one's wife, and three for a letter to one's beloved. His quip characterizes true love as necessarily going against the grain of socially prescribed practices of marriages. While *Pardesi/Khozhdenie* rhetorically and narratively frames its love story as a brief detour, spectators may not have necessarily apprehended it as such. Through ethnographic work with Soviet audiences who watched Hindi films during the Soviet Thaw, for example, Sudha Rajagopalan found that "most viewers interviewed for the project commented that [Hindi] films made a deep impression on them at the time because of their 'love themes,' and secondarily for their social narratives."[36]

The "love themes" in *Pardesi/Khozhdenie* take off only after Afanasy is forced to halt his journey. Following his arrival in India, Afanasy hops on his horse to continue inland toward Bidar, and the distinctive, staccato strains of a sarode (plectrum lute) sustains a montage of panoramic landscape shots motivated by Afanasy's intended onward journey. However, his plans are quickly interrupted by the first rains of the monsoon, a season associated with romance in several Hindustani folk songs and film songs. The coming of the monsoon forces Afanasy to turn around, which finally occasions his coming face to face with Champa after her father invites him to stay as a guest in their home through the end of the season. When Afanasy and Champa are introduced for the first time, the camera lingers on each of their faces as they gaze at one another, with the *aalaap* leitmotif rising up and taking the place of any exchange of words between the two of them. The manner in which Afanasy gazes at Champa recalls the manner in which he had been transfixed upon his first glimpse of India and said aloud, "I've been dreaming of you for so long," as Champa, the star Nargis, and India mesh together in a feminine, Orientalized figure of erotic fantasy that narratively triangulates the friendship between Afanasy and Sakharam as the most enduring bond within the film.

Among the most spectacularly exuberant moments of the film is a dream sequence, which begins while Afanasy is torn between his feelings for Champa and his knowledge that the obstacles of religion, cultural background, and societal

CLIP 4. Romantic dream sequence from *Khozhdenie Zi Tri Morya* (1958).

To watch this video, scan the QR code with your mobile device or visit DOI: https://doi.org/10.1525/luminos.130.4

expectations stand in the way of their union (clip 4). Afanasy is shown to be looking out at the rain through the bars of a window, and as he closes his eyes, snow is superimposed over the rain. We are whisked away by an orchestral score to a Russian winter, and the sounds of chiming bells are heard as a horse-driven sleigh comes up over the horizon of a painted panorama of a snow-filled, fairytale-like landscape. The music crescendos into a joyful, symphonic melody while the painted landscape cuts to a medium shot of Afanasy and Champa in a sleigh, with the superimposition of a fast-moving painted landscape giving the impression that we are riding along as the sleigh is speeding through a flurry of falling snowflakes.

Champa wears a white bridal veil, and Afanasy is beaming with his arm outstretched, as he says, "This is our unbounded Russia! Is it to your liking?" He pulls Champa's veil back, declares his love, and asks if she loves him, to which she happily responds in the affirmative, "My love is as pure as the Ganges' water, as this snow" (fig. 21). However, when Afanasy asks if she will marry him, Champa appears downcast and says that such a thing is impossible, owing to their different countries and religions. In utter anguish, Afanasy calls out, "O God! Where is your Truth? Why is the world organized in this way? Answer me, or I'll rebel!" (fig. 22). Champa vanishes, and the music recedes, leaving only the sounds of bells and hooves as Afanasy finds himself alone in the sleigh and begins screaming, "Champa!" It is at this moment that he awakens and realizes that he had been dreaming. The nondiegetic sounds of bamboo flutes establish that he yet remains in India, and Afanasy once again looks out of the window, as he begs, "O merciful

FIGURE 21. Still from *Khozhdenie Zi Tri Morya* (1958): Afanasy's romantic reverie.

FIGURE 22. Still from *Khozhdenie Zi Tri Morya* (1958): Afanasy's momentary rage over prohibitions against love.

God, forgive me in my insanity." Seeing that the rain has stopped, Afanasy resolves to leave the village.

The dream sequence portrays love as a disruptive force that is diametrically opposed to socially sanctioned practices of marriage, thereby posing a radical challenge to the structural organization of the world. Afanasy's anguish over the insurmountable difficulties of being with Champa lead him to demand answers and cry out, "Why is the world organized in this way? Answer me, or I'll rebel!" When Afanasy wakes up and asks to be forgiven of his "insanity," the never-to-be romance between Champa and him elicits pathos, and the questions that Afanasy had posed in his delirium linger past the film's short-lived escape into an exceedingly joyful place where he and Champa could proclaim their love for one another. In an earlier scene, Champa had stood before the altar of a Hindu deity and prayed that the rains would never stop, so that Afanasy would continue to stay on. However, no divine intervention prevents Afanasy's departure. Champa hides herself behind a door and is nowhere to be found as Afanasy bids her parents farewell, his heart heavy that he will be leaving without even saying goodbye to Champa. Her parents reveal to Afanasy that Champa is soon to married to her betrothed, to whom she was promised when she was but an infant. Thus, Afanasy and Champa's union is one that is wholly relegated by the brutal "organization" of their own rational world into the realm of a cinematic world: a space of utopian dreams that indict that which structures their impossibility on the ground.

On the one hand, the film seems to renounce its love story, as it frames the romance between Afanasy and Champa as a brief, star-crossed interlude before

Afanasy moves along in his journey. On the other hand, the love story forms a core cinematic attraction of the film, in terms of the *rim jhim* song sequence, the depiction of the stars Nargis and Strizhenov in a snow-filled romance, and Afanasy's thunderous critique. The film rhetorically retracts this question when Afanasy apologies for questioning God's will in a weak moment of insanity. He virtuously accepts his imminent separation from Champa as a divinely ordained matter, after he and Champa have separately beseeched the helping hand of Christian and Hindu deities, respectively. The film implies that the lack of any divine intervention is in fact a providential blessing for Afanasy's larger mission. As in other contemporaneous Hindi films, the narrative of *Pardesi/Khozhdenie* presents a gendered opposition between romantic love as a personal indulgence and work as a duty to the nation or world. While the excess of love is subordinated to the exigencies of duty in diegetic narratives of heroic sacrifice, it is hardly the case that either the films' formal strategies or spectators' engagements necessarily conceded to this hierarchy.

The contemporaneous iconic romance *Mughal-e-Azam* (The Great Mughal, K. Asif, 1960), which became the highest grossing Hindi film to date upon its release, is a case in point. The audiovisual climax of the lavish period film is the song sequence "*pyaar kiyaa to darnaa kyaa*" (So what if I have loved, what is there to fear?), in which the maidservant Anarkali (Madhubala) fearlessly and openly declares her love for the Prince Saleem (Dilip Kumar) in a song-dance performance. Her declaration, in the voice of playback singer Lata Mangeshkar, flies in the face of the emperor Akbar's (Prithviraj Kapoor) command that she abandon the affair that has jeopardized the dynasty's future. The shooting of "*pyaar kiyaa to darnaa kyaa*" in Technicolor heightened the spectacular effect of its set, which was an elaborately designed and painstakingly constructed replica of the Mughal-era Lahore Fort's Sheesh Mahal (Palace of Mirrors). The well-known offscreen romance between Madhubala and Dilip Kumar further heightened the film's erotic charge, and the film's legacy remains not in its didactic parables of duty to the nation, but in its iconicity as a spectacularly lyrical, song-filled, erotically charged ode to prohibited love.[37]

I read the conflict between the libidinal excess of romantic love and the disciplined austerity of work as an opposition in *Pardesi/Khozhdenie* that betrays a reflexive ambivalence over the value of cinematic pleasure. The film's renunciations of romance through Afanasy's encounters with both Champa and Padmini are ambivalent because they are merely rhetorical. The film, after all, does not actually forego these elements. Several posters and publicity images, moreover, highlighted the transnational love story as the film's major attraction (figs. 23, 24). By narratively subordinating romantic fulfilment and commercial success to a greater homosocialist cause, the film claims an explicitly progressive vision that becomes, through its gendered hierarchy of love and work, paradoxically less so. Such a claim devalues romance and sexuality as feminine excesses whose value

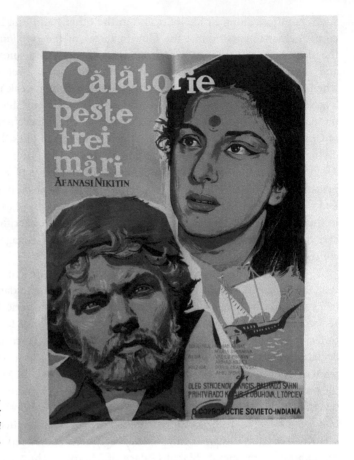

FIGURE 23.
Romanian poster for
Khozhdenie Zi Tri
Morya (1958).

lies only in their potential to ultimately serve and invigorate a masculine, socially oriented ethos of work for its far greater scale of production.

The film's most radical moment perhaps emerges when Afanasy questions the "organization" of the world in his delirium of ostensible insanity. For it is in this brief delirium that the film explicitly acknowledges the centrality of injunctions against love across certain thresholds—and the control of sexuality—to practices that organize the world along hierarches of gender, race, caste, and class. One cannot work against the latter hierarchies without also rejecting the naturalization of the gendered hierarchies of value that sustain their reproduction. Thus, rather than devaluing love as an apolitical excess that necessarily undercuts work, what would it mean to think of the politics of love as a question of work?[38] Or to think of the libidinal excess of cinephilia in terms of "inconsequential" spectatorial labors that reject masculine imperatives of productivity? Imperatives for pleasure to be (re)productive, after all, have served both fascistic regimes and oppressively heteropatriarchal regimes of sexuality.[39] Herein lie the stakes of revisiting the 1960s as a decade of popular Hindi cinema that has often been defined by—and decried

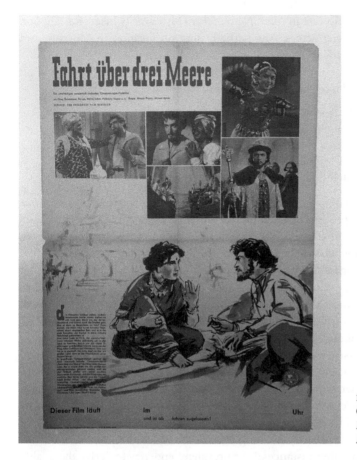

FIGURE 24. East German poster for *Khozhdenie Zi Tri Morya* (1958).

for—its excesses of romance, uncritically conflated in turn with the excesses of crass commercialism and consumption.

Among a spate of contemporaneous Hindi film coproductions that were zealously announced but never completed was an India–East Germany prestige film in the mid-1960s titled *Alexander and Chanakya*.[40] Announced as a 70-mm venture featuring elaborate sequences starring dancer-actress Padmini, the title strongly suggests a homosocialist endeavor in the vein of *Pardesi/Khozhdenie*, as it teases a similarly ambitious period film that imagines and depicts an East-West encounter between Alexander the Great and Chanakya, whose popular legacy has been that of a brainy brahmin strategist-adviser to Emperor Chandragupta Maurya. Padmini's casting in not only *Pardesi/Khozhdenie* and the shelved *Alexander and Chanakya* but also in an Indo-Malay coproduction titled *Singapore* (Shakti Samanta, 1960) reveals a contemporaneous pattern of marshalling star dancer-actresses to headline cross-industry productions aimed at multilingual distribution both within and beyond

India. Padmini was also cast in *Mera Naam Joker* (My name is Joker; Raj Kapoor, 1970), which cast Soviet actors, was partially shot on location in Moscow, and was written by *Pardesi/Khozhdenie*'s codirector and cowriter K. A. Abbas.

A 1975 Indian trade journal's profile of Padmini, among other South Indian actresses who moved into the Hindi film industry, notes:

> Glamorous Padmini arrived with "Mr. Sampat." In "Raj Tilak," she shared stellar honours with Vyjayanthimala. For a time she worked in B class films like "Singapore," "Payal" and "Ragini." Her big break came when Raj Kapoor cast her in his "Jis Desh Mein Ganga Behti Hai." After working in a number of films she got married and is now settled in the U.S. Her last film was "Mera Naam Joker."[41]

The characterization of *Singapore* as a "B class" endeavor offers a striking contrast to the ambition of a prestige production like *Pardesi/Khozhdenie*, as the latter took so seriously the task of cross-industry collaboration that its commercial success, at least in India, was ultimately weighed down by this burden. For Abbas, however, the fact that *Pardesi/Khozhdenie* did not go on to be a lucrative box office hit was a testament to its sincerity. In subsequent occasional reports that laud India's few forays into coproduction and often advocate for further exploration of such opportunities with various nations, *Pardesi/Khozhdenie* is almost always listed, while *Singapore* is almost always elided.[42] By comparing the two films, which were only three years apart, we are able to consider how the coproductions entailed highly varied ideological ambitions, on the one hand, and shared strategies of practice, on the other, within an overlapping context of the Bombay industry over the long 1960s. The classification of *Singapore* as a "B class" film was due neither to its production values nor to its production practices but rather to its presumed orientation toward a primarily working-class South Asian diaspora in Southeast Asia. This was yet another instance of the prevalent tendency to derive the quality of a film from the presumed quality of its audiences, as elaborated in chapter 1.

Across multiple cross-industry productions in this period, the dancer-actress—as both a diegetic figure and a star—was vested with a central role in both imagining and facilitating the business of multilingual film distribution. Recent scholarship on dance and Indian cinema has contributed poignant insights into gendered hierarchies of value and cinematic form, which have tended to privilege speech over song, acting over dancing, and ostensibly natural modes of expression over gestural, embodied ones.[43] Dancer-actress Padmini, who stars as a dancer in both *Pardesi/Khozhdenie* and *Singapore*, was the second of three dancing sisters known as the Travancore sisters. She made her cinema debut in Uday Shankar's Hindi film-ballet production *Kalpana* (1948), after which she established herself as dancer-actress in Tamil cinema.[44] While she also starred in a few other Hindi films in the early 1950s, her initial Hindi films were all produced by Madras studios.

Prominent dancer-actresses in this period, particularly those who worked in South Indian industries, were mobile in unique, albeit highly gendered, ways.[45]

It was much rarer for prominent male stars to appear in films in different languages, even when they starred in films produced by another industry.[46] Star dancer-actresses featured prominently as anchors in cross-industry productions, including the India–United States coproduction *Guide* (Vijay Anand, 1965), whose screenplay was written by Pearl S. Buck and adapted from R. K. Narayan's eponymous English-language novel.[47] The casting of dancer-actresses allowed for narratively motivating and marketing spectacular dance-oriented production numbers as a specific attraction of the Indian involvement in high-budget prestige ventures, whose inclusion of such numbers was also a strategy of reaching for distribution across multilingual audiences. In addition, in both *Pardesi/ Khozhdenie* and *Subah-O-Sham/Homa-ye Saʾadat* (Tapi Chanakya, 1972), an India-Iran coproduction that I examine in chapter 5, the singing dancer-actress unfolds as a metonymic figure through whom reflexive arguments about the intelligibility and ethical sincerity of Hindi song-dance films unfold onscreen. While *Singapore* is far less reflexive and far less invested in its self-presentation as a prestige film than *Pardesi/ Khozhdenie* or *Subah-O-Sham/Homa-ye Saʾadat, Singapore*'s casting of dancer-actress Padmini embraces a shared strategy of capitalizing on the ostensible exchange value and translatability of the stardom of Indian dancer-actresses, specifically.

An Indo-Malay coproduction shot in Singapore, *Singapore* was a coproduction between F. C. Mehra's Bombay-based Eagle films, with Shaw Studios and Cathy-Kris,[48] the two major studios in Singapore. Shaw Studios was run by it namesake Hong Kongese founders, whose Singapore productions were aimed at a multilingual Southeast Asian market. "As the longest running studio in Chinese-language film," writes Darrell William Davis, "Shaw Brothers negotiated, compromised, and co-opted its way through almost 90 years."[49] Several scholarly accounts characterize the Shaw brothers as ruthlessly pragmatic managers of a diasporic commercial empire of film distribution and production who positioned themselves early on as providers of entertainment for colonial territories across East and Southeast Asia. By the 1930s, they "had linked British Hong Kong, China and Southeast Asia into a transnational entertainment businesses."[50] In addition to producing and distributing Chinese films for a large diaspora across East and Southeast Asia, they, along with Cathay-Keris, were central to the development of Malay cinema as it flourished over the 1950s and 1960s, when Singapore was the major center of production.[51] Although Singapore initially merged with Malaysia upon the latter's establishment as an independent nation-state in 1963, Singapore separated and became its own nation-state within two years.[52]

Singapore was an Indo-Malay coproduction undertaken at the tail end of a peak period of Malay film production in Singapore. Among the production practices that had been employed by Shaw Studios in Singapore was the hiring of directors from other parts of Asia, including Indian (though not necessarily Bombay or Hindi film) directors like Lakshmana Krishan, B. N. Rao, and S. Ramanathan. Their influence and presence in the Malay commercial film

industry—alongside the popularity of Indian films that had been circulating through Southeast Asia as part of a larger colonial network—is attributed to the song-dance forms of Malay films of the period.[53] As a Hindi film coproduced by a Bombay producer along with Singapore-based Malay-film-producing studios, all parties stood to benefit from *Singapore*'s potential for availing multiple channels of distribution. There was a ready market for Indian films in Malaya, though the largest South Asian community was a Tamil-speaking diaspora rather than a Hindi-speaking one. *Singapore*'s extended production numbers shot on location in Singapore were among the first instances of what went on to become a vogue for foreign location shooting in 1960s Hindi cinema.[54] Thus, two interconnected contexts of multilingual distribution—those of South Asia and Southeast Asia—figure in the production of *Singapore*, particularly in its strategic casting of actresses.

The stars that headline the film are Shammi Kapoor, a brother of Raj Kapoor whose legacy includes being known as the "Elvis of India," alongside Malay star Maria Menado and dancer-actress Padmini. Dance numbers additionally highlight Anglo-Burmese dancer-actress Helen, who was known as a Hindi film star of cabaret production numbers specifically.[55] In *Singapore*, Helen plays a Malaysian village dancer. Another feminine side character who is part of an intendedly comic subplot is named Chin Chin Choo, in an echo of the jazzy Helen-starrer *"meraa naam chin chin chuu"* (My name is Chin Chin Choo), a song sequence from the hit 1958 Hindi film *Howrah Bridge*, which was also directed by Shakti Samanta just two years earlier. *Singapore*'s status as a heavily Indian-helmed coproduction becomes evident in its playing up of generic, racialized caricatures within a Southeast/East Asian milieu of characters at a time when tensions between India and China over issues in Tibet and other northern regions were building.[56] Maria Menado plays a seductive Malay woman named Maria, and her vamp—who is later revealed to be a gang leader—is the foil to the pristine, virtuous femininity of Padmini's Indian diasporic character Lata.

The plot revolves around a crime intrigue: Shammi Kapoor's character Shyam is the Indian scion of a Singaporean rubber estate. He travels to Singapore to see what is amiss when his on-location estate manager Ramesh suddenly goes incommunicado after having just revealed to Shyam that he found a map pointing to a treasure buried at the rubber estate. Several local—and generically East/ Southeast Asian—gangs, in addition to Lata's own father Shivdas, attempt to wrest control of the map and take possession of the hidden treasure. The narrative significance of the rubber estate belies a material history of coloniality and labor that bind the two contexts of production, as the origins of a significant Tamil diaspora in Malaya and Singapore lay in their colonial transport and exploitation as indentured plantation laborers under (and within) the British empire. Here, Padmini's status as both a well-known dancer-actress in Tamil films and a stage performer of Indian classical dance who had been dancing for audiences in Malaya connects

1960

(SYNOPSIS)

Shyam deputed his manager Ramesh to sell off his Rubber Estate in Singapore. While going through the old records Ramesh finds a map revealing that there is a huge treasure in the Rubber Estate. He immediately writes to Shyam. But to Ramesh's surprise neither Shyam replies his letters nor he comes to Singapore.

Ultimately Shyam is contacted on the phone. But the line is cut in between the talk. Failing to understand anything Shyam flies to Singapore.

In the plane he meets a Malayan beauty, Maria, who falls in love with Shyam at the very first sight.

In Singapore Shyam comes to know that Ramesh is missing since his talk on phone was abruptly cut off. Shyam desperately starts searching Ramesh — he informs Police, taps every source which could lead him to Ramesh. In his search he meets Lata, an Indian dancer and comes to know that Lata's sister Shobha is infatuated to Ramesh. Now he visits Lata's place occasionally. He is treated like a member of the family by Shivdas, the uncle of Lata.

One day Lata, Shobha, Shivdas and Shyam go to the Rubber Estate for pic-nic. At the very first opportunity Shivdas steals that map leading to the treasure from Shyam's bag. Shobha sees and follows Shivdas in the jungle. Shyam too follows them.

At a distance Shyam finds Shivdas's deadbody in the jungle. No sooner Shyam is recouped from the shock he is attacked by the gangsters. Struggling hard he reaches back in his Rubber Estate where Police is already waiting for him with the warrant of arrest on the charge of murdering Shivdas.

Is Shyam exenorated from the charge of murder ?

Who wins Shyam's love — Marla or Lata ?

To know this all see film **Singapore** in your favourite theatre.

FIGURE 25. Image from a press booklet for *Singapore* (1960).

the linguistic specificity of a Tamil diaspora in Southeast Asia to a Hindi-language Bombay coproduction's casting of a star who was prominent not only in Tamil films but also through performance circuits that connected the subcontinental Tamil mainland to its diaspora in Southeast Asia (fig. 25).

Pardesi/Khozhdenie explicitly extolls the value of the singing dancer-actress's expressive modes as metonymic for the song-dance-based Hindi cinema's ability to cross boundaries of language. Yet, *Pardesi/Khozhdenie* rhetorically disavows the libidinal excess generated by the formal and commercial excesses of song-dance elements as well as romance. The film subordinates the latter pleasures to the work of homosocial world-making, rather than leaving them as non-(re)productive ends in and of themselves. One irony, of course, is that this hierarchy becomes inverted in practice, as the onscreen presence of the singing dancer-actress, the embodied presence of the star dancer-actress, and "love themes" have occupied primary rather than secondary interfaces for spectatorial engagement. Another irony is that the onscreen figure of the singing dancer-actress required the cross-over labor of dancer-actresses from South Indian film industries, even as this figure was deployed as one who was metonymic for Hindi cinema's unique propensity for scale-making enterprises of multilingual distribution through its very excesses both within and beyond India.

In considering the contemporaneity of coproductions like *Pardesi/Khozhdenie* and *Singapore* in an account of 1960s Hindi cinema, I have refused the ostensible valuelessness that might be accorded either to a "B class" film like *Singapore*, to *Pardesi/Khozhdenie*'s commercial failure in India, or to both films' status as largely forgettable historical exceptions. Instead, I am interested in these films precisely for the ways in which they reveal historical—and highly gendered—patterns of cinema's world-making ambitions and practices via the Bombay industry. Through the prominence accorded to South Indian dancer-actress Padmini, for example, both films highlight the Bombay cinema's multilingual, cross-industry conditions of both production and distribution within India. These domestic conditions were continuous with the transnational coproductions' ambitions and strategies of marshalling various formal excesses toward the scale-making enterprise of multilingual distribution as a practice of world-making through cinema. In order to emphasize these historical continuities, I turn in the next chapter to one of the most undertheorized and underhistoricized aspects of popular Hindi cinema over the long 1960s: that of a string of Madras-produced Hindi remakes of Tamil comedies. Easily devalued either as quickly churned-out remakes on the one hand or as politically vacuous entertainment on the other, several of these comedies are among the most reflexive films that not only made energetic ekphrastic arguments about their own value but also betray a keen awareness and engagement with the ostensible formal and commercial excesses of Hindi cinema as the key to their cinephilic, world-making potential over a highly volatile period for Indian filmmakers, the nation, and the world.

4

Comedic Crossovers and Madras Money-Spinners

Padosan's *(1968) Audiovisual Apparatus*

Film World, an India-based trade journal that was initially published out of Madras, launched its first issue in 1964. A glossy publication oriented toward journalists and film industry personnel, as well as a broader segment of film enthusiasts, the first issue announced in a preface by editor M. Ranganathan:

> **film world,** a current study of international films and filmfolk, makes its bow in a world of film periodicals and books with this inaugural issue. This is the first time that a publication of this kind is being made available to the public throughout the length and breadth of the world.
>
> The object of this publication is to promote understanding, friendship and collaboration among filmfolk and movie fans living in all parts of the world. This volume will greatly supplement the work of International Film Festivals, which serve a useful purpose in bringing together the leading luminaries of the motion picture world on a common platform with the object of instilling spirit of *camaraderie* and creating opportunities for greater partnership between them.[1]

While in earlier chapters I have referred to various articles and opinions voiced either in *Film World* or by prolific film journalist T. M. Ramachandran, who stepped in as *Film World*'s editor in 1967, I now briefly turn to *Film World* itself as an object of inquiry. What prompted its founding in the mid-1960s? If we take the first issue's preface at its word, the answer would simply be that it wished to promote friendship and camaraderie through the (film) world of the 1960s, evocatively rendered on the first issue's cover as a celluloid-encased globe (fig. 26). A foreword by Satyajit Ray emphasizes the unique potential of cinema to engender a sense of global cohesion in a Cold War era:

FIGURE 26. Cover graphic for the first
issue of *Film World* (1964).

Today, in this jet age, it is no longer possible to consider films of a nation in isolation.
. . . And while it is true that a feeling of proximity between the peoples of the world
has been achieved through faster travel, the vital need of getting to know each other's
hearts and minds can be best fulfilled by the media of communication, of which
cinema is by far the most powerful.[2]

Indeed, the journal showed a commitment, at least in its first issue, to coverage of
film industry happenings in a range of countries, irrespective of political tensions,
through features on filmmaking in Pakistan, China, and countries of both sides
of the Iron Curtain. In addition to garnering the support of several overseas state
institutions of film production and export, the journal spotlights contributions by
industry insiders from around the world, and each issue is replete with accompa-
nying photos.

I surmise, however, that the orientation and high production values of *Film
World* were centrally concerned with a more specific aim that became urgent by
the mid-1960s: to forge networks between the South Indian film industries—par-
ticularly that of the Madras-based Tamil film industry—and the Bombay-based
Hindi film industry. This concern was palpable through the outsized number of
pages and advertisements in each of the next several issues, which were devoted to
introducing and showcasing the skills and talents of producers, crew members, and
stars from Tamil—in addition to Telugu, Malayalam, and Kannada—film indus-
tries. A profile of Tamil producer-director S. S. Vasan of Gemini Studios in the
first issue highlights his milestone contribution to the potential for cross-industry
ventures: "The movie-makers, especially producers of Hindi films in Madras, owe
a deep debt of gratitude to him for effectively projecting the South in Northern
India with his spectacular Hindi film 'Chandralekha' [1948] and paving the way
for the production of more and more Hindi films in South India."[3] This additional

For International Casting

Res: 85506

K. BALAJE

29-B, Pantheon Road,
MADRAS-8.

JAI SHANKAR

149, Nandanam Extension,
MADRAS-35.

Res: 42394

(MISS) JAYALALITHA

8/1, Sivagnanam Road,
MADRAS-17.

Res: 71412

KALYAN KUMAR

4, Fourth Cross Street
C. I. T. Colony, MADRAS-4.

Res: 81712

(MISS) KANCHANA

5, Giri Road,
MADRAS-17.

Office: 83184 Res: 71183

R. RANJAN, M. Litt.

Office : *Residence :*
RANJAN'S HOTEL, 5/7, Lattice Bridge Road,
135, Mowbrays Road, MADRAS-41.
MADRAS-14.

Res: 81682

(MRS.) SOWCAR JANAKI

16, Giri Road, 1st Street,
MADRAS-17.

Res: 72188

(MISS) L. VIJAYALAKSHMI

"VIJAYA",
16, Third Street, Abhiramapuram,
MADRAS-18.

FIGURE 27. Business cards printed in second issue of *Film World* (1964).

avenue of profit for the Madras studios—that is, through their production of Hindi films—was particularly pressing in light of a mid-1960s industry crisis of poor box office returns, which made financiers risk averse.[4] The next issue of *Film World* actually features printed business cards of several above-the-line personnel from South Indian film industries, ostensibly for international recruitment but in all likelihood aimed at the Bombay industry (fig. 27). By 1968, *Film World* had shifted its primary headquarters from Madras to Bombay.

While a comprehensive history of Madras-produced Hindi films in this period is beyond the scope of my analysis, I focus in this chapter on the production and impact of a 1960s strand of hit Madras studio comedies—"money-spinners," as they were not-so-infrequently and dismissively called—that were remade in Hindi. I first outline how these comedies provide important context for understanding Jyoti Swaroop's hit 1968 Hindi comedy *Padosan* (Girl next door). While *Padosan* was a Bombay-based home production of by-then comic superstar Mehmood (aka Mahmood), the film's production and form are inextricable from a thread of cross-industry ventures that brought a distinct brand of Madras studio comedies into the contemporaneous repertoire of Hindi cinema. An account of *Padosan*'s highly reflexive, rollicking defense of commercial cinema ensues specifically from its status as a comedy, as part of a 1960s legacy of Hindi films that took the excesses of "romance, comedy, and somewhat jazzy music" to an extreme with the advent of color, as they evacuated the IPTA-influenced 1950s mise-en-scène of the street and its publics[5] for either the dollhouse-like studio set or the glamour of exotic, picturesque outdoor locations.

Even as India faced mounting financial, diplomatic, and political crises, as well as the death of Prime Minister Jawaharlal Nehru in 1964, popular Hindi cinema of the 1960s had considerably escapist fare on offer: color, foreign locations, high romance, ornately fashionable interiors, lavish budgets.[6] On one level, this marked an inward focus in the form of the social, away from the 1950s social realism of the street and toward the construction of an increasingly consumerist, middle-class domestic space of the heterosexual couple, even as the locations of their romancing encompassed a dazzling touristic array of outdoor locations.[7] This modern, cosmopolitan imagination dovetailed with global visual cultures of the "swinging" 1960s.[8] Meanwhile, in a fascinating strand of highly reflexive Madras-produced comedies remade in Hindi, the couple was often significantly defamiliarized if not displaced as the central attraction of the films. The politics of these seemingly apolitical Hindi remakes of Tamil comedies, I would argue, lie in their ekphrastic engagements with pleasure, in highly reflexive exaggerations that often critiqued the hierarchies of the film industry while defending the egalitarian potential of love-as-cinephilia.

This is a key stake of my analysis of *Padosan*, which I include in a strand of cross-industry productions despite its status as a Mehmood Productions venture. Toward the end of the chapter, I contrast the window-as-cinema in *Padosan* to the window's operation in the new wave film *Dastak* (Knock; Rajinder Singh Bedi, 1970). Together, the films reveal contemporaneous polemics over cinema and libidinal excess through the motif of noise. By tracking *Padosan*'s defense of both its means and its ends, I open up the film's own theorization of cinema and cinephilia in that very multilingual, multi-industry, cacophonous world of *Film World*, where staying afloat through intranational networks was as (if not more) pressing a concern as the forging of "camaraderie" through international networks.

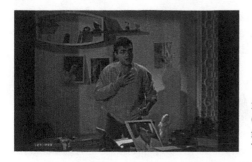

FIGURE 28. Still from *Pyar Kiye Jaa* (1966): Mehmood plays Atma, an aspiring filmmaker who names his company Wah Wah Productions.

In the late 1960s, students in the Tamil-speaking state of Tamil Nadu (formerly Madras State) protested the imposition of Hindi as a national language, which they understood as a gross overreach by the central government. They blocked Hindi film screenings in the state, and in retaliation, the Shiv Sena, a nativist organization that sought to claim Bombay for disenfranchised Marathi speakers, blocked the exhibition of Tamil films as well as Madras-produced Hindi films. Meanwhile, film producers, exhibitors, and distributors were in a deadlock.[9] As costs of color film production as well as theater rental had risen, distributors abandoned a minimum guarantee system, by which they had borne responsibility for deficits incurred by box office failures.[10] Distributors instead demanded advances, which placed the burden of box deficits on producers.[11] By the late 1960s, Nehru's daughter, Indira Gandhi, had come to power, and mass protests were widespread amid political and economic crises marked by deep disenchantment with unfulfilled promises of independence for social equality, employment, freedom from authoritarianism, and freedom from poverty.[12] A slew of other agitations would culminate not in any political resolution but in Gandhi's 1975 draconian declaration of the Emergency and suspension of the Constitution for twenty-one months to forcefully quell dissent.[13]

As the Tamil film industry approached a nadir in its profits in 1964, an exception to that year's weak box office performers was C. V. Sridhar's lighthearted comedy *Kadhalikka Neramillai* (No time for love). Backed by the same Madras-based Chitralaya Pictures, Sridhar directed its 1966 Hindi remake *Pyar Kiye Jaa* (Keep on loving). The Hindi version stars Mehmood as a show-stealing caricature of an aspiring filmmaker named Atma, whose company is parodically named Wah Wah Productions (whose English equivalent might be something like So Cool Productions) (fig. 28). The film's setting is mainly that of a house and its idyllic surroundings, as Atma and his two sisters' parallel romances unfold in step with the comedy. Such lighthearted comedies, like contemporaneous high-budget Hindi romance spectaculars, seem incongruously out of touch with their historical contexts of widespread political and economic upheavals. At the same time, the emergence and persistence of Madras-produced Hindi comedies in this period were due precisely to the precarity of filmmaking in a time of crisis. In light of

this volatility, several Madras-produced comedies in both Tamil and Hindi were intensely reflexive and introspective, as they offered ekphrastic arguments that wrestled with the value, pleasures, and limits of commercial cinema. The annual Filmfare Awards, headlined by the preeminent Bombay-based *Filmfare* magazine, registered the impact of such comedy-centered Hindi film ventures through its creation of a new award category, Best Comedian, in 1967, whose inaugural winner was Mehmood for his role in *Pyar Kiye Jaa*.

Pyar Kiye Jaa was followed by another reflexive Hindi comedy: S. S. Vasan's 1968 *Teen Bahuraniyaan* (Three dear daughters-in-law), a remake of K. Balachander's 1967 Tamil comedy *Bama Vijayam* (Bama's visit) produced by Manohar Pictures. The Hindi version, as well as a Balachander-directed Telugu version titled *Bhale Kodallu* (1968), were produced by Madras-based Gemini Studios. The three main actresses in the Tamil film also starred in the Telugu and Hindi versions. In the latter, they appear as daughters-in-law of a patriarch played by Prithviraj Kapoor, whose dialogues were dubbed by a voice actor due to Kapoor's weakened health. In *Teen Bahuraniyaan*, the three sibling-couples live in one house with their father(-in-law) as a joint family. The pairs, whose names correspond to pairs of Hindu deities, are clichés of upper-caste, middle-class Hindu couples: Shankar and Parvati, Ram and Sita, and Kanhaiya and Radha.

When a glamorous film star named Sheila moves next door in *Teen Bahuraniyaan*, the three women and their husbands are utterly mesmerized, and all six of them are desperate to earn Sheila's favor and attention. As the couples sink further and further into debt after recklessly going to great lengths to keep up appearances to impress her, the cautions patriarch—a retired schoolmaster—intervenes to help them, imparting a lesson on frugality, simplicity, and living within one's means. The actress Sheila, meanwhile, is not demonized, but is instead portrayed as incredibly down to earth and impervious to the superficial glitz and glamour of her "filmi" lifestyle and milieu. *Teen Bahuraniyaan* reflexively considers the seductions of globally circulating (cinematic) images of décor, ornamentation, and consumption during a time of economic crisis. The film ultimately vouches for the goodness and grounded character of film personnel through the figure of the film star Shelia, in spite of the industry's reputation for and production of superficially flashy and materialistic images. The lesson that Prithviraj Kapoor's schoolmaster Dinanath imparts is one of consuming these images—and indeed all the fun and joy that they bring—with a grain of salt, in order to love them for their underlying sincerity rather than for their outward appearance.

While Prithviraj Kapoor stars in *Teen Bahuraniyaan*, the thundering patriarch of Hindi cinema along with his son Raj Kapoor and grandson Randhir Kapoor are instead parodied by superstar comedian Mehmood in *Humjoli* (Fellow), a 1970 Hindi remake of the 1964 Tamil film *Panakkara Kudumbam* (Rich family). Both films were directed by T. R. Ramanna, and *Humjoli* stars Mehmood in a triple role that essays the one played by comedian Nagesh in the Tamil version. Mehmood's

FIGURE 29. Still from *Humjoli* (1970): In-house trial, featuring Mehmood in a son-father-grandfather triple role that parodies Randhir, Raj, and Prithviraj Kapoor.

triple role unfolds as a primary attraction of the Hindi version for its recognizable caricatures of Randhir, Raj, and Prithviraj Kapoor, far outshining the role of the romantic hero played by the much greener Jeetendra. In the Tamil version, Nagesh is the comedian to reigning Tamil star M. G. Ramachandran's hero in *Panakkara Kudumbam*. This was typical in South Indian cinemas, as the onscreen relationship between the comedian and hero often scripted the offscreen relationship between the subaltern-as-fan and star-as-representative for each linguistic state constituted by the 1956 States Reorganization Act.[14]

The onscreen relationship between the comedian and star was a phenomenon specific to a postcolonial vacuum of sovereignty and the emergence of subnationalisms in the South Indian linguistic states, which had been carved out of erstwhile princely states.[15] Consequently, this localized importance of the comedian was untranslatable, begging the question of where and how one locates the politics of comedy in the Hindi remakes. Mehmood's stardom as a comedian was such that several top male stars in the Bombay industry refused to work with him, fearing that he would outshine them.[16] In several Hindi comedies headlined by Mehmood, a primary object of ridicule becomes the Bombay industry itself. The films wrestle with the question of cinema's role in the Nehruvian project of national integration and its limits, and they defamiliarize mainstream cinematic hierarchies of exclusion that tended to reserve romantic fulfillment for specific kinds of idealized bodies.[17] At the same time, the films uphold the sincerity of a cinema that aspired to offer an open invitation for all, to partake in a vast array of pleasures that are ekphrastically iterated as love-as-cinephilia.

Perhaps the most clever subplot in *Humjoli* is that of a tomboyish neighbor who takes a purely platonic fancy to Shivram (Mehmood's third-generation character and Radhir Kapoor parody), whose intentions are misunderstood by everyone including Shivram's incensed wife. A hilariously absurd home-trial ensues, presided over by the Prithviraj Kapooresque grandfather-judge, in a manner that calls attention to the striking inability of not only a broader social milieu but more specifically, the diegetic world of popular Hindi cinema to accommodate cross-gender platonic relationships (fig. 29). The sequence also collapses a

prevalent postcolonial binary between the public and private by not only depicting a cine-juridical process within the space of the home but also bringing this process to ridiculously bear upon the adjudication of whether a man and a woman can indeed have a nonsexual relationship.

Mehmood again essays Tamil comedian Nagesh's famous lead in the 1964 film *Server Sundaram*, remade in Hindi in 1971 as *Main Sunder Hoon* (I am Sundar). Krishnan-Panju directed both films, and K. Balachander, on whose play *Server Sundaram* was based, wrote the screenplay for both films. In both versions, the main character is a poor waiter who considers himself ugly. Through his talent for role-playing and a stroke of luck, he becomes a film star. He gains all the material wealth and fame that he could ever dream of, but when he finally reveals his feelings to the woman with whom he had fallen in love during his waiter days, he is devastated to realize that what he mistook for romantic interest was platonic affection on her part. Most of *Main Sunder Hoon* takes place on set—that is, the set of the home as well as the set of film shoots within the film, which were taking place in actual Madras studios. The latter are an incredible treat in both versions, as they elaborately portray, pay homage to, and parody familiar conventions and genres of commercial cinema. An especially memorable moment is that of a myth-ological-drama-turned-family-planning-lesson (framed as a stage performance within the film), which mocks the excesses of both commercial cinema and statist didacticism (clip 5).

The 1968 film *Padosan* was made in the midst of the above string of come-dies. *Padosan* is a remake of a 1952 Bengali film, *Pasher Bari* (Sudhir Mukherjee), which had, in the meantime, been first remade in Telugu as *Pakkinti Ammayi* by the Calcutta-based East India Film Company under the direction of Chittajallu Pullaya and then in Tamil in 1960 as *Adutha Vettu Penn* by director Vedantam Raghavaiah under the banner of Anjali Pictures, named after Anjali Devi, who starred in both the Telugu and Tamil versions. More than the Bengali film *Pasher Bari*, which actually opens and closes in the urban milieu of a train station, the set of the small-town home in *Padosan* strongly invokes a contemporaneous Madras studio style, whose reflexive parodies of the inner workings of the film industry were the highlights of films like *Server Sundaram* and *Kadhalikka Neramillai*, as well as their Hindi remakes.[18] Sunil Dutt, a top star of Hindi cinema, agreed to play the country bumpkin Bhola in *Padosan*. This comic role, which his wife, Nargis, purportedly urged him to decline, was an exception not only in his career but also in being a rare case of a top star of Hindi cinema agreeing to act with Mehmood.[19]

While star actresses were evidently translatable, insofar as they frequently worked across commercial remakes in different languages, star actors rarely appeared across versions in different languages, even if they acted in films produced by another industry. Remakes in this period, as in the case of *Padosan* and its antecedents in Telugu and Tamil, almost always featured original music

CLIP 5. Onstage mythological-drama-turned-family-planning-lesson from *Main Sunder Hoon* (1957).

To watch this video, scan the QR code with your mobile device or visit DOI: https://doi.org/10.1525/luminos.130.5

and songs. Thus, despite prevalent characterizations of music—and film songs—as immanently legible and translatable, music was clearly regarded as quite specific in its various textures. Audiences had developed a discerning ear not only for specific playback singers as (aural) stars in their own right,[20] but also for the specific styles of film music that emerged from the creative labor of personnel associated with films of each language or commercial industry.

In *Padosan*, even the credits[21] by graphic designers Ansari and Nasir playfully and reflexively foreground the film's construction—as artifice, as performance, as technologically mediated (fig. 30). The graphics call to mind Albert Zacharias's playful animations that open *Chalti Ka Naam Gaadi* (That which moves is called a car; Satyen Bose, 1958) a similarly unique Hindi comedy that was produced by Kishore Kumar, who also stars in *Padosan*. *Adutha Vettu Penn*, the 1960 Tamil version that preceded *Padosan*, also features animated credits by Dayabhai Patel, which were a novelty for the time. Comprised of zany, animated line drawings, the credit sequence in *Adutha Vettu Penn* did not visualize either the film industry or its own processes of filmmaking as *Padosan*'s and *Chalti Ka Naam Gaadi*'s opening credits did. At the outset of *Padosan*'s credits, R. D. Burman's jazzy horn-and-percussion

FIGURE 30. Stills from *Padosan* (1968): Paper cut-out cartoon stills caricature the Bombay film industry and various processes of film production.

score accompanies a set of stills featuring paper-cut-out cartoons. The distributor's banner dissolves into a title proclaiming "Mahmood Productions Present Their First Ambitious Motion Picture" (figs. 30.1, 30.2). In its self-presentation of a folksy amateurishness, the film appeals to the lovability of bad or low art, strongly associated with comedy in the case of Hindi cinema. This is epitomized within

the diegesis by the Pancharatna Natak Mandal (Five Gem Drama Company), an ironically named amalgam of not five, but four, actors who form a local theatre company led by the exuberant, perpetually betel-chewing Vidyapati aka Guru, or "Learned One," played by playback singer and actor Kishore Kumar.[22]

Each title card gives way to the next by transitions that imitate an opening window, playing upon the window as a motif within the diegesis that—like cinema—affords a range of voyeuristic and exhibitionistic opportunities.[23] The presentation title is illustrated by colorful houses and as an "opening-window" effect gives way to the title screen, two empty open windows on a house in the bottom corner of the previous frame become the enlarged, primary illustration for the title (fig. 30.3). In the next credit, actor Sunil Dutt appears through one window as a cartoon holding a heart on a plate with an outstretched arm (fig. 30.4)—ostensibly toward his neighbor, the heroine played by Saira Banu, who then appears in her own window in the next credit (fig. 30.5). The three subsequent credits feature caricatures of the comic actors Mehmood, Kishore Kumar, as well as Om Prakash in a "Friendly Appearance" (figs. 30.6, 30.7, 30.8). The later credits continue to caricature the people involved with the film as well as the film's production processes, beginning with illustrations of other actors and extras as a multitude of individuals clamoring behind a gate (fig. 30.9), of writer Arun Chowdhury as a bookish type (fig. 30.10), from whose Bengali short story *Pasher Bari* the film is adapted, and of lyricist and screenplay and dialogue writer Rajendra Krishan as a typewriter-savvy, cap-wearing, bespectacled gentleman (fig. 30.11).

The credits for camerawork, for art, and for stills and publicity humorously draw attention to an overwhelming preoccupation with the image of the actress as the primary attraction of cinema (figs. 30.12–14, 30.20). The stills-and-publicity credit has a caricature of a brahmin man sitting back in a chair and gazing at cards that display pin-up-style images of women in bikinis.[24] In the credit for camerawork, the cameraman displays a look of extreme irritation toward the oblivious assistant who is the one actually working the camera, although he has it faced upward in the direction of a second floor window, out of which leans a large-breasted older woman with whom he is flirting. The art credit has a caricatured artist holding an enormous, framed painting of a woman, which he is attempting to hang. Within the cartoon cut-out illustration, the "painting" here is actually a photograph of an actress.

Throughout and beyond its credits, *Padosan* plays self-consciously upon its status as a film, and furthermore, as a film positioned amid the milieu of the Bombay industry. The specificity of Hindi cinema is further underscored within the film by comic actor Mehmood's thickly accented Hindi, marking his memorable performance as Master Pillai, an effeminate South Indian brahmin and classical music and dance teacher.[25] An outsider, Master Pillai's artistic expertise is rhetorically portrayed within the film as exaggeratedly rigid and unpleasurable compared to the wider appeal and organic nature of something like Guru and company's theatrical productions, despite their hodgepodge of influences, disregard for classical

forms, and downright amateurishness that amounts to a highly reflexive parody of the Bombay industry and its films. Ultimately, however, despite Master Pillai's ostensibly unpleasurable performances, thickly accented Hindi, and outsider status, he steals the show and constitutes the very heart of the comedy.

As the cartoon stills in *Padosan*'s credit sequence caricature the figures involved in the film's production, the instrumental background score exemplifies the eclecticism of what came to be revered as the signature of music director R. D. Burman, who burst upon the scene of Hindi film music in the 1960s. Burman was the son of music director S. D. Burman, and it was Mehmood who first took a chance on the younger Burman by hiring him as the music director for *Chhote Nawab* (Little prince; S. A. Akbar, 1961). At the outset of *Padosan*'s credit sequence is a jazzy horn-and-bongos instrumental track, which gives way to a trilling bamboo flute. Soon, an instrumental leitmotif (which resurfaces in the "la la la la" portion of the first song sequence) takes over, until it ends in a *tihaaii*, or cadence indicated by a triple repetition, which is common in styles of Indian classical music. The *tihaaii* cadence segues into a solo on a mridangam, a drum associated with modes of South Indian, or Carnatic, classical music. The mridangam solo is joined by a melody played on a nadaswaram, a double-reed wind instrument that is also associated with South Indian styles of music. Eventually, a full orchestra also joins in.

As *Padosan*'s credits roll onward, more illustrated stills render the film's production processes and its narrative and performance elements as inextricably interwoven. A conspicuous seam in the middle of the editing credit foregrounds the work of cutting and splicing film, making the outstretched arms of a man and woman on the two separate panels appear as if in a reciprocal gesture of embrace (fig. 30.15). A dressed-up, colorfully painted mannequin illustrates the credit for makeup, hair, and costuming (fig. 30.17), and the credit for playback singers features a woman sandwiched between an enormous gramophone and a standing corded microphone into which she is enthusiastically singing, underscoring and celebrating sound-recording technologies as well as the aural performance of the playback singer (fig. 30.21). Such illustrations celebrate the film as a film, understood to be a set of processes and performances indebted to technologies of (re) production.

The caricatured brahmin who appeared in the credits for Mehmood, author Arun Chowdhury, and the enthusiast of pin-up photos in the stills-and-publicity credit reappears for three more credits. In the choreography credit he is instructing a young woman in dance (fig. 30.16); in the background music and recording credit, he is preoccupied with a gramophone (fig. 30.22); and in the credit for music director R. D. Burman, he is conducting a band comprising a horn player, a violinist, and an accordionist (fig. 30.24). The drawings of the brahmin as bookworm, connoisseur of pin-up photos, technology enthusiast, and music-and-dance instructor make for a caricatured reference both to the powerful influence and disproportionate dominance of brahmins across a number of fields and to the

role-playing talents of actor Mehmood, cast in this film as a South Indian brahmin who is the music and dance instructor of the heroine, for whom he is simultaneously a desirous and aspiring—albeit ultimately defeated—suitor.

In addition to emphasizing various processes of its own production, the credit sequence of *Padosan* also caricatures the status of the commercial film industry out of which it ensues. Aside from an earlier credit that depicts lesser-known actors as a large crowd, assistants are shown as nonprofessionals, collectively illustrated as a complacent child holding a balloon and lollipop (fig. 30.18). Commercial and business aspects of the industry are referred to in the credits for the production managers and the production executives (figs. 30.19, 30.23). The former features a man weighed down by an immense stack of ledgers and paperwork, and the latter depicts an all-powerful businessman sitting high and mighty at a table behind several stacks of bills as a horde of people below him are clamoring for a handout. The credit for the producer shows a confident, grinning man presenting a profusion of flowers to a slender woman, who appears much more coy (fig. 30.25). Ostensibly, she is an actress, and the illustration depicts the oft-gossiped-about affairs involving actresses, among the romantic intrigues and liaisons between figures in the film industry in general.[26]

Amid all the tumult and chaos—the hordes of extras, nonprofessional assistants, endless red tape and paperwork, tight budgets, and "special interests" including those related to love affairs—that characterize the film industry according to the credit sequence, the director emerges in the final credit as a director of traffic (fig. 30.26). In this illustrated pun on the word *director*, cinema is positioned among technologies of urban modernity related to motion and transportation. Building on an association of cinema with technologies of mass transit as discussed in chapter 2, the positioning of the film-director-as-traffic-director in the credit sequence could very well serve as a companion illustration to M. Madhava Prasad's identification of popular Hindi films' "heterogeneous mode of production," which underlies their seemingly disjointed narrative in comparison to a tightly unified, classical Hollywood model.[27] Like the traffic director who tries to implement a semblance of organization or at the very least prevent collisions among an overabundance of vehicles headed in an infinite number of directions, here, the film director streamlines several constitutive elements—these would be song picturizations, dance production numbers, fight scenes, dialogue sequences, and so on—in the act of assembly.

Within the model identified by Prasad, post-production processes take on a crucial and conspicuous role, and the separate recording of a song via playback emerges as an exemplary instance not only of parts assembled in postproduction but also of the commercial logic of industries, as playback recording allowed for the separate production of film music as a distinct saleable product on the part of record companies. Ethical questions surrounding playback were certainly raised as in the 1940s, before it grew to become the norm.[28] With playback song recording,

there is no hiding the technological apparatus, and especially with a dual star system of acting/visual and singing/aural celebrities as identified by Neepa Majumdar, the illusion of the audiovisual image as something "natural" or emerging from a single authorial voice is not only rendered unstable but in fact a site of pleasure that emerges from the aural stardom of the voice that does not actually emanate from the onscreen body from which it appears to be coming.[29] *Padosan* not only stages an ethical validation of playback singing but also offers a validation of the enterprise of popular cinema, for which the ostensible duplicity and commercial expediency of playback becomes metonymic. The film indulges in comedically foregrounding all the "bad" qualities associated with popular cinema, to defend the sincerity of the end that it achieves in the consensual pleasure it affords its spectators, who have repeatedly proven themselves willing to be captivated by its cheap tricks.

Ashish Rajadhyaksha has emphasized the unique placement of Hindi cinema vis-à-vis the Indian state, with the former, despite its cultural power and popularity, having been historically regarded by the latter as an illegitimate, insufficiently modern form. According to Rajadhyaksha, Indian cinema, and particularly the Bombay industry due to its "cultural disqualification from the status of a 'national cinema,'" has had to continually and publicly justify itself:

> That all film narratives also produce self-validating accounts of why they exist and what work they do, is a basic film studies truism. Such an umbrella narrative, internalizing various institutionalized explanations, takes on a particular edge in places like India, where a cinematic text is inevitably required to handle a range of responsibilities supplementary to that of narration proper. Given that the "narrative account" of a film always (again, especially in India) considerably exceeds the boundaries of plausible story-telling, it is perhaps best to see it as existing on top of the story, shored up with additional surrounding layers that provide an "instruction manual" on how the film should be read and, even more significantly, used.[30]

Rajadhyaksha historically situates a degree of self-consciousness on the part of Indian cinema, especially Hindi cinema, in light of the industry's questionable cultural legitimacy and long-standing tensions between the film industry and the state. He thus positions the films' self-consciousness and manner of self-presentation as self-validating arguments within highly public negotiations of national culture in a postcolonial moment. However, while Rajadhyaksha seems to suggest the cinema's implicitly developmentalist orientation toward a spectator in need of instruction, this was not always the case. Films like *Padosan* instead construe a spectator who, even if superficially cinephobic, is deeply cinephilic. *Padosan* ultimately celebrates the affair that ensues from the spectator's enthusiastic consent to the seduction at hand, *despite* knowing better.

In 1952, the five-year-old Indian state set up the Sangeet Natak Akademi, or National Academy for Music, Dance, and Drama. As part of its program for the

development and preservation of what it deemed as proper national heritage and culture, the state-sponsored All India Radio (AIR) station famously banned the broadcast of film songs. That same year, Radio Ceylon, a station based on the island of present-day Sri Lanka, first aired the program *Binaca Geet Mala*, a countdown of Hindi film songs that was broadcast through Radio Ceylon's newly launched Hindi service.[31] Throughout the 1950s and 1960s, *Binaca Geet Mala*, among other programs dedicated to film songs broadcast by Radio Ceylon, grew to immense popularity. In the midst of the highly public opposing positions taken by AIR and Radio Ceylon toward film songs, the film song came to stand in as a primary representative object of contention in debates over the cultural value of the film industry's output. *Padosan* riffs on this legacy in a number of ways, beginning with its Pancharatna Natak Mandal, a stand-in for the film industry that constitutes a fictional low-brow antithesis of the Sangeet Natak Akademi.[32] A climactic singing competition stages the defeat of classically trained Master Pillai by Bhola, whose ineptness as a singer is overcome with the assistance of his friend Guru, the head of the Pancharatna Natak Mandal played by actor-cum-playback-singer Kishore Kumar, who sings playback for Bhola within the narrative as Bhola merely mouths the words sung by Guru in order to woo and impress Bindu, the girl next door, titular heroine of the film.

Tongue-in-cheek elements of comedy thoroughly infuse *Padosan*, from its credit sequence to its dialogue riddled with ironic puns and Freudian slips, its host of characters whose antics are replete with jokes on regional and linguistic stereotypes, and parodic acting styles that play on the their (and the film's) supposed, ironic aspirations toward high art.[33] Philip Lutgendorf's online "philipsfilums: notes on Indian popular cinema" has a page dedicated to *Padosan*– perhaps lengthiest treatment of this film by a scholar—that identifies the film in terms of genre and literary-antecedent analogs:

> The chief virtue of this screwball comedy (which the credits announce as the "first ambitious motion picture" of Mahmood Productions) is that it affectionately spoofs a world seldom seen in commercial films: the milieu of middle class, north Indian Hindus in a provincial town. As in a Shakespeare comedy, or a prahasana (farce) in Sanskrit drama, the various types portrayed—the good-hearted simpleton, the lascivious aging Rajput, the bumbling artistes of a low-grade theatrical troupe and their effusive, paan-chewing director, and the Hindi-butchering South Indian dance teacher—are all recognizable despite their exaggerated caricatures, and their language—richly spiced with (often sarcastic) folk idioms and humorous allusions to Hindu mythology—is likewise on-target. Add strong performances by a talented cast who all appear to be having a good time (including producer Mahmood as the much-maligned Madrasi), and you get a colorfully beguiling if light-weight entertainment.[34]

The above description is on point in noting several comedic aspects of the film, but by situating the film within the genre of the screwball comedy and likening its structure to the older dramatic genres of the Shakespearean comedy or the *prahasana* genre of classical Sanskrit drama, the description misses an important

inside joke, although it comes close in later noting that the film includes "a charming spoof on the playback convention." *Padosan*'s rollicking farce soars to its greatest heights upon neither the inanity of its characters nor its narrative twists alone, but upon a reflexive validation of itself as engendered by the foibles of an audiovisual cinematic apparatus that continually reveals itself to be a formulaic farce, albeit a beloved one. The performance of playback singing within *Padosan* unfolds as a quintessential example of artifice and technologized audiovisual excess, and it serves as a portal between the film's diegetic farce and its ekphrastic claims about commercial cinema as farce.

Defined as a "high-energy dramatic-comedic piece with improbable situations, exaggeration, and oftentimes playful roughhousing,"[35] farce outlines a general form of theatrical comedy that is useful not only for describing the style of *Padosan*'s comedy, especially at the level of acting, but specifically for emphasizing the subtext of the Pancharatna Natak Mandal as a low-brow theatre company that emerges as a parody of the Bombay industry. *Padosan* highlights the influence of and presence within cinema of stage performance genres and styles, which in the modern South Asian context have in turn drawn upon a number of genealogies, including Shakespearean and British drama, classical Sanskrit drama, Parsi theatre, and vernacular modes of musical theatre. While the example of *Padosan* highlights the importance of theatrical influences upon cinema, *Padosan* is not merely an instance of theatre styles seeping into a film adaptation, but rather a film that features a farcical, theatrical performance of itself as a film. In other words, the film presents itself through a subtext of theatre but with the ultimate dramatic effect of spoofing itself as a film coming out of specificities of the Bombay film industry of which it is part.

The girl-next-door heroine of *Padosan*, played by actress Saira Banu, is initially introduced, yet unnamed and unseen, through a photo presented by a fraudulent holy-man-cum-matchmaker to an older uncle of the hero Bhola. Only the back of the photo is visible to the audience, and as the uncle leans back and approvingly beholds its contents, a bright, sunlit song-picturization sequence commences as the film cuts to a low-angle medium close-up shot of the heroine Saira Banu in her role as the young girl-next-door character Bindu, who sits atop her bicycle. Cycling and lip-syncing to the unmistakable falsetto of playback singer Lata Mangeshkar, Bindu sings, "*main chalii main chalii dekho pyaar kii galii mujhe roke na koii main chalii main chalii!*" (Look, I am on my way, on my way, going down the lane of love, may no one stop me, I am on my way, on my way!) (clip 6). Filmed outdoors in the South Indian cities of Mysore and Bangalore, renowned for their greenery and *gulmohar* trees bursting with profusions of scarlet blooms, the sequence features an entourage of girls attired in Western-style clothing, singing, and bicycling. The voices of playback singer Lata Mangeshkar and her sister Asha Bhosle alternate in a back-and-forth style, the former singing playback for Bindu and the latter singing for multiple friends of the heroine at various points in the sequence.[36]

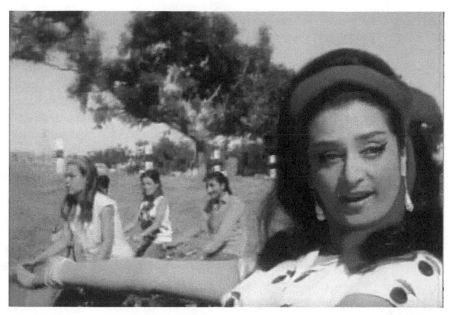

CLIP 6. *"main chalii main chalii"* song sequence from *Padosan* (1968).

To watch this video, scan the QR code with your mobile device or visit
DOI: https://doi.org/10.1525/luminos.130.6

The practice of playback, like the circulation of printed song lyrics, opens
up the audiovisual cinematic text to a range of possible meanings, since, first of
all, one may consume a song sequence either as an audiovisual song-picturization
sequence (on film, video, television, or DVD, depending on the historical period
in question), as purely audio (radio, tape, compact disc, or MP3 file), or even as
a template for spin-off performances (audio, visual, or audiovisual remixes, live
dance performances, song medleys, etc.).[37] As audio alone, one hears *"main chalii
main chalii"* as a duet between the singing-star sisters Lata Mangeshkar and Asha
Bhosle, but out of a synchresis with the image in the film sequence, the duet
between the sisters becomes a dialogue between Bindu and not just one other
friend, but a whole entourage of friends.[38]

Lata's high-pitched voice, associated with a virginal, girlish innocence, is cru-
cial for not just underscoring but for developing the naiveté of Bindu's character.
Furthermore, Lata's well-known dominance as the older sister and as a shrewd
monopolizer of opportunities for women playback singers enhances Bindu's posi-
tion as the leader of her entourage, marking her as the heroine of the film. The
fact that Asha's voice—associated with a more playful, flirtatious, and even vamp-
ish femininity—sings playback for all of Bindu's friends is a means of rendering
all the friends as completely generic, subordinate to Bindu in their importance,

and collectively less naïve than Bindu as they all playfully caution her, in Asha's singing voice, to beware the dangers of falling in love. The inexperienced, hopelessly romantic Bindu, however, desires nothing more.

Bhola's uncle, to whom Bindu's photo is presented by the matchmaker, clandestinely wishes to pursue a marital alliance with this attractive young woman, due to having fought with his wife, from whom he is separated. Even before the audience sees Bindu, she is an object of the uncle's lustful desires and contemplations, and the mise-en-scène of the uncle sitting and gazing at the photo right before the cutaway to the song sequence featuring Bindu atop her bicycle replicates the caricatured image of the brahmin gazing at pin-up-style photos of bikini-clad women in the photography credit. Preceding Laura Mulvey's breakthrough 1978 feminist-psychoanalytic critique of Hollywood narrative cinema's complicity in upholding the regime of a patriarchal male gaze that objectifies feminine figures, *Padosan* overtly invokes and plays on the operation of such a gaze not only by caricaturing its workings in the credit sequence and again through the figure of the older uncle but also through the motif of the window. The construction of Bindu as the primary, passive object of this gaze proceeds through the characterization of Bindu as an extremely naïve, immature girl, despite the more mature, full-figured appearance of Saira Banu, the actress cast as Bindu. Yet, this unequal and exploitative set of gendered looking relations is eventually complicated by the film's imagination of the cinematic apparatus as a *two-way* audiovisual device in addition to Bindu's active role in being knowingly and repeatedly manipulated by its seductions.

As the orphaned simpleton-hero Bhola (literally "innocent one") happens upon the scene of his uncle talking with the matchmaker to the uncle's embarrassment, the disgusted nephew angrily chastises his uncle for the inappropriateness his pursuit, reprimanding him for being a married man and lusting after another woman, and such a young girl at that. Bhola storms out with his belongings, intending to seek out and take the side of his dear aunt, the estranged wife of his erstwhile guardian, who has revealed himself to be but a dirty old uncle. Unknown to Bhola, Bindu, the very girl in the photo presented by the matchmaker to his uncle, occupies an upstairs room in the house adjacent that of his aunt. Bhola moves into the upstairs room in his aunt's house, and it turns out that his window faces that of the *padosan*, or girl next door. Predictably, Bhola falls in love with Bindu, but rather than experiencing love at first sight through the window, it is love at first sound. Although Bhola was smitten earlier in a chance encounter with Bindu at the end of the bicycle sequence, Bhola does not yet know that the very same girl lives next door, and he is this time charmed not by seeing her again in the window but by overhearing her sing as the second song-picturization sequence commences: "*bhaii battuur bhaii battuur ab jaayenge kitnii duur*" (Dear friend, how far away will we go now?).

Bhola's innocence as an enraptured, blind spectator listening only to Bindu's song is juxtaposed with the erotic gaze of not only his uncle but also the audience,

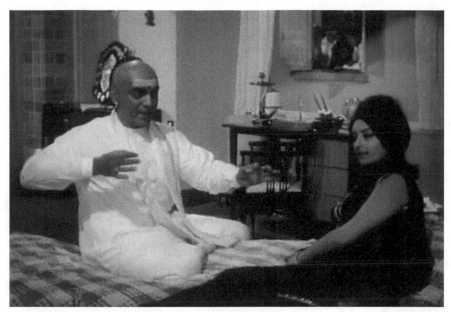

CLIP 7. *"aao aao saanvariyaa"* song sequence from *Padosan* (1968).

To watch this video, scan the QR code with your mobile device or visit
DOI: https://doi.org/10.1525/luminos.130.7

as the camera intrudes into Bindu's room and reveals the curvy actress noncha-
lantly taking a bubble bath, drying off, changing clothes, and prancing around
the room as she sings in the voice of Lata Mangeshkar. As Neepa Majumdar has
argued, Lata Mangeshkar's star persona and crystalline playback voice that came
to embody an idealized essence of pure Indian womanhood works to (at least rhe-
torically) neutralize sexualized visual representations of femininity, especially in
lieu of the singer's public image of a desexualized woman clad in white sari, which
has more recently taken on matronly overtones.[39] As an acousmatic figure, the star
playback singer persists as not only an aural presence but as an auratic presence
that contributes to a synchresis whereby her idealized voice and its host of associa-
tions takes on an effect of transcendence and deeply influences the overall effect of
an audiovisual sequence.[40]

In an inversely gendered version of the bathtub sequence, Bhola and his four
pals who form the Pancharatna Natak Mandal crouch by the window as they hope
to catch a glimpse of Bindu, though they (and the audience) are caught off guard
by the sudden entrance of Master Pillai, a clumsy South Indian teacher of classical
music and dance who has an obvious interest in Bindu. Upon Bindu's request for a
song, he sings to her suggestively and lecherously, prancing around the room and
singing *"aao aao saanvariyaa"* (Come, come, my beloved; clip 7) in the voice of
Manna Dey. As a result of the acousmatic presence of the playback singer, two very

different effects subsist simultaneously: on one hand, the audiovisual sequence is comedic, and on the other, the song itself is highly sentimental and deeply romantic.

The song to which Master Pillai appears to sing and dance is reminiscent of a *thumrii*, which became especially popular in the eighteenth century as a form of romantic North Indian sung poetry in which the poetic voice was typically that of a woman, often a woman who has been pining for her beloved.[41] In some thumris, this woman is aligned with the figure of Radha, the fervent lover of the Hindu deity Krishna, and while it is not uncommon for men to perform thumri compositions, and even less uncommon for men to have written thumri compositions, the form is popularly known for being within the repertoire of *tawaifs*, or courtesans who performed in eighteenth-century salons, most famously in the North Indian city of Lucknow. The erotic, feminine associations of the thumri form are activated and rendered queer by Master Pillai's expressive dance, reminiscent of the *mujraa* dance performances of the tawaif-courtesan, and Master Pillai's performance shocks Bhola, Guru, the rest of the Pancharatna Natak Mandal, and to some degree the audience—who may have instead expected a sequence that reprised the earlier bathtub one—as all are spying from Bhola's window into Bindu's, only to be presented with the spectacle of a ridiculous Master Pillai, instead of Bindu, singing about love and dancing around the room.[42]

Known for his extremely pliable, smooth voice and some degree of formal training in styles of Indian classical music, Manna Dey has been lauded for his rendition of "*aao aao saanvariyaan,*" perceived as a beautiful, heartfelt, even virtuoso performance that has precipitated more contemporary nostalgic reactions, such as the following:

> This is by far the toughest song from the film. . . . Though it did not become so famous, I can bet on the number of singers who can actually sing this as flawlessly as the great Manna De [*sic*] did.

Or:

> So beautiful, so innocent.[43]

The above are comments made by YouTube users on an upload of the "*aao aao saanvariyaa*" sequence, as is the following one, which confesses:

> I always feel so bad for poor Masterji at the end of this movie :-([44]

As an acousmatic figure, Manna Dey infuses Mehmood's campy performance with an authoritative sincerity that contributes to the empathy that the character of Master Pillai generates, even though he is the rival of the hero Bhola as a suitor also vying for Bindu. This pathos becomes more trenchant through the material contexts that underlie Mehmood's (and several of his characters') marginality.

Mehmood was marked by the excess of a comedian, by which he could never emerge as a convincingly ideal, romantic hero onscreen, despite his superstardom as a comedian. He was also marked by the excess of his outsider status as a Muslim

South Indian, whose dark skin and ostensible ugliness and sexual undesirability are pejoratively referenced in the climactic "*ek chatur naar*" song sequence in *Padosan* and throughout the 1971 film *Main Sunder Hoon*. In both films, Mehmood's characters makes overtures toward heroines who do not return their affections, and their overtures are as uncomfortable as the extent to which Mehmood's (characters') bodily excess precludes the romantic fulfillment that remains the privilege of men and women whose idealized bodies, social locations, and locations in hierarchies of stardom allow them to exist onscreen as icons of romance. *Humjoli* additionally shows—even if not critically enough—the undue burden borne by women with non-idealized bodies. The heroine's mother is ironically named Rupa, which means "beautiful." The daughter of a rich family, Rupa is abandoned by her groom at their wedding because she is considered ugly, as her dark skin is naturalized to unattractiveness. The character who becomes the villain steps forward to charitably marry her, only to plot her murder after she gives birth to a daughter, inherit her wealth, and go on to marry his sweetheart.

When Master Pillai makes his dramatic entrance in *Padosan*, Bhola retreats from the window and seeks the counsel of Guru, who never seems to realize that he is offstage as he theatrically plays the role of an all-knowing seer. Guru parses out the situation to the group, declaiming that it most certainly cannot be Master Pillai's looks that have caught Bindu's attention, and therefore it can only be Master Pillai's artistic faculties. Guru advises that Bhola learn music in order to impress Bindu, and Bhola tries, only to fail miserably. Ironically, while Bhola, Guru, and the rest of the Pancharatna Natak Mandal regard Master Pillai as a grave threat, it is clear to the audience that Bindu only flirts with Master Pillai because she knows that Bhola and his friends (along with the audience) are trying to watch her from Bhola's window, and she wants to teach them a lesson.

Further dejected by his failed attempt at singing, Bhola and the rest of the group hang their heads as Guru paces the room. A radio plays in the background, and the voice of renowned playback singer Mohammed Rafi croons, "*aanchal men sajaa lenaa kaliyaan*" (Adorn the drape with tender buds), the refrain of a song from the film *Phir Wohi Dil Laya Hoon* (I have brought the same heart once again; Nasir Hussein, 1963). Guru is suddenly struck with a plan, which he explains, tries out, and excitedly reiterates to Bhola with the phrase "*aavaaz merii, shakl terii!*" (My voice, your face!) Inspired by the cinematic convention of playback song recording, Guru develops a ruse, and he and Bhola practice by singing and lip-syncing, respectively, to the even older film song from the film *Ratan* (Gem; M. Sadiq, 1944), "*jaanevaale baalamvaa lautke aa lautke aa lautke aa*" (My departing lover, turn around and come back, turn around and come back, turn around and come back).

Directly referring to earlier film songs as well as the star playback singer Mohammed Rafi as the collective source of inspiration for Guru's plan, *Padosan's* direct engagement with the convention of playback is unmistakable in the ruse

that Guru comes up with. Guru thus recruits the resources of popular Hindi cinema and film songs for a project of romance with his characteristic over-the-top, theatrical panache. Dramatizing the endeavor to help Bhola woo Bindu and defeat Master Pillai (even though Master Pillai does not actually pose much of a threat), the members of the Pancharatna Natak Mandal execute an inane but highly entertaining scheme that arises in the first place out of their inability to behold—or for that matter *want* to behold—a world that exists apart from the idioms and situations of the theatre. The extent to which they are enveloped by the theatre and its fictional world parodies the world of popular Hindi cinema that is dearly loved by its most dedicated cinephiles, where and for whom everything is stylized performance: performances of romance, performances of song (including performances by playback), performances of comedy, and performances of even death, as *Padosan* later shows.[45] The reflexive motif of performance in *Padosan* is especially layered around Kishore Kumar, a film actor who plays the leader of a theatre company within the film, who doubly sings playback for several songs in *Padosan* as well as singing playback for Bhola within the diegesis as the character Guru, and who is in turn inspired to do so by the playback singer Mohammed Rafi, whose song from another film plays on a radio within this one.

However, it is emphatically not the isolated practice of playback singing that is the butt of the film's farcical parody or its argument. As noted earlier, following All India Radio's brief unwillingness to broadcast Hindi film songs, film music—like romance—became a representative object in debates over the cultural value of popular cinema.[46] *Padosan* uses the ruse of playback within the diegesis as a means of validating the endeavor of Hindi popular cinema itself. As the equation of playback with the film industry is drawn out in *Padosan* through the Pancharatna Natak Mandal's playback ruse for impressing Bindu, the Pancharatna Natak Mandal is further aligned with the popular Hindi film industry. The theatre troupe has already been shown in various scenes of *Padosan* to be referring to, rehearsing, or performing lovably bad versions of the Persian Laila-Majnun romance and Hindu parables and epics, which have been popular subjects for several earlier popular Hindi films.[47] In addition, Guru is perhaps inspired by William Shakespeare's play *The Taming of the Shrew* when he insists that Bhola must ignore, insult, and even slap Bindu in order to tame her feisty demeanor into one that will exude tender affection. The heterogeneity of texts and influences that the Pancharatna Natak Mandal draws upon and inadvertently parodies as a result of maintaining little regard for their formal or classical integrity is a well-known attribute of the Bombay industry in terms of histories of influence as well as labor.[48] Additionally, Hindi cinema's primary preoccupation with romance is also shared by the Pancharatna Natak Mandal.

The low-brow Pancharatna Natak Mandal has further resonances with the film industry in being of questionable repute and in being depicted as teeming with amateurs who pour in from all sorts of places, which is similar to the manner in

which the film industry is depicted by *Padosan*'s opening credits. The members of the Pancharatna Natak Mandal not only confuse different plays even while they are acting in them but are also much more interested in Bhola's love life than they are disciplined or focused on their professional pursuits. They are shown in one scene to grandly and shamelessly walk offstage in the middle of a performance in front of a packed hall as soon as the equally uninhibited Bhola runs onstage and poorly improvises some dialogue in order to give his actor-friends an update regarding Bindu.

Aside from Guru, the three other members of the Pancharatna Natak Mandal carry names that identify them squarely as representatives of the cities and regions from which they hail. These names are Benarasi, Calcuttiya, and Lahori, Benares being a Hindu pilgrimage city in the heartland of Hindi-speaking North India; Calcutta, the capital of West Bengal in the Bengali-speaking eastern region of the subcontinent; and Lahore, the capital of Punjab in what was then West Pakistan. Far from being random, each of these regions and the linguistic, religious, and even national communities with which they are associated are well-known origins for several film-industry figures who immigrated to Bombay, some as refugees during the violent 1947 Partition of India and Pakistan, when two wings on either side of the subcontinent became the Punjabi/Urdu-language-dominated West Pakistan and the Bengali-speaking East Pakistan (present-day Bangladesh).[49]

The figure of the "Madrasi," an often pejorative generic term for a person not necessarily from the city of Madras but from the southern regions of the subcontinent, is conspicuously absent in the Pancharatna Natak Mandal's microcosm of the pan-South-Asian makeup of the Hindi popular film industry of Bombay, a city that has been synonymous with cosmopolitanism. But the "Madrasi" is present in *Padosan*—as none other than Master Pillai, played by the comic superstar Mehmood, who was himself of South Indian heritage and had been working in a string of Madras-produced Hindi films at the time of *Padosan*'s production and release.[50] Recognizable both as a second-generation insider to the popular Hindi film industry and as a distinctly comic star of South Indian heritage, Mehmood/Master Pillai is similarly recognizable in *Padosan* as one who is simultaneously inside the film as well as the Pancharatna Natak Mandal, even as a rival/antagonist. The latter is largely a conceit, since Master Pillai's character is endearing in his sincerity and in fact poses no actual competition to Bhola for Bindu's affections.

After Guru devises the cinematic playback-inspired scheme for helping Bhola one-up Master Pillai and win Bindu, the plan is soon put into action. Bhola is positioned in the window that faces Bindu's, as Guru and the other members of the Pancharatna Natak Mandal conceal themselves in corners of the room that Bindu will not be able to see (fig. 31). Kishore Kumar/Guru sings while Sunil Dutt/Bhola lip-syncs the not-so-subtle opening lines of the next song, "*mere saamanevaalii*

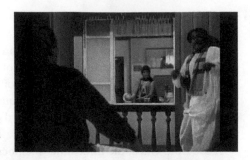

FIGURE 31. Still from *Padosan* (1968):
The window as a two-way audiovisual
apparatus that both reveals and conceals.

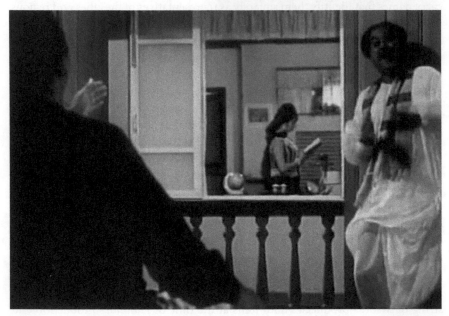

CLIP 8. "*mere saamanevaalii khidkii*" song sequence from *Padosan* (1968).

To watch this video, scan the QR code with your mobile device or visit
DOI: https://doi.org/10.1525/luminos.130.8

khidkii men ik chaand kaa tukdaa rehtaa hai" (In the window opposite mine lives
one as dear as a piece of the moon) (clip 8). As anticipated, Bindu is drawn by the
singing and comes to the window that once again offers the chance to look, listen,
laugh, and fall in love—depending on where one is positioned in relation to it.

The window, like the photos held by the brahmin in the credit sequence and the
uncle in the beginning of the film, is initially a device by which the pleasurable,
erotic image of a feminine figure is offered as an object for the presumably het-
eropatriarchal gaze of the voyeur-spectator. But unlike the photo, the window,
like cinema, additionally affords an opportunity not only to witness a variety of

moving visual spectacles but also to hear a variety of *sounds* that ensue forth. The window both reveals and conceals, like the technology of film that takes us into Bindu's chamber and reveals her to be in the nude as she is bathing, though the mise-en-scène (the bathtub, bubbles, towel, etc.) and the frame together orchestrate the withholding of a fully nude view.[51] As Bhola closes his eyes during this sequence while Bindu's/Lata's voice floats through the window and puts him in a reverie, Bhola is shown as absolutely and utterly *bholaa*, or innocent, in the same way that Bindu is innocently unaware that she is being watched as she sings in the bathtub and dances around her room after getting out.

When Bhola takes his friends from the Pancharatna Natak Mandal to spy on Bindu through the window so that they can see the woman with whom he has fallen in love, they are presented with a very different sight than the one they expected. Instead of the group fully becoming, like the brahmin in the credits or the uncle at the beginning of the film, lustful male voyeurs who seek pleasure in the erotic image of a feminine figure, their plan to spy on Bindu through in the window is thwarted when she notices them looking at her and purposefully incites a song-and-dance performance by Master Pillai instead, who then becomes the spectacle put on display for the (dis)pleasure of the aghast onlookers. Yet even this displeasure is a conceit. Comedic sequences constitute *Padosan's* primary attractions and sites of spectatorial pleasure, as they defamiliarize dominant —and dominant presumptions of gendered—looking relations and modes of spectatorial pleasure.

Guru quickly catches onto the potential for romance afforded by this concealing-revealing two-way window of audiovisual spectacle, and he aims to make the most of it. Under the direction of Guru, Bhola soon becomes an exhibitionist, a performer who desires to not only be seen and desired but also be heard. Like the filmmaker who understands the apparatus within which a series of images and sounds can captivate the spectator, Guru, the head of the film-industry-microcosm that is the Pancharatna Natak Mandal, is shown to take full advantage of the apparatus of the window by using it to conceal himself as an out-of-frame playback singer while Bhola is spectacularly and magically "revealed" as flawlessly and passionately singing to Bindu. As the window in *Padosan* becomes an endlessly reflecting mirror of itself within a technological apparatus of cinema, all trickery on both sides is rhetorically vouchsafed by the impassioned sincerity of the romance that it ultimately engenders.

The tight association of popular film and romance in terms of the particular way in which romance is stylized and performed in Hindi cinema, as well as the cinephilic romance that emerges through the spectator's impassioned reciprocity, is parodied in a sequence that soon follows as Bhola expresses doubts as to whether it is right for him to win Bindu over by letting her think he is singing to her, essentially deceiving her because he does not actually possess the ability to sing that well. Guru convinces Bhola that his worries are irrelevant and that once Bindu falls

in love with him, she will be so overcome by tenderness that she will forgive and forget the deception by which he initially courted her. Guru confidently imitates the way that he foresees Bindu acting toward Bhola once she falls in love with him, and Guru sings to Bhola, punning on his name and role-playing as if Bindu, "*mere bhole balam, mere pyare balam*" (My innocent/Bhola beloved, my dear beloved).[52]

This brief song sequence continues as Guru sings to Bhola in the manner in which he believes that Bindu will herself do in no time, and Guru's song awkwardly crams together several commonplace expressions of love. What emerges is a humorous string of clichés of romantic Hindustani poetry, parodying its cloying sentiments and florid styles as Guru spouts his own version in such a relentlessly repetitive manner that the love lyric disintegrates into doggerel. The occasional conspicuous insertion of highly Sanskritized words—the word *bhaashaa* (language), for example, in the phrase *nainon kii bhaashaa* (language of the eyes)—sounds extremely awkward and out place in expressions of romance that derive not from Sanskritic idioms or literary forms but from Urdu and colloquial Hindustani forms. Like the scenes in which different theatrical forms and epic narratives are jumbled together or confused by the actors of Pancharatna Natak Mandal, here the Sanskritization of familiar Hindustani idioms renders them obnoxious, as the ardor of their romantic content cools off into series of tepid banalities whose overall effect is comical.

The images and motifs of Hindustani love poetry in "*mere bhole balam*" have been repeatedly deployed in countless popular Hindi film songs, often crafted without any strict adherence to standardized conventions of the classical literary and musical forms that they build on. As Guru, Benarasi, Calcuttiya, and Lahori sing and dance around Bhola, Benarasi plucks an *ektaaraa*, a small single-string, single-note lute associated with wandering folk minstrels. The twanging of the single-string ektaaraa works as a comic repetitive sound effect, like the "wah-wah-wah" effects used in cartoons, and with the ektaaraa sound woven into Guru's boisterous singing and dancing that elicits the participation of the rest of the Pancharatna Natak Mandal, this fifth song sequence effectively and humorously parodies the monotony of the romantic clichés that often appear in popular Hindi film songs.

Bhola is enchanted as Guru sings, apparently fantasizing that Bindu will indeed sing to him so, to the extent that Bhola begins to worry over how he will respond. Guru chuckles, assuring Bhola that when one is in love, one's responses emerge spontaneously and melodiously—just like in the movies! Guru suggests that Bhola could begin by calling out his beloved's name, and he demonstrates by passionately summoning, "Anuradha!" Quickly, Guru is reminded by Benarasi that the name of Bhola's neighbor and love interest is not Anuradha but Bindu. Not too perturbed, Guru simply replaces the former name with the latter and goes on to sing out Bhola's hypothetical response in a "spontaneous"—yet clearly formulaic—melodic verse. Just as Guru punned earlier on "Bhola" and "innocent," he puns on the name

"Look, very soon you'll see -"

CLIP 9. *"merii pyaarii bindu"* song sequence from *Padosan* (1968).

To watch this video, scan the QR code with your mobile device or visit
DOI: https://doi.org/10.1525/luminos.130.9

"Bindu" as "bindi," a mark that adorns a woman's forehead and is often, particularly in the case of a married woman, vermillion in color. Guru's lyrics yield further parodic nonsense: *"merii pyaarii binduu, merii bholii rii binduu, merii maatherii binduu, merii sinduurii binduu, merii binduurii binduu . . ."* (My lovely Bindu, my innocent Bindu, my forehead-y Bindu, my vermillion Bindu, my bindi-like Bindu . . .) (clip 9).

The originality of the *"mere bhole balam"* sequence lies paradoxically in its unoriginality that makes it a parodic prototype of the popular romantic Hindi film song. By exaggeratedly showing the omnipresent romantic film song to have been reproduced to the point of meaninglessness, *"mere bhole balam"*—as yet another one—indicates the compulsion to still continue witnessing, repeating, and performing these songs as sincere expressions of love.[53] What Guru presents to Bhola as a song that is spontaneous and passionate could not be further from the truth. Clearly, it is something we have already seen and heard before in the form of numerous other film songs—and yet at the same time, Guru's song is somehow original, creative, entertaining, and catchy.

Presenting itself as a collective hyper-cliché of love songs found in popular Hindi films, *"mere bhole balam"* sings out in praise of commercially produced film songs like itself, which are beloved because of, rather than despite, their formulaic

qualities, as their ostensible non-specificity yields an infinite degree of iterability. Rather than positing commercially produced forms as utterly devoid of content, however, *Padosan* posits them as constituting valuable raw materials for their range of expressive possibilities and functions. It is not just one film after another but one lover after another who is urged by these repetitions to continue to repeat and believe in the free-floating, endlessly proliferating form(ula) of love in popular Hindi cinema, apparently unmoored from any authentic origin as it thrives in a world external to any single text, whose address encompasses lovers within the films, lovers outside the films, and most especially, the cinephilic lovers *of* the films who keep coming back with their eyes and ears wide open.

The climactic sequence of the film *Padosan* is undeniably that of the song "*ik chatur naar*," itself based on a version that was originally sung by Kishore Kumar's older brother Ashok Kumar for the 1941 film *Jhoola* (Swing; Gyan Mukherjee). The "*ik chatur naar*" sequence features a singing battle between Master Pillai and Bhola/Guru that stages the triumph of the playback (and implicitly cinematic) duo over the classically trained music and dance teacher. Bindu enjoins Master Pillai, who visits her home to instruct her in music and dance, to teach Bhola a lesson and put him in his place, complaining that Bhola has been harassing her through his window, which faces her own. Bindu's pride has been wounded because Bhola sweetly "sang" the song "*mere saamanevaalii khidkii men*" to her earlier, only to rudely pull down his blinds (upon Guru's insistence) as soon as Bindu appeared to show some interest in him. Unlike Guru, Master Pillai is unable to intuitively grasp either the situation or the proper way of making the most out of the facing windows by, for example, purposely using them to intimidate Bhola. When Bindu indicates to Master Pillai that Bhola is watching them from his window, instead of immediately picking up on her hint and sensing that Bhola is a threat, Master Pillai goes over and begins greeting Bhola in a warm, friendly manner. Bindu has to stop him and spell out that she is upset over the arrogance with which Bhola has displayed his musical talents from his window.

Finally, Master Pillai understands that he must regard Bhola as a threat, and on the spot, a singing competition ensues as the two face off through their windows (clip 10). Master Pillai marshals the resources of his classical training in music, dance, and drama, praising the beauty and intelligence of a woman—Bindu—in highly reverential, Sanskritized Hindi to which he, in the voice of playback singer Manna Dey, also adds displays of improvisational virtuosity in classical South Indian Carnatic–style *aalaap, konnakol,* and *svaraa,* which are, respectively, free-form melodic phrases, vocalized poetic compositions of percussive syllables, and rhythmic improvisions of solfege that require an understanding of *raaga,* or melodic frame, as well as *taala,* or beat cycle. Master Pillai further includes *nritta,* a portion of pure dance that occurs within performances of South Indian classical

CLIP 10. "*ik chatur naar*" song sequence from *Padosan* (1968).

To watch this video, scan the QR code with your mobile device or visit
DOI: https://doi.org/10.1525/luminos.130.10

dance styles like *bharatanaatyam*, which involves stamping the feet and displaying hand gestures in a virtuoso show of dexterity.

Hidden away, Guru has the task of singing back to Master Pillai as he sings playback for Bhola in a *savaal-javaab* (question-and-answer) form that occurs as a competition at the level of the film and emerges simultaneously as a *jugalbandii*, or musical duet, featuring the playback singers Manna Dey and Kishore Kumar. In contrast to Master Pillai, Guru sings in language that is much more colloquial, and he also sings of a woman—again, Bindu—as clever, although Guru means it insultingly as he describes her getting caught in her own trap, compares Master Pillai's dark countenance and singing to that of an ugly, annoying crow, likens Bindu's grace as a dancer to that of a hobbling mare, and sarcastically proclaims Master Pillai to be her perfect romantic complement, given his expertise in classical dance. Guru responds to Master Pillai's displays of virtuosity with gibberish and yodeling, and by suddenly changing the raga and key in the middle of the song,[54] Guru throws off Master Pillai. Such abrupt changes in either the raga or the key, especially, are rarely tolerated in standardized forms of Indian classical music; it is the adherence to such rules, in fact, that sets these forms apart from semiclassical or so-called lighter styles of music. At one point during the singing duel, Master Pillai, despite the fact that he is being insulted, becomes so rapt by Guru's singing

that without even realizing what he doing, Master Pillai starts to visibly enjoy his opponent's song, closing his eyes and rocking and swaying to the beat until a very irritated Bindu elbows him to stop immediately.

In the end, Guru and Bhola triumph as Master Pillai's voice eventually cracks, not only foreshadowing a victory for Bhola in his pursuit of Bindu but also upholding the creative enterprise of playback and the apparently organic, creative, and much less formalized structure of film songs with which playback is associated, in contrast to the classical forms offered by Master Pillai, which are shown to be less pleasurable, less flexible, and less spontaneous—and yet indispensable to the overall pleasure of the viewer. In this sense, the competition between Guru/Bhola and Master Pillai is much less a showdown between a North Indian versus South Indian character than it is an exaggeratedly polemical juxtaposition of classical and film music. The former may seem to be the case when, for example, Guru insults Master Pillai's dark complexion as an undesirable trait, which resonates with prejudices against darker skin and generalized stereotypes of South Indians as being of darker complexions than their North Indian counterparts. However, given the equation of Guru/Bhola with the convention of playback and the self-consciousness with which *Padosan* parodies itself as coming out of an illegitimate, inauthentic, and amateur film industry (akin to the diegetic Pancharatna Natak Mandal) that exploits a technological apparatus that in turn enables pleasures of looking, listening, and romancing (akin to the diegetic window), the "*ik chatur naar*" sequence also becomes engaged in *Padosan*'s ultimate endeavor of validating itself as a stylized spectacular, cinematic performance. The convention of playback becomes metonymic, both within and without the diegesis, for the commercial cinema's excesses of "romance, comedy, and somewhat jazzy music."

Manna Dey's singing playback for Master Pillai in *Padosan* would have been recognized as a parody of Carnatic or classical music rather than an authentic sign of the same.[55] Furthermore, Master Pillai holds a harmonium, an instrument typically used in folk, semiclassical, and North Indian and Hindustani styles of classical music and less immediately associated with Carnatic styles of classical music. Guru also uses a harmonium, and he is accompanied by the other members of the Pancharatna Natak Mandal, who do not play instruments commonly used in systems of classical music, but play rudimentary, makeshift instruments that are either like the ektaaraa played earlier or fashioned out of simple household objects whose apparent sounds emerge as audio effects that came to mark R. D. Burman's film songs made of eclectic and highly percussive sounds. While standardized forms of North Indian/Hindustani and South Indian/Carnatic styles of classical music each have distinctive, recognizable styles of *aalaap, bol,* and other improvisational forms, Master Pillai's apparently South Indian/Carnatic classical expertise is counterposed not to North Indian/Hindustani classical styles but to Guru's nonsensical gibberish, his abrupt change in the raga and key, and his yodeling, which was also a hallmark of Kishore Kumar's style of playback signing—all of

which were as rare in both Carnatic and Hindustani systems of classical music as they were common in contemporaneous film songs.

The seductive pleasure to be found in film songs is upheld not only by Master Pillai's defeat but also by his unwitting, demonstrative enjoyment of his opponent's singing as well as the fact that an enraged Bindu loudly turns up a radio after Master Pillai has lost in order to tune him out. The radio plays and gives way to a jazzy instrumental leitmotif that surfaces throughout *Padosan*, and Master Pillai is oblivious to Bindu's intentions to spurn him as he naively praises her excitedly for coming up with the great idea of turning on the radio. The song competition forms the climax of the film, though it is not the climax of the diegetic narrative—here, the layers of *Padosan* separate into the narrative of suitors contending for Bindu, which is largely secondary to its farcical drama of spoofing and validating its own endeavor as film that is loveable despite its undisciplined mishmash of influences and participants. As mentioned earlier, the former drama of Bhola and Master Pillai competing for Bindu is largely precipitated by the Pancharatna Natak Mandal's initial perception of Master Pillai as a threat. He then actually becomes a rival only because Bindu wishes to spite Bhola after Guru, à la *The Taming of the Shrew*, ludicrously insists that Bhola show some arrogance toward his neighbor. Guru insists that this arrogance will stoke Bindu's desire and redirect the feisty behavior she displays toward him.

In fact, the next two songs are sentimental numbers that feature the eventual blissful budding romance of Bindu singing to Bhola and then Bhola singing to Bindu, as Guru predicted and previewed earlier, and these songs do not constitute either the resolution or the most memorable song sequences of the film. Instead, the last two romantic songs only reprise the defeat of classical forms by cinematic modes of performance in the "*ik chatur naar*" competition sequence, as *Padosan*'s self-parody circumscribes the narrative of the couple's union within a metatext that reveals *Padosan* to be an instance of the romance-cum-farce that is cinema. Through parody, *Padosan* illustrates popular cinema as a paradox. Despite all that popular films, here under the sign of film songs rendered via playback, seemingly lack in terms of finesse, sophistication, plausibility, authenticity, discipline, and originality, people still fall head over heels for them, over and over and over again.

For example, "*mere bhole balam*" lays bare the clichés of film songs and even has a line in which Guru pretends, as Bindu, to sing to Bhola, "*tere qadamon men meraa pyaar, meraa sansaar, merii qismat hai mujhe apnaa banaa le*" (My love, my world, and my fate are at your feet, make me yours). A later sequence in which Bindu actually sings to Bhola is not at all campy in any overt way, but its sentiments are expressed in terms that are strikingly similar to that which was just parodied in the earlier sequence, with the latter song actually echoing the very cliché of the feminine lover placing herself at her beloved's feet as the opening lines confess, "*sharam aatii hai magar aaj ye kahanaa hogaa, ab humen aap ke qadamon*

hii men rahanaa hogaa" (I feel coy, yet I feel I must say that all I want now is to remain at your feet).

In both this song as well as the final one, *"kahanaa hai . . . aaj ye tumse pehlii baar, tum hii to laaii ho jiivan men meraa pyaar pyaar pyaar"* (I have to say this to you today, for the first time, you have brought love love love into my life), in which Bhola is again assisted by Guru to sing back to Bindu, emphasis is placed on the respective phrases *"kahanaa hogaa"* and *"kahanaa hai."* These are different conjugations of the same verb phrase denoting a compulsion on the part of the poet/singer/speaker to *say* something. Yet the authority of what the speaker/ actor merely says or speaks is not enough in matters of intense emotion—namely, those connected with love. As a result, the playback singer is recruited, entering as an acousmatic character whose voice emerges for its spectator-listener within the diegesis as a one that, for the spectator beyond the diegesis, appears to transcend both the diegesis as well as the world outside of it.

During the last song, one of Bindu's friends recognizes the voice of Guru, and she whispers her suspicions. As Bhola/Guru continue singing to the other friends who have assembled in Bindu's window to witness her lover-neighbor sing to her on her birthday, Bindu and her friend quietly slink away, enter the house next door, and come up the stairs behind Bhola and Guru to catch them red-handed in their playback-inspired ruse. Guru even continues singing for some time before he turns around and sees the girls angrily staring at him. The window as a revealing-concealing audiovisual apparatus has been dismantled, its illusion destroyed. Incensed that Bhola has deceived her, Bindu spitefully resolves that she will marry Master Pillai. While this may constitute the climax for the narrative of the couple's union, which has just been jeopardized, it occurs only in the last few minutes of the film as part of the series of moments that reprise the *"ik chatur naar"* duel that I hold as the climax of the film as whole, which I have tracked along *Padosan's* primary ekphrastic register, where the duel occurs as an instance of popular cinema's triumphant public solicitation of the hearts belonging to its vast audiences.

In these last moments of the film, Guru once again comes to the rescue—with yet another ruse. He has Bhola lie down on his bed with a noose thrown around his neck, and as the wedding of Bindu and Master Pillai commences, Guru and the rest of the Pancharatna Natak Mandal enact a dramatic performance of bereavement in front of Bindu, telling her that Bhola has committed suicide and martyred himself in the name of his unrequited love for her. As Bindu wails that she only wanted to teach Bhola a lesson and does in fact love him, Guru tells Bindu that there is yet the hope if she is pure of heart, like the mythological Savitri, who wrangled her husband's life from Yama, the lord of death. Guru thunderously proclaims that like the legendary Savitri, Bindu, too, may be able to defeat the god of death and breathe life back into Bhola, should she confess her love and agree to marry him instead of Master Pillai. Also saddened by Bhola's "death," Master Pillai in fact urges Bindu onward, and surely, Bindu's confession miraculously "resurrects"

Bhola, who then takes Master Pillai's place as Bindu's bridegroom. The last shot shows Bhola and Bindu enjoined in the Hindu wedding ritual of taking steps around a fire, and in a corner of the foreground, a shehnai—an instrument that has become synonymous with South Asian weddings—is being played by Master Pillai, who has tears streaming down his face.

Like the spectators who repeatedly fall for the illusion with which they are presented, Bindu once again falls for the Pancharatna Natak Mandal's theatrics—this time, its staging of Bhola's death—despite having just discovered that Guru and company have collectively deceived her in helping Bhola sing to her from his window in a voice that was not his own. Juxtaposed with a film like *Singin' in the Rain* (Stanley Donen, 1952), *Padosan* has no investment in finally synchronizing faces to their respective voices and paying out the ideological dividends of this unity through a coinciding narrative resolution.[56] Rather than upholding an ethic of honesty in straightforward, realist storytelling, *Padosan* celebrates the excess and duplicity of cinema as epitomized by the convention of playback, validating an ethic of technologically mediated love that affords repetitious audiovisual pleasures that proliferate despite their crude appearances, inciting an honest, cinephilic affair that endures despite the spectator's awareness of the fraudulent nature of popular cinema's seductions.

As a film that is exemplary in the reflexivity of its presentation and parody, *Padosan* offers an opportunity to contextualize the primacy of the film song as an autonomously circulating form as well as an object that became metonymic for the industry from which it emerged amid highly public debates over the cultural value of the popular cinema industry that congealed most explicitly in the 1950s around the positions taken by AIR toward film songs. The centrality of the song picturization sequence to Hindi cinema becomes an opportunity to re-evaluate classical film theory's overwhelming concerns with the image as an erotic object that can work with cinema's technological apparatus toward the consolidation a patriarchal gaze. While Christian Metz crucially located the semiotic paradox of "offscreen sound" in the fact that no sound actually emanates from the onscreen image but nonetheless seems to do so as an effect of synchronized sound, *Padosan* makes an interesting theoretical proposition in its manner of depicting facing windows as a mutually constitutive, two-way *audio*visual cinematic apparatus that solicits its intended spectators of various genders, who may or may not respond in a predictable manner.

If one regards *Padosan* as an argument, then one is presented with a thesis that collapses the endeavor of popular Hindi cinema into its cumulative diegetic excess of romance that repeatedly ensnares its viewing-listening spectators through their consenting—if unpredictable—willingness to be captured by cinema's blatant trickery, epitomized by the paradoxically straightforward duplicity of imbuing a

lip-syncing face with the voice that emanates from the elsewhere that is the invisibly conspicuous playback star. An other to the diegesis, the playback singer's voice implodes the self-containment of the film, which emerges not just as a specific unified audiovisual object whose erotic delights absorb the spectator into contemplation, but as an overt performance whose spectacularly technologized pleasures of "romance, comedy, and somewhat jazzy music" constitute repeating, reproducible formulae that recognize themselves as such across iterations that also serve as a templates for subsequent iterations.

Playback practices lay bare the technological construction of the audiovisual object in its most heightened, conspicuous moments of song sequences, which were both denigrated and revered as excess. Reflexivity was thus embedded both technologically and discursively in popular Hindi cinema not as a result of a set of purely aesthetic preferences leaning toward what one might term "postmodern," but as a result of the industry's historical position of illegitimacy as a cultural form vis-à-vis not only Hollywood but also, over the 1960s, the institutionalization of an auterist world cinema and a state-sponsored discourse that sought a properly modern, authentically national cinema. Amid this polemic, the competition that is staged between implicitly cinematic and classical musical forms in *Padosan* takes a position that validates the film song as a representative object that speaks for the ethics of popular cinema in the sincerity of its belovedness.

Padosan thus evidences the degree to which song sequences in popular Hindi cinema were charged not only by their own audiovisual spectacular effects and affects, but also by their historical contexts, their promiscuous blending of disparate musical styles, their foregrounding of performance and technology, and their thematic preoccupation with romance and seduction by which they became both iterations of formulae as well as templates for further repetitions. In their proliferation, songs emerge as aural and textual objects that circulate independently from any given film as a whole at the same time that they become representative of their film sources as well as the affective and material excess of commercial cinema's reach in their ubiquity across public and private spaces. *Padosan* depicts and defends the twin cumulative romances that ensue out of the affective relationships structuring the production, narration, and collective spectatorship of popular films on the grounds of their sincerity, as they are collapsed into one another to render the cinephile and the cinema as yet another modern iteration of the classical figures of the lover and beloved who have been allegorically invoked by countless song lyrics in countless moments of romantic song sequences.

The concerns that ensue out of a reading of *Padosan* engage larger debates over film and commercial media, beginning with the classic, hotly debated question of what degree of spectatorial agency may or may not be afforded by profit-oriented mass media industries, the stakes of which reside in whether popular cinema holds the potential for understanding and critiquing its contexts and for imagining and creating less oppressive and increasingly egalitarian social formations.

Walter Benjamin's oft-cited meditation on this question in what has come to be known as his "Artwork Essay" has remained powerful and influential, its hallmark being the intense ambivalence with which Benjamin forecasts the future trajectory of cinema, which he identifies as an art form that is tied to the historical moment of modernity at the level of its medium specificity as a mechanized, reproducible form, for better and for worse.[57]

Writing in the wake of Nazism's rise, Benjamin is poignantly aware of the fascist ends to which cinema has been and may once again be recruited, but he also holds out hope in cinema's potential to liberate the masses from authoritarian power structures. For Benjamin, this hope is warranted by the fact that such an art form, characterized by mechanical reproducibility, has already marked a radical epistemological shift. Arising out of modern technologies of reproduction, cinema, according to Benjamin, has the capacity to reinvigorate the consciousness of the masses by having displaced the elitist aura of uniqueness, individuality, and originality that, in an earlier era, held art objects as transcendent—as above and apart from their social formations. As an art object, cinema thus reintegrates itself into social formations by virtue of its status as a mechanized medium that is inextricably intertwined in its modern historical contexts.

Theodor Adorno and Max Horkeimer, fellow intellectuals of the Frankfurt School, were much less forgiving in their equally renowned indictment of commercial media, especially in relation to Hollywood, as a "culture industry" whose pleasures lulled the masses into a stupor of complacency that in turn enabled their exploitation by lurking dominant capitalist interests.[58] The saturation of media formations by commercial corporate interests has only intensified in an era of late-capitalist globalization, as transnational media conglomerates continue to consolidate their reach over increasingly vast audiences.

In a comprehensive monograph that treats the genre of the American film musical, however, Rick Altman argues for the degree of agency afforded to the spectator precisely through cultures of interactivity and participation around popular media.[59] Toward the end of *The American Film Musical*, Altman directly engages Adorno and Horkeimer's critique of the culture industry, particularly with respect to the stance of condemnation they take toward popular music, which they hold to be utterly unsophisticated and vapid. Adorno and Horkeimer instead laud the alternatives of highly atonal or dissonant music, which in their view productively stimulates the listener to begin intellectualizing and questioning the very category and nature of music itself.

Altman, however, defends the simplicity of popular music, especially that which was composed for film musicals during their heyday, arguing that this apparent simplicity was not a result of flawed construction but the result of the creative labor undertaken by composers to write songs through which audiences could easily sing along and actively participate.[60] By noting that sheet music would sell out instantly on the heels of a successful film musical's release and that piano sales

remained extremely high during the same period despite the economic depression of the 1930s, Altman argues that the simplicity and popularity of songs from American film musicals poised spectators to become active performers and musicians who would continue to sing, play, and perform their own renditions of the numbers that they witnessed in the space of the theatre. For Altman, the problem with unfamiliar, complex musical forms like those exalted by Adorno and Horkeimer is that in the end, large numbers of people do not have the means of (re)producing such forms and are then left in the very position of the passive spectator-listener-consumer that Adorno and Horkeimer abhor.[61]

Altman's argument, in this sense, suggests that the form of popular (film) music, in its invitation for repetition and repurposing, can transfer the agency of its field of ideological meaning from the text itself to the listener-viewer, who can repurpose it for a number of creative and expressive possibilities. To what end, however? If the capacity for world-making is embedded in this propensity for popular media forms to invite active modes of engagement and meaning-making on the part of its listener-viewers, as important would be the question of the content—that is, the politics—of its ensuing practices.[62] This is especially evident in a digital era, as participation as an end in itself can just as easily yield nefarious consolidations of violently chauvinistic, majoritarian collectivities.

Padosan's staging of the ethical *ends* to which popular forms of music are put is thus a key part of its argument, wherein love—particularly as cinephilia—is invoked as both the driver of its production and the outcome of its expressive capacity. On the one hand, the film defamiliarizes the workings of a heteropatriarchal, upper-caste gaze—and its aural equivalent—through its play with the apparatus of the window in a way that perhaps most provocatively suggests that such a *gaze/listening position* itself is an excess, rather than its conventionally feminine object. In addition, while the Panchatantra Natak Mandal goes to clearly absurd ends to manipulate Bindu into falling in love with Bhola, the suggestion by the end of the film is that she is a consenting party to its ongoing (cinematic) manipulation, owing to the sincerity of the enterprise on *both* sides of the apparatus.

On the other hand, the formation of the romantic couple (heterosexual, middle-class, upper-caste, Hindu) in *Padosan*, amounts to yet another cliché among the rest that it bares. To an extent, this is parodied from the outset of the film, as Bhola reads an orthodox Hindu text that prescriptively outlines the four stages of a man's life. He is suddenly hit with the realization that, having reached the age of twenty-five, he is supposed to get married. However, the film's construction of its idealized couple is less self-aware in, for example, its naturalization of Bindu's transformation from a flirtatious—if naïve—young girl, to a paragon of an ideal, wifely, sari-clad Indian woman. Additionally, in one of the few serious moments of the film, Bhola is beaten up by a gang of visibly Muslim men paid off by Master Pillai, which naturalizes aggression to "bad" Muslims in constructions of Muslim minority figures through binaries of good versus bad, of nonviolent versus violent

and of, eventually, secular versus religious.[63] Mehmood, who was known for playing characters with the Hindu name Mahesh across multiple films, explicitly avowed his Gandhian commitments and his status as a peace-loving "good" Muslim.[64]

Cinephilia, conceived as an impassioned practice of reading through viewing and listening, cannot preclude trenchant critiques and rejections of deeply problematic representational regimes and hierarchies of power. In *Padosan's* two-way—though not necessarily equally distributed—audiovisual apparatus, the capacity for spectators to actively respond is the thing that accords cinema its value and vitality. The pathos elicited by the closing image, as the ostensibly ugly South Indian Mehmood-as-Master-Pillai plays the shehnai and cries in the foreground, is one that mourns the limits of the possible. For even the most imaginatively escapist world of cinema can never unmoor itself from the material hierarchies of the world from which it springs. At best, a two-way apparatus allows for the possibility that the two worlds can, indeed, transform one another through unrelenting practices of *savaal-javaab*, or "question-and-answer."

Titled "More Noisy Than Comic," N. C. Sippy's short 1969 review of *Padosan* criticizes the film for its low production values, crude humor, and noise: "*Padosan* is a musical farce which strains all its resources to create humour. Unfortunately, the resources appear to be meagre, the strain shows and the humour is mostly of a crude and noisy kind." Curiously, the author goes on to admit several positive aspects of the film, even as he seems compelled to reiterate the poor quality of the film as a foregone conclusion:

> Some of the most successful comic moments are provided by Kishore Kumar. Sunil Dutt makes a game, even if often embarrassing, try at playing clown. Saira Banu looks fairly lively. Mahmood, quite entertaining now and then, doesn't offer anything really fresh.
>
> Composer Rahul Dev Burman offers a couple of catchy songs.[65]

Despite admissions of the film's moments of playful and lively acting, comedic success, and catchy songs, the review's lede comes down on *Padosan* as "noisy" film. Here, noisiness does not refer to actual sound but instead connotes an unspecified offending excess that emanates from the film's low production values, low-quality humor, and lack of "anything really fresh" in Mehmood's performance.

Quite often, critics who were writing for contemporaneous English-language periodicals allow that Mehmood's comedies were highly entertaining. Yet, in the same breath, they seem compelled to dismiss Mehmood and his films in consistently general terms: as noisy, obscene, vulgar, unwholesome, and unoriginal, with very little specificity. Sippy's review emphasizes *Padosan's* low production values, from which he seems to automatically derive the film's low quality overall. While the term *noisy* can evoke a disembodied, unpleasurable, aural excess, it also operates—as

in the case of Sippy's review—as a pejorative metaphor for other excesses that are uncritically naturalized to devalued entities, whether specific kinds of films or specific kinds of bodies. In *Padosan*, the small-town romance itself—even if sidelined by the comedic farce in *Padosan*—invokes a distinctly urban issue of unwanted sounds and of the propensity of sounds to transgress thresholds of the public and private. This theme in *Padosan* surfaces in the contemporaneous 1970 film *Dastak* (Rajinder Singh Bedi), and together, the films point to a polemical discourse of noise—and a statist discourse of noise pollution—as intimately tied to problems and possibilities of excess, modernity, and sexuality.

Much more recently, a 2005 judgment of the Supreme Court of India sought to establish nationwide rules for curbing noise pollution. The judgment occurred in response to a pro bono publico petition by a citizen, Anil K. Mittal. As recounted in the opening statements of the judgment, Mittal was moved to file a petition by the rape of a thirteen-year-old girl in Delhi, whose cries for help "sunk and went unheard due to blaring noise of music over loudspeaker in the neighborhood," after which the girl immolated herself and died. The judgment's recounting of this tragic rape vilifies "noise polluters" as the assailants and the "blaring noise of music over loudspeaker" as their weapon before going on to note that their other hapless victims include students who are unable to study.[66] That a tragic instance of violent sexual assault precipitated the Supreme Court's recent ruling on noise pollution raises the historical inextricability of noise regulation, on the one hand, from patriarchal state control, modern technologies, and gendered violence, on the other. By thematizing the propensity for sound—and for cinema, through its songs—to breach gendered thresholds of the public and private, both *Padosan* and *Dastak* intuitively grasp the transgressive potential of popular cinema, in challenging the heteropatriarchal organization of its world with the mere suggestion of nonconjugal, nonreproductive feminine sexuality and its pursuit of pleasure.

In revisiting M. Madhava Prasad's keen analysis of *Dastak* in his groundbreaking *Ideology of the Hindi Film: A Historical Construction*, I want to tug at an important thread in Prasad's reading of *Dastak*, with an ear toward further unraveling the tremendous potential for ongoing analyses of aurality and sound in the historiography of cinema and modernity. Prasad's reading of *Dastak*, a film released within two years of *Padosan*, situates the film in a historical discussion of middle-class cinema, whose major ideological project was that of constituting the modern nuclear family unit within a realist domain of conjugality. For the middle-class cinema that emerged alongside the establishment of the state-funded Film Finance Corporation in 1960, the problem of popular cinema was the public woman who was readily available onscreen as an erotic object for the spectator's gaze in exchange for the price of a ticket. Prasad notes:

> As such the task that the film-makers undertook was not a confrontation with the
> popular cinema but an education of their audience in narrative form which could

retain its integrity while absorbing the libidinal excess of the polymorphous popular film text. From the contracted voyeurism of the popular film text (and the brothel), the middle-class cinema turned its audience towards a "realist" voyeurism in which sexuality occurred in the depths of screen space, as an attribute of subjectivity.[67]

Indeed, the central narrative and formal tensions in *Dastak* revolve around the neighborhood's expectation that Salma, a newlywed who moves with her husband Hamid into a modest Bombay flat that happens to be in a red-light district, is a prostitute whose sexuality is on offer to any customer who is willing to pay. The camerawork, as well as the density and porosity of urban spaces, allows passersby within the diegesis—and spectators without—to readily intrude into the private domain of the couple as voyeurs and prospective clients, regarding Salma as a public woman even after they come to know better. Hamid and Salma's attempt to establish their middle-class respectability in a red-light district unfolds as an allegory of the middle-class cinema's attempt to establish its respectability in a popular medium associated with the raucous libidinal excess of entertainment, spectacle, and sensual pleasure. As Prasad notes, the constraints on the middle-class aspirations of the young couple in *Dastak*, whose private intimacies are threatened by the gaze of omnipresent voyeurs—including the spectators—are intensified by their marginalized Muslim minority status in a predominantly Hindu milieu.[68]

While *Dastak* has since emerged as a quintessential film in discussions of middle-class cinema, the Indian New Wave, the Hindi film genre of the Muslim social, and the recurrent archetypal dichotomy of the virgin/whore in films from the 1950s and 1960s, *Dastak*, like *Padosan*, invites analyses that attend to sound as a fundamental motif, texture, and problem of urban modernity.[69] For in *Dastak* it is the knock at the door, among other unexpected sounds of urban dwelling, that poses the most severe and uncontrollable threat to the privacy of the couple. The film's title itself, which means "knock," highlights the series of ongoing intrusions by strangers who come to the apartment and assume that Salma is, or is like, the woman who had previously occupied it and conducted her business of entertaining men as an artist and sex worker in the tradition of the courtesan-tawaif.[70]

Prasad's analysis of *Dastak* highlights the voyeuristic gaze that is produced by the film's camerawork and then redirected by its middle-class, realist narrative as a libidinal excess (of popular cinema). Yet, the uninvited intrusions that violate the couple's conjugal domain are patently and thoroughly sonic, as much as—if not even more than—they are scopophilic. While similarly constituting the window as a threshold between the public and private, *Padosan* instead defends popular cinema's audiovisual and libidinal excess precisely for breaching this threshold to engender love-as-cinephilia within a domain of consent and reciprocity between the spectator and cinema. This divergence notwithstanding, the two films ensue from a 1960s context of crises that propelled their deeply reflexive considerations of cinematic form and pleasure in ethical terms, energized by Cold War–era imperatives of cultural diplomacy through cinema, the proliferation of state institutions

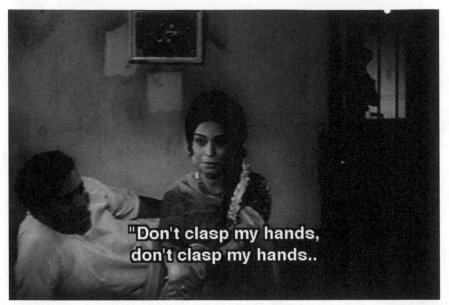

CLIP 11. *"baiyaan na dharo"* song sequence from *Dastak* (1970).

To watch this video, scan the QR code with your mobile device or visit
DOI: https://doi.org/10.1525/luminos.130.11

that sought to modernize Indian cinema, and the emergence of a grassroots film society movement.

The very first diegetic song sequence in *Dastak*, *"baiyaan na dharo,"* juxtaposes simultaneous expressive performances of feminine desire across a virgin/whore dichotomy (clip 11). The faint background strains of the same lyrical composition, an offscreen sound, float into Hamid and Salma's apartment from without. Salma's recognition of the composition as one that she knows in a different melody motivates her own performance of the song for her husband. Belonging to the musical genre of the thumri, the song is coy and suggestive.[71] The initial faint offscreen voice is throaty and low pitched, and the spectator recognizes that it very likely belongs to a sex-worker-cum-entertainer who is singing for her clients, given that the apartment is in a red-light district. Salma's naïveté is apparent in the fact that she does not pick up on this, and her rendition proceeds in the recognizably high-pitched, saccharine falsetto of star playback singer Lata Mangeshkar, which came to be naturalized to an idealized, virginal femininity.[72] While Salma is expressing her romantic and sexual feelings for her husband, sideways pans and cuts reveal that she, like Bindu in *Padosan'*s bathtub sequence, has an audience of which she is unaware. In *Dastak*, the spectator is aligned with the men in the neighborhood, who perk up at the sound of her voice and approach her window aroused not merely as voyeurs but, more specifically, as eavesdroppers.

This opening song sequence thus characterizes the difference between the vamp and the virgin as a matter of the bodies, vocal textures, address, and spatial context for their expressions of sexual desire, rather than as a difference in the genre of the expressions themselves. In *Dastak* this becomes, in turn, a reflexive allegory for the presence of songs in a cinema that is addressed to a middle-class spectator. The implicit ideological argument is that the difference between the clatter of a vulgar popular cinema—which *Padosan* goes to great lengths to celebrate and defend— and the tunefulness of a middle-class cinema does not lie in the films' opposi- tional aesthetics per se—for example, in the presence or absence or even divergent genres of songs. Rather, the distinction lies in whether the songs emanate from a domain of propriety and respectability, which circumscribes expressions of feminine sexuality and desire within the private space of conjugality. Directed by Rajinder Singh Bedi, an Urdu writer and member of the Progressive Writer's Association, *Dastak* is infused by an anti-commercial, writerly orientation that rhetorically eschews the gratuitousness of raw audiovisual spectacle epitomized by the libidinal excess of feminine sexuality.

It is in the policing of the boundary between music and noise—of what sounds, from which bodies, and from where are acceptable and pleasing—that the ideological desires of a middle-class cinema overlapped rhetorically with the ideo- logical workings of a patriarchal state. In *Dastak* Hamid is utterly ineffective in blocking the sonic excess—the knocks, for one thing—that continually penetrate the private space of his marital home. Despite the couple's resolve to maintain that Salma's sexuality is not available to the public, Salma is betrayed by the window— that is, the porosity of her private space, which can neither contain her desires nor protect her from desirous others in a (cinematic) world where solicitations and sexual advances are expressed either as music, if properly middle class and respectable, or as noise, if it is in excess of middle-class propriety (fig. 32).

When Salma sings desirously to her husband, her voice, unbeknownst to her, is audible to eavesdroppers. Her entertainment's public availability—even if inadvertently—is interpreted as proof that she is available as a woman of the night. The sounds that in turn enter Hamid and Salma's apartment as unwanted noise—knocks on the door, audible brawls, and the songs of the sex workers who entertain their clients in the red-light district—make Salma perpetually anxious about her sexual desires for her husband. Hamid becomes enraged by his inability to prevent the breaching of boundaries by these various sounds, despite mandat- ing that Salma stay within the confines of the apartment, in the same way that he gifts her a bird and insists that it must not be freed from its cage for its own good.

As Hamid's frustrations come to a head, it is amid the cacophony of the crowd's aural intrusion into the couple's intimate space that Hamid forces himself on Salma in an act of marital rape. Although Salma is newly wedded, the shy couple has not yet consummated their marriage. Halfway through the film, after having gotten into a brawl with neighbors who yet again assume that Salma is available as a sex worker, Hamid seethes with anger and insists that he must have Salma himself

FIGURE 32. Still from *Dastak* (1970):
Here, too, the window is a two-way
audiovisual apparatus that both reveals
and conceals.

before she is snatched away and enjoyed by another man. Whereas *Padosan* embraces a literal window of opportunity for consensual seduction, Hamid's act of aggression is driven by his inability to control the sounds that flout the boundaries between the private, intimate space that he shares with his wife and the space of the public bazaar outside. As the marital rape unfolds fully within the confines of the apartment, the audible tide of a roaring crowd below surges up as an offscreen sound into the frame of the couple's private space. This is the only sound besides the dialogue between Hamid and Salma as he rapes her. In this way, noise—as unwanted sonic intrusions and leaks—becomes a central motif in both *Padosan* and *Dastak* for sexual exchanges that spill over the boundaries of middle-class propriety. The *lakshmana rekhaa*, or mythic patriarchal barrier within which the honor of a married woman is impervious to violation so long as she stays within its demarcation, is apparently not soundproof.

Discourses of noise in South Asia arise as a problem of modernity specifically because of sounds' abilities to flagrantly violate the spatial and social autonomy of the public and private, whose gendered binary has been central to dominant articulations of a national modernity.[73] *Dastak* thus dramatizes noise as a conflict between the modern urban organization of middle-class families into atomized units, on the one hand, and the population density and limited availability of affordable private housing in urban centers, which forces strangers to live in cramped quarters and close proximity, on the other.[74] Noise from without crosses the bounded, private arena of the modern couple and nuclear family unit—an arena that is spatially depicted in *Dastak* and other films as that of the middle-class urban apartment, which *Padosan* strongly invokes even in its small-town set(ting). In turn, noise becomes an issue that is inextricable from sexual politics of modernity in South Asia, insofar as the heteropatriarchal control of sexuality has continued to define boundaries of caste, communal identity, and class.

The issue of noise—and characterization of noise as a pollutant, moreover—highlights the conflict between the preservation of sociospatial boundaries of (sexual) purity that scaffold the modern lives of caste, communal identity, and class, on the one hand, and the demand for affordable urban housing that forces proximity to strangers and the omnipresent risk of (sexual) contact that threatens the

patriarchal control of women's sexuality, on the other. Historical and contemporary policies concerning noise pollution, among other environmental issues, have seemed neutral in the rational voice of the state, as it insists on taking action in the name of public good. *Dastak* highlights the segmentation of a listening public into bodies that carry gender, class, caste, and communal identities. The comforts of certain (e.g., upper-middle-class and upper-caste) bodies are differentially and systematically prioritized by a patriarchal statist discourse, just as the propensity of certain bodies (working-class, Dalit, Muslim) to engage in the production of pollution of various kinds is much more frequently assumed.

As the discourse of noise pollution has resurfaced in contemporary India, so, too, have the exclusionary politics that often belie complaints of noise. For example, a controversy spiraled out from a 2007 tweet by Hindi playback singer Sonu Nigam in which he complained, "God bless everyone. I have to be woken up by the Azaan [Islamic call to prayer] in the morning. When will this forced religiousness end in India."[75] Several ordinary citizens, politicians, and Bollywood stars weighed in with various positions, some asking why Nigam chose to single out the azaan when "forced religiousness" emanated just as much from Hindu temples and festivals such as Ganesh Chaturti, Diwali, and Navaratri, among a host of industrial disturbances.[76] Indeed, a follow-up judgment by the Supreme Court regarding noise pollution was issued in October 2005, three months after the initial judgment, which addressed this (communal) elephant in the room: a specifically Indian (if not South Asian) debate over the constitutionality of noise pollution policies that potentially curbed free expression and, more particularly, the free (public) expression of (private) religion. Fascinatingly, the follow-up Supreme Court judgment turned to an editorial published by the "Speaking Tree," a pop-spirituality column in the *Times of India*. The judgment quotes the editorial at length, in order to advance an argument about the inauthenticity of loudspeakers in religious traditions:

> Wait a minute. There were no loudspeakers in the old days. When different civilisations developed or adopted different faiths or when holy books were written to guide devotees, they did not mention the use of loudspeakers as being vital to spread religious devotion. So the use of loudspeakers cannot be a must for performing any religious act. Some argue that every religion asks its followers to spread its teachings and the loudspeaker is a modern instrument that helps to do this more effectively. They cannot be more wrong. No religion ever says to force the unwilling to listen to expressions of religious beliefs.[77]

The judgment goes on to reproduce the remainder of the editorial, which selectively quotes passages from the Bhagavad Gita, Qur'an, and Bible to argue that Hinduism, Islam, and Christianity all advise against preaching to those who are unwilling to listen and that loudspeakers are entirely irrelevant to these religious traditions due to their nonexistence when each of the three faiths were established. In averring, "In our opinion [the quoted "Speaking Tree" editorial] very correctly

states the factual position as to the objective of several religions and their underlying logic," the Supreme Court judgment thus exerts its own authority not only as an interpreter of religious texts (via the "Speaking Tree" no less) but also in promoting a conservative position that assumes the establishment of pure, monolithic traditions of world religions that become corrupted with any historical change.[78] I point this out not to argue against the regulation of noise pollution per se but to push the point that the discourse over noise and noise pollution in India—parallel to the politics of noise abatement elsewhere—has been deeply enmeshed with the normalization of problematic discourses and structures of gender, class, caste, and religion, to the extent that they appear apolitical and merely factual.[79]

Just one year before the famous attempt to ban film songs on All India Radio, the erstwhile Indian state of Madhya Bharat passed a Control of Music and Noise Act in 1951. In the same vein as the older version, the redrawn and renamed Indian state of Madhya Pradesh passed its *kolahal niyantran adhiniyam* (Noise Control Act) in 1985, which offers a series of definitions that include the following for loud music, noise, and soft music:

(a) "loud music" means sound produced on or from band, bag pipe, clarionet, shahnai, drum, bugle, dhole, daf, dafda, nagara, tasha or jhanj and includes any loud sound produced by any other instrument or means. . . .

(c) "noise" means sound from any source whatsoever of such character as causes or is likely to cause mental or physical discomfort to a man of ordinary sensibility or susceptibility or causes or is likely to cause disturbance in the study. . . .

(f) "soft music" means sound produced on or from any of the following instruments, namely:

 (i) sitar, sarangi, ektara, violin, bansi, dilrubam, bin, veena, sarod, jaltarang;

 (ii) piano, harmoniyam, gramophone, tabla, khanjari, dholak and mridang;

 (iii) transistor, record-player, stereo or radio in so far as musical programmes only are concerned.[80]

A number of things are striking about these definitions enshrined as law. For starters, the instruments that produce "loud music" and are thereby imbued with the propensity to create noise are all associated with folk and brass band (i.e., nonclassical, nonelite) forms. By objective standards, for example, the daf (which supposedly produces loud music) and the khanjari (which supposedly produces soft music) are similar tambourinelike instruments. A major difference, completely unrelated to volume, is that the khanjari, also known as the kanjira, has been standardized as an instrument in South Indian classical music and dance performance. This, perhaps, merits its inclusion alongside the mridang or mridangam, a barrel drum used for the same purpose. In this way, the post-independence state enshrined notions of propriety that privileged classical forms of expression that came to be associated with upper-class, upper-caste practices as authentic and inoffensive.[81] *Padosan* shrewdly participates in this music/noise polemic by

exaggerating and ultimately rejecting this very hierarchy of bodies, instruments and styles: brahmin versus folk actor, harmonium versus rudimentary household objects, and classical versus film music.

When cast as an object of statist and social control, noise can emerge by default as an unbelonging, threatening outsider—a pollutant, an uncontrolled excess, a hazard. Even when noise is characterized as disembodied, atmospheric, and alien, however, it often remains intimately tied to the bodies that are systemically and violently implicated as similarly unbelonging. Comedy's woeful neglect across the volumes of scholarly writing on Hindi cinema is, perhaps, a symptom of the extent to which comedy's historical status as a "low" form has persisted, alongside its assumed vacuity as mere noisy entertainment. Although *Padosan*, a hugely popular hit comedy, and *Dastak*, a canonical film of the Indian New Wave, may seem to be an odd couple for analysis, their connections are in fact organic, beyond their mere contemporaneity.

As the pages of publication like *Film World* suggest, the 1960s were marked by imperatives to not only produce good cinema but also make use of cinema's potential for doing good in the world. What either of these ambitions looked like—good cinema, on the one hand, and doing good in the world, on the other— was no straightforward matter. An array of films enthusiastically converged over this question even if they diverged in their answers, with *Padosan* and *Dastak* as cases in point. *Film World*, through its orientation that was at once international and intranational, had sought to bring together a fractured world of the "jet age" through cinema's commensurate potential for scale. As the Madras industry continued to produce Hindi films through this period of volatility, it sought new avenues for distribution. Emerging from this ambition, the 1972 India-Iran coproduction *Subah-O-Sham/Homa-ye Sa'adat* came to fruition as a Madras- and Tehran-backed joint venture that was released in both Hindi and Persian.

Subah-O-Sham/Homa-ye Sa'adat's Indian leads include South Indian dancer-actress Waheeda Rehman and *Dastak* lead Sanjeev Kumar, who were by then established as figures of the Bombay industry. The heroine of *Subah-O-Sham/Homa-ye Sa'adat* is a trafficked Indian singer-dancer in Iran played by Waheeda Rehman, who becomes metonymic for the unregulated overseas circulation of Indian films of questionable quality. *Subah-O-Sham/Homa-ye Sa'adat* reflexively engages and defends not only the libidinal excess of feminine sexuality in song-dance films but also the material excess of their circulation through unregulated channels of informal and clandestine distribution. *Subah-O-Sham/Homa-ye Sa'adat* recuperates the value of popular cinema amid disillusionment with not only state-driven internationalisms, but also the nation-state itself. As I detail in the next chapter, the material contexts and ethical stakes of the long 1960s culminate in the film's ekphrastic vision of a fraternal postnational world constituted through love-as-cinephilia as an ethical horizon of the popular.

5

Foreign Exchanges

Transregional Trafficking through Subah-O-Sham *(1972)*

The 1967 Hindi film *Ram Aur Shyam* (Ram and Shyam), a comedy of errors that stars Dilip Kumar in a double role, was a production of the Madras-based Vijaya Vauhini Studios under B. Nagi Reddy and Chakrapani. The film was a remake of the 1965 Tamil film *Enga Veettu Pillai* (Son of our house), which was in turn a remake of the 1964 Telugu film *Ramudu Bheemudu* (Ram and Bheem). In a tour-de-force of mistaken identities, reigning stars N. T. Rama Rao and M. G. Ramachandran headlined the double role of separated twins in the Telugu and Tamil versions, respectively. The Telugu version was the maiden venture of the Hyderabad-based Suresh Productions, and the films marked major successes for the young filmmaker Tapi Chanakya, who directed all three. Among Chanakya's first films was the 1955 film *Rojulu Marayi* (The days have changed), in which Waheeda Rehman, who would go on to become a major star in the Bombay industry, made her screen debut as a dancer. Rehman, a classically trained dancer who hailed from an Urdu-speaking Deccani (South Indian) Muslim background, was first cast in Hindi films by filmmaker Guru Dutt, which launched her career in the Bombay industry in the mid-1950s. Over the 1960s, she remained a leading star of Hindi cinema. Rehman's hits in this period included the aforementioned *Ram Aur Shyam*, a Madras-produced Hindi remake of a Tamil remake of a Telugu remake. All three versions were directed by Chanakya, in whose earlier Telugu film Rehman had made her screen debut as a dancer twelve years prior.

Such an account only scratches the surface of cross-industry networks of production and labor—in their most visible instances of circulating stars and directors—between media capitals both within India, and as a wider phenomenon of the global 1960s. The 1972 film *Subah-O-Sham* (From dawn to dusk), whose Persian title is *Homa-ye Sa'adat* (Bird of happiness), seems an exceptional instance of

a high-profile international coproduction via Bombay. The film was released in both Hindi and Persian versions, and it features by-then Hindi film star Waheeda Rehman in a transnational love story opposite Persian film star Fardeen, with Hindi film star Sanjeev Kumar playing Fardeen's brother. Indeed, there was no other India-Iran coproduction to speak of during this period. Yet, the ostensibly exceptional joint venture of *Subah-O-Sham/Homa-ye Sa'adat* was nonetheless beholden to other continuities, including the contemporaneity of other joint ventures that emerged from ambitions in both India and Iran to engage the world through cinema.[1] Emerging as yet another drop in a steady trickle of transnational prestige productions, *Subah-O-Sham/Homa-ye Sa'adat* also ensued from a wave of Madras-produced Hindi films. Written by B. Radhakrishna, the film was coproduced by the Madras-based Shree Ganesh Prasad Movies and Tehran-based Ariana Studios. It was directed by Chankaya—the director in whose 1955 Telugu film Waheeda Rehman had made her debut and in whose Hindi film *Ram Aur Shyam* she had starred as Hindi film star Dilip Kumar's love interest.

In *Ram Aur Shyam*, Dilip Kumar plays a double role of long-lost twins who happen to cross paths and end up switching their identities.[2] One twin is a painfully shy heir to the fortune of a wealthy household who meekly suffers the villainy of his avaricious brother-in-law, and the other twin is a charismatically outgoing and mischievous country boy who has grown up under the care of an adoptive mother in a village. While Waheeda Rehman is cast as a wealthy, educated young woman who is the love interest of one twin, actress Mumtaz plays the role of a village belle who is the love interest of the other twin. The film marked a huge break for Mumtaz, brokered by comic star Mehmood's insistence that Dilip Kumar cast her in the film. Kumar's published autobiography details the calculations that gave tremendous decision-making power to a leading hero when it came to casting a heroine:

> [Producer] Nagi Reddy was all admiration for Saira [Banu] and her recent performances and was certain that her pairing with me in the comedy situations would be a huge draw since she possessed a wonderful flair for spirited comedy. Since it was my practice to take an active interest in the making of my film, I voiced my opinion that I did not agree with Nagi Reddy on this issue because I felt she was too delicate and innocent in appearance for a character that had to have loads of seductive appeal and a bold, buxom appearance. At the same time, Mehmood Ali, the famous comedian, was persistent that for this role we should cast vivacious Mumtaz, his co-star in many of his and wrestler Dara Singh's movies. He was so sincere in his recommendation of her that he even carried tins of film reels depicting Mumtaz to exhibit how talented she was. Mumtaz eventually bagged that role.[3]

The same publication features musings by others about Dilip Kumar, and it includes a recollection of this casting decision from Mumtaz's perspective. She

offers a glimpse into the hierarchies of bodies and labor that were attached to hierarchies of production values and market values of A versus B versus C films and to notions of quality. Mumtaz recalls:

> I owe my rise in Bollywood as a star and an actress of consequence to Dilip Sahab. At the time when comedian Mehmood suggested my name to Dilip Sahab for a role in *Ram Aur Shyam* (released in 1967), I was mostly working in films starring the famous wrestler Dara Singh, apart from Mehmood himself. The Dara Singh films came under the "C" category in commercial terminology. As a result some heroes who were nowhere near Dilip Sahab in stature were refusing to work with me. . . . It was in such a scenario that Mehmood took tins of reels of a film starring me with him to Madras to show Dilip Sahab who was looking for a heroine to play the rustic character opposite the character Ram. It was very good of Mehmood to take the trouble because he and I were a good successful team and, in normal circumstances, no actor would like to break a successful team and go all out to recommend his heroine to a superstar and pave the way for her rise. . . . Just imagine the scenario. An actress who has faced the humiliation of being rejected by a few A-list lead actors is picked by the legendary thespian Dilip Kumar to star opposite him. It made sensational news. I remain eternally indebted to Dilip Sahab for changing the course of my career. Overnight, after the announcement of the casting appeared in the media, I was in great demand.[4]

In Mumtaz's description, stardom unfolds as embodied, speculative quality that directly impacts the valuation of both the star and the film. It is a category of labor that the star internalizes as a sense of personhood, as the star is slotted into tiered categories of films. Both Kumar's and Mumtaz's anecdotes emphasize the power of men in industry hierarchies in a casting decision that was fully negotiated between men (the producer, the leading star, the comic star–friend), with the leading hero having final say.

The above anecdotes set the stage for a tail end of a long 1960s period that had teemed with world-making aspirations through cross-industry, multilingual film projects that espoused explicit commitments to collaboration and exchange, alongside attempts to make use of both extant and new channels of distribution. Hierarchies of business remained interlaced with deeply personal networks, and men—whether stars, producers, or distributors—often reigned over decision making through their speculative assessments of value and risk. While *Subah-O-Sham/Homa-ye Sa'adat* presents itself as an India-Iran coproduction, an account of the film solely through its dual nationality not only flattens the involvement of Madras, Bombay, and Tehran as three networked media capitals but also obscures the film's endeavor as a global-popular rather than state-driven practice of world-making. Neither the actress Mumtaz nor the comic actor Mehmood were part of *Subah-O-Sham/Homa-ye Sa'adat*. Yet, their own backgrounds recall material histories of business, travel, and commodity circuits across South and West Asia, which contextualize the India-Iran coproduction *Subah-O-Sham/Homa-ye Sa'adat*

in networks that predated the emergence of and did not necessarily go on to align with the ambitions of their respective modern nation-states.

Like several others who ended up in the Bombay film industry, neither Mumtaz nor Mehmood's families were native to Bombay.[5] Mumtaz hailed from an ethnically Afghan family in Mahshad, Iran, and her father was a dry fruits vendor who traveled to Bombay for business, where Mumtaz grew up with her mother following her parents' divorce when she was an infant.[6] Mehmood hailed from a South Indian nawabi (princely) background. When his father was an infant, the family left for Mecca by sea, for the dual purposes of pilgrimage and job-seeking.[7] In 1920, just a few years after their arrival, a storm hit Mecca and left some members of the family dead and the others bereft of means. Mehmood's aunt, suddenly a teenage widow, boarded a ship for Bombay with her brother, Mumtaz Ali.[8] As a child wandering around Bombay, young Ali happened to befriend B. G. Horniman, the British editor of the *Bombay Chronicle*. Ali eventually formed a theatre company, and one day, Horniman introduced him to Himanshu Rai, who had established the famed Bombay Talkies film studio with his wife, Devika Rani. Ali eventually joined Bombay Talkies studio as a dancer in the early 1930s.

Accounts of both Mumtaz's and Mehmood's arrivals in Bombay emphasize histories of trade, empire, and routes of pilgrimage across South and West Asia and an Indian Ocean world in which the port city of Bombay constituted a key node of travel and commerce. *Subah-O-Sham/Homa-ye Saʿadat* stands out as a unique cross-industry collaboration that nonetheless emerged from extant, robust networks of transregional travel and commerce, which included thriving informal practices of film distribution. Where the 1957 *Pardesi/Khozhdenie Za Tri Morya*, as discussed in chapter 3, paints travel and trade as the domain of men who, like its hero Afanasy, move across the world while women remain rooted in the home and nation, *Subah-O-Sham/Homa-ye Saʿadat* spotlights an uprooted and ultimately re-rooted heroine who moves as an exploited object within illicit circuits of trafficking. *Subah-O-Sham/Homa-ye Saʿadat*'s milieu of seedy networks of exploitation allegorically invokes the contemporaneous context of Indian films' informal circulation in Iran and the Middle East, more generally, as referred to, for example, in a 1963 Indian state agency's lament in a trade journal that "third-rate [Indian] films are imported at cheap prices and exhibited in the Iranian market."[9]

Subah-O-Sham/Homa-ye Saʿadat reflexively extols "foreign exchanges" not only through commercial film production but also through commercial film distribution. The film forwards an ethical vision of popular cinema as a medium of world-making through a distinction between economies of greed and solidarities of love. The figure of Waheeda Rehman's character Shirin, a trafficked Indian singer-dancer in Iran, becomes metonymic for the trafficked object of the Indian song-dance

film. The film reflexively defends the value of even ostensibly low-quality, "cheap" films in their potential to transcend their circumstances and engender a postnational, fraternal world borne of love/cinephilia rather than marriage/transaction. *Subah-O-Sham/Homa-ye Sa'adat* conflates the libidinal excess of song-dance films with the libidinal excess of feminine sexuality in order to argue the (re)productive potential of both as a means of world-making through love/cinephilia.

While Shirin, as a fallen woman, becomes metonymic for the trafficked film object, *Subah-O-Sham/Homa-ye Sa'adat* does not place the burden of reform entirely on her. Instead, *Subah-O-Sham/Homa-ye Sa'adat* emphasizes the (re)productive potential that equally lies in the lover's (cinephilic) regard for even the fallen woman's purity of heart. This love redeems Shirin from the trafficked context of her cross-cultural mobility in order to engender a postnational future that emerges from a genuinely impassioned, loving, cross-cultural (cinematic) affair. *Subah-O-Sham/Homa-ye Sa'adat* ekphrastically extols popular cinema as a uniquely convertible, feminine token of exchange for producing a world forged in an ethos of fraternity. In part, this diegetic allegory was underlain by the ostensible status of the star dancer-actress as both exceptional to Indian cinema and translatable as a source of exchange value across commercial industries both within and beyond India.[10] For Iranian audiences, the figure of the singing dancer-actress was familiar through not only the popularity of Indian films in Iran but also the prominence of sequences motivated by the contemporaneous trope of the café dancer in popular Iranian films.

In an intriguing manner, the narrative of *Subah-O-Sham/Homa-ye Sa'adat* refers to a material history of Indian films' overseas distribution. Practices of unregulated distribution easily escape the radar of official records, and a major challenge of piecing together their histories is that their fragmentary traces are spread across multiple locations and languages. Intensely reflexive cross-industry productions like *Subah-O-Sham/Homa-ye Sa'adat* straddle multiple locations that were already networked through transnational circuits of film distribution. The films themselves thus emerge as robust historical artifacts, whose layers reveal their material practices of production, formal strategies, and dual address to audiences split by both language and location, vis-à-vis two or more distinct commercial-industrial cinematic contexts.[11]

While perusing periodicals, parliamentary proceedings, and trade journals in an attempt to excavate histories of Bombay films' overseas circulation over the 1960s, I came across a few mentions of a smuggling ruse involving waste celluloid headed for bangle factories. Over the 1960s, large quantities of celluloid waste— that is, film scraps—were being imported by Indian manufacturers of brightly colored, cheaply produced plastic bangles, which were in turn being exported for valuable foreign exchange. In what follows, I detail the material and affective economies of (waste) celluloid vis-à-vis the bangle scheme as revelatory of the politics

of sexuality in the Indian state's concerns over smuggling and its endeavors to both regulate overseas film distribution and encourage the influx of foreign exchange. I go on to highlight the ways in which *Subah-O-Sham/Homa-ye Sa'adat* depicts and responds to the issue of Indian films' unregulated overseas distribution through its gendered constructions of cinema, pleasure, and world-making.

What finally emerges is not only a remarkably "colorful" story but also an opportunity to consider the materiality of celluloid as plastic and to insist that the stakes of film import-export regulation, as well as overtures of diplomacy through cinematic coproduction, remained intimately concerned with questions of modernity and sexuality. In its attempts to regulate overseas distribution over the 1960s, an Indian statist discourse often presumed that the capital excess of illicit circulation (e.g., films that were being smuggled) entailed the libidinal excess of illicit content (e.g., exploitation and poor-quality films circulating as Indian culture).[12] In allegorically framing Shirin as trafficked feminine cinematic object from India, *Subah-O-Sham/Homa-ye Sa'adat* both assumes and reorients the heteropatriarchal terms of Indian statist anxieties over unregulated overseas distribution. *Subah-O-Sham/Homa-ye Sa'adat* thus engages, and itself emerged from, a material history of Indian films' circulation through a transregional economy of cheaply produced, discarded, and repurposed plastic commodities.

Amid the financial crises and food grain shortages in India during the 1960s, the plastic bangle manufacturing sector constituted a significant, growing export industry that was bringing in valuable foreign exchange.[13] A 1965 Indian trade journal report shows that among other plastic goods, bangles trailed only polythene lined jute, PVC cloth and sheeting, and plastic raw materials in terms of export earnings.[14] With plastic bangle manufacturers having consolidated their interests into the All India Celluloid Bangles Manufacturers' Association (AICBMA), the industry was a prolific one.[15] With the 1962 onset of the Sino-Indian war, foreign exchange earnings were touted as a patriotic imperative. "Save Foreign Exchange," urges the headline of a December 1962 *Times of India* brief, which goes on to report that the state of Maharashtra's minister for industries attended a meeting of the AICBMA in order to emphasize "the need to save foreign exchange and divert it for purchasing arms to meet Chinese aggression."[16]

More than a decade later, after the Bombay Municipal Corporation levied an 8 percent sales tax on plastic bangles, a press report cites the potential loss of foreign exchange as an oppressive consequence of the increased tax on plastic bangles:

> Though a small-scale industry, the plastic bangle is an important foreign exchange earner. Annual exports of plastic bangles, started in 1957–58, are now of the order of Rs. 90 lakhs per annum. Bombay is an important centre for this industry.[17]

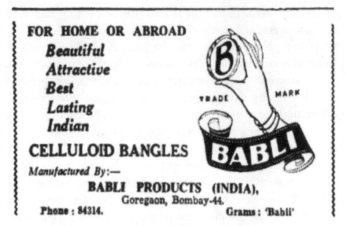

FIGURE 33. Advertisement for Babli Celluloid Bangles.

The report additionally mentions the dissatisfaction of the "all-India plastic bangles manufacturers' association" with "the imposition of heavy import duties on raw materials." Referring to AICBMA as a *plastic* bangles manufacturers' association, the report suggests an interchangeability between celluloid and plastic in this particular manufacturing context. In contrast, the defendant of a 1962 court case tried to argue that as a seller of celluloid bangles, he was not subject to a special tax levied on the sale of plastic bangles. Ultimately, invoking the authority of none other than the Encyclopedia Britannica, the Maharashtra High Court "negatived [no pun intended!] the applicant's contention that the bangles were made of cinematograph films . . . and therefore were not made of plastics."[18]

Among the raw materials used to produce plastic bangles was waste celluloid, cheaply imported in large quantities. This association was popularly known. In his foreword to an anthology of filmmaker Pier Paolo Pasolini's poetry, for example, filmmaker James Ivory remarks on the instability of celluloid and loss of films that are not adequately preserved: "In India, old films are sometimes made into women's bangles; when a film is a flop, it's said to have 'gone to the bangle factory.'"[19] The mythologized trope of the film-turned-bangle is a variant of other similar tropes throughout the history of cinema, from varnish[20] to silver earrings, to clicking heels,[21] to bangles. Invoked as the fate that awaits discarded celluloid, these objects spectacularly render the failure of films that are far better off as mere trifles, with their conversion into feminine accessories putting a fine point on the films' inconsequence. Given the popular knowledge that waste celluloid was a raw material for the production of plastic bangles, this material relationship between cinema and plastic bangles also came to imbue the latter commodity, as a women's fashion item, with the popular allure of contemporaneous moving images—colorful, decorative, modern, feminine, sensual. In some advertisements, the glamour of this association was explicitly invoked (fig. 33).

In 1963, the Indian government established the India Motion Pictures Export Corporation (IMPEC). Between its founding in the early 1960s and dissolution into the National Film Development Corporation by the late 1970s, what repeatedly arises across parliamentary proceedings and press reports is that the principal impetus for IMPEC's founding was twofold: to nationalize export in order to curtail film smuggling and access the valuable foreign exchange that was being otherwise lost to racketeers, in addition to regulating the kinds of films that were being imported as well as exported. A 1989 report on national communication policy, published by the Centre for Black and African Arts and Civilisation, characterizes the aims of the erstwhile entity in these very terms: "In 1963, the India Motion Pictures Export Corporation was set up to streamline the export of films. The corporation ensures that foreign films brought into India are worthwhile and culturally relevant."[22]

Despite the touted success of IMPEC's dealings in a dedicated "Filmotsav 78" film market, which was held in Madras and concluded with the sale of "100 movies fetch[ing] Rs. 17 lakhs," IMPEC's forays into controlling overseas film distribution was largely a story of failure.[23] A 1980 national film policy report published by the Indian Ministry of Information and Broadcasting includes a postmortem of sorts on IMPEC, which, along with the Film Finance Corporation, had been folded into the National Film Development Corporation (NFDC). While lauding some inroads made by IMPEC toward its twin goals of serving as "the sole canalising agency for the export of Indian feature films," which was intended to in turn "promote export of Indian films and discourage malpractices," the report ultimately concludes that IMPEC fell short on both counts due to its inability to establish and nourish robust networks with overseas distributors.[24] "In other words," the report states, "IMPEC had become [yet another] competitor of Indian exporters basically in the field of exporting Hindi films which were already being handled by [several] commercial exporters."[25]

As a story of export regulation attempts and failures therein, the story of IMPEC attests to the very robustness of a thriving, unregulated network of commercial film distribution via Bombay. In addition, IMPEC's rather general aim of "discourag[ing] malpractices" begs the question of what such "malpractices" might have encompassed and what, exactly, IMPEC sought to gain from nationalizing film distribution. Several overlapping concerns emerge, which also point to the difficulty of fixing cinema as an object. Even saleable units, for example, range from the individual print to the negative, to more abstract notions of intellectual property.[26] Concerns over the smuggling ruse involving plastic bangle industries came to light alongside the activities of IMPEC: according to parliamentary proceedings and press reports, sex and exploitation films, also known as blue films, were being clandestinely relayed from the Middle East, disguised as waste celluloid headed for bangle factories.[27]

In the case of the bangle scheme, statist concerns over both film contraband and unauthorized channels of celluloid export-import sought to exert control over

a range of ostensible excesses. Anxieties over informal cash flows were figured as the exploitation of Indian culture—coded as feminine—among unknown foreign bodies. Through such a stance, the state assumed the very objectifying heteropatriarchal gaze that feminist scholars have critiqued as a dominant structure of exploitation, which can operate across a range of films from pornography to mainstream commercial films.[28] Subsequent feminist scholarship, in the wake of 1970s psychoanalytic theories of the male gaze, has insightfully argued that with regard to practices of reception, pornographic content in itself does not automatically entail uncritical objectification, just as non-pornographic content in itself does not preclude the same.[29] In the case of IMPEC, statist anxieties over the excess of unregulated film distribution were interwoven with anxieties over the excess of feminine sexuality, as they overlapped in a material and affective economy of mass-produced plastic commodities that encompassed bangles, waste celluloid, popular Hindi cinema, and blue films.[30]

Associations between black money, the Bombay film industry, and the Middle East as a haven for smuggling have long been reported and dramatized in the Indian public sphere.[31] Indeed, in the expected absence of a readily accessible paper trail left by agents operating within unofficial or illicit film distribution networks, much—including the methodological question of how one excavates such histories—remains crucially beholden to imaginative conjecture over potential avenues of historiography. My own inadvertent discovery of the bangle scheme was fully indebted to its happenstance discovery by journalists and state authorities in the 1970s, as a result of which it was documented in parliamentary proceedings as well as local press reports. As a set of practices, this history of illicit film distribution draws attention to the materiality of celluloid and its impact on circulation. To put it another way, the same ruses would not have worked for smuggling VHS tapes and vice-versa.

Under the headline "Where Smuggling is King," a 1974 Indian newspaper report notes that "blue films are imported illegally against the clandestine export of Hindi feature films to West Asian countries."[32] This particular scheme is mentioned as one that worked hand in hand with others, according to another Indian newspaper article published seven months later:

> A flourishing racket in the smuggling in crime-sex thriller films has come to light. According to one estimate, about 50 films a year are smuggled in from abroad. . . .
>
> The smuggled films are exhibited mostly in rural and semi-urban areas either with forged censor certificates or without certificates, according to censor board officials.
>
> Among the methods adopted to smuggle the films in are (A) getting them under the garb of waste films, meant for the bangle industry and (B) substituting the thrillers for Indian films to be brought back after exhibition abroad. The sources said that the bangle industry was permitted to import waste film as raw material and this was exploited by smugglers.[33]

The former article refers to "West Asian countries" generally, as a key conduit for sourcing sex films in the guise of returning prints of Indian feature films. The latter article not only reiterates this particular scheme but additionally describes the practice of clandestinely importing "thrillers" in the guise of waste celluloid headed for bangle factories for subsequent illegal exhibition in "rural and semi-urban areas" within India. Together, these reports draw attention to the porosity—even interdependence—of manifold distribution practices and film objects that lie along a continuum between licit and illicit, epitomized by the trope of smuggled films disguised as returning prints. The precise contents of such films remains unclear: Were they pornographic? Were they C films that, in actress Mumtaz's aforementioned description, included wrestling and stunt films? Or were they merely smuggled films that were presumed to harbor illicit content because of their unauthorized circulation or the less desirable audiences (e.g., "rural and semi-urban") who were viewing them?

While the press reports play up the more sensational, lurid aspects of the above schemes, Indian parliamentary proceedings reveal far more generalized anxieties over controlling overseas distribution. The question of regulation emerges in the proceedings as not merely a matter of seizing contraband (e.g., sex films and black money) but, much more so, as a conundrum over having arrived late to the party, so to speak, with the establishment of IMPEC constituting a floundering attempt to retroactively exert control over an already-thriving set of ad hoc networks of overseas film distribution.[34] The perceived stakes are revealed in these proceedings to be about the loss of foreign exchange and tax income, which was in turn projected as a set of patriarchal anxieties over what kinds of moving images were circulating as Indian culture among overseas patrons. In this logic, the cinematic object of statist regulation is rendered feminine, and the state's own heteropatriarchal gaze is presumed as the operative one on the part of overseas patrons as well.

An import tax was levied on celluloid waste, which sparked widespread opposition among the AICBMA. Members of the manufacturers' organization somewhat predictably accused the government of curtailing the livelihoods of their scores of workers in addition to curbing the valuable foreign exchange that the plastic bangle industry was contributing to the Indian economy through their export dealings.[35] Eventually, the attempts to curtail film smuggling with a tax on waste celluloid—and more generally, IMPEC's endeavor to "canalise" the export of celluloid reels—failed. Akin to the postmortem on IMPEC that appears in the 1980 national film policy report, the "Questions and Answers" portions of parliamentary proceedings that were recorded on at least two occasions between 1973 and 1974 reveal a set of grave concerns. They admit tremendous difficulties in reliably reporting the number of Indian films being exported, the films that were being exported, to where they were being exported, and the amount of money that was involved. In detailing the bangle scheme having come to light, the proceedings

acknowledge both the ingenuity of such schemes as well as their proliferation, noting that the bangle scheme was certainly but one among several other sophisticated, as-yet-unknown methods.[36]

The ingenuity of the bangle scheme in particular is strikingly cinematic by virtue of not only the bangle's material associations with celluloid but also its status as a physical object that, like cinema, is imbued with properties of aural and visual expression and deeply associated with negotiations of modern feminine sexuality. Glass bangles in many South Asian communities were held to be a quintessential—even talismanic—accoutrement for a married woman. In several instances, a refrain of "out with the old, in with the new" characterizes reports about the ascendant popularity of the plastic bangle from the 1950s onward as a replacement for the more traditional, highly audible glass bangle. A 1953 newspaper report, for example, laments the fact that "one of the ancient small-scale industries of our country with an All-India demand, the glass bangles industry is now in desperate straits unable to meet the competition of plastic bangles."[37]

In another instance almost two decades later, the replacement of glass bangles by plastic bangles is similarly invoked—albeit slightly less melancholily—in a letter to the editor about the impact of modernization upon small towns in North India:

> The biggest and most noticeable change is in the number of radios and transistors in the villages. When I came to live here I was perhaps the second or third radio licence holder in the village. Since then the number has gone up many times.
>
> The vegetable vendor is here and the goods that other vendors sell have changed. Glass bangles and coarse cloth have been replaced by plastics, table cloth, lip-stick, nail polish and bright-patterned cloth of synthetic fibre. Young girls wear tight shirts and *chudidars* and none of the village elders even take notice of this. Daughters-in-law only make a pretense of veiling their faces. In panchayat meetings female members, generally middle aged women, enthusiastically participate in decision making.[38]

For the author, the glass bangle's replacement by the plastic bangle heralds the onset of modernity not only as an influx of communication technologies (e.g., radios) but more particularly, as growing brazenness on the part of women who are more aware of their sexuality, expressive of desires for fashionable commodities, less modest, and more vocal as decision makers in public—rather than merely domestic—spaces.

An ambivalence toward the plastic bangle as a sign of the "modern," associated with shifting gender roles, commodity consumption, fashion, and cinema, underlay contemporaneous reports of the potential dangers that it could pose to its wearers. These included bad luck, according to a 1971 report that "plastic bangles are being thrown away in their thousands in Surat following a rumour that they bring ill-luck."[39] The author remains skeptical, wryly surmising that "perhaps, the Surat rumour is the handiwork of a shrewd manufacturer of glass

bangles or an imaginative goldsmith," before confidently concluding that "plastic bangles will undoubtedly survive the malaise."[40] A few years later, a news story reported on the bizarre instance of an "upcountry merchant" traveling to a city, purchasing celluloid bangles, and stashing them with a lawyer friend in that city so that he would not have to carry them around before he was due to catch his homebound train.[41] In the meantime, inspectors happened to visit the lawyer and find the bangles on premises, for which the lawyer was fined:

> To keep celluloid-based articles on business premises without a licence is an offence and the lawyer was duly charged. The magistrate did not agree with the lawyer's arguments and fined him Rs. 200. The magistrate said the lawyer, of all the people, should have known the law.[42]

Celluloid was thus administered as a controlled substance, subject to regulation not only because of the potential dangers posed by its moving-image contents but also because of the apparent dangers posed by virtue of its physical properties (e.g., flammability).

Chief among the plastic bangle's physical properties—and one that was hardly unrelated to its material and affective associations with celluloid and cinema—was its primarily visual allure as a colorful, feminine commodity that was widely affordable and accessible. Its associations with modern femininity and cinema coalesce in a song sequence from Madhusudhan Rao's 1970 Hindi film *Saas Bhi Kabhi Bahu Thi* (Even the mother-in-law was once the daughter-in-law). In the song sequence, whose lyrics were penned by writer Rajendra Krishan, the hero is outfitted as a bangle seller holding a pole that displays a colorful array of bangles (fig. 34). In the voice of playback singer Kishore Kumar, actor Sanjay Khan croons the song's chorus to his beloved, played by actress Leena Chandvarkar (clip 12):

> *lelo chuudiyaan, jii lelo chuudiyaan* (Take some bangles, yes, take some bangles)
> *haan niilii niilii piilii piilii* (Hey, blue-blue, yellow-yellow)
> *laal harii aasmaanii* (Red, green, azure)

Offered in a romantic overture as spread of colors, the celluloid bangles are visually enticing in their many hues. This is reinforced by the lyrics, and the word *aasmaanii* (azure) is particularly evocative of a playful, modern option among an eye-catching array of choices. The overture is distinctly sensual and erotic, as a marked departure from the glass bangles whose wearing and color—often green, white, or red, according to the customs of a particular community—are expectations and signs of marriage.

In lyrical genealogies of South Asian courtly and folk poetry, the chief attributes of (glass) bangles, as a poetic trope, have included their physical propensities toward chiming, on the one hand, and breaking, on the other. In this textual domain, bangles are largely either a liability for the married woman who must wear them or an aural apparatus that can ventriloquize the desire that she is too

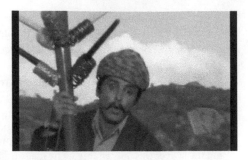

FIGURE 34. Still from *Saas Bhi Kabhi Bahu Thi* (1970): As a romantic overture, the hero offers an array of colorful plastic bangles to the heroine.

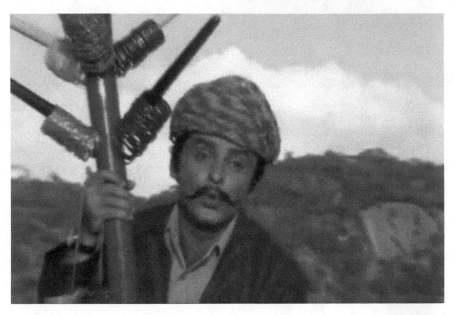

CLIP 12. "*lelo chuudiyaan*" song sequence from *Saas Bhi Kabhi Bahu Thi* (1970).

To watch this video, scan the QR code with your mobile device or visit DOI: https://doi.org/10.1525/luminos.130.12

coy to voice.[43] These conventional poetic situations include a woman fearing that her bangles may be broken by a lover who grabs her by the wrist, whether the advance is welcome or not, with their breakage portending misfortunes for her husband. Or a woman's stealthy movements—for example, to meet a lover other than her husband—being betrayed by the clinking of her bangles. Or the clinking of a married woman's bangles expressing the desire that she is too bashful to voice.

In the "*lelo chuudiyaan*" sequence (clip 12), the sense of "out with the old, in with the new" is thus epitomized by the shatterproof, colorful plastic bangle, whose chief attribute is visual rather than aural and which is chosen by a woman

FIGURE 35. Still from *Saas Bhi Kabhi Bahu Thi* (1970): As an acceptance of the hero's romantic overture, the heroine stretches out her arm desirously, as the plastic bangles herald sensual pleasure.

of her own volition, rather than prescribed as a formality of marriage. During a brief musical interlude between the man's opening overture and the woman's response, we see Leena Chandvarkar's character slyly removing a gold bangle from her left wrist and transferring it to her right wrist, whereby she is able to display her unadorned left wrist and solicitously sing in the voice of playback singer Lata Mangeshkar (fig. 35):

> *dedo chuudiyaan, jii dedo chuudiyaan* (Give me bangles, yes, give me bangles)
> *ye suunii hai kalaaii merii dhol jaanii* (These my wrists are empty, my dear)

Following her rejoinder, Sanjay Khan's character takes the hand that she offers and sensuously slides a plastic bangle along her arm. As he does so, the close shot of Sanjay Khan slipping the bangle on Leena Chandvarkar's arm pans to the right, showing her character to be overcome with pleasure.

This particular sequence, along with a trail of advertisements, press reports, and editorials, explicitly cements contemporaneous gendered associations between women's expressions of sexuality and desire, cinema, and celluloid bangles as a cheap, colorful, modern alternative to the (married woman's) much more audible glass bangles. Whether smuggled films that appeared as mere waste headed for the bangle factory or colorful celluloid bangles that were decorative but did not chime, such "illicit" economies of celluloid point to modes of audiovisual excess that escape statist and patriarchal regulation. In this manner, illicit economies of celluloid waste not only emerge as highly cinematic, both materially and affectively, but also point to a more plastic (pun intended) history of Indian cinema in this period, both domestically and overseas. A media ecology of plastic draws together seemingly disparate histories of cross-industry Madras-Bombay productions, *Subah-O-Sham/Homa-ye Sa'adat*, the mobile and ostensibly translatable stardom of dancer actresses, waste celluloid, plastic commodities, transregional channels of informal distribution, film smuggling, and debates over excess and sexuality.[44]

A 1967 edition of the *Hindustan Times Weekend Review* features an article whose headline puts forward the question "In the re-vitalisation of the Indian film indus-

try, what is the role of the proposed 'kissing seminars'?" The article, by renowned film critic and historian Chidananda Das Gupta, cites a recent turn of events by which Union Minister of Information and Broadcasting K. K. Shah apparently found himself at the center of a controversy owing to "charges of a 'double standard' between foreign and Indian films around the question of kissing."[45] Das Gupta notes that as a consequence, Shah "has offered to hold seminars and elicit public opinion on the question: to kiss or not to kiss."[46] Das Gupta goes on to playfully engage the question, and in doing so, he underscores the conundrums of such proscriptions—even if self-imposed, rather than enforced, practices of censorship[47]—on a medium that is bound to continue to circulate beyond the territorial jurisdiction of a nation:

> The problem in regard to co-productions has not arisen but may rear its ugly head. In a production owned by India and another country: whose moral code is to be observed? Will Indian actors be allowed to kiss the foreign girls and vice versa in such films? Will a co-production be considered a foreign film for Indian audiences, or an Indian film for foreign audiences, or an Indian film for Indian audiences?
>
> In the Middle East where quite a few Indian films are exported, codes of public demonstration of sentiments towards the other sex are, if anything, more severe than in India. Should we selfishly consider the morals of our youth and help to corrupt theirs for the sake of a little foreign exchange? What's a little foreign exchange between friends—us and the Arabs? Instances are known of Indian women being asked to cover their fashionably bare midriffs in the streets of Cairo. The sex appeal of Indian films derives more from the bare midriff than any other single sector of female pulchritude. Is it then a friendly act towards these countries to subject them to these sights? . . .
>
> Seminars on kissing, apart from deciding the Indianness of the act and the desirability of performing it on the screen, may profitably go into these finer branches of the problem, so as to settle it once and for all.[48]

Even if somewhat facetious, Das Gupta's remarks refer not only to the prolific export of Indian films to the Middle East, specifically, but also to their presumed circulation as exploitation films owing to their feminine sex appeal among (implicitly masculine) Arab—among other Middle Eastern—audiences. This presumption emerged in part from statist anxieties and their attendant racialized and classist notions of reception and in part from the status of Hindi films as a cheaper commodity in a global film market, by which they became associated with the viewing practices of lumpen masculine audiences.[49]

Das Gupta's larger point is a critique of the double standards by which the censorious, moralist impulse to oppose titillation and stave off the corrupting effects of celluloid seems to apply only to Indian audiences, since the same concerns ostensibly vanished in the face of business opportunities for Indians to earn foreign exchange from overseas audiences. Among overseas audiences, Das Gupta suggests, attractions such as the bare midriff—rather than the kiss—can

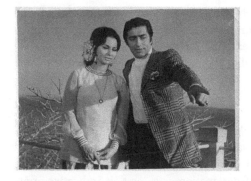

FIGURE 36. Production still from *Subah-O-Sham* (1972): Hindi film star Waheeda Rehman with Persian film star Fardeen.

FIGURE 37. Production still from *Subah-O-Sham* (1972): Persian film star Fardeen with Hindi film stars Waheeda Rehman and Sanjeev Kumar.

constitute a veritable peep show. In asking, "What's a little foreign exchange between friends?" Das Gupta invokes a presumed cultural intimacy between Indians and "the Arabs" by which the cash earned for the sale of an Indian actress's onscreen sex appeal is little more than a familial exchange to the benefit of both parties. These two senses of "foreign exchange"—as a purely monetary transaction, on the one hand, and as a diplomatic token of friendship, on the other—are central to *Subah-O-Sham/Homa-ye Sa'adat*'s endeavor as a coproduction (figs. 36, 37).

Furthermore, Das Gupta's concerns are on point with respect to the issue of onscreen sexuality becoming particularly fraught in contexts of coproductions. The heroine of *Subah-O-Sham/Homa-ye Sa'adat* emerges as metonymic for Hindi films whose song-dance attractions captivated foreign audiences, and the narrative arc of the film delivers a melodramatic defense of Hindi song-dance films' potential to buttress foreign exchange in the diplomatic sense of cross-cultural friendship—in contrast to which, foreign exchange as profit and spending power is eschewed as an end in and of itself. The stakes of this disavowal lie in an exaltation of the world-making capacities of cinema through independent—that is, non-state—industry logics, whose commercial priorities are rhetorically eschewed as a primary end in order to distance industry practices from the realm of exploitation

and duplicity. What the film reflexively avows in this manner is the sincerity of its endeavor. Excesses of Hindi cinema—that is, "romance, comedy, and somewhat jazzy music"[50]—are reflexively extolled for their capacity to engender an impassioned excess of love-as-cinephilia, which is rhetorically contrasted to and separated from the excess of profit.

Although Hamid Naficy refers to the "good bit of coproduction history between Iran and India" over the early artisanal period (1897–1941) and subsequent industrializing period (1941–1978) of Iranian cinema prior to the Revolution, *Subah-O-Sham/Homa-ye Sa'adat*'s self-designation as a "first" is indicative of an ostensibly unprecedented degree of collaboration between the two industries, as the film was aimed at a dual release from the outset.[51] The Madras-based Ganesh Rao Movies oversaw the Hindi version, and the Tehran-based Ariana Studios, the Persian one. Moreover, the film's aspirational project of cinematic exchange is embedded as a diegetic attraction and ekphrastically argued through the romance that unfolds between Persian film star Fardeen and Hindi film star Waheeda Rehman.

Subah-O-Sham/Homa-ye Sa'adat also stands out as distinct from a key earlier moment in the coproduction history between Iran and India when Iranian filmmaker Abdolhossein Sepanta traveled to India and directed the first five Persian talkies in collaborations with studios in Bombay and Calcutta.[52] In this earlier moment, the primary impetus for collaboration was technology, as Sepanta traveled to India to use the studios' sound film facilities. The impetus for *Subah-O-Sham/Homa-ye Sa'adat* was much more thoroughly embedded in an industrial mode of film production, as it offered an opportunity for a Madras studio to capitalize on a market for Hindi films through stars associated with the Bombay cinema, and for a Tehran studio to do the same with a Persian-dubbed version among an audience who was readily familiar with both Hindi and Persian films and stars.

Subah-O-Sham/Homa-ye Sa'adat presents itself primarily as a cinematic exchange between stars of the Bombay and Tehran industries—Hindi film stars Waheeda Rehman and Sanjeev Kumar are featured abroad in Iran at the same time that Persian film star Fardeen is featured in a Hindi film. In the Hindi version, the opening credits roll against a nighttime urban background with the camera moving quickly—as if driving—through the colored lights of a city by night. Superimposed text is displayed in bright neon-green letters to the accompaniment of music directors Laxmikant-Pyarelal's upbeat jazzy score led by horns. The credits are all presented in English, with the exception of the film's title, which is triply displayed—as was typical for Hindi films at the time—in Roman (English), Devanagari (Hindi), and Nastaliq (Urdu) scripts. The film is declared to be the "First

FIGURE 38. Still from *Subah-O-Sham* (1972): Title credit.

Hindi Film Shot in Iran" (fig. 38), and it takes pride in "Introducing Fardeen (The Matinee Idol of Iran)." Additional credits single out the participation of Iranian crew members and production facilities, making it clear that this Hindi-language version of the film is addressing an audience that is much more familiar with Hindi cinema than with Persian cinema. The credit sequence in the Persian version, in contrast, highlights a flashing, chandelier-like background, accompanied by a score that features ostensibly Eastern instruments.

As Anupama Kapse has noted, Sepanta's journey in the 1930s to produce the first Persian talkie in collaboration with Ardeshir Irani's Imperial Film Company of Bombay reveals the status of Bombay as an alluringly modern metropole within networks across South and West Asia.[53] What is striking about *Subah-O-Sham/Homa-ye Sa'adat* is that this relationship seems reversed: while the Persian version emphasizes an India-facing Eastern milieu at its outset, the opening credits of the Hindi version present Tehran as a jazzy, ultramodern metropole in a manner that gelled with a contemporaneous vogue in Hindi cinema for shooting in glamorous international locations like Paris, London, Rome, Beirut, and Tokyo.[54] The contemporaneous Iranian government under Shah Mohammad Reza Pahlavi supported film coproductions and foreign productions on location, in addition to sponsoring modern architectural projects that aimed to highlight Tehran's status as modern, cosmopolitan, global city.[55] While the Iranian film industry at this point had developed ample resources in terms of capital and technology, Indian—as well as Hollywood and Egyptian—films still remained popular enough that they posed a degree of competition to Iranian films in Iran in a way that was completely untrue the other way around.[56] The dual-star strategy of casting Hindi film star Waheeda Rehman opposite Persian film star Fardeen attempts to strike a sense of balance in the coproduction. Yet, in light of a fundamentally imbalanced field of reception, this highly visible calculation may have been what led to the film's failure in India.

FIGURE 39. Cover image: Time-N-Tune
2007 VCD edition of *Subah-O-Sham*
(1972).

In fact, while the Hindi *Subah-O-Sham* is currently available as a nondescript and unsubtitled two-disc set of VCDs released by the Delhi-based distribution company Time-N-Tune (TNT) in 2007, nothing on the VCD's packaging notes that the film is an India-Iran coproduction. Instead, with Waheeda Rehman and Sanjeev Kumar prominently featured in the top image and appearing to be in a sort of embrace in the center image, the VCD cover—taken from a publicity image for the Hindi film—strongly suggests a love story between the two of them (fig. 39), although this is not at all the case in the film. Fardeen, a Persian film star and popular romantic hero also known by his full name Mohammed Ali Fardeen, is in fact the hero of the film. It is he who stars as the love interest of Hindi film actress Waheeda Rehman, and it is their romance that melodramatically unfolds over the course of the film. Sanjeev Kumar, meanwhile, plays Fardeen's fun-loving and kind brother Nasir.

In contrast to both the 2007 VCD packaging of a 138-minute Hindi version[57] of *Subah-O-Sham* and the packaging of an LP released in India alongside the film (fig. 40), a Persian poster that accompanied *Homa-ye Sa'adat*'s Iranian release prominently displays the fact that the film is a coproduction. The poster's artwork highlights close-up, painted renditions of all three leads (Persian film star Fardeen, Hindi film star Waheeda Rehman, and Hindi film star Sanjeev Kumar), and directly below the film's title, the text prominently announces the film as the first Iranian and "Hindi" film to have been undertaken as a coproduction (fig. 41). The fact that Iranian audiences were much more familiar with Hindi films and stars surfaces in subtle ways within the film and certainly in its publicity.[58] The film's diegetic self-presentation as a genuine coproduction that was motivated by love

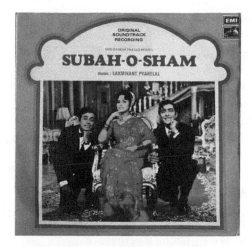

FIGURE 40. Cover image: EMI record album of songs from *Subah-O-Sham* (1972).

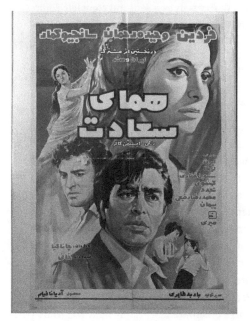

FIGURE 41. Persian poster for *Homa-ye Sa'adat* (1972).

and friendship, rather than by profit, constituted an overture of cross-industry diplomacy at a moment when Iranian filmmakers were frustrated by the imbalances of exchange, as the popularity of Hindi films in Iran was not accompanied by a reciprocal popularity of Iranian films in India. At the same time, the film constituted a Madras producer's attempt to make a Hindi film that could take advantage of the prestige—and potential returns—of a star-studded transnational coproduction shot on location in Iran.

Among the central preoccupations of a 1971 report on the progress of the Iranian film industry is the issue of competition from Indian films, and the report's insights are critical for understanding the landscape—or perhaps minefield— of film policy, cash flows, and histories of transregional distribution out of which *Subah-O-Sham/Homa-ye Sa'adat* emerged. The report, published one year before *Subah-O-Sham/Homa-ye Sa'adat*'s release, notes that it was only very recently that a few Iranian films had finally managed to outcompete their Indian counterparts in Iran.[59] For the Iranian film industry, the issue was not merely domestic competition with Indian films but also having to compete with Indian films as Iranian films aspired for wider transregional distribution. "In markets like Afghanistan," the report surmises, "Iranian films need more time to surpass the prosperity of Indian films."[60] It adds that the Iranian industry of late was well-poised to finally overtake the popularity of Indian films because of the recent strides it had made in technological and infrastructural investments:

> A superior feature of the Iranian movie industry is its excellent and complete equipment. Large amounts of capital and foreign currency reserves have allowed the movie studios to import the most modern type of equipment. . . . Iranian stories are considered more attractive visually than Egyptian or Indian stories. . . . In many cases, audiences are more eager to hear the latest songs by their favorite singers than to see a film. . . . India does not permit Iranian films because it does not want hard currency to leave the country. This closes the Indian market.[61]

The report's comparison between Iranian and Indian films is striking in two ways: Firstly, it emphasizes Iranian films' superiority in terms of production values that made their stories "more attractive visually," in comparison to both Indian and Egyptian films. Secondly, the report diminishes the artistic value of Indian films by construing their songs as an exception and relegating them to a distinctly non-cinematic element that appealed to audiences, by which the films' low quality could then be derived from their inferior stories.

In this contemporaneous context of Iranian filmmakers' concern over Indian films' popularity among Iranian audiences, the reflexive melodrama at stake in *Subah-O-Sham/Homa-ye Sa'adat* is one of justifying the enterprise of a lucrative singing Indian cinema in Iran. The Persian title *Homa-ye Sa'adat* (Bird of happiness) refers to a mythical bird (*homa*) in Persian lore, which is believed to be perpetually in flight and bestow prosperity upon any person who falls in its shadow. This "bird of happiness" is simultaneously a fitting reference to Waheeda Rehman's character Shirin. For, like the mythical bird perpetually in flight, Shirin is a displaced migrant from India who has inherited her mother's occupation as a dancing girl, akin to the trope of the café dancer that was a staple of contemporaneous Persian films. Shirin is subject to the whims of an older man who basks in the prosperity of her shadow through arranging her dance programs for audiences in Tehran, where he has continued to keep her as a cash cow.

Waheeda Rehman was well-known not only as a dancer-actress but in particular for her roles as the prostitute Gulabo in *Pyaasa* (Guru Dutt, 1957); the courtesan-dancer Rosie who, like Shirin, inherits her profession from her mother in the prestige film *Guide* (Vijay Anand, 1965); and the dancing girl Hirabai in *Teesri Kasam* (The third vow; Basu Bhattacharya, 1966). In *Subah-O-Sham/Homa-ye Sa'adat*, Shirin first appears in a song sequence that begins within the first few minutes of the film, after she is invited to perform by the host of the party, who introduces her as "Miss Shirin . . . born in India, but an excellent artist of our nation."[62] The adoption of Shirin as a singer-dancer of "our nation" (i.e., Iran) despite her birth in India parallels the manner in which Hindi films were frequently "adopted" by overseas audiences, sometimes by being redubbed in the languages of their respective target audiences.

Subah-O-Sham/Homa-ye Sa'adat's narrative project aims to move Shirin, a dancing girl who has been brought to Tehran from India, out of the stigmatized spaces of exploitation and into an upper-middle-class space of respectability, while simultaneously moving an upper-middle-class strata to accept love rather than socioeconomic status as a (re)productive foundation for world-making. Melodramas that switched around protagonists' class positions were a well-established staple of both Persian and Hindi films, with the Hindi film *Awara* (Raj Kapoor, 1951) being a classic precedent that would have been familiar to both audiences. *Subah-O-Sham/Homa-ye Sa'adat* puts forward and ultimately pries apart an association between singing Indian films and exploitation/flesh trade through the character of Shirin/Waheeda Rehman, whose diegetic occupation as a dancer from India reflexively pointed to Waheeda Rehman's actual occupation as a star dancer-actress in Hindi films. While Persian films, too, featured café-dancer sequences, popular Hindi films, in Iran among other places, were virtually synonymous with their song-dance sequences.[63]

In this manner, the coproduction addresses two sets of contemporaneous anxieties. The first was an Indian statist anxiety over informal modes of transregional film distribution by which not only illicit content but also the necessarily lower-class status of such films' patrons were presumed. The second of these anxieties was the sense of unequal exchange on the part of the Iranian film industry, given the one-sided popularity of Indian films in Iran. Through the first song sequence in *Subah-O-Sham/Homa-ye Sa'adat*, Shirin is presented to the gaze of the audiences both within and outside the film, with the hero Aram (Fardeen) among the diegetic audience. She sings and dances suggestively, and within the film, the pleasure that the Iranian audience takes in her performance is framed as a cosmopolitan appreciation of an Indian art form, evidenced by the host's introduction and subsequent repetition of the fact that she is "born in India, but an excellent artist of our nation." Shirin wears the unmistakably Indian garb of a saree, in sharp contrast to the audience of upper-middle-class Iranians outfitted in formal, Western attire (fig. 42).

FIGURE 42. Still from *Subah-O-Sham* (1972): Shirin's clothing marks her as Indian, in contrast to the upper-middle-class Iranians outfitted in formal Western attire.

Throughout the film, Shirin's Indian origins are visually highlighted by her attire, which continues to stand out against the Western-style attire of the Iranian characters who surround her. Shirin's visually marked identity as an Indian singer-dancer in Tehran constitutes an address toward the film's contemporaneous Iranian audiences for whom Indianness would have been equated with the song-and-dance-based Hindi films that were popular in Iran at the time. In a heavy, drunken stupor as she dances, Shirin sings (synced to playback singer Lata Mangeshkar's omnipresent falsetto), "*chhod meraa haath mujhe piine de, aaj saarii raat mujhe piine de*" (Let go of my hand, that I may drink, All through this night, let me drink). In the Persian version, her status as a fallen woman is emphasized in sequences that show her ordering and downing vodka at a bar. These scenes of her gratuitous drinking at a bar are not in the Hindi version, perhaps because its associations would have tipped her over into vamp territory.

Both black-and-white and color YouTube clips from *Homa-ye Sa'adat*, the Persian version, indicate that several of the song sequences in the film were dubbed in Persian, many of which feature the voice of Googoosh, a sensational star-singer in Iran.[64] Googoosh's Persian version of the first song begins with the refrain "*maste mastam kon*" (Make me drunk). Known for her stylistic impersonations, Googoosh adopts a high-pitched falsetto that imitates the high-pitched singing style of playback star Lata Mangeshkar in her Persian versions of the film's songs.[65] A few user-uploaded YouTube clips from *Homa-ye Sa'adat* are stamped with the insignia of Iranian Television Network (ITN), a satellite channel that targets diasporic Persian audiences. Yet, the clips from the film that were ostensibly captured and uploaded to YouTube from ITN broadcasts are color Hindi versions of the song sequences, which additionally feature Arabic subtitles.[66] A more complete 122-minute Persian version features a mix of songs in Hindi and Persian, sung by Lata Mangeshkar and Googoosh, respectively. This indicates—as per the aforementioned 1971 report on the progress of the Iranian film industry—that

the reception of Hindi song-dance sequences among overseas, non-Hindi-speaking audiences over the postwar decades (and after) was not contingent on formal translation. Formal translations of Hindi films' dialogue through dubbing or subtitling were undertaken in some cases by independent overseas studios and distributors, whether as a matter of national film policies or as a matter of preference in specific reception contexts.[67]

In fact, Googoosh's official recording of Persian versions of the film's Hindi songs was something of an exception. Song lyrics were rarely translated, even when Hindi films' dialogues were dubbed or subtitled in this period. It is crucial to recognize, however, that audiences actively labored and learned to understand the formal and gestural languages of the melodramatic and song-dance films, whose expressive qualities resonated among them. This is evident through the fact that *Subah-O-Sham/Homa-ye Sa'adat*'s scores were different in the Persian and Hindi versions. While the duo Laxmikant Shantaram Kudalkar and Pyarelal Ramprasad Sharma, known as Laxmikant-Pyarelal, composed the score for the Hindi version as well as the songs for both versions, renowned film composer Rubik Mansuri composed the score for the Persian version.[68] In the case of contemporaneous commercial remakes across languages and industries within India, too, such translations of music and songs were par for the course, through practices that were specific to each linguistic-industrial cinematic context. This strongly pushes against received notions that music and songs were automatically and immanently legible and translatable without any decoding across cultural, national, and linguistic boundaries.

Thus, while songs—or, at times, entire films that resorted to visual externalizations of inner conflicts—were untranslated and did not depend on formal translations, this did not mean that they were automatically less sophisticated in their creative production, less meaningful for audiences, or less exacting on audiences' intellectual capacities in comparison to films that happened to have higher production values and formal translations. This bias, I contend, was prevalent among critics through Hollywood-centric Anglophone discourses and Eurocentric discourses of world cinema. The influence of Euro-American discourses of quality was often palpable in third world contexts' espousal of modernizing aspirations for their cinemas.[69] In official and written discourses about cinema in both Iran and India, for example, aesthetic notions of a given film's quality were often naturalized to a film's economic value and presumed proximity to an idealized spectator: bourgeois, cosmopolitan, educated, modern.[70]

In the aforementioned 1963 trade journal report, for example, an Indian state agency expresses concerns over the respectability of Indian culture being tarnished through unregulated economies and base forms of "third-rate films." This concern plays out in *Subah-O-Sham/Homa-ye Sa'adat* through a tug-of-war between a defensive avowal of Shirin's art as a sincere form of expression and the circumstances in which her art has been commodified and stigmatized within an

exploitative economy of flesh trade, with her body being sold through her forced labor that is euphemistically characterized as that of a dancing girl.[71] It remains far from incidental that Shirin, as a dancing girl who is metonymic for the song-dance enchantments of Indian cinema, is depicted to be in high demand among Iranian audiences, whose willingness to pay for her entertainments yields a lucrative opportunity the elderly man who in turn exploits her, acting as a kind of manager-pimp. One can easily read the tensions within the film over Shirin's occupation as being tied to her status as a bearer of Indian culture as it is bought, sold, and exchanged through unregulated, sprawling networks of film distribution.

At the same time, however, the film unfolds as being much more specifically about her status as a figure of Hindi cinema and its modes of formal excess, which tended to be naturalized to working-class bodies. The endeavor to pry Shirin's art out of a context of exploitation is a reflexive argument that both avows the song-dance modes of commercial Indian cinema and insists on their scale-making capacity for ethical modes of foreign exchange. The film's material excesses of style foreground a sense of its high production values. Sets, recurring motifs of chandeliers among other décor, costumes, music, and its mise-en-scène that ranges from immaculate interiors of homes to bars, nightclubs, and the film's glamorous outdoor locations all work to elaborate its modern spaces of consumption, which emphasize the film's cosmopolitan form and ostensible aesthetic as well as production values.

Through a series of melodramatic twists and turns, romance comes to the rescue, neutralizing the stigma of Shirin's occupation by prying it apart from an economy of commodities. The narrative rescues both the enchantments of her song-dance—that is, the enchantments of Hindi films—and the patronage of her audiences by rendering them as art and love, respectively, in order to relocate Shirin within a transnational, upper-middle-class space of respectability. Her sexuality is repositioned from being a commodity to being a sincere, embodied—and ultimately reproductive—expression of her own desire. It is ultimately not Shirin's art or culture that changes but rather its location, motivation, and reception, as she is shown to enter an upper-middle-class space where she and her arts of song and dance are beloved and organic, rather than forced and exploited. To an extent, this parallels the trade journal report's emphatic recommendation that "the distribution of Indian films has . . . to be entrusted to well established firms for screening at first class halls."[72]

By night, public urban space becomes a sinister location of imminent bodily harm to Shirin in the Hindi version, although it is a world that she must inhabit due to her profession as a dancing girl, thereby remaining in a perpetual state of vulnerability. Early in the film, Aram happens to be driving by, and he witnesses the danger that she is in. He quickly gets out of the car, heroically beats up her would-be assailants, and saves Shirin, to whom he offers a ride home.[73] She is so intoxicated that once they arrive at her house that Aram ends up getting out of the

car to help her. When he brings her to the bedroom, she looks at him and says, "Ah, so you have come this far? Well, you are a man of the second type [i.e., of another kind]—there is no need for excessive formalities," as she falls supine on the bed.

The seeming innuendo, as the two are alone in Shirin's bedroom, leaves Aram uncomfortable and confused, and through the similar-sounding words *qism* (type) and *qasam* (oath) that are indistinguishable through Shirin's drunken slurring, the Hindi version's dialogue also incorporates a subtle reference to the 1966 Hindi film *Teesri Kasam*. In *Teesri Kasam*, Waheeda Rehman plays a dancing girl who becomes the love interest of a bullock-cart driver played by Raj Kapoor, and their romance first blossoms over the course of a ride that he gives her. *Teesri Kasam* ends with the bullock-cart driver taking his third and final vow over the course of the film that never again will he transport a dance girl in his bullock cart. After Aram leaves without exploiting Shirin for sex, Shirin reaches for a notepad and reads a note aloud that Aram has scribbled to her along with his phone number: "Respected Lady, Among men, there is a third type as well, whom you have not yet encountered." In the Hindi version, she wonders aloud, "*tiisrii qism kaa aadmii?*" (Third type of man?), which further extends the subtle intertextual reference to the film *Teesri Kasam*.

In both versions, Shirin soon calls Aram, and they arrange a date at a club. In the Hindi version, she tells him that she would like to meet a man of the "third type." The respective sounds of generically Middle Eastern melodies of plucked lutes in the Hindi version and percussive sounds of a Middle Eastern drum in the Persian version bridge a cut to a belly dancer at a club. In the Hindi version, this scene opens with a view of a lighted stage in a nightclub, with a dancer beginning to writhe to the opening music of a belly-dance-style cabaret routine (fig. 43). In the Persian version, the dancer is initially framed by a medium shot, as she rapidly shakes her hips. For audiences familiar with Iranian popular cinema, the dancer would have been recognizable as the famous cabaret and screen dancer Fatemeh Sadeghi, popularly known by her stage name Jamileh. Jamileh herself, according to Ida Meftahi, began as a stage performer who "mostly [performed] self-trained [Hindi-film-]style Indian dance."[74] In both the Hindi and Persian versions of *Subah-O-Sham/Homa-ye Sa'adat*, each with its own diegetic music, Jamileh is soon joined by an entourage of dancers. A cut reveals Shirin among the members of the audience, as she attentively watches Jamileh dance while waiting for Aram to join her at their designated meeting place. The cabaret sequence, motivated by the film's shooting on location in Tehran, presents a racy routine that is emphatically framed as a special display of Iranian culture for its equally cosmopolitan Indian audience, the irony being that Jamileh's dance style was categorized in Iran as having been drawn from those of Hindi cinema.[75] Shirin is positioned as the prime (Indian)

FIGURE 43. Still from *Subah-O-Sham* (1972): Belly dance cabaret sequence featuring a cameo by popular Iranian dancer Jamileh.

spectator, who watches the performance intently and appreciatively, while Aram arrives only after it ends.

The nightclub scene further highlights Tehran's jazzy modernity through shots that emphasize, in both versions, social dancing that cuts across genders. When Aram arrives, Shirin tells him that he missed a wonderful performance, to which he replies in the Hindi version, "But I am quite sure that dance would not have been anything like your dance." Aram's compliment leads into a conversation in which he asks her where she learned to dance, and after explaining that her mother was also a dancer, she says in the Hindi version, "Often, that which we cannot say with our tongue we can express so easily through the gestures of dance" (clip 13). Shirin's explanation of gestures' abilities to transcend language barriers is strikingly similar to Sakharam's explanation of Lakshmi's dancing in *Pardesi/ Khozhdenie*, as detailed in chapter 3.

Roughly bookending a period of the long 1960s, both films present conversations that explicitly remark that dance in general and expressive, gestural Indian dance styles in particular can transcend barriers of language and speech. In both coproductions, presentations of dance within the film—as ekphrastic invocations of the song-dance sequences for which commercial Hindi films were known abroad—are in this way translated by Indian characters, who teach their foreign companions to appreciate and understand a form whose value and meaning lies in the fact that it can be universally comprehended. While this apparently universal comprehension is paradoxically belied by the Indian characters' explanatory dialogue, in both cases, the cross-cultural value of such gestural modes is acknowledged as being realizable only through the spectator's grasp of their value and openness to learning how to appreciate their expressivity. In *Subah-O-Sham/ Homa-ye Sa'adat*, the initial declaration of "I love you" also occurs not through speech but through gestural modes in both versions.

The fraught cultural politics of dance—especially in terms of its associations with public displays of feminine sexuality—propel defensive justifications of dance as art in both films, although Shirin's occupation as a dancer as well as her status

CLIP 13. Belly dance cabaret sequence from *Subah-O-Sham* (1972).

To watch this video, scan the QR code with your mobile device or visit
DOI: https://doi.org/10.1525/luminos.130.13

as a trafficked woman remain a much more central problem in *Subah-O-Sham/ Homa-ye Sa'adat*.[76] At one point early in the film, Aram caustically asks Shirin in the Hindi version, "What can be the difference between a prostitute and you?" Later, when she is inside her home, the elderly man who acts as Shirin's manager urges her to get ready for her evening program, though she refuses, reflecting over Aram's words and remaining adamant that she no longer wishes to dance for money. Having fallen in love with Aram, Shirin decides that she will dance only to express her love for him and drink only the wine of their love.

The song that constitutes a titular reference in the Hindi version punctuates a reconciliation between Shirin and Aram after Aram apologizes, and the two of them meet along a sparkling beach. Shirin in a peach salwar-tunic bedecked with crystals and Aram in a dapper tan suit wear the glamour of their stardom against a backdrop that offers touristic views of the Caspian Sea (clip 14). Shirin begins to croon, in the voice of Lata Mangeshkar, "*saaqii kii zaruurat hai na jaam kii zaruurat hai, hamko to sanam tere bas naam kii zaruurat hai, subah kii zaruurat hai na*

CLIP 14. *"subah-o-sham"* song sequence from *Subah-O-Sham* (1972).

To watch this video, scan the QR code with your mobile device or visit
DOI: https://doi.org/10.1525/luminos.130.14

shaam kii zaruurat hai, hamko to sanam tere bas naam kii zaruurat hai" (There is
neither a need for a cup-bearer nor a need for wine, for me, my dearest, there
is only the need of your name; there is neither a need for dawn nor a need for dusk,
for me, my dearest, there is only the need of your name.) Aram, with whom the
audience is aligned in watching Shirin dance, is smitten with love, as the formal
and libidinal excess of song-dance is removed from the space of the bazaar and
placed in the domain of love—construed allegorically as a space of cinephilia that
arises from consent and reciprocity rather than a space of transaction that arises
from greed and exploitation.

The issues of class difference that lurk beneath Shirin and Aram's relationship
surface after Aram's brother Nasir accidently lets slip in front of their mother that
Aram has a romantic interest. To preemptively stanch her objections, he lies
that Shirin is the daughter of an Indian maharajah. When Aram's mother
insists that their families meet, Nasir and Aram pull a very hesitant Shirin into

FIGURE 44. Still from *Subah-O-Sham* (1972): A shot of domed architecture, from a touristic montage that highlights a series of Iranian monuments as well as views of Tehran by day and night.

the charade. Aram's mother buys the charade, and she remains extremely pleased with the prospect of having Shirin, whom she thinks is an Indian princess, for a daughter-in-law. The Hindi version foregrounds Aram's mother's modern attitudes, which gel with her class status and are made explicit when she encourages Aram to go out on an extended excursion with Shirin, having approved of her and her (supposed) family background. She tells Aram in the Hindi version, "It is very important to get to know one another before marriage."

With the encouragement of his mother, Aram takes Shirin along for a tour of Iran. This segment, which does not appear in extant Persian versions, is delivered in a travel-documentary-style voice-over, as Aram provides commentary over a montage of shots that pan over a series of national monuments and attractions that were standard fare in other contemporaneous Iranian prestige coproductions: the Shah Mosque in Isfahan, views of Tehran by night and day, the Golestan Palace, and the Peacock Throne (fig. 44). Through the entire sequence, as Shirin and Aram are not in the picture, the explanatory voice-over's effect is one of a direct address that presents the series of monuments and views through slow, panning movements of the camera over the structures and interiors of the monuments along with wide still shots of Tehran by day and night.

The opportunity of cinematic coproduction, in this case, is usurped as an opportunity to directly showcase and exchange views of one another's heritage, alongside the indirect showcasing that takes place through the cinematic exchanges between two sets of stars. Given Iranian audiences' familiarity with Hindi film stars, this exchange would have been readily apparent. In the Hindi version, however, the touristic vistas are offered as additional attractions that compensate for the fact that the Iranian stars would not have been widely recognizable as attractions to Hindi film enthusiasts. Toward the end of the touristic montage of Iranian monuments in the Hindi version, the score abruptly changes with a cut to a shot of swans in a lake, as the earlier soft music of a zither is replaced by bold, jazzier strains that announce the beginning of a song sequence. Aram and Shirin sit in

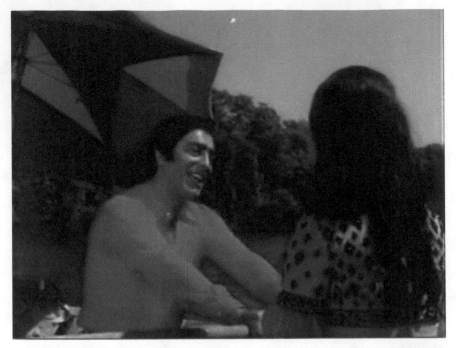

CLIP 15. Touristic sequence and beginning of "*terii merii merii terii nazar lad gayii*" song sequence from *Subah-O-Sham* (1972).

To watch this video, scan the QR code with your mobile device or visit
DOI: https://doi.org/10.1525/luminos.130.15

a colorful rowboat in the middle of a deep blue lake, as they alternate in a duet that features the voices of playback singers Kishore Kumar and Asha Bhosle, "*terii merii merii terii nazar lad gayii*" (Your gaze wrestled with mine, mine with yours).

While the style and sound of the back-to-back sequences—the touristic montage and the romantic duet (clip 15)—are markedly different, they both celebrate the specificity of cinema as a medium that allows for audiovisual cultural exchanges across language and geography. The touristic montage directly addresses an overseas audience, and the romantic song revels in a romance of consent as reciprocity, as it is the first song that occurs as a duet between Hindi film star Waheeda Rehman/Shirin and Persian film star Fardeen/Aram. The end of the song sequence gives way to a sitar *jhaalaa*, a fast-paced musical conclusion that bridges a montage of ancient Indian stone sculptures—similar to those featured in *Pardesi/ Khozhdenie*—of various deities in poses of erotic communion, superimposed over a twilight beach landscape. The figures are not only suggestive of consummation but also highlight and celebrate the nature of a cross-industry, star-studded tryst that is bookended by montage sequences of monuments, Iranian on one side and

Indian on the other. With a sudden cut, Shirin and Aram are shown in conversation on a beach, with Shirin regretting aloud that she let herself go while Aram assures her not to worry, as they will anyway be married.[77] The context—that they have had sex—is clear, and despite Shirin's misgivings, the sincerity of their passion is sanctioned by the monuments that stand both as witnesses to the lovers' consummation and as participants in a tryst of their own, through an exchange of stars and vistas afforded by intimacies of the coproduction.

Naturally, all that is well cannot end well just yet. The burden borne by the narrative in having to successfully transform not Shirin but the upper-middle-class milieu that shuns her occurs as an ekphrastic engagement with the contemporaneous burden borne by Hindi films in having to defend their merits both domestically and overseas. The resolution offered by *Subah-O-Sham/Homa-ye Sa'adat* comes about through labors of love on multiple levels, deployed as a wedge to drive apart the insistent coupling of exploitation and profit in order to make room for both love and art. The elderly man who acts as Shirin's manager proves himself a villain by blowing her cover purposely, thinking that she will then be forced to return to him and resume her dancing. In speaking to Aram's mother, he refers to Shirin as *maamuulii raqqaasaa*, an ordinary dancing girl, in the Hindi version. Enraged, Aram's mother confronts Aram in both the Hindi and Persian versions. Aram boldly retorts that he will marry no other and that he will simply leave the household if Shirin is unwelcome. Aram's mother's next move is to pay Shirin a visit and offer her a large sum of money with the assumption that Shirin is simply after wealth. When Shirin insists that she wishes to wed Aram out of love itself and not for money, Aram's mother in turn implores Shirin to let go of Aram for the same reason—that is, out of love itself. The elderly woman tells Shirin that by marrying Aram, she will ruin his life, as the stigma that she carries as a dancing girl will irrevocably damage him socially and professionally.

As with Aram's mother's attempt to pay Shirin, every economic transaction in the film becomes a test of character, and the appearance of money in any scene portends only the worst. Earlier in the film, the workers who were easily bribed to play the parts of the maharajah's entourage are shown as not only boorish and gluttonous but also dishonest in attempting to steal extra cash from inside the house. The thick wads of cash that Aram's mother offers Shirin in exchange for leaving her son both carry the mother's mistaken assumptions of Shirin's greed and foretell of the heartache of separation. Taking Aram's mother's words to heart, Shirin puts on her own charade so that Aram will distance himself from her in both versions, for his own good. She lets Aram come to her while she puts on an appearance of being intoxicated, and she tells him that she tricked him as she has done with many other men of his class, whom she seduces in order to extort large sums of money from their mothers, who inevitably bribe her to leave their sons. She enhances her

charade with the wads of cash that Aram's mother had in fact left her, which Shirin waves under Aram's nose as proof of her supposed scheme.

Aram responds not only by insulting Shirin by calling her a base and vicious woman but also by calling her Indianness into question. Crushed by what he beholds—that Shirin's love was apparently only a façade for her greed—he slaps her in anguish and says in the Hindi version, "Now I see how base and vicious a woman you are! Indian women are never dishonest! They will put their own lives at stake, but they will never disgrace their own love! And even this I doubt, that the blood in your veins is Indian!" The whole scene in the Hindi version and the slap in particular in Hindi and Persian versions are dramatized by loud musical chords. Before leaving, Aram sarcastically adds that if it is money that Shirin is after, then he might be able to send a few of his friends her way.

To taint love with money constitutes the ultimate disgrace, and for Aram, it is unthinkable that an Indian woman would do such a thing. While Shirin is in a sense playing a part that is scripted for her by her occupation as a dancing girl/café dancer whose body is publicly available for sale, this script of questionable virtue remains at odds with her Indianness, the film suggests. The dramatic irony of the film's narrative is drawn out through the fact that the audience knows that it is the sincerity of Shirin's love that drives her to take on the overdetermined role of a dancing girl who sells her body, and the second half of the film takes several twists and turns in order to arrive at the resolution that comes about through Aram's recognition of Shirin for what she is: a woman who is unwavering in a love that is uncontaminated by economic motivations, her profession notwithstanding.

The film is critical not only of economies of greed that are tied to bribery but also of classist attitudes that hinge conjugal arrangements upon desires for status and wealth. The marriage between Aram's brother Nasir and his wife, Afzaan, implied to have been arranged by his mother, is a comedic caricature of an unhappy, bickering couple. At one point when Afzaan picks a fight with Nasir in the bedroom, a playful song sequence in the Hindi version lampoons their pairing, as Nasir expresses his confoundedness over why Afzaan is always angry and unhappy through the voice of Mohammed Rafi in the bouncy number, "*merii biivii jahaan se niraalii hai, jaan zaalim ne merii nikaalii hai*" (My wife is one of a kind in this world, her tyranny has vanquished my life). The comedic song sequence includes such verses as "*har ghadii mujhse ladne ko taiyaar hai, merii taubaa ye kitnii vafaadaar hai, mujhko jannat mile ya jahannum mile, har jagah saath ye jaanevaalii hai*" (She is prepared to fight with me at every moment, it's incredible that she is so loyal, whether I am sent to heaven or hell, she will be there wherever I go).

Utterly disillusioned by what Aram regards as Shirin's betrayal, Aram apathetically agrees to marry Nazneen, a woman his mother chooses for him, and the second loveless marriage of the household goes forward. Nazneen turns out to be an exaggeratedly poor wife and mother who perpetually smokes, gambles, and

goes out to nightclubs with her girlfriends. The deplorable foundation of status and wealth that drives the alliance between Aram and Nazneen is juxtaposed with Shirin's selflessness in coming to see Aram's mother on the day of the wedding in order to return the money that Aram's mother had offered her as a bribe. Before Shirin is able to leave, Aram enters the room, angrily asks whether she has come in pursuit of more money, and spitefully declares that he will pay her more than any other rich man she has had.

Serving Shirin the crowning humiliation of dragging her downstairs despite her protests as well as those of Nasir in both versions, Aram announces before the wedding guests that Shirin will dance before them as the hired entertainment of the evening. In an elegiac, mournful melody sung by playback singer Lata Mangeshkar in both a 122-minute Persian version and 158-minute Hindi version, Shirin renders a song that is laced with pathos as she dances and wryly sings: "*tumko mubaarak ho ye shaadii khaanaa aabaadii*" (Congratulations to you on this wedding, this making of a prosperous home). The mournful melody calls into question the assumed happiness of the occasion. A verse of the song states, "*pyaar nasiibon se miltaa hai, har ek phuul kahaan khiltaa hai*" (Those who are fortunate find love—where is it that every flower blooms?) The lines characterize love as something that makes one fortunate, as well as something that is a privilege limited to those who are more fortunate in terms of their class status.

The blind spots of the film's critiques of class hierarchies and prejudices are evident in its earlier scenes of the working-class "actors" hired to perform as the fake-maharaja's coterie in order to convince Aram's mother that Shirin is an Indian princess. The working-class men are depicted as obscenely ill-mannered and unrefined, in addition to being greedy insofar as they are willing to do anything for material gain. Similarly lumpen men are depicted in later scenes as ruffians who are prone to aggression and more than willing to be paid off for their acts of violence. *Subah-O-Sham/Homa-ye Sa'adat* strains itself to place Shirin—who is metonymic for Hindi song-dance films—within a space of respectability, while not only distancing her from a working-class milieu that is perceived to be unrefined but also critiquing the cold rigidity of an upper-middle-class segment that enjoys her performances but stigmatizes her as a person who engages in this form of (forced) labor. For the film to arrive at its resolution, the tables of class have to be turned through lessons learned on all sides, as labors of love are melodramatically divorced from those of profit.

In the film's insistent opposition between the libidinal excess of love and the capital excess of greed, the sole character who remains irredeemably villainous is the elderly manager, who aims to manipulate and control Shirin in order to profit from the exhibition of her body. He inquires over her whereabouts with two neighborhood ruffians, who point Nasir out as he goes to and fro, visiting Shirin's

apartment quite regularly to look in on her. The ruffians assume that the two are having an affair, and they are eager to play police and beat Nasir up. The elderly man offers them cash to do so, and the visibility of money signals his violent, exploitative, and greedy intentions. Although Nasir financially supports Shirin by renting an apartment for her and bringing her groceries, cash remains completely out of view during the interactions between them, and Nasir's intentions toward her are shown to be uncontaminated by greed or lust.

The film's climax occurs when Aram returns from Ahvaz to Tehran for a visit and trails Nasir to investigate why he has been wandering off. Aram is furious to find Nasir in Shirin's company, and he assumes that Nasir has been a client of Shirin's in an ongoing affair. He deduces that Razak, the fatherless boy who is a classmate of his and Nazneen's son, Romin, is "the fruit of your sins," to which Shirin emotionally indicts Aram's misplaced suspicions as she finally reveals to him that Razak is in fact "the delicate flower of our love." In both Hindi and Persian versions the distinction between sinful and chaste reproduction occurs outside of any invocations of legitimacy through marriage, instead drawing on a distinction between sex/cinema that is motivated by profit, on the one hand, and that which emerges out of love, on the other.

The chain of events by which Shirin will eventually take the place of Nazneen in the house as a wife and mother is set off when Nazneen bribes the same neighborhood ruffians to kill Shirin and Razak. However, because Romin happens to be playing with Razak, the ruffians end up taking all three of them toward Shiraz, which Aram's mother comes and tells Nazneen in a panic. Nazneen, too, begins to panic, and she and Aram's mother speed in the direction of Shiraz. Meanwhile, Nasir and Aram have also chased the ruffians, whom they fight and defeat through a finale action sequence. Shirin and the boys are rescued just as Nazneen's car approaches, veers of the road, and meets with a collision. Nazneen sustains lethal injuries, and as she dies, she asks for forgiveness and urges Shirin to step in and be a mother to Romin.

An earlier scene in both versions, like the intertextual references to Waheeda Rehman's other roles as a dancer-actress, reflexively foregrounds the coproduction as a showcase of its stars. This cross-industry labor of love is rendered through the love story between its romantic leads and the brotherly relationship between its male leads. During an initial chance encounter between Razak and Aram at a train station, neither recognizes the other, although Razak says to Aram, "Excuse me, sir, you look just like my favorite film star!" (fig. 45) In the aftermath of the fight-sequence finale and Nazneen's death against the backdrop of the desert landscape of Shiraz, Razak says to Nasir, "Excuse me, Uncle—is that film star my father?" Nasir confirms, and Razak and Romin are happy to find that they are in fact brothers. In the Persian version, this moment is extended, as the brothers hold hands, prance about, and joyfully exclaim, "We're brothers, we're brothers!"

The Hindi version ends as the camera zooms out to a wide shot of the landscape that shows the members of the family walking toward the center and embracing

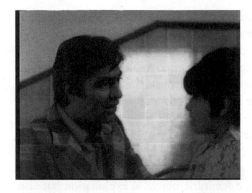

FIGURE 45. Still from *Subah-O-Sham* (1972): "Excuse me, sir, you look just like my favorite film star!"

one another. The Persian version extends this slightly, to show the family getting into their cars and driving off. While a dramatic Western orchestral score had accompanied the fight scene, this score is overtaken by a jazzy melody that incorporates more generically Eastern instruments and motifs, as the newly (re)constituted family is drawn together in the Persian version's closing moments. In both the Persian and Hindi versions, the conclusion envisions a postnational third-world modernity constituted by cinema, as a force that engenders intimacies of brotherhood and love. With Razak's realization that his father is his favorite film star, Fardeen merges with the character of Aram as a figure of Persian cinema, who is joined together with Waheeda Rehman/Shirin as a figure of Hindi cinema. Shirin has finally overcome the stigma of her profession as a dancing girl/café dancer, as Aram's upper-middle-class milieu has been moved to finally accept her within a domain of love and art, rather than relegating her to a domain of greed and profit.

In *Subah-O-Sham/Homa-ye Sa'adat*, as in *Pardesi/Khozhdenie*, the project of coproduction is in this manner allegorized through transnational diegetic romances and brotherly exchanges, which vociferously distance themselves from motives of profit and lust. Love, within the diegesis of each film, is imbued with the potential for constituting cross-cultural social formations against the grain of hierarchies of caste, class, and nation. Nonetheless, both films rhetorically subordinate the libidinal excess of romantic love to their ethical constructions of a homosocial world through reciprocal, fraternal exchanges between brothers. The project of "films for friendship"—in the words of *Pardesi/Khozhdenie* codirector K. A. Abbas –becomes a project of cross-industry exchanges in *Subah-O-Sham/Homa-ye Sa'adat*, with coproduction reflexively extolled as a primary end in itself rather than as a strategy of cofinancing.

Ekphrastic concerns over the form, function, and value of cinema, in addition to material contexts of informal distribution, are negotiated within the diegetic spaces of both *Pardesi/Khozhdenie* and *Subah-O-Sham/Homa-ye Sa'adat*. Both extol the value of cinema as a medium that is accessible to a vast public, as they defend the seductions of song-dance-based modes of expression that are beloved by audiences across lines of class, language, and nationality. Read as ekphrastic arguments about

cinema, cross-industry productions like *Subah-O-Sham/Homa-ye Sa'adat* contain a plethora of fragments that reference a world of networked media capitals (e.g., Bombay, Madras, Moscow, Tehran) and distribution circuits in the world, outside the contemporaneous arena of so-called world cinema. Analogous to the cleavage of voice and body precipitated by the practice of playback, the cleavage of language and (dual) authorship wrought by the coproductions' self-presentation turns the seams of the films' production outward, inviting their audiences to take pleasure in the cinematic romances at hand and to themselves participate in the exchanges of songs, stars, landscapes, monuments, and friendships that are on offer onscreen.

Subah-O-Sham/Homa-ye Sa'adat not only depicts and allegorizes the trafficking of Indian films through Shirin, as a feminine object of exploitation but also offers a pedagogical response to contemporaneous statist concerns ensuing from this material context of informal distribution. *Subah-O-Sham/Homa-ye Sa'adat* engages the anxieties over smuggling and unreported foreign exchange that prompted the establishment of IMPEC in the first place, as well as anxieties over "third-rate" Indian song-dance films circulating as exploitation fare overseas. It additionally engages contemporaneous anxieties on the part of Iranian filmmakers over the competition that Indian song-dance films posed to Iranian films and the one-sidedness of their popularity in Iran. *Subah-O-Sham/Homa-ye Sa'adat's* proposed solution is neither to eliminate the formal and libidinal excess of commercial Indian films nor to clamp down on their circulation among foreign audiences. Rather, the ekphrastic registers of *Subah-O-Sham/Homa-ye Sa'adat* suggest that Hindi cinema audiences take pride in the merits of its song-dance-based modes of popular cinema and its insistently modern production value, at the same time that foreign (e.g., Iranian) audiences view the libidinal excess of Hindi song-dance films as a sincere, embodied form of expression that inspires love above and beyond greed or exploitation. The film thus celebrates the sincerity of the Hindi celluloid object's song-dance expressions for its ability to inspire equally sincere affections in the foreign lover-cinephile—rather than mere customer—in its forays abroad.

Subah-O-Sham/Homa-ye Sa'adat encodes the intimate labors of cross-industry diplomacy in the feminine figure of Shirin as a stand-in for Hindi song-dance films circulating among foreign audiences. Thus, the film's vision and practice of world-making extolls popular cinema's propensity to catalyze fraternal and familial bonds among its audiences, distributors, and producers across and beyond Madras, Bombay, and Tehran. Shirin-as-cinema, in the closing moments of the film, is the embodied (re)productive force that restores the fraternal intimacy between Aram/Fardeen and Nasir/Sanjeev Kumar, as two male stars who are emblematic of their respective industries. In addition, the motif of adoption, with which the film opened in its characterization of Shirin as an artist adopted

by Iran despite her Indian origins, is re-invoked in the closing moments of the film.[78] Shirin's integration into Aram's (that is, the Persian film industry's) family seals her own adoption process. Furthermore, her adoption of Romin solidifies the bonds between him and Razak, who are envisioned as the assured future of a cross-cultural brotherhood[79] that constitutes the (re)productive aspirations of the coproduction.

This layered, fraternal microcosm constitutes *Subah-O-Sham/Homa-ye Sa'adat*'s closing argument. The film ekphrastically renders the intimate reciprocities of its own coproduction across chasms of language, class, industries, state borders, and national borders. These cinephilic reciprocities, the film argues, are made possible through song-dance modes of Hindi cinema, through stars as figures of a global-popular imagination of modernity, and through modes of commercial filmmaking whose excesses of scale were well suited to world-making imperatives of a Cold War, nuclear age. In *Subah-O-Sham/Homa-ye Sa'adat*, it is the libidinal excess of love-as-cinephilia that finally overcomes exploitative hierarchies of transaction to engender an insistently modern, postnational world constituted through the scalable intimacies of cross-cultural cinematic exchanges. Not unlike heteropatriarchal Indian statist discourses that perceived what was beyond its control through the ostensible excess of feminine sexuality, *Subah-O-Sham/Homa-ye Sa'adat*, too, conflates feminine sexuality with the libidinal excess of Hindi films' song-dance modes. In contrast to a statist discourse that perceived this excess as a threat, however, *Subah-O-Sham/Homa-ye Sa'adat* instead defends this excess by extolling its (re)productive capacity for world-making through the reciprocity of love-as-cinephilia, beyond the limiting forms of either upper-class conjugality or the nation-state.

The telling irony of this argument is that *Subah-O-Sham/Homa-ye Sa'adat* was not (re)productive of much, at least in an Indian context, where it flopped. One could say, in this regard, that it was destined for the bangle factory. Such an expression, premised on an equation of femininity with inconsequence, ensues from a material and affective history of economic value that begs for an excavation— for a visit to the bangle factory, so to speak. Indeed, objects like *Subah-O-Sham/Homa-ye Sa'adat* allow us to weigh the historical terms of their failures and devaluations in spite of their ambition and insistence that the world could be otherwise and that cinema had the potential to make it so. Throughout this book, I have taken up such objects not to uncritically reinvest them with value, but to dwell upon the very politics of their inconsequence, then as well as now. I remain enamored with each and every film that I have discussed in this book, even as I find them deeply flawed. There is little need to resolve these contradictions, as loose ends are—like the excess of feminine sexuality—perhaps all too often regarded as something in need of tying up.

ACKNOWLEDGMENTS

A concatenation of interactions has somehow turned into an object that bears my name. I lack the words to adequately thank all who have had a hand in this alchemy. As wholeheartedly expressed by Dara Singh in *Chalbaaz* (Kamran, 1969) through the voice of Mohammed Rafi in a song composed by Lala Sattar and penned by Farooq Qaiser: *shukriyaa aapkii inaayat kaa mehrbaan shukriyaa*. Thank you, for gracing me with your kindness, thank you.

To Betty Joseph, Kirsten Ostherr, and Ratheesh Radhakrishnan, who have led by example in their generosity as scholars and mentors-turned-friends. To Tani Barlow, Jeffrey Kripal, Joseph Campana, Elora Shehabuddin, Indranil Dutta, Charles Dove, Tish Stringer, Rachel Boyle, and guest appearances by Moinak Biswas, Nitya Vasudevan, Priya Jaikumar, and Subhajit Chatterjee, who contributed to my strangely carefree, yet edifying, time at Rice University—due in no small part to Rice Cinema, the Center for the Study of Women, Gender, and Sexuality, and the Chao Center for Asian Studies.

To Jennifer Rickel, Kattie Bassnett, Caroline Olivia Wolf, Uzma Quraishi, Ana-Maria Seglie, Başak Demirhan, Heba Khan, and Olivia Banner, whose friendships have remained the best takeaways from graduate school. To Katie Sullivan for the nerve-quelling reminders not to take things so seriously. To JD Pluecker for Russian-translation insights and for reminding me, with their existence, that words do matter. To Prathiba Natesan, Kirti Gandhi, Gaitry Sharma, Veena Courtney, Ramesh Bosamia, Ashwin Rode, and Harsh Narayan (and family) for being along for the ride, then and now.

To Tina Sabuco, Shellye Arnold, Anissa Dwiggins, Wendy Haardt, and all the Arts Alive! Inc. Lous, who invited me to play along and experience such joy through teaching and dancing with "smaller" groups of students.

To SV Srinivas, Tejaswini Niranjana, Ashish Rajadhyaksha, Madhuja Mukherjee, Chen Kuan-Hsing, Nishant Shah, Namita Malhotra, Baidurya Chakrabarti, Ayesha Mualla, and Sabreena Ahmed, who were part of my experience of (un)learning so much over the course of the Bangalore Inter-Asia institute that I was fortunate to attend several summers ago.

To Arti Kharkhanis and Veena Kshirsagar for their knowledge and guidance through several lovely months—spent many years apart—at the National Film Archive of India.

To Sonja Mechjer-Atassi, Adam J. Waterman, Sirene Harb, Tariq Mehmood, Rima Iskandarani, Marwa Ramadan, Michael Vermy, Tariq Mehmood, Wafaa Abudllatif, Anaheed Al-Hardan, Maya Kesrouany, Alireza Khatami, Sumayya Kassemali, Tamara Abdul-Hadi, Rita Topdjian, Hana Nimer, Angelina Bertrand, and Esmat Elhalaby, who I was lucky to know as colleagues and friends in and around the American University of Beirut, as well as the Migrant Community Center – Beirut.

To Hatim El-Hibri, Tania Haddad, and Nazanin Shahrokni, who are nothing short of gifts, as are Darshana Sreedhar Mini, R. Benedito Ferrão, Alia Yunis, Nadya Sbaiti, and Anjali Nath. Your impossibly bright collective being has shined through mountains of disenchantment and grief.

To my chairs at the University of Virginia, Farzaneh Milani and Nizar Hermes, and to my associate deans, Francesca Fiorani and Alison Levine, who have unwaveringly supported and encouraged me through this process. To Cameron Clayton and Tishanna Johnson, without whom nothing would get done. To each and every one of my colleagues in the Department of Middle Eastern & South Asian Languages & Cultures (MESALC), including Mehr Farooqi for reading portions of the manuscript; Shankar Nair, Hanadi Al-Samman, and Tessa Farmer for their additional book-writing wisdom; Abdul Nasir for discussing the minutiae of adequate English equivalents for a word or phrase, here and there; and Mahshad Mohit for watching (and delivering live translations!) of unsubtitled Persian films.

To Debjani Ganguly, Camilla Fojas, and Anne Gilliam in the UVA Institute of the Humanities and Global Cultures, and to my fellow Mellon Humanities Fellows for the chance to share and tinker with our works-in-progress.

To Geeta Patel, my mentor who went above and beyond any reasonably required effort to offer feedback and advice, as well as Manishita Dass, Aswin Punathambekar, Kaveh Askari, Anupama Prabhala, Katelyn Knox, Sarah O'Brien, and the anonymous reviewers, whose magnanimous, collective feedback has infused the best parts of every page. To Barbara Armentrout and Rye Gentleman for the incredible attentiveness of their copyediting and indexing, respectively.

To my non-MESALC colleagues at the University of Virginia in whose company I am honored to find myself: Paul Dobryden, Aynne Kokas, Maya Boutaghou, Chris Gratien, Joshua M. White, Sylvia Chong, Ahmed al-Rahim, Jim Igoe, Fahad Bishara, Nomi Dave, Noel Lobley, Mrinalini Chakravorty, Lana Swartz, Kevin Driscoll, Shilpa Dave, Natasha Heller, Federico Cuatlacuatl, Mandira Banerjee, Nitya Kallivayalil, Simone Pollilo, Ajay Limaye, Nasrin Olla, Swayam Bagaria, and Pallavi Rao. To Jody Kielbasa and Chandler Ferrebee for the chance to collaborate through the Virginia Film Festival. To Phil McEldowney and Leigh Rockey, among all the UVA library staff who labored to source countless films, periodicals, and books. To Caitlin Wylie, especially, for leading the writing group that worked so much magic on that dreaded blinking cursor and blank screen.

To Finnie Coleman, Robin Ellis, Tiffany E. Barber, Feyza Burak-Adli, Sreerekha Sathiamma, Bilal Hashmi, Nevila Pahumi, Taylor M. Moore, Zarrin Ansari, Gladness Msumanje, Angilee Shah, and the Nooria family who were, somehow, in just the right place at the right time.

To Karuna Mantena, Harry Blair, Kasturi Gupta, and Amaar Al-Hayder in the South Asia Studies Council at Yale University's Macmillan Center and to Dudley Andrew in the Film and Media Studies Program for the opportunity to be in residence for a semester. To Ayesha Ramachandran, Shawkat Toorawa, Kathryn Lofton, Navin Kumar, Rohit De, Ashish Koul, and M. Madhava Prasad, whose kindness I was lucky to encounter in this time.

To Negar Taymoorzadeh, Ada Petiwala, Claire Cooley, Anirban Baishya, Navaneetha Mokkil, Maithreyi M.S., Ramesh Bairy, Usha Iyer, Rumya Putcha, Swarnavel Eswaran Pillai, Monika Mehta, Sangita Gopal, Neepa Majumdar, Anuja Jain, Ritika Kaushik, Salma Siddique, Kartik Nair, Gohar Siddiqui, Debashree Mukherjee, Bindu Menon, Dale Hudson, and Firat Oruc, among a milieu of kindred travelers in this thing that we refer to as a "field." To Jenson Joseph for the ruthless feedback that I could not have done without.

To the *Cinema Cultures in Contact* series editors Richard Abel, Giorgio Bertellini, and Matthew Solomon, to whom I remain indebted for taking a chance on this project. To Raina Polivka, whose editorial patience and wizardry shepherded this project through a pandemic, and to Madison Wetzell, Julie Van Pelt at University of California Press and Paige MacKay at Ubiquity Press for working with me and bringing this to completion!

To my research assistants Sajedeh Hosseini, Ilma Qureshi, and Sophia Ali, whose enthusiasm has been contagious. To all of my students, from whom I continue to learn.

To my family, chosen and otherwise: To Chandra Auntie and David Uncle for their musical and non-musical gifts alike, to the Lims and Nguyens for adopting me, to Aadi for letting himself be adopted, to the Bandealis for embracing me as one of their own. To all my aunties, uncles, and cousins, by whom I'm blessed in

terms of both quality and quantity. To my three darling cats Ali, Kajra, and Selda, for all the extra spice and all the extra sweetness. To Amma and to my sisters Cherie and Apoorva for everything. To Anna and to my nieces and nephews for the memories: past, present, and future.

NOTES

"AKIRA KUROSAWA": A RETROSPECTIVE PROLOGUE

1. Iyer emphasizes distinctions between production numbers and narrative numbers (and their specificities in various moments of Hindi cinema) as a way of accounting for the varied genres of song-dance sequences whose material practices of production and production of social meaning are distinct. The production number, for example, proliferated in the post-independence period of the 1950s and 1960s through the composite labor of many: from women dancer-actresses to choreographers, to production designers. Iyer notes that production numbers in this period tended to marginalize the centrality of the couple and/or romance plot, in their spotlight on the spectacular excess and kinesthetic prowess of the star dancer-actress. Iyer, "Dance Musicalization"; Iyer, *Dancing Women*.

2. Dwyer, *Bollywood's India*.

3. Mukherjee, "Behind the Green Door."

4. Menaka is the name of an *apsaraa*, a heavenly dancer in the court of the Hindu deity Indra. Across several stories, apsaraas recur as feminine figures of erotic temptation through their dancing.

5. Gopal, *Conjugations*, 40.

6. Mooallem, "The 1940s."

7. A book of famous celebrity quotes, first issued in 1959, features a version of Vreeland's quote in its subsequent 1963 and 1973 editions: "You know, don't you, that the bikini is only the most important thing since the atom bomb?" Amory, Blackwell, and Probst, *Celebrity Register*, vol. 2, 636; Amory and Blackwell, *Celebrity Register*, vol. 3, 506.

8. Horvat poignantly writes: "Even today when we read or hear the word 'bikini' or when we encounter a two-piece swimsuit on the beach, we don't generally think about the nuclear experiments that left levels of radioactivity 1,000 times higher than Chernobyl. Yet, it is the word 'bikini'—like J. L. Borges's 'Aleph'—into which a whole Apocalypse can fit. . . .

Because it opens an ontological abyss in which it is not only the future of those local populations that disappeared, it is also our own future that is at stake and the future of the planet itself, given that the effects of the nuclear testings won't simply disappear even when the Marshall Islands vanish into the ocean. For instance, Plutonium-239 that was used in these tests has a half-life for radioactive decay of 24,000 years." Horvat, *After the Apocalypse*, 143.

9. Rajadhyaksha, *Indian Cinema in the Time of Celluloid;* Joseph, "Just a Buffalo, or Not?: A Nuanced Take on Lijo Jose Pellissery's Jallikattu."

10. Director Ranjit Kapoor states that his lyrics for "Akira Kurosawa" were intended as an homage to the "masters" of world cinema. Kapoor, "The Making of *Chintu Ji.*"

11. For a compelling account of "cine-politics" as a specific phenomenon that emerged in three out of the four major South Indian popular cinemas, see Prasad, *Cine-Politics.*

12. In this regard, the film departs from other contemporaneous films set in small towns, such as *Joker* (Shirish Kunder, 2012), a science fiction comedy that depicts a backward village finally gaining visibility through media representation. Several small-town Hindi films, like *Joker*, privilege the heroic masculinity of an upper-caste brahminical savior, who delivers small-town subjects from their own abjection. *Chintu Ji* inverts this to a significant degree, showing the film star "savior" himself as most abject and in need of deliverance by the Hadbadehians, who emerge collectively as the heroes. For an account of the politics of caste and masculinity in a spate of recent Hindi films set in small towns of North India, see Rao, "Soch Aur Shauch."

13. In a 1979 issue of *Illustrated Weekly of India*, for example, a columnist highlights Ray's birthday in a blurb that states, "If Phalke brought the motion picture to India, [then] Ray put Indian Cinema on the world map." Kelkar, "You Share Your Birthday with—Satyajit Ray," 59.

More recently, this narrative was repeated in a monograph on India's contemporary soft power: "Before Bollywood went global, India had internationally respected film makers like Satyajit Ray, whose first Bangla film, *Pather Panchali*, released in 1955, put India on the global cinema map, winning international critical acclaim and running for more than seven months in New York, a new record for foreign films released in the United States. Known internationally as a master craftsman whose deep humanism and attention to detail set the standard for serious cinema, Ray was presented with Legion d'honneur by the French president in 1990 and, in 1992, was awarded an Oscar for Lifetime Achievement in film, the only Indian to be thus honored." Thussu, *Communicating India's Soft Power*, 151. In both pronouncements—as well as other similar ones—"going global" is increasingly hinged to visibility in the US, as the US and Hollywood films ascended to global economic dominance after World War II. I detail this further in chapter 1.

INTRODUCTION: "ROMANCE, COMEDY, AND SOMEWHAT JAZZY MUSIC"

1. Van Fleit Hang, "'The Law Has No Conscience'"; Gürata, "'The Road to Vagrancy': Translation and Reception of Indian Cinema in Turkey"; Fair, "They Stole the Show!"

2. Abbas, *I Am Not an Island*, 380.

3. Abbas, 380.

4. Meiyappan, "Statement of Events as They Happened," 1.

5. Talwalker, "Shivaji's Army and Other 'Natives' in Bombay."

6. "Thackeray Wants Panel to Cure Film Industry's Ills."

7. Prashad, *The Darker Nations*.

8. Bhagavan, *The Peacemakers*.

9. Gulzar, "Lyrics 1903–1960"; Mazumdar, "Aviation, Tourism and Dreaming in 1960s Bombay Cinema"; Booth, "R. D. Burman and Rhythm"; Sawhney, "An Evening on Mars, Love on the Moon"; Sunya, "On Location."

10. Swapnil Rai is among scholars who have explored histories of women not only as actresses but also as businesswomen in the Bombay industry's production cultures. These crucial contributions of women as producers and businesswomen tended to go against the grain of an industry whose practices *and* imaginations often tended to be rather homosocial. Rai, "From Bombay Talkies to Khote Productions."

11. For excellent, detailed accounts of specific dancer-actresses, see Iyer, *Dancing Women*; Iyer, "Bringing Bharatanatyam to Bombay Cinema: Mapping Tamil-Hindi Film Industry Traffic through Vyjayanthimala's Dancing Body"; Bhurgubanda, "Travels of the Female Star in Indian Cinema of the 1940s and 50s: The Career of Bhanumathi."

12. Marwick, *The Sixties*; Jian et al., *The Routledge Handbook of the Global Sixties*.

13. I take this term from Maasri. She frames Beirut as a nodal point of the global 1960s in her compelling history of the city as a crucial node in global aesthetic and political movements, as they unfolded through translocal visual cultures of graphic design over the decade. Maasri, *Cosmopolitan Radicalism*.

14. See, for example, Maasri; Quraishi, *Redefining the Immigrant South*; and Gerhardt and Saljoughi, *1968 and Global Cinema*.

15. Ramachandran, *The Worldmakers*.

16. Chow, *The Age of the World Target*.

17. Chow; Shaw and Youngblood, *Cinematic Cold War*; Ginsberg, "The McCarthyist Foundations of Academic Cinema Studies"; Gharabaghi, "The Syracuse Mission to Iran during the 1950s and the Rise of Documentary Diplomacy"; Ginsberg, "Cold War Foundations of Academic Film Studies."

18. Cinema's relationship to diplomacy—and propaganda—in the world was of grave concern well before World War II. See, for example, Dobryden's argument that diplomacy through cinema, like espionage, constituted war by other means in post–WWI Germany; or Jaikumar's multi-sited history of cinema at the end of the British Empire in India, which details cinema's role in imperial propaganda in the colonies. In addition, notions of world cinema in film criticism, as Dass points out in late colonial Bengal, preceded the more particular institutionalization of world cinema as a category that crystallized in post–World War II Europe. In other words, while a post–WWII European discourse institutionalized the category of world cinema in criticism and through festivals and other institutions, this is not to say that a sense of cinema's relationship to worldmaking and diplomacy had not existed before. Dobryden, "Spies: Postwar Paranoia Goes to the Movies"; Jaikumar, *Cinema at the End of Empire*; Dass, "Distant Observers."

19. Chow, *The Age of the World Target*.

20. Danan, "Dubbing as an Expression of Nationalism."

21. Betz, *Beyond the Subtitle*.

22. In a 1979 issue of *Illustrated Weekly of India*, for example, a columnist highlights Ray's birthday in a blurb stating that "if Phalke brought the motion picture to India [then]

Ray put Indian Cinema on the world map." Kelkar, "You Share Your Birthday with—Satyajit Ray," 59. More recently, this is repeated in a monograph on India's contemporary soft power: "Before Bollywood went global, India had internationally respected film makers like Satyajit Ray, whose first Bangla film, *Pather Panchali*, released in 1955, put India on the global cinema map, winning international critical acclaim and running for more than seven months in New York, a new record for foreign films released in the United States. Known internationally as a master craftsman whose deep humanism and attention to detail set the standard for serious cinema, Ray was presented with Legion d'honneur by the French president in 1990 and in 1992 was awarded an Oscar for Lifetime Achievement in film, the only Indian to be thus honored." Thussu, *Communicating India's Soft Power*, 151. In both pronouncements—among other similar ones—"going global" is increasingly hinged to visibility in the US, as the US—and Hollywood films—ascended to global economic dominance in the aftermath of World War II. I detail this further in chapter 1.

23. Bazin, "De Sica: Metteur-en-Scène"; Majumdar, "Pather Panchali."

24. Majumdar, "Pather Panchali."

25. Majumdar.

26. Majumdar, 563.

27. Such omnivorousness seems to have been a condition of many filmmakers as well as audiences in Third World contexts. In her a forthcoming book-length examination of the Tashkent Film Festival, Masha Salazkina notes the exceptional status of the festival not only as a "contact zone" for filmmakers from across Asia, Africa, and Latin America over the 1960s and 1970s, but also as a festival whose program was uniquely broad in the range of films that it featured. Through a study of Tashkent, she invokes the term *world socialist cinema* to describe a capacious—yet important and vibrant—transnational milieu of films and film culture in this Cold War period. For a preview of this forthcoming project, see Djagolov and Salazkina, "Tashkent '68."

28. Dass, "The Cloud-Capped Star"; Mukherjee, "Arriving at Bombay."

29. Kaur, "Bertrand Russell in Bollyworld."

30. Rajadhyaksha, *Indian Cinema in the Time of Celluloid*; Prasad, *Ideology of the Hindi Film*.

31. Betz, *Beyond the Subtitle*.

32. Majumdar, "Debating Radical Cinema"; Majumdar, "Art Cinema"; Cherian, *India's Film Society Movement*.

33. Mazumdar, "Aviation, Tourism and Dreaming in 1960s Bombay Cinema"; Sunya, "On Location."

34. Prasad, *Ideology of the Hindi Film*.

35. Majumdar, "Art Cinema"; Oruc, "Petrocolonial Circulations and Cinema's Arrival in the Gulf"; Askari and Sunya, "Editors' Note."

36. While these binaries may seem to be iterations of a tradition-modernity binary, I am instead arguing that films idealized love (as/and cinephilia) as thoroughly modern and as an antidote to an extractive global modernity. I read this as a theorization of cinema's role in the world, rather than (only) as a theorization of an Indian modernity.

37. Wani, *Fantasy of Modernity*.

38. Wani; Orsini, *Love in South Asia*.

39. Wani, 13.

40. Wani, 13.

41. Chandra, *The Sexual Life of English*; Bairy, *Being Brahmin, Being Modern*; Jaaware, *Practicing Caste*; Mitra, "'Surplus Woman'"; Rao, "Soch Aur Shauch."

42. Majumdar, *Marriage and Modernity*; Chandra, *The Sexual Life of English*.

43. Mokkil, *Unruly Figures*, 28.

44. Chatterjee, *The Nation and Its Fragments*, 121; Yengde, "Dalit Cinema"; Chakravarti, *Gendering Caste*.

45. Wani paraphrases Ravi Vasudevan. Wani, *Fantasy of Modernity*, 6; Vasudevan, "'You Cannot Live in Society—and Ignore It.'"

46. Majumdar, *Wanted Cultured Ladies Only!*; Prasad, *Ideology of the Hindi Film*.

47. Mulvey, "Visual Pleasure and Narrative Cinema."

48. hooks, "The Oppositional Gaze: Black Female Spectators."

49. McHugh and Sobchack, "Introduction"; Iyer, *Dancing Women*.

50. Williams, "Film Bodies"; Paasonen et al., *Objectification*.

51. Naficy, "Theorizing 'Third-World' Film Spectatorship."

52. Such a portrayal of an Iranian social milieu aligned itself with the liberal, Western-backed regime of Shah Mohammad Reza Pahlavi in Iran.

53. Gopal, *Conjugations*.

54. Thompson, "The Concept of Cinematic Excess."

55. Salazkina, *In Excess*.

56. Williams, "Film Bodies," 3.

57. Majumdar, *Wanted Cultured Ladies Only!*; Wani, *Fantasy of Modernity*; Iyer, "Bringing Bharatanatyam to Bombay Cinema."

58. Prasad, *Ideology of the Hindi Film*; Majumdar, *Wanted Cultured Ladies Only!*

59. Mitra, *Indian Sex Life*.

60. Majumdar, *Wanted Cultured Ladies Only!*

61. Mokkil, *Unruly Figures*.

62. Rajadhyaksha, *Indian Cinema in the Time of Celluloid*.

63. Rajadhyaksha, 7.

64. Williams, "Film Bodies."

65. Thompson, "The Concept of Cinematic Excess."

66. Betz, *Beyond the Subtitle*.

67. Rajagopalan, *Indian Films in Soviet Cinemas*.

68. Keller, *Anxious Cinephilia*; Elsaesser, "Cinephilia or the Uses of Disenchantment"; Richards, *Cinematic Flashes*; Willeman, "Through the Glass Darkly: Cinephilia Reconsidered"; and Shambu, *The New Cinephilia*. Scholars have also broadened the term *world cinema*. See, for example, Limbrick, *Arab Modernism as World Cinema*; Andrew, "An Atlas of World Cinema"; Stam, *World Literature, Transnational Cinema, and Global Media*; Radhakrishnan, "The 'Worlds' of the Region." My account maintains a focus on world cinema's historical emergence in order to maintain the tension between the postwar institutionalization of world cinema as a category and Hindi cinema's negotiations of its exclusion from this category despite its prolific circulation throughout the world.

69. Keller, *Anxious Cinephilia*, 50.

70. Keller.

71. Keller; Valck and Hagener, *Cinephilia*; Elsaesser, "Cinephilia or the Uses of Disenchantment."

72. Dass, *Outside the Lettered City*.

73. Eleftheriotis and Iordanova, "Introduction."

74. Mehta and Mukherjee, "Introduction: Detouring Networks."

75. Majumdar, "Pather Panchali: From Neo-Realism to Melodrama."

76. Patel, *Lyrical Movements, Historical Hauntings*; Mir and Mir, "Progressive Poetry and Film Lyrics"; Khanna, *The Visceral Logics of Decolonization*.

77. Abbas, "Films for Friendship."

78. As Mitchell notes, ekphrasis "may refer to an object, describe it, invoke it, but it can never bring its visual presence before us in the way pictures do. Words can 'cite,' but never 'sight' their objects." Mitchell, "Ekphrasis and the Other," 152.

79. Gopalan, *Cinema of Interruptions*; Majumdar, *Wanted Cultured Ladies Only!*; Sarkar, "Metafiguring Bollywood"; Prateek, "Inward Bound: Self-Referentiality in Bombay Cinema"; Mukherjee, *Bombay Hustle*.

80. Mitchell, "Ekphrasis and the Other," 157.

81. Mitchell, 151–82.

1. PROBLEMS OF TRANSLATION: WORLD CINEMA AS DISTRIBUTION HISTORY

1. Nowell-Smith, *The Oxford History of World Cinema*, xix.

2. Andrew, "An Atlas of World Cinema"; Nagib, Perriam, and Dudrah, *Theorizing World Cinema*; Nagib, *World Cinema and the Ethics of Realism*; Dass, *Outside the Lettered City*, 2015; Deshpande and Mazaj, *World Cinema*; Stam, *World Literature, Transnational Cinema, and Global Media*; Limbrick, *Arab Modernism as World Cinema*.

3. Julian Stringer, "Global Cities and the International Film Festival Economy"; Rosalind Galt and Karl Schoonover, *Global Art Cinema*.

4. Valck, *Film Festivals*, 49; Rotha, *The Film Till Now: A Survey of World Cinema*, 323–25.

5. Rotha and Manvell, *Movie Parade, 1888–1949: A Pictorial Survey of World Cinema*, 6.

6. Rotha, *Movie Parade: A Pictorial Survey of the Cinema*, ix; Rotha and Manvell, *Movie Parade*, 6.

7. See Abel and Dobryden for accounts of tension over films and Americanization in Europe in earlier periods: first in the 1910s, then after World War I. Abel, *The Red Rooster Scare*; Dobryden, "Spies: Postwar Paranoia Goes to the Movies."

8. Danan notes: "American companies' monopoly on the entire European film industry was at its strongest between the early thirties and the early fifties. . . . American domination over all European markets reached its peak between 1949 and 1952." Danan, "Dubbing as an Expression of Nationalism," 608.

9. Betz, *Beyond the Subtitle*, 2. Emphasis mine.

10. Merziger, "Americanised, Europeanised or Nationalised?"

11. Merziger.

12. A body of emerging scholarship has started to explore practices of language translation across industries and publics, with a focus on the contemporary digital era. See, for example, the recent introduction to a dossier on screen voices: Dwyer and O'Meara, "Introduction." In the context of South Asia, this emerging work also includes anthropologist Tejaswini Ganti's current research on contemporary practices of dubbing for multinational and multilingual blockbusters: Ganti, "Blurring the Boundaries between Bollywood and Hollywood."

13. Nornes, *Cinema Babel.*

14. See Ascheid, "Speaking Tongues"; Danan, "Dubbing as an Expression of Nationalism"; Thompson, *Exporting Entertainment.*

15. Nornes, *Cinema Babel.*

16. Nornes.

17. Armes, *Third World Film Making and the West.*

18. Merziger, "Americanised, Europeanised or Nationalised?"

19. Danan, "Dubbing as an Expression of Nationalism," 608.

20. Danan, 612–13.

21. Ascheid, "Speaking Tongues."

22. Ascheid, 36.

23. Ascheid, 36.

24. Danan, "Dubbing as an Expression of Nationalism," 612; Ascheid, "Speaking Tongues," 35.

25. Danan, "Dubbing as an Expression of Nationalism," 612; Ascheid, "Speaking Tongues," 35.

26. Accent would also impact audiences' sense of the dubbed body's ethnicity and nationality. For example, in a memorable passage from the 2003 novel *The Kite Runner* by Khaled Hosseini, Afghan child characters assume John Wayne is Iranian, due to the Iranian dubbing artist's accent. Nornes, *Cinema Babel*, 140.

27. "India Latest Foreign Land to Badly 'Misunderstand' U.S. Film Economics," 10. For a post-liberalization account of global Bollywood, its relationship to US and other diasporic Indian stakeholders, and convergences of media industries and practices, see Aswin Punathambekar, *From Bombay to Bollywood.* For a historical account of the relationship between Hollywood and the Hindi film industry, see Nitin Govil, *Orienting Hollywood.*

28. For detailed accounts of interactions between Indian and US film and media industries in various periods, see Govil, *Orienting Hollywood*; Punathambekar, *From Bombay to Bollywood.*

29. "India Latest Foreign Land to Badly 'Misunderstand' U.S. Film Economics."

30. "India Latest Foreign Land to Badly 'Misunderstand' U.S. Film Economics."

31. "India Latest Foreign Land to Badly 'Misunderstand' U.S. Film Economics."

32. This remained an annual award category until 2020, when its name was changed to Best International Feature Film.

33. Ascheid, "Speaking Tongues," 33.

34. Ascheid, 33.

35. Betz, *Beyond the Subtitle*, 48.

36. Betz, 51; Bordwell and Thompson, *Film Art*, 303.

37. Askari emphasizes the materiality of film as both a method of historiography and a conceptual way of understanding film as an object in transit. Modification of the material object is thus an integral part of the life of the film object (and of the history of cinema). Askari, *Relaying Cinema in Midcentury Iran.*

38. Betz, *Beyond the Subtitle*, 69.

39. Yampolsky and Joseph, "Voice Devoured."

40. Yampolsky and Joseph.

41. Yampolsky and Joseph.

42. De Sica, *Bicycle Thieves* (1949).

43. Eleftheriotis and Iordanova, "Introduction," 80.

44. Nornes, *Cinema Babel*, 130.

45. Goswami, "The Empire Sings Back."

46. Thussu, *Communicating India's Soft Power*, 151.

47. Dass, "The Cloud-Capped Star."

48. Dass.

49. A section of *Indian Cinema* on Ray's 1977 film *Shatranj Ke Khilari* comments: "And naturally Ray is averse to the dubbing of his films into other languages as that would spoil the flavour of the original."

50. The ad appears in several periodicals of the time, two instances of which include The Gramophone Company of India Limited, "HMV Records Take the Music of India around the World," *Film World* 5, no. 2 (April-June 1969), ed. T. M. Ramachandran: inside cover; and *The Times of India Annual* (Bombay: Bombay Times of India Press, 1970), 69.

51. Lavezzoli, *The Dawn of Indian Music in the West*, 57.

52. Lavezzoli, 59.

53. Lavezzoli, 9.

54. Booth, "R. D. Burman and Rhythm."

55. Rajagopalan, *Indian Films in Soviet Cinemas*, 107.

56. Ramachandran, "Editor's Note," front flap.

57. Ramachandran, front flap.

58. At the time, several of these individuals were active in a grassroots film society movement that spanned multiple centers across India. Majumdar, "Debating Radical Cinema"; Cherian, *India's Film Society Movement*.

59. Abbas, "Indian Cinema: Retrospect and Prospect," 4.

60. Abbas, 6.

61. Abbas, 6.

62. Khanna, "Indian Film Abroad: Search for New Horizons," 30.

63. Malik, "The Indian Cinema Looks Forward in the Seventies," 44.

64. Malik, 44.

65. Galbraith, Howe, and Moraes, *John Kenneth Galbraith Introduces India*, 178–79. Emphasis mine.

66. Galbraith, Howe, and Moraes, 178–79.

67. Malik, "The Indian Cinema Looks Forward in the Seventies," 44.

68. Ramachandran, "Indian Films in Non-European Countries," 72.

69. Dharap, *Indian Films*, 486.

70. India Working Group on National Film Policy, *Report of the Working Group on National Film Policy*, 33.

71. Sunya, "On Location."

72. Eleftheriotis, *Cinematic Journeys*, 165. Also see Larkin, "Indian Films and Nigerian Lovers."

73. Eleftheriotis, "'A Cultural Colony of India,'" 103.

74. Gürata, "'The Road to Vagrancy.'"

75. "Iran: Cinematographic Films," 1384. From the late 1960s onward, Ray emerged as the most visible figure of Indian cinema in Iran as far as critics were concerned, and he was invited as juror of the first Tehran International Film Festival in the early 1970s. Commercial Indian films continued to enjoy popularity, even if they failed to attract the

interest of critics. (I am thankful to Kaveh Askari for this information.) For more on Indian films in Iran, see Cooley, "Soundscape of a National Cinema Industry"; Partovi, "Popular Iranian Cinema before the Revolution"; and Askari and Sunya, *Film History: An International Journal*.

76. Iran: Cinematographic Films," 1384.

77. Iran: Cinematographic Films," 1384.

78. I thank Kaveh Askari for this information. In his monograph about cinema in mid-century Iran, Askari presents a historiography of media circulation through a compelling emphasis on the materiality of film, whose modifications in transit are fundamental to an understanding of cinema. Askari, *Relaying Cinema in Midcentury Iran*.

79. Oruc's account of colonial administrators' concerns over allowing a public cinema for natives in the Gulf elaborates such hierarchies of development that underlay colonial theories of reception. Oruc, "Petrocolonial Circulations and Cinema's Arrival in the Gulf." In Chandra's account of women's English-language education in colonial India, similar needs-based hierarchies were mobilized not only by colonial administrators but also by upper-caste, upper-class Indians who slotted women's educational needs—such as for English versus vernacular education—into caste- and class-stratified hierarchies that attached women's English-language education to the domain of upper-caste, upper-class conjugality. Chandra, *The Sexual Life of English*.

80. Malik, "The Indian Cinema Looks Forward in the Seventies."

81. Mukherjee, *Bombay Hustle*; Iyer, *Dancing Women*.

82. "Weekly Notes."

83. Larkin, "Itineraries of Indian Cinema"; Rajagopalan, *Indian Films in Soviet Cinemas;* Gürata, "'The Road to Vagrancy'"; Prasad, *Cine-Politics*; Cooley, "Bachchan Superman—Hindi Cinema in Egypt, 1985–1991"; Joseph, "Just a Buffalo, or Not?"

84. Yampolsky and Joseph, "Voice Devoured."

2. MOVING TOWARD THE "CITY OF LOVE": HINDUSTANI LYRICAL GENEALOGIES

1. *Hindustani* adjectivally refers to Hindi- and Urdu-speaking areas of South Asia as well as a milieu of culture and arts associated with these northern regions. *Hindustani* can also mean "Indian"—that is, "of Hindustan." It additionally refers to an overlapping, colloquial, mutually intelligible linguistic domain of Hindi and Urdu; in contrast, modern standardized Hindi is written in the Devanagari script and draws its higher vocabulary from Sanskrit, and modern standardized Urdu is written in the Nastaliq script and draws its higher vocabulary from Perso-Arabic sources. In his memoir, Aziz explicitly opts for the term *Hindustani* rather than *South Asian*. At times, I opt for the adjective *Hindustani* (versus *Hindi*) for cultural forms, as a way of highlighting certain literary, musical, or stylistic antecedents that arose prior to the standardization of Hindi under an Indian nationalist discourse. However, when referring to the Bombay film industry, I opt for the term *Hindi* because of the manner in which the industry itself has certainly come to align and identify with a project of modern Hindi, even when its form and influences may be more precisely referred to as *Hindustani*.

2. Translations are my own. The epigraph credits Hasrat Jaipuri as the lyricist, though the lyricist for the song was actually D. N. Madhok. Aziz, *Jalsa 2*.

3. Aziz.

4. Aziz.

5. Quraishi, *Redefining the Immigrant South.*

6. Aziz, *Jalsa* 2.

7. For analyses of lyrical engagements with contemporary Hindi film songs, see, for example, Pavitra Sundar, "Usha Uthup and Her Husky, Heavy Voice."

8. Compared to songwriters in an American context, lyricists in the Hindi film industry were typically literary figures—often poets—for whom the film lyric came to constitute a genre. Unlike songwriters, lyricists tended to have very little to do with the composition and arrangement of the music of any songs they penned. For decades, this responsibility lay with the music director, who took charge of the music (both background music and songs) of each film with which they were associated.

9. For a detailed account of Bombay as a cinematic city and of the city as space of romance in 1950s Hindi cinema, respectively, see Mazumdar, *Bombay Cinema*; Wani, *Fantasy of Modernity.*

10. Critical analyses of the utopian imaginations of various periods of Hindi cinema include Mukherjee, "Tracking Utopias"; and Dass, "Cinetopia."

11. For an exceptional account of the print circulation of song lyrics in the Hindi public sphere, see Duggal, "Seeing Print, Hearing Song."

12. Prasad, *Ideology of the Hindi Film*, 111.

13. Mukherjee, *Bombay Hustle*, 126.

14. Duggal, "Seeing Print, Hearing Song."

15. "Catalogue—Seventeenth National Awards for Films."

16. Singh and Arya, "Nehru's Strategy of National Integration."

17. Mir and Mir, "Progressive Poetry and Film Lyrics," 125.

18. Gulzar, "Lyrics 1903–1960," 287.

19. In the 1990s, Susan Sontag famously lamented the passing of a certain kind of cinema that reached its peak in "the 1960s and early 1970s." Even as she acknowledges that the experience of wonder was central to the experience of cinema in its earliest days, across the realist proclivities of actualities and fantastic proclivities of trick films, she privileges a genealogy of postwar European art cinema as the epitome of the medium's expression through "masterpieces" against the crass commercialism of industrial cinemas. With some skepticism over "art versus industry" polemics in the postwar decades as well, I am suggesting—in a similar vein as Sontag at another point in her essay—that the nostalgia for various golden ages of cinema may have much less to do with the content of films and much more to do with the centrality of cinema to public cultures and projects of world-making through the early 1970s. Sontag writes: "Perhaps it is not cinema that has ended but only cinephilia—the name of the very specific kind of love that cinema inspired. Each art breeds its fanatics. The love that cinema inspired, however, was special. It was born of the conviction that cinema was an art unlike any other: quintessentially modern; distinctively accessible; poetic and mysterious and erotic and moral—all at the same time." Sontag, "The Decay of Cinema."

20. Clarke, *The Cinematic City.*

21. Giuliana Bruno, for example, emphasizes experiential associations between site and sight as well as motion and emotion in laying out connections between art, architecture, film, and modernity. Bruno, *Atlas of Emotion.* Compelling explorations of the city and cinema in South Asian contexts include Mazumdar, *Bombay Cinema*; and Dass, *Outside the Lettered City.*

22. Among several collections that explore the cinematic city as an interface for architectural and film theory are a 1998 special issue of *Wide Angle* that dedicates itself to "exploring film and video in relation to architecture and space," especially with respect to the urban context of Los Angeles. *Architecture and Film*, a collection edited by Mark Lamster, explores connections between experiences onscreen and in built environments. Arnwine and Lerner, *Wide Angle*; Lamster, *Architecture and Film*.

23. David Desser, "Race, Space and Class"; Prakash and Kruse, *The Spaces of the Modern City*; Prakash, *Noir Urbanisms*.

24. Brunsdon, "The Attractions of the Cinematic City," 218–19.

25. Brunsdon, 221.

26. *Hindavi* refers to a regional dialect, among many that have since fallen under the classificatory rubric of modern standard Hindi.

27. Wakankar, "The Question of a Prehistory."

28. Wakankar, 287. Wakankar compares the weight of the prehistory of untouchability that Kabir signifies in contemporary Dalit politics to the prehistory of slavery that the Middle Passage signifies in contemporary African-American politics.

29. Omvedt, *Seeking Begumpura*.

30. Kabir, *One Hundred Poems of Kabir*, 74.

31. Denis Matringe, "Krsnaite and Nath Elements in the Poetry of the Eighteenth-Century Panjabi Sufi Bullhe Sah," 197.

32. Mir, "Teachings of Two Punjabi Sufi Poets."

33. Translation my own. This is a popular composition attributed to Bulleh Shah, one version of which was recorded on an album by the Wadali Brothers, a singer-duo that performs Sufi poetry. Brothers, *Wadali Brothers – Yaad Piya Ki . . .*

34. Kabir, *One Hundred Poems of Kabir*, 74.

35. Kabir, *One Hundred Poems of Kabir*, 74.

36. Govindrajan, "Labors of Love," 200–201.

37. Burchett, "Bhakti Rhetoric in the Hagiography of 'Untouchable' Saints"; Keune, *Shared Devotion, Shared Food*.

38. Thus, "Kanwal Bharti and Dharamveer, two prominent Hindi Dalit literary critics, have complained about the co-option of Kabir by the brahmanical elite who have turned his legacy into one of 'mysticism' (rahasyavād). And according to Hindi author Namwar Singh, though Kabir may not have written anything like what we now consider Dalit literature, the heart of the Dalits yet resonates in his voice." Brueck, *Writing Resistance*, 29–30.

39. Burchett, "Bhakti Rhetoric in the Hagiography of 'Untouchable' Saints"; Keune, *Shared Devotion, Shared Food*.

40. Omvedt, *Seeking Begumpura*; Wakankar, *Subalternity and Religion*; Katulkar, "Critical Analysis of Indian Historians' Writings on Buddhism."

41. Tagore, *The English Writings of Rabindranath Tagore: Poems*, 622.

42. Tagore, 622.

43. For an analysis of singing as itself enacting the investments of *sant* poetry—in this case, that of the fifteenth-century blind poet Sur Das—see Hawley, *Sur Das*.

44. On the circulation and censorship of anti-colonial content in Hindustani film song lyrics (and printed song booklets), Ali Husain Mir and Raza Mir write: "Since the recordings were not of great quality, the lyrics were printed on cheap booklets and distributed with the records. The British administration banned several of these songs, but the booklets

circulated freely carrying the word around." Mir and Mir, "Progressive Poetry and Film Lyrics," 117. See also Duggal, "Seeing Print, Hearing Song."

45. Mir and Mir, "Progressive Poetry and Film Lyrics," 119.

46. Patel, *Lyrical Movements, Historical Hauntings*; Mir and Mir, *Anthems of Resistance*.

47. On the idea of both the city and cinema as modern attractions that are represented as such in films in the journey either to the city or to the theatre within the city, Charlotte Brunsdon writes, "The journey within diegetic space to participate in the spectacle of the city enacts the very activity of the cinema spectator in extradiegetic space . . . which provoke[s] self-reflexivity about cinematic pleasures." Brunsdon, "The Attractions of the Cinematic City," 116.

48. The notion of deferral has been central to theories of postcolonial and alternative modernities. In "'Postcolonial' Literature in a Neocolonial World," Saree Makdisi notes that several modernist works of Arab literature "reject all unproblematic or univocal relationships to either past or future, whether in terms of narrative or history. . . . The possibility of a return to the mythic past is rejected along with the alternative possibility of an uncompromised and perpetually deferred great leap 'forward' to development. All that is left is, indeed, a highly unstable and contradictory present." Makdisi, "'Postcolonial' Literature in a Neocolonial World," 99. Writing on postcolonial theorist Homi Bhabha's notion of difference and postcoloniality, which Bhabha treats in his introduction as well in several of his essays in *The Location of Culture*, Bill Ashcroft, Gareth Griffiths, and Helen Tiffin note: "The 'difference' Bhabha emphasizes here is clearly connected with the radical ambivalence that he argues is implicit in all colonial discourse. He insists that the same ambivalence is implicit in the act of cultural interpretation itself since, as he puts it, the production of meaning in the relations of two systems requires a 'Third Space.' This space is something like the idea of deferral in post-structuralism. While Saussure suggested that signs acquire meaning through their difference from other signs (and thus a culture may be identified by its difference from other cultures), Derrida suggested that the 'difference' is also 'deferred,' a duality that he defined in a new term 'difference.' The 'Third Space' can also be compared to this space of deferral and possibility." Bhabha, *The Location of Culture*, 20; Ashcroft, Griffiths, and Tiffin, *Post-Colonial Studies*.

49. In 1952, for example, B. V. Keskar banned the broadcast of film songs on the state-controlled All-India Radio, in an attempt to cultivate the national public's taste for good music—that is, indigenous classical, semiclassical, and folk music.

50. In her study of the postcolonial context in which Karnatic (South Indian classical) music became institutionalized as an authentic cultural form, Amanda Weidman theorizes a "politics of the voice" in that "modern subjectivity hinges on the notion of voice as a metaphor for self and authenticity and on the various techniques—musical, linguistic, and literary—by which particular voices are made to seem authentic." Weidman, *Singing the Classical, Voicing the Modern*, 7–8.

51. Mir and Mir, *Anthems of Resistance*. Mir and Mir, "Progressive Poetry and Film Lyrics."

52. Shackle and Snell, "Premchand: Urdu Hindi Aur Hindustani," 141.

53. Mir, "Lyrically Speaking: Hindi Film Songs and the Progressive Aesthetic," 209. M. Madhava Prasad has influentially identified the Bombay film industry's heterogenous mode of manufacture, "characterized by the separate production of component parts of a product and their final assembly into one unit." Prasad, *Ideology of the Hindi Film*, 42.

Components included music, lyrics, fight sequences, the "scenario" or story, dialogues, and lyrics. On dialogues, see Prasad, 46. More recent scholarship has explored material histories of production practices in specific periods, from the role of the script to labor practices in the studio era. See, for example, Sengupta, "Writing from the Margins of Media"; Sengupta, "Towards a Decolonial Media Archaeology"; Mukherjee, *Bombay Hustle*. For a compelling account that positions its exploration of *The Mill* to consider historiographies of lost films in a colonial context, see Mukherjee, "A Specter Haunts Bombay."

54. Bhattacharya, "Writing and Making Money: Munshi Premchand in the Film Industry, 1934–35."

55. Bhattacharya.

56. Bhattacharya, 92.

57. Bhattacharya, 92.

58. Song booklet, *Mazdoor*, Cinema Bulletin Press, Bombay 4, 1934, National Film Archive of India, Pune, Maharashtra.

59. Coppola, "Premchand's Address to the First Meeting of the All-India Progressive Writers Association," 21.

60. Coppola, 21.

61. Coppola, 29.

62. Coppola, 29.

63. Coppola, 25.

64. An Urdu copy of Premchand's address was published in 1960 by Dr. Qamar Rais. I am relying on the English translations of sections that Coppola provides in his essay on the address. Both the (Urdu) original page numbers are provided, as well as the pages of Coppola's article in which relevant, translated sections appear in English. Premchand, "Adab Ki Gharaz-o-Gayat (The Purpose of Literature)," 238; Coppola, "Premchand's Address to the First Meeting of the All-India Progressive Writers Association," 26.

65. I am quoting a recent publication of an English translation of Raipuri's 1935 essay. Raipuri, "Literature and Life," 128.

66. Wakankar, "The Question of a Prehistory," 288.

67. Premchand, "adab Ki Gharaz-o-Gayat (The Purpose of Literature)," 239; Coppola, "Premchand's Address to the First Meeting of the All-India Progressive Writers Association," 26.

68. Kumar, *Premchand*, 26.

69. Kumar, 26–27.

70. Kumar, 26.

71. Elam, *World Literature for the Wretched of the Earth*.

72. As discussed earlier in this chapter, this is evident in the phenomenon of printed song booklets.

73. Benjamin, "The Work of Art in the Age of Mechanical Reproduction"; Hardt, "For Love or Money"; Berlant, "A Properly Political Concept of Love"; Ahmed, *The Cultural Politics of Emotion*.

74. Gopal, *Conjugations*, 36.

75. Gopal, 37.

76. Gopal, 37.

77. For an account of romantic love in the decade of 1950s Hindi cinema specifically, see Wani, *Fantasy of Modernity*.

78. It was in 1948, for example, that the state set up the Films Division under the Ministry of Information and Broadcasting, which actively produced and distributed several state-sponsored documentaries. In 1960, the same ministry set up the Film Finance Corporation and the Film and Television Institute in an effort to groom filmmakers and produce films other than the kind that were being produced by the Bombay industry.

79. Note on translation: In Hindi/Urdu, nouns are gendered, and the word *nagar* in *prem nagar* is a masculine noun meaning "place" in the bounded sense of a municipality or city. The words *nagarii* and *nagariyaa* are derivative variants that are feminine and feminine-diminutive nouns, respectively. In table 1, I have translated *nagarii* and *nagariyaa* as "township." The connotative implications of these slight variations are related to the size of the city being referred to, although in film song lyrics, diction is often related more to rhythm and meter than to any difference in the meanings of, for example, *prem nagar* versus *prem nagarii* versus *prem nagariyaa*.

80. Script, *Miss Punjab Mail* (N. Vakil, 1958), 52–54, National Film Archive of India, Pune, Maharashtra.

81. Script, *Miss Punjab Mail*.

82. Song booklet, *Masoom*, Delight Process Studio, Bombay-4, 1960, National Film Archive of India, Pune, Maharashtra.

83. Shailendra, *Andara kī āga*.

84. Since my first viewing of this print held by the National Film Archive of India in 2012, a copy of the film has surfaced on YouTube.

85. Gulzar, "Lyrics 1903–1960," 287.

86. Gulzar, "Lyrics 1903–1960," 287.

87. Prasad, *Ideology of the Hindi Film*.

88. Omvedt, "Hinduism and Politics"; Rajagopal, *Politics after Television*; Ambedkar, *Beef, Brahmins, and Broken Men*.

89. Rajadhyaksha, "The 'Bollywoodisation' of the Indian Cinema," 129. Rajadhyaksha quotes Partha Chatterjee's formulation of political society to connect it to cinema's function as a mediating institution: "The domain of civil social institutions . . . is still restricted to a fairly small section of 'citizens.' The hiatus [this gap] is extremely significant because it is the mark of non-Western modernity as an always-incomplete project of modernization," Chatterjee, "Beyond the Nation? Or Within?," 1–2.

90. See Ananya Jahanara Kabir's account of Kashmir's representation as a feminized "territory of desire" in Kabir, *Territory of Desire*. Hindi films in particular have violently erased Kashmiris' aspirations for self-determination in the face of Kashmir's ongoing occupation by the Indian state. Here, too, a patriarchal nationalist discourse violently unfolds in the language of protection. Even as Hindi films of the 1960s participated in this deeply problematic representational regime, they also offered theorizations of cinephilia, feminine pleasure and sexuality, and libidinal excess that upheld the potential for spectatorial engagements that were agential and critical, rather than solely ones of passive consumption. Shah quoted in Mathur, "Rajesh Khanna Was a Poor Actor: Naseeruddin."

3. HOMOSOCIALIST COPRODUCTIONS: *PARDESI* (1957) CONTRA *SINGAPORE* (1960)

1. Acharya and Tan, *Bandung Revisited*.
2. Bhagavan, "Introduction."

3. Abbas, *I Am Not an Island*, 386.

4. Abbas, 394–95.

5. Abbas, 394–95.

6. That is, a digitized color version was not available at the time of writing.

7. Holmes, "37. The Stranger"; Romer, Vidal, and Siboun, *40ème*, 90.

8. In her compelling account of gender and cinema through a history of dancing stars in Hindi cinema, Iyer reads a number films over the 1950s and 1960s as enacting "melodramas of dance reform." Iyer, *Dancing Women*. I read a complementary history in coproductions of this period, as the figure of the singing dancer-actress featured not only in melodramas about dancing (which in turn motivated diegetic production numbers) but also in ekphrastic arguments about the merits of a singing, dancing cinema, for which the figure of the singing dancer-actress was metonymic.

9. This video has since been taken down. The comment was posted in 2016 by user Ekaterina Zelenova. Pronin and Abbas, परदेसी—*Pardesi*.

10. Abbas and Pronin, *Journey beyond Three Seas*, "Collection History."

11. Rajagopalan, "Emblematic of the Thaw."

12. Dina Iordanova asks, "Can we think of any other film from the 1950s that was seen in so many countries and was as widely acclaimed as *Awaara?* Most film history books analyse other films and mention *Awaara* only in passing, yet I cannot think of any other film from that period that would have enjoyed such popular success transnationally." Iordanova, "Indian Cinema's Global Reach."

13. On panoramic cinema during the Soviet Thaw, see Oukaderova, *The Cinema of the Soviet Thaw*. *Pardesi/Khozhdenie* was released (and has continued to circulate) in multiple versions, with differences in language, length, and aspect ratios. A 1958 British catalog by Holmes, for example, mentions the SovScope (70mm widescreen) version as well as a 35mm version. Holmes, "37. The Stranger."

14. Patel notes the importance of Gandhi's calls for women's public participation in the nationalist movement at the same time that she is critical of the extent to which Gandhi is credited as a feminist figure of the women's movement in India, given crucial limitations of his ideas about gender. Gandhi, for example, located gender difference as a biological fact. Even as he acknowledge domestic labor as labor, called for reforms of Hindi practices like dowry and sati, and encouraged women's participation in politics, he also valorized marriage and sexual purity, viewed nonreproductive sex as abnormal, and strongly urged the sublimation of (particularly women's) sexual desire, which he viewed as an impediment to working toward the greater good of society. Patel, "Construction and Reconstruction of Woman in Gandhi."

15. Abbas, "Films for Friendship," 12–13.

16. Abbas, "Films for Friendship"; "Official Selection 1958."

17. By the time of *Journey*'s release, Nargis, along with Raj Kapoor, had become a huge star in the Soviet Union. In the same year that *Journey* was released, in fact, "Nargis was the first foreign actor to grace the cover of a Soviet film journal when she appeared on the cover of *Sovietskii Ekran* in 1957." Rajagopalan, "Emblematic of the Thaw," 95.

18. Following an abridged credit sequence, this is the opening scene of an unsubtitled, black-and-white, 97-minute Hindi DVD version.

19. In the 97-minute Hindi DVD version, there is no specific mention of Lithuania, only of Afanasy's wanderlust more generally.

20. Kaveh Askari provides an important analysis of the ambitions of prestige coproductions that do not fit easily within histories of either a specific national cinema or world cinema. Such productions also challenge assumptions about what constitutes success and failure and how such assumptions can dictate the terms and objects of media historiography. Askari, "Eastern Boys and Failed Heroes."

21. Oukaderova, *The Cinema of the Soviet Thaw.*

22. Mossaki and Ravandi-Fadai, "A Guarded Courtship."

23. As quoted of critic Adachi Chu in Nornes, *Cinema Babel*, 138. Emphasis mine.

24. Brooks, *The Melodramatic Imagination*; Vasudevan, *The Melodramatic Public*; Majumdar, "Pather Panchali: From Neo-Realism to Melodrama"; Gledhill and Williams, *Melodrama Unbound*; Anker, *Orgies of Feeling.*

25. Rudakov and Imanov quoted in Bikmukhametova and Sindelar, "In Russia, 'Horde' Blockbuster Drawing Tatar Objections."

26. Abbas, *I Am Not an Island*, 396.

27. Abbas, 396.

28. Abbas, 396.

29. Nikitin, *Khozhenie Za Tri Morīa Afanasiĭa Nikitina 1466–1472 Gg*; Shaw, "Mastering Nature through Science."

30. See for example Haase, "The Arabian Nights, Visual Culture, and Early German Cinema."

31. Dass, "Cinetopia."

32. Mazumdar, *Bombay Cinema*; Dass, "Cinetopia."

33. For an excellent discussion of the song "*ye hai bombay merii jaan*," see Kaviraj, "Reading a Song of the City."

34. The word *pariah* in both Hindi and English comes from *paraiyar*, the name of a "lower-caste" community. The normalization of this word's usage—as in the instance of these lyrics—for generally describing an undesirable condition of ostracization emerges from casteist histories.

35. One of M. K. Gandhi's most renowned—and critiqued—legacies was his use of the term *harijan* ("people of God") for formerly "untouchable" castes. Among other anti-caste thinkers, B. R. Ambedkar critiqued Gandhi's move as patronizing in merely deploying a euphemism that insufficiently addressed the past and present material circumstances of caste, toward its annihilation. See Kumar, "Apotheosis of the Unequal: Gandhi's Harijan."

36. Rajagopalan, "Emblematic of the Thaw."

37. Sardar, "Dilip Kumar Made Me Do It"; Singh, "A Subaltern Performance."

38. Govindrajan, "Labors of Love."

39. Kapur, "Love in the Midst of Fascism"; Arondekar, *For the Record*; Mitra, "'Surplus Woman.'"

40. Vasunia, "Sikandar and the History of India"; Basu, "Filmfare, the Bombay Industry, and Internationalism (1952–1962)."

41. K. A. V., "From Madras with Love," 64.

42. Mahmood's 1974 book on Indian cinema, for example, devotes a section to (largely failed) coproductions. It mentions *Pardesi/Khozhdenie, Subah-O-Sham/Homaaye Saadat*, and even the shelved *Alexander and Chanakya*. It does not mention *Singapore*, however. Mahmood, *The Kaleidoscope of Indian Cinema.*

43. Iyer, *Dancing Women.*

44. Krishnan, *Celluloid Classicism.*

45. See for example Iyer, "Bringing *Bharatanatyam* to Bombay Cinema."

46. For example, a number of Madras studios produced Hindi films featured top male and female stars from the Bombay industry. Dancer-actresses such as Padmini, Vyjayanthimala, and Waheeda Rehman, however, worked not only across industries but also across languages. Among actors, Malayalam film star Prem Nazir is an exception, as he starred in Tamil films as well.

47. Iyer, *Dancing Women.*

48. Sometimes spelled Cathay-Keris.

49. Davis, "Questioning Diaspora," 41.

50. Fu, *China Forever,* 3.

51. Teo, "Malay Cinema's Legacy of Cultural Materialism"; Bloom, "Circumambient Geographies of Cinema."

52. Teo.

53. "Former Malay Production Film Studios."

54. Mazumdar, "Aviation, Tourism and Dreaming in 1960s Bombay Cinema."

55. Basu, "'The Face That Launched a Thousand Ships.'"

56. McGarr, *The Cold War in South Asia*; Bhagavan, "Introduction."

4. COMEDIC CROSSOVERS AND MADRAS MONEY-SPINNERS: *PADOSAN'S* (1968) AUDIOVISUAL APPARATUS

1. Ray, "Foreword." Emphasis in the original.

2. Ray.

3. "Studio Owners—Producers: S. S. Vasan."

4. "The current year—1964—is not a happy one for the Tamil film. In fact, there is almost a crisis facing the industry. Due to the failure of many pictures, finance has become shy. The returns from box-office collections have dwindled while the cost of production has gone up. Production of Tamil films is now at the lowest ebb. The problems that face the Tamil producer to-day are so many and huge that not even a miracle-maker, not to speak of a moviemaker, can hope to survive. Of the twenty films released during the year, only one film— Sridhar's breezy romantic comedy 'Kathalikka Neramillai' (No Time for Love-making) has turned out to be the biggest hit. The film, photographed in Eastman color, was notable for the introduction of the two new-comers to the screen, Ravichander and Kanchana. The most important producers, who are now striving hard to keep the show going, are S. S. Vasan of Gemini Studios, A. V. Meiyappan of A.V.M. Studios, M. M. A. Chinnapa Thevar of Devar Films, B. R. Panthulu of Padmini Pictures, T. R. Ramanna of R.R. Pictures, G. N. Velumani of Saravana Films, A. L. Srinivasan of A.L.S. Productions, Sridhar of Chitralaya, Sivaji Ganesan-Shanmugam-Thangavelu of Sivaji Films, P. S. Veerappa of P.S.V. Pictures, L. V. Prasad of Prasad Productions, M. G. Ramachandran-M. G. Chakrapani of Emgeeyar Pictures and Modern Theatres, Salem. Leading and efficient directors like K. S. Gopalakrishnan, Sridhar, K. Shankar, S. Balachander, Krishnan-Panju, B. R. Panthulu and Bhim Singh are all working hard to achieve fresh laurels for the Tamil screen and they have every chance of putting the Tamil film on the film map of the world." "The Tamil Film," 125–27.

5. Dass, "Cinetopia"; Dayal, "In the Wink of an Eye: The Comedic Universe of Johnny Walker."

6. Mazumdar, "Aviation, Tourism and Dreaming in 1960s Bombay Cinema."

7. Mazumdar; Sawhney, "An Evening on Mars, Love on the Moon: 1960s Science Fiction Films from Bombay"; Sunya, "On Location"; Maasri, *Cosmopolitan Radicalism*.

8. Mazumdar, "Aviation, Tourism and Dreaming in 1960s Bombay Cinema."

9. Times of India News Service, "Shah Explains Film Industry Crisis."

10. Times of India News Service.

11. Times of India News Service.

12. Prakash, *Emergency Chronicles*.

13. Prakash.

14. Christopher, *Beyond the Star: Telugu Comedy Films and Realpolitik in Andhra Pradesh*; Prasad, *Cine-Politics*.

15. Dechamma and Prakash, *Cinemas of South India*; Christopher, *Beyond the Star*; Prasad, *Cine-Politics*; Radhakrishnan, "The 'Worlds' of the Region."

16. Zaveri, *Mehmood—A Man of Many Moods*, 108–10.

17. If Mehmood was coupled in romantic subplots, it was often with actresses like Mumtaz Ali and Aruna Irani, who were associated with lesser-quality films than those of A-list actresses. In these cases, too, notions of quality and value naturalized certain lower-budget genres, such as comedy and wrestling, to the underdeveloped tastes of their presumedly lower-class audiences.

18. Pillai, *Madras Studios*.

19. Salam, *Housefull: The Golden Years of Hindi Cinema*.

20. Majumdar, "The Embodied Voice: Song Sequences and Stardom in Popular Hindi Cinema"; Indraganti, *Her Majestic Voice: South Indian Female Playback Singers and Stardom, 1945–1955*.

21. The Tamil version also featured animated credits by Dayabhai Patel, which were a novelty for the time. But they were not reflexive in their portrayal of the film industry in the manner of *Padosan*'s opening credits.

22. *Vidyapati* means "knowledgeable one," and Guru is a highly reverential address for a teacher that has connotations of a spiritual guide as well. Pancharatna Natak Mandal means "Five Gem Drama Company," which alludes to the popular legends of kings such as the Mughal emperor Akbar, who touted the unsurpassed reputations of artists held in their courts by referring to them as jewels. Kishore Kumar was unique as a playback singer who was incidentally an actor in the 1950s and 1960s Hindi popular film industry, though singer-actors like K. L. Saigal were much more common in earlier decades.

23. Laura Mulvey's groundbreaking psychoanalytic-feminist essay initiated a series of rich debates over the voyeuristic-exhibitionist pleasures of cinema, especially with respect to the question of whether this is contingent on a total objectification of the feminine body-as-spectacle expressly for the gratification and consolidation of a spectatorial subject position that, according to Mulvey, wields an active, consuming gaze that is necessarily masculine under a patriarchal regime of looking relations within which Hollywood narrative cinema operates. Mulvey, "Visual Pleasure and Narrative Cinema."

24. *Brahmin* refers both to an upper-caste segment of Hindu society that was historically a powerful priestly class and to a Hindu male priest belonging to this caste, generically represented as having a half-shaven head and/or tuft and wearing robes. Critiques of brah-

mins—more common in Tamil cinema than Hindi cinema—emphasize an elite, chauvin-istic, privileged class, whose greed, lust, and power-hunger exposes an ostensible piety and simplicity to be a façade. Such depictions individualize the disproportionate power of this caste by depicting good versus evil individuals as the problem, rather than the system of caste that has upheld, and been upheld by, upper-caste privilege and power over centuries. I am an insider to and beneficiary of this unethical accumulation.

25. The name Pillai may not refer to someone from a brahmin caste, but it would be recognized as a South Indian name. Thus, the "types" in the film are meant to conjure associations, imprecision notwithstanding.

26. Wani, *Fantasy of Modernity*.

27. Prasad, *Ideology of the Hindi Film*, 42–45.

28. Indraganti, "Of 'Ghosts' and Singers: Debates around Singing Practices of 1940s Indian Cinema"; Indraganti, *Her Majestic Voice*.

29. Majumdar, "The Embodied Voice."

30. Rajadhyaksha, *Indian Cinema in the Time of Celluloid*, 4, 16.

31. Punathambekar, "Ameen Sayani and Radio Ceylon."

32. The name Pancharatna Natak Mandal exaggerates the Sangeet Natak Academy's (among other official national institutions) pretensions of antiquity, which are evident in the Mandal's anachronistic invocations of Sanskritized idioms and words.

33. The film's ironic aspirations toward high art are first apparent in the title card that describes itself as Mehmood Production's "First Ambitious Motion Picture." In addition, there is of course the Pancharatna Natak Mandal (see note 32).

34. Lutgendorf, "Padosan."

35. New York Conservatory for Dramatic Arts, "Acting for the Comedy Genre."

36. Their fans address the sisters Lata and Asha by their first names, sometimes with the suffix "Ji" to convey respect.

37. Iyer, "Dance Musicalization."

38. Chion and Murch, *Audio-Vision: Sound on Screen*.

39. Majumdar, "The Embodied Voice," 176. On Lata Mangeshkar in later periods of cinema, see Sundar, "Meri Awaaz Suno"; and Jhingan, "Lata Mangeshkar's Voice in the Age of Cassette Reproduction."

40. The stardom of playback singers has changed over time. The popular Hindi film industry of the golden era of the 1950s and 1960s was characterized by just a handful of playback singers who were huge stars. Presently, certain playback singers are certainly stars who periodically headline "Bollywood" tours, such as Rahat Fateh Ali Khan, Sonu Nigam, Shreya Ghoshal, and Sunidhi Chauhan. Additionally, a number of television shows (like Zee TV's *Sa Re Ga Ma* and *Sa Re Ga Ma Pa*) are modeled as talent competitions for the next big playback star. However, several film songs are performed by less well-known or relatively unknown playback singers.

41. Manuel, *Thumri in Historical and Stylistic Perspectives*.

42. Bhaskar, *Islamicate Cultures of Bombay Cinema*.

43. Comments, "Aao Aao Aao Sawariya—Saira Banu, Mehmood & Sunil Dutt—Padosan," YouTube, accessed May 21, 2018, http://www.youtube.com/watch?v=jv4wxnYJmzQ.

44. Comment, "Aao Aao Aao Sawariya—Saira Banu, Mehmood & Sunil Dutt—Padosan."

45. Zaveri, *Mehmood—A Man of Many Moods*.

46. Patil, *Report of the Film Enquiry Committee (1951)*.

47. Tales from Sanskritic epics or puranic Hindu tales formed the earlier popular genre of "mythological" films. Perso-Arabic tales and romances, such as that of Laila-Majnun, also served as the foundation for several films. For more on mythological Hindi films, see Dwyer, *Filming the Gods*. For more on Arabian Nights-inspired epic fantasy films, see Thomas, *Bombay before Bollywood*.

48. Bhaumik, "Querying the 'Traditional' Roots of Silent Cinema in Asia."

49. For accounts of how migration to urban centers shaped South Asian cinemas (namely, Hindi, Urdu, Punjabi, and Bengali cinemas) in the wake of the 1947 Partition of India and Pakistan, see Sarkar, *Mourning the Nation*; and Siddique, *Evacuee Cinema*.

50. Zaveri, *Mehmood—A Man of Many Moods*.

51. Christian Metz describes the concealing-revealing apparatus of the camera and frame as orchestrating a "strip-tease." Metz, *The Imaginary Signifier*, 77.

52. Queer performance in popular Hindi cinema and/or through popular engagements with Hindi film songs has been described in terms of "*yaar/yaarii*" and "*dostanaa*," terms that refer to intimate friendships, often between men. For more, see Dudrah, "Queer as Desis"; and Khubchandani, *Ishtyle*.

53. In fact, a recent highly stylized animated video is based on a remix of *mere bhole balam*: "Meri Pyari Bindu (Remix)," YouTube, http://www.youtube.com/watch?v=LKGKas022hc.

54. A well-known early-2000s Hindi film song from the film *Kaho Na Pyaar Hai* (Rakesh Roshan, 2000) is similar in its foregrounding of filmi romantic clichés that appear in songs, because this song opens with "*chaand sitaare phool aur khushbu ye to saare puraane hain, taaza taaza kali khili hai hum uske diwaane hain*" (The moon, stars, flowers, fragrance—these are all old hat, the bud that is freshly blooming—it is that for which we are crazy). Here, too, the irony is that the song is parodying the very clichés of Hindi film songs through which it expresses its sentiments.

55. The polarizations of classical music, folk music, and film music (and dance) have occurred largely through institutionalized practices, such as the establishment of the Indian state-sponsored Sangeet Natak Academy, as well as the brief ban on film music in the early 1950s by the state-controlled All India Radio station.

56. Doane, "The Voice in the Cinema"; Majumdar, "The Embodied Voice"; Siefert, "Image/Music/Voice: Song Dubbing in Hollywood Musicals."

57. Benjamin, "The Work of Art in the Age of Mechanical Reproduction," 217–52.

58. Adorno and Horkeimer, "The Culture Industry: Enlightenment as Mass Deception," 94–136.

59. Altman, *The American Film Musical*.

60. Altman.

61. Altman.

62. Punathambekar and Mohan, "A Sound Bridge: Listening for the Political in a Digital Age."

63. Chadha and Kavoori, "Exoticized, Marginalized, Demonized: The Muslim 'Other' in Indian Cinema."

64. Zaveri, *Mehmood—A Man of Many Moods*.

65. Sippy, "More Noisy than Comic," 5.

66. "Forum, Prevention of Environmental and Sound Pollution v. Union of India & Anv., No. 21851/03 (2005.7.18) (Noise Pollution) | ELAW."

67. Prasad, *Ideology of the Hindi Film*, 186–87.

68. Prasad, 183.

69. Prasad; Bhaskar, "The Indian New Wave."

70. Booth, "Making a Woman from a Tawaif—Courtesans as Heroes in Hindi Cinema."

71. Manuel, *Thumri in Historical and Stylistic Perspectives.*

72. Majumdar, "The Embodied Voice."

73. Chatterjee, *The Nation and Its Fragments.*

74. Bhaskar, "The Indian New Wave."

75. Desai, "Sonu Nigam's Tweets on Noisy 'azaan' Spark Row."

76. Scroll Staff, "Sonu Nigam Grumbles about 'Forced Religiousness' after Muslim Call to Prayer Wakes Him Up."

77. "Forum, Prevention Of Envn. & Sound . . . vs Union Of India & Anr on 28 October, 2005."

78. "Forum, Prevention Of Envn. & Sound . . . vs Union Of India & Anr on 28 October, 2005."

79. Thompson, *The Soundscape of Modernity.*

80. The M.P. Kolahal Nityantran Adhiniyam, 1985.

81. Krishnan, *Celluloid Classicism*; Iyer, *Dancing Women*; Putcha, "The Mythical Courtesan."

5. FOREIGN EXCHANGES: TRANSREGIONAL TRAFFICKING THROUGH *SUBAH-O-SHAM* (1972)

1. In addition to the 1957 India–Soviet Union *Pardesi/Khozhdenie Za Tri Morya* and the 1960 India-Malay *Singapore* detailed in chapter 3, other coproductions with Indian involvement included the India-US film *Guide* (Vijay Anand, 1965) and the India-US-Philippines film *The Evil Within* (Lamberto V. Avellana, 1970). Meanwhile, other coproductions with Iranian involvement included the Iran-US film *The Heroes/Qahremanan/The Invisible Six* (Jean Negulesco, 1969), the Iran-Italy film *Hashem Khan/Appointment in Esfahan* (Tony Zarinast, 1966), and the later Iran-US film *Caravans* (James Fargo, 1978). On prestige films in Iran, see Askari, "Eastern Boys and Failed Heroes"; Guha, "Traversing *The Evil Within* (1970)"; Basu, "Filmfare, the Bombay Industry, and Internationalism (1952–1962)."

2. Majumdar, *Wanted Cultured Ladies Only!*

3. Kumar, *Dilip Kumar.*

4. Kumar.

5. Mukherjee, "Arriving at Bombay: Bimal Roy, Transits, Transitions, and Cinema of Intersection."

6. Nagwekar, "Birthday Special."

7. Zaveri, *Mehmood—A Man of Many Moods*, 1.

8. Zaveri, 1.

9. *Indian Trade Journal*, 1384.

10. See Iyer's detailed account of not only gender, labor, and dance in Hindi cinema but also Waheeda Rehman's stardom as a dancer-actress. Iyer details a history of her role in *Guide* (1965), an India-US coproduction. *Guide* is different from the coproductions that I examine in the sense that they were attempts to capitalize on extant "traditional" networks

of distribution for commercial Indian films, rather than aspiring toward new ones. In these productions, the logic of stardom operates as a way of hedging risk, since the stars were recognized as such in the dual contexts of the films' targeted releases. Iyer, *Dancing Women*.

11. Salazkina, "Soviet-Indian Coproductions: Alibaba as Political Allegory."

12. Mehta, *Censorship and Sexuality in Bombay Cinema*; Mazzarella, *Censorium*.

13. Mazumdar, "Aviation, Tourism and Dreaming in 1960s Bombay Cinema."

14. Patel, "Export Potential of Plastics."

15. "Save Foreign Exchange."

16. "Save Foreign Exchange."

17. "Sales Tax on Plastic Bangles Must Go."

18. Our Legal Correspondent, "Special Tax Leviable: Sale of Celluloid Bangles."

19. Ivory, "Foreword," xii.

20. Askari, "An Afterlife for Junk Prints."

21. Selznick, *The Invention of Hugo Cabret*.

22. Nnaemeka, Uvieghara, and Uyo, *Philosophy and Dimensions of National Communication Policy*.

23. Our Special Correspondent, "100 Movies Fetch Rs. 17 Lakhs at Film Market."

24. India Working Group on National Film Policy, *Report of the Working Group on National Film Policy*, 56.

25. India Working Group on National Film Policy, 57.

26. Askari, *Relaying Cinema in Midcentury Iran*.

27. India Parliament Rajya Sabha, *Parliamentary Debates*, 1973.

28. Mulvey, "Visual Pleasure and Narrative Cinema"; Williams, "Film Bodies"; Hoek, *Cut-Pieces*; Mini, "Transnational Journeys of Malayalam Soft-Porn."

29. Paasonen et al., *Objectification*.

30. Mukherjee, "A Specter Haunts Bombay."

31. Mazumdar, "Gangland Bombay."

32. "Where Smuggling Is King."

33. U.N.I., "'Racket in 'Import' of Thriller Films."

34. India Parliament Rajya Sabha, *Parliamentary Debates*, 1973; India Parliament Rajya Sabha, *Parliamentary Debates*, 1975.

35. "Sales Tax on Plastic Bangles Must Go."

36. India Parliament Rajya Sabha, *Parliamentary Debates*, 1973; India Parliament Rajya Sabha, *Parliamentary Debates*, 1974.

37. "Bangle Factories Hit by Slump."

38. Takulia, "Winds of Change: To the Editor, Times of India."

39. "Current Topics: The Rumour Makers Leaves & Seeds."

40. "Current Topics: The Rumour Makers Leaves & Seeds."

41. "Unfriendly."

42. "Unfriendly."

43. Such lyrical inheritances appear in several Hindi film songs as well. A few examples: "*hare kaanch kii chuudiyaan*" (Bangles of green glass), from Kishore Sahu's 1967 film of the same name; "*bole chuudiyaan*" (My bangles shall speak) from *Kabhi Khushi Kabhie Gham* (Karan Johar, 2001); "*mere haathon men nau nau chuudiyaan*" (Nine bangles on each of my arms) from *Chandni* (Yash Chopra, 1989).

44. Sarkar, "Plasticity and the Global"; Mukherjee, *Bombay Hustle.*

45. Das Gupta, "In the Revitalisation of the Indian Film Industry What Is the Role of the Proposed 'Kissing Seminars.'"

46. Das Gupta.

47. Prasad, *Ideology of the Hindi Film.*

48. Das Gupta, "In the Revitalisation of the Indian Film Industry What Is the Role of the Proposed 'Kissing Seminars.'"

49. Cooley, "Bachchan Superman—Hindi Cinema in Egypt, 1985–1991."

50. Abbas, *I Am Not an Island,* 380.

51. Personal correspondence, 2014.

52. Fish, "The Bombay Interlude"; Milani, "Through Her Eyes"; Askari and Sunya, "Editors' Note"; Cooley, "The 'Problem of Respectable Ladies Joining Films': Industrial Traffic, Female Stardom and the First Talkies in Bombay and Tehran."

53. Kapse, "Afterword."

54. Mazumdar, "Aviation, Tourism and Dreaming in 1960s Bombay Cinema."

55. Askari, "Eastern Boys and Failed Heroes."

56. Cooley, "Soundscape of a National Cinema Industry."

57. I discuss this Hindi version in my analysis of the film, while also noting its divergences from a 122-minute Persian version uploaded to YouTube. Where mentioned, all translations of Hindi dialogue and lyrics are my own.

58. The producer who is named at the bottom of the Persian-language poster is the Tehran-based Ariana Studios, while the Hindi VCD lists the Madras-based producer B. Radhakrishna and Ganesh Rao Studios.

59. Cooley, "Soundscape of a National Cinema Industry."

60. A'yin, "Iranian Film Industry Progresses," 21.

61. A'yin, 21–22.

62. I distinguish between Hindi and Persian versions of the film through their respective titles. I invoke both titles when referring to aspects that are common to both.

63. In addition to the 1963 Indian trade report's references to the circulation of cheap, "third-rate" Indian films in Iran and Malik's (likely exaggerated) references to rumors of stampedes across the borders of Iran, Afghanistan, and Pakistan for consignments of gramophone records of Indian film songs, Iordanova cites personal correspondence with Hamid Naficy, who anecdotally recalls that "Indian films were big in Iran from the 1930s before the war and in the 1950s and 1960s, their songs were sold in music stores and played on the radio and kids used to sing them to each other. . . . There was a close interaction between Indian, Egyptian, Turkish, and Iranian cinemas." *Indian Trade Journal,* 1384; Malik, "The Indian Cinema Looks Forward in the Seventies," 44; Iordanova, "Indian Cinema's Global Reach," 115.

64. Nima Bigloo, *Googoosh Maste Mastam Kon—Homaye Saadat Soundtrack.*

65. Majumdar, "The Embodied Voice: Song Sequences and Stardom in Popular Hindi Cinema."

66. These videos have been taken down or made private since I first accessed them in 2012 at the following web addresses: *Milad Shabkhiz—Subah O Sham* ["*chhod meraa haath*" song sequence with Arabic subtitles recorded from ITN], accessed October 16, 2012, http://www.youtube.com/watch?v=gm8HyIhGryw&feature=youtube_gdata_player; *Milad*

Shabkhiz—Subah O Sham [*"terii merii merii terii"* song sequence recorded from ITN], accessed September 9, 2017, http://www.youtube.com/watch?v=Mmpk2qIgmiI&feature=y outube_gdata_player; *Film O Honar—Homaye Saadat*, accessed July 20, 2019, https://www .youtube.com/watch?v=gCoI1NdN7wM.

67. Sunya, "On Location."

68. See Askari, *Relaying Cinema in Midcentury Iran*, for more on Rubik Mansuri, in a detailed account of scoring practices in midcentury Iranian films.

69. See for example Gürata, ""The Road to Vagrancy": Translation and Reception of Indian Cinema in Turkey."

70. Askari and Sunya, "Introduction."

71. *Indian Trade Journal*, 1384.

72. *Indian Trade Journal*, 1384.

73. In Persian versions available on YouTube, Aram and Shirin go to a bar after her performance, where she downs copious amounts of vodka. The scene of her close call with an assault, from which Aram rescues her, is left out.

74. Meftahi, *Gender and Dance in Modern Iran*, 88.

75. Meftahi, 88.

76. Gehlawat and Dudrah, "The Evolution of Song and Dance in Hindi Cinema"; Krishnan, *Celluloid Classicism*; Iyer, *Dancing Women*; Putcha, "The Mythical Courtesan."

77. The bluntness of a cut at the end of the song sequence/montage of sculptures suggests the possibility of a censor cut.

78. For a comparative account of the orphan as a figure of industrial modernity in melodramas of Chinese cinema, see Zhang, "Transnational Melodrama, Wenyi, and the Orphan Imagination."

79. Critiques of the primacy accorded to friendships between men in contemporaneous Hindi films cite a troubling populism at work, which continued through the 1970s. As Priya Jha argues, resolutely antimodern fantasies of masculinity proliferated, as "the emasculation of the male Indian imaginary through [increasingly authoritarian prime minister Indira Gandhi's] political agency in part served to resurrect the 'simple' and 'pure' notion of male-to-male friendship . . . that projected a precolonial fantasy onto the articulation of a postcolonial future" ("Lyrical Nationalism," 52). However, homosocial constructions—particularly in the case of contemporaneous coproductions—were working out questions not only of the national but also of cinema. In part, the homosocial constructions within the coproductions ensued from homosocial industry hierarchies and practices of film financing and distribution. Ultimately, the heterosexual presumptions that drove rhetorical exaltations of men's friendships over romance hardly meant either that spectators took these arguments at face value or that these arguments adequately theorized gender and pleasure at the level of reception, as I argue in chapter 3.

Abbas, Khwaja Ahmad. "Films for Friendship." *Film World* 5, no. 2 (June 1969), edited by T. M. Ramachandran.

———. *I Am Not an Island: An Experiment in Autobiography*. New Delhi: Vikas Publishing House, 1977.

———. "Indian Cinema: Retrospect and Prospect—Mosaic of Complex and Creative Design." *Foreign Trade of India: Accent on Indian Cinema* (1970): 4–8.

Abbas, Khwaja Ahmad, and Vassily Pronin. *Journey beyond Three Seas* (1957). DVD. Moscow: Ruscico, 1999.

Abel, Richard. *The Red Rooster Scare: Making Cinema American, 1900–1910*. Berkeley: University of California Press, 1999.

Acharya, Amitav, and See Seng Tan, eds. *Bandung Revisited: The Legacy of the 1955 Asian-African Conference for International Order*. Singapore: National University of Singapore Press, 2008.

Adorno, Theodor, and Max Horkeimer. "The Culture Industry: Enlightenment as Mass Deception." In *Dialectic of Enlightenment: Philosophical Fragments*, edited by Gunzelin Schmid Noerr, translated by Edmund Jephcott, 94–136. Stanford, CA: Stanford University Press, 2002.

Ahmed, Sara. *The Cultural Politics of Emotion*. New ed. Edinburgh: Edinburgh University Press, 2014.

Altman, Rick. *The American Film Musical*. Bloomington: Indiana University Press, 1989.

Ambedkar, B. R. *Beef, Brahmins, and Broken Men: An Annotated Critical Selection from* The Untouchables. Edited by Alex George and S. Anand. New York: Columbia University Press, 2020.

Amory, Cleveland and Earl Blackwell. *Celebrity Register: An Irreverent Compendium of American Quotable Notables*. Vol. 2. New York: Simon and Schuster, 1963.

——. *Celebrity Register: An Irreverent Compendium of American Quotable Notables.* Vol. 3. New York: Simon and Schuster, 1973.

Andrew, Dudley. "An Atlas of World Cinema." *Framework: The Journal of Cinema and Media.* 45, no. 2 (2004): 9–23.

Anker, Elisabeth Robin. *Orgies of Feeling: Melodrama and the Politics of Freedom.* Durham, NC: Duke University Press, 2014.

Armes, Roy. *Third World Film Making and the West.* Berkeley: University of California Press, 1987.

Arnwine, Clark, and Jesse Lerner. *Wide Angle: A Quarterly Journal of Film History, Theory & Criticism* 20, no. 3. Athens: Ohio University Department of Film, 1998.

Arondekar, Anjali. *For the Record: On Sexuality and the Colonial Archive in India.* Durham, NC: Duke University Press, 2009.

Ascheid, Antje. "Speaking Tongues: Voice Dubbing in the Cinema as Cultural Ventriloquism." *Velvet Light Trap* 40 (Fall 1997): 32–41.

Ashcroft, Bill, Gareth Griffiths, and Helen Tiffin. *Post-Colonial Studies: The Key Concepts.* London: Routledge, 2013.

Askari, Kaveh. "An Afterlife for Junk Prints: Serials and Other 'Classics' in Late-1920s Tehran." In *Silent Cinema and the Politics of Space*, edited by Anupama Kapse, Laura Horak, and Jennifer M. Bean, 99–120. Bloomington: Indiana University Press, 2014.

——. "Eastern Boys and Failed Heroes: Iranian Cinema in the World's Orbit." *Cinema Journal* 57, no. 3 (May 3, 2018): 29–53.

——. *Relaying Cinema in Midcentury Iran: Material Cultures in Transit.* Oakland: University of California Press, 2022.

Askari, Kaveh, and Samhita Sunya. "Editors' Note: On a Press Booklet for Black Eyes (1936)." *Film History: An International Journal* 32, no. 3 (2020): 184–96.

——. "Introduction: South by South/West Asia: Transregional Histories of Middle East–South Asia Cinemas." *Film History: An International Journal* 32, no. 3 (2020): 1–9.

A'yin, Hushang Mihr. "Iranian Film Industry Progresses." Translation of Persian article published in *Keyhan*, March 31, 1971. In *Translation on Near East and North Africa*, 612–15. Washington, DC: United States Joint Publications Research Service, 1971.

Aziz, Ashraf. *"sigret sinemaa sahgal aur sharaab"* (cigarettes, cinema, Sahgal, and spirits). In *Jalsa 2: Exile*, edited by Asad Zaidi. Gurgaon, Haryana, India: Three Essays Collective, December 2011.

Bairy, Ramesh. *Being Brahmin, Being Modern: Exploring the Lives of Caste Today.* London: Routledge, 2016.

"Bangle Factories Hit by Slump." *Times of India*, August 16, 1953.

Basu, Anustup. "'The Face That Launched a Thousand Ships': Helen and Public Femininity in Hindi Film." In *Figurations in Indian Film*, edited by Meheli Sen and Anustup Basu, 139–57. London: Palgrave Macmillan UK, 2013.

——. "Filmfare, the Bombay Industry, and Internationalism (1952–1962)." In *Industrial Networks and Cinemas of India: Shooting Stars, Shifting Geographies and Multiplying Media*, edited by Monika Mehta and Madhuja Mukherjee, 137–50. London: Taylor & Francis, 2020.

Bazin, André. "De Sica: Metteur-en-Scène." In *What Is Cinema?* Berkeley: University of California Press, 2004.

Benjamin, Walter. "The Work of Art in the Age of Mechanical Reproduction." In *Illuminations: Essays and Reflections*, edited by Hannah Arendt, translated by Harry Zohn, 217–52. New York: Schocken, 1969.

Berlant, Lauren. "A Properly Political Concept of Love: Three Approaches in Ten Pages." *Cultural Anthropology* 26, no. 4 (2011): 683–91.

Betz, Mark. *Beyond the Subtitle: Remapping European Art Cinema*. Minneapolis: University of Minnesota Press, 2009.

Bhabha, Homi K. *The Location of Culture*. London: Routledge, 2004.

Bhagavan, Manu. "Introduction." In *India and the Cold War*, edited by Manu Bhagavan. Chapel Hill: University of North Carolina Press, 2019.

———. *The Peacemakers: India and the Quest for One World*. New Delhi: Harper Collins, 2012.

Bhaskar, Ira. "The Indian New Wave." In *The Indian New Wave*, edited by K. Moti Gokulsing and Wimal Dissanayake, 19–33. Routledge Handbooks Online, 2013. https://doi.org/10.4324/9780203556054.ch3.

Bhaskar, Ira, and Richard Allen. *Islamicate Cultures of Bombay Cinema*. New Delhi: Tulika, 2009.

Bhattacharya, Sabyasachi. "Writing and Making Money: Munshi Premchand in the Film Industry, 1934–35." *Contemporary India* 1, no. 1 (March 2002).

Bhaumik, Kaushik. "Querying the 'Traditional' Roots of Silent Cinema in Asia." *Journal of the Moving Image* (2008). http://www.jmionline.org/article/querying_the_traditional_roots_of_silent_cinema_in_asia.

Bhurgubanda, Uma Maheswari. "Travels of the Female Star in Indian Cinema of the 1940s and 50s: The Career of Bhanumathi." In *Industrial Networks and Cinemas of India: Shooting Stars, Shifting Geographies and Multiplying Media*, edited by Monika Mehta and Madhuja Mukherjee, 61–76. London: Taylor & Francis, 2020.

Bikmukhametova, Rimma, and Daisy Sindelar. "In Russia, 'Horde' Blockbuster Drawing Tatar Objections." RadioFreeEurope/RadioLiberty, September 19, 2012, sec. Tatar-Bashkir. http://www.rferl.org/content/the-horde-film-tatarstan-stereotypes-russia/24713352.html.

Bloom, Peter. "Circumambient Geographies of Cinema: The Shaw Brothers' Malay Film Production Studio in Mid-Century Singapore." In *Industrial Networks and Cinemas of India: Shooting Stars, Shifting Geographies and Multiplying Media*, edited by Monika Mehta and Madhuja Mukherjee, 124–36. London: Taylor & Francis, 2020.

Booth, Gregory. "Making a Woman from a Tawaif—Courtesans as Heroes in Hindi Cinema." *New Zealand Journal of Asian Studies* 9, no. 2 (2007): 1–26.

———. "R. D. Burman and Rhythm: 'Making the Youth of This Nation to Dance.'" *BioScope: South Asian Screen Studies* 3, no. 2 (July 1, 2012): 147–64.

Bordwell, David, and Kristin Thompson. *Film Art: An Introduction*. New York: McGraw Hill, 2008.

Brooks, Peter. *The Melodramatic Imagination: Balzac, Henry James, Melodrama, and the Mode of Excess*. New York: Columbia University Press, 1984.

Brueck, Laura R. *Writing Resistance: The Rhetorical Imagination of Hindi Dalit Literature*. New York: Columbia University Press, 2014.

Bruno, Giuliana. *Atlas of Emotion: Journeys in Art, Architecture, and Film*. New York: Verso, 2007.

Brunsdon, Charlotte. "The Attractions of the Cinematic City." *Screen* 53, no. 3 (Autumn, 2012): 209–27.

Burchett, Patton. "Bhakti Rhetoric in the Hagiography of 'Untouchable' Saints: Discerning Bhakti's Ambivalence on Caste and Brahminhood." *International Journal of Hindu Studies* 13, no. 2 (August 2009): 115.

Burman, R. D., composer. "Aao Aao Aao Sawariya." *Padosan.* Jyoti Swaroop, dir. YouTube. http://www.youtube.com/watch?v=jv4wxnYJmzQ.

"Catalogue—Seventeenth National Awards for Films." New Delhi: Ministry of Information and Broadcasting, Government of India, November 21, 1970. https://dff.gov.in/images /Documents/98_17thNfacatalogue.pdf.

Chadha, Kalyani, and Anandam P. Kavoori. "Exoticized, Marginalized, Demonized: The Muslim 'Other' in Indian Cinema." In *Global Bollywood,* edited by Anandam P. Kavoori and Aswin Punathambekar, 131–45. New York: NYU Press, 2008.

Chakravarti, Uma. *Gendering Caste: Through a Feminist Lens.* Rev. ed. New Delhi: Sage Publications, 2019.

Chandra, Shefali. *The Sexual Life of English: Languages of Caste and Desire in Colonial India.* Durham, NC: Duke University Press Books, 2012.

Chatterjee, Partha. "Beyond the Nation? Or Within?" *Economic and Political Weekly* 32 (1997): 1–2.

———. *The Nation and Its Fragments: Colonial and Postcolonial Histories.* Princeton, NJ: Princeton University Press, 1993.

Cherian, V. K. *India's Film Society Movement: The Journey and Its Impact.* SAGE Publications India, 2016.

Chion, Michel, and Walter Murch. *Audio-Vision: Sound on Screen.* Translated by Claudia Gorbman. 14th ed. New York: Columbia University Press, 1994.

Chow, Rey. *The Age of the World Target: Self-Referentiality in War, Theory, and Comparative Work.* Durham, NC: Duke University Press Books, 2006.

Christopher, Joe. *Beyond the Star: Telugu Comedy Films and Realpolitik in Andhra Pradesh.* Edited by K. Moti Gokulsing, Wimal Dissanayake, and Rohit K. Dasgupta. London: Routledge, 2013.

Clarke, David B. *The Cinematic City.* London: Routledge, 1997.

Cooley, Claire. "Bachchan Superman—Hindi Cinema in Egypt, 1985–1991." *Jump Cut: A Review of Contemporary Media* 59 (2019). https://www.ejumpcut.org/archive/jc59.2019 /Cooley-Bachchan/.

———. "The 'Problem of Respectable Ladies Joining Films': Industrial Traffic, Female Stardom and the First Talkies in Bombay and Tehran." In *Industrial Networks and Cinemas of India: Shooting Stars, Shifting Geographies and Multiplying Media,* edited by Monika Mehta and Madhuja Mukherjee, 35–47. London: Taylor & Francis, 2020.

———. "Soundscape of a National Cinema Industry: Filmfarsi and Its Sonic Connections with Egyptian and Indian Cinemas, 1940s–1960s." *Film History: An International Journal* 32, no. 3 (2020): 43–74.

Coppola, Carlo. "Premchand's Address to the First Meeting of the All-India Progressive Writers Association." *Journal of South Asian Literature* 21, no. 2 (1986): 21–39.

"Current Topics: The Rumour Makers Leaves & Seeds." *Times of India,* September 13, 1971.

Danan, Martine. "Dubbing as an Expression of Nationalism." *Meta* 36, no. 4 (1991): 606–14.

Das Gupta, Chidananda. "In the Revitalisation of the Indian Film Industry What Is the Role of the Proposed 'Kissing Seminars.'" *Hindustan Times Weekend Review*, July 1967.

Dass, Manishita. "Cinetopia: Leftist Street Theatre and the Musical Production of the Metropolis in 1950s Bombay Cinema." *Positions: Asia Critique* 25, no. 1 (2017): 101–24.

———. "The Cloud-Capped Star: Ritwik Ghatak on the Horizon of Global Art Cinema." In *Global Art Cinema: New Theories and Histories*, edited by Rosalind Galt and Karl Schoonover, 238–51. New York: Oxford University Press, 2010.

———. "Distant Observers: Film Criticism and the Making of Bengali Film Culture." In *Outside the Lettered City: Cinema, Modernity, and the Public Sphere in Late Colonial India*, 149–82. Oxford: Oxford University Press, 2015.

———. *Outside the Lettered City: Cinema, Modernity, and the Public Sphere in Late Colonial India*. Oxford: Oxford University Press, 2015.

Davis, Darrell William. "Questioning Diaspora: Mobility, Mutation, and Historiography of the Shaw Brothers Film Studio." *Chinese Journal of Communication* 4, no. 1 (March 2011): 40–59.

Dayal, Radha. "In the Wink of an Eye: The Comedic Universe of Johnny Walker." In *Indian Film Stars: New Critical Perspectives*, edited by Michael Lawrence. London: Bloomsbury Publishing, 2020.

Dechamma, Sowmya, and Sathya Prakash, eds. *Cinemas of South India: Culture, Resistance, and Ideology*. New Delhi: Oxford University Press, 2010.

Desai, Mohua. "Sonu Nigam's Tweets on Noisy 'azaan' Spark Row." *Times of India*, April 18, 2007. http://timesofindia.indiatimes.com/india/sonu-nigams-tweets-on-noisy-azaan-spark -row/articleshow/58231599.cms.

Deshpande, Shekhar, and Meta Mazaj. *World Cinema: A Critical Introduction*. New York: Routledge, 2018.

De Sica, Vittorio, dir. *Bicycle Thieves*. 1949; Criterion, 2007.

Desser, David. "Race, Space and Class: The Politics of Cityscapes in Science-Fiction Films." In *Alien Zone II: The Spaces of Science-Fiction Cinema*, edited by Anette Kuhn, 80–96. New York: Verso, 1999.

Dharap, B. V. *Indian Films*. Pune: National Film Archive of India, 1974.

Djagalov, Rossen, and Masha Salazkina. "Tashkent '68: A Cinematic Contact Zone." *Slavic Review* 75, no. 2 (2016): 279–98.

Doane, Mary Ann. "The Voice in the Cinema: The Articulation of Body and Space." *Yale French Studies*, no. 60 (January 1, 1980): 33–50.

Dobryden, Paul. "Spies: Postwar Paranoia Goes to the Movies." In *A Companion to Fritz Lang*, edited by Joe McElhaney, 76–93. London: John Wiley & Sons, 2014.

Dudrah, Rajinder. "Queer as Desis: Secret Politics of Gender and Sexuality in Bollywood Films in Diasporic Urban Ethnoscapes." In *Global Bollywood*, edited by Sangita Gopal and Sujata Moorti, 288–307. Minneapolis: University of Minnesota Press, 2008.

Duggal, Vebhuti. "Seeing Print, Hearing Song: Tracking the Film Song through the Hindi Popular Print Sphere, c. 1955—75." In *Music, Modernity, and Publicness in India*, edited by Tejaswi Niranjana, 135–57. Oxford: Oxford University Press, 2020.

Dwyer, Rachel. *Bollywood's India: Hindi Cinema as a Guide to Contemporary India*. London: Reaktion Books, 2014.

———. *Filming the Gods: Religion and Indian Cinema*. London: Routledge, 2006.

Dwyer, Tess, and Jennifer O'Meara. "Introduction." *JCMS: Journal of Cinema and Media Studies* 59, no. 4 (2020): 153–55.

Elam, J. Daniel. *World Literature for the Wretched of the Earth: Anticolonial Aesthetics, Postcolonial Politics*. New York: Fordham University Press, 2020.

Eleftheriotis, Dimitris. *Cinematic Journeys: Film and Movement*. Edinburgh: Edinburgh University Press, 2010.

———. "'A Cultural Colony of India': Indian Films in Greece in the 1950s and 1960s." *South Asian Popular Culture* 4, no. 2 (2006): 101–12.

Eleftheriotis, Dimitris, and Dina Iordanova. "Introduction." *South Asian Popular Culture* 4, no. 2 (2006): 79–82.

Elsaesser, Thomas. "Cinephilia or the Uses of Disenchantment." In *Cinephilia: Movies, Love and Memory*, edited by Marijke de Valck and Malte Hagener, 17–43. Amsterdam: Amsterdam University Press, 2005.

Fair, Laura. "They Stole the Show!: Indian Films in Coastal Tanzania, 1950s–1980s." *Journal of African Media Studies* 2, no. 1 (April 1, 2010): 91–106.

Fish, Laura. "The Bombay Interlude: Parsi Transnational Aspirations in the First Persian Sound Film." *Transnational Cinemas* 9, no. 2 (June 12, 2018): 1–15.

"Former Malay Production Film Studios." Roots, last updated 1 April, 2021. National Heritage Board. https://www.roots.gov.sg/places/places-landing/Places/landmarks/balestier-heritage-trail-faith-film-and-food/Former-Malay-Film-Productions-Studio.

Forum, Prevention of Environmental and Sound Pollution v. Union of India & Anv., No. 21851/03 (2005.7.18) (Noise Pollution). ELAW. https://www.elaw.org/es/content/india-forum-prevention-environmental-and-sound-pollution-v-union-india-anv-no-2185103-200571.

Forum, Prevention of Envn. & Sound . . . vs Union of India & Anr on 28 October, 2005. https://indiankanoon.org/doc/541057/.

Fu, Poshek. *China Forever: The Shaw Brothers and Diasporic Cinema*. Champaign: University of Illinois Press, 2008.

Galbraith, John Kenneth, Edward Howe, and Francis Robert Moraes. *John Kenneth Galbraith Introduces India*. London: Andre Deutsch, 1974.

Galt, Rosalind, and Karl Schoonover. *Global Art Cinema: New Theories and Histories*. London: Oxford University Press, 2010.

Ganti, Tejaswini. "Blurring the Boundaries Between Hollywood and Bollywood: The Production of Dubbed Films in Mumbai." In *Industrial Networks of Indian Cinema: Shooting Stars, Shifting Geographies and Multiplying Media*, edited by Monika Mehta and Madhuja Mukherjee. London: Routledge, 2021.

Gehlawat, Ajay, and Rajinder Dudrah. "The Evolution of Song and Dance in Hindi Cinema." *South Asian Popular Culture* 15, no. 2–3 (September 2, 2017): 103–8.

Gerhardt, Christina, and Sara Saljoughi. *1968 and Global Cinema*. Detroit: Wayne State University Press, 2018.

Gharabaghi, Hadi. "The Syracuse Mission to Iran during the 1950s and the Rise of Documentary Diplomacy." *Journal of Cinema and Media Studies* 60, no. 4 (2021): 9–36.

Ginsberg, Terri. "Cold War Foundations of Academic Film Studies." In *Governing Genealogies of Film Education*, edited by Terri Ginsberg and Hadi Gharabaghi, 2021. Manuscript in preparation.

———. "The McCarthyist Foundations of Academic Cinema Studies: Abstract Expressionism, U.S. Cultural Diplomacy, and the Institutional Study of Film." Presentation in panel "Post-WWII Governing Genealogies of Cinematic Institutions," at Society for Cinema and Media Studies conference, Toronto, 2018.

Gledhill, Christine, and Linda Williams, eds. *Melodrama Unbound: Across History, Media, and National Cultures*. New York: Columbia University Press, 2018.

Gopal, Sangita. *Conjugations: Marriage and Form in New Bollywood Cinema*. Chicago: University of Chicago Press, 2012.

Gopalan, Lalitha. *Cinema of Interruptions: Action Genres in Contemporary Indian Cinema*. London: British Film Institute, 2002.

Goswami, Namita. "The Empire Sings Back: Aesthetics, Politics, and Postcolonial Whimsy." *Contemporary Aesthetics* no. 2 (2009).

Govil, Nitin. *Orienting Hollywood: A Century of Film Culture between Los Angeles and Bombay*. New York: NYU Press, 2015.

Govindrajan, Radhika. "Labors of Love: On the Political Economies and Ethics of Bovine Politics in Himalayan India." *Cultural Anthropology* 36, no. 2 (May 11, 2021): 193–221.

Guha, Pujita. "Traversing *The Evil Within* (1970): Transnational Aspirations, Stardom, and Infrastructure in a Cold-War Asia." In *Industrial Networks and Cinemas of India: Shooting Stars, Shifting Geographies and Multiplying Media*, edited by Monika Mehta and Madhuja Mukherjee, 151–63. London: Taylor & Francis, 2020.

Gulzar. "Lyrics 1903–1960: A Song Travels . . . " In *Encyclopedia of Hindi Cinema*, edited by Gulzar, Govind Nihalani, and Saibal Chatterjee, 279–94. Mumbai: Popular Prakashan, 2003.

Gürata, Ahmet. "'The Road to Vagrancy': Translation and Reception of Indian Cinema in Turkey." *BioScope: South Asian Screen Studies* 1, no. 1 (January 1, 2010): 67–90.

Haase, Donald. "The Arabian Nights, Visual Culture, and Early German Cinema." *Fabula* 45 (July 1, 2004): 261–74.

Hardt, Michael. "For Love or Money." *Cultural Anthropology* 26, no. 4 (2011): 676–82.

Hawley, John Stratton. *Sur Das: Poet, Singer, Saint*. Seattle: University of Washington Press, 1984.

Hoek, Lotte. *Cut-Pieces: Celluloid Obscenity and Popular Cinema in Bangladesh*. New York: Columbia University Press, 2013.

Holmes, Winifred. "37. The Stranger." In *Orient: A Survey of Films Produced in Countries of Arab and Asian Culture*. London: British Film Institute, 1959.

hooks, bell. "The Oppositional Gaze: Black Female Spectators." In *Media Studies: A Reader*, edited by Sue Thornham, Caroline Bassett, and Paul Marris, 462–70. Edinburgh: Edinburgh University Press, 2009.

Horvat, Srećko. *After the Apocalypse*. Hoboken, NJ: John Wiley & Sons, 2021.

"India Latest Foreign Land to Badly 'Misunderstand' U.S. Film Economics." *Variety*, February 27, 1957, 10.

Indian Cinema. Delhi: Directorate of Film Festivals, Ministry of Information and Broadcasting, 1978.

"Iran: Cinematographic Films." *Indian Trade Journal* 224, no. 9 (1963): 1384.

India Parliament, Rajya Sabha. *Parliamentary Debates: Official Report*, vol. 86, 21–30. Delhi: Council of States Secretariat, 1973.

——. *Parliamentary Debates: Official Report*, vol. 89, 25–29. Delhi: Council of States Secretariat, 1974.

——. *Parliamentary Debates: Official Report*, vol. 19, 11. Delhi: Council of States Secretariat, 1975.

India Working Group on National Film Policy. *Report of the Working Group on National Film Policy*. Delhi: Ministry of Information and Broadcasting, Government of India, 1980.

Indraganti, Kiranmayi. *Her Majestic Voice: South Indian Female Playback Singers and Stardom, 1945–1955*. Oxford: Oxford University Press, 2016.

——. "Of 'Ghosts' and Singers: Debates around Singing Practices of 1940s Indian Cinema." *South Asian Popular Culture* 10, no. 3 (October 1, 2012): 295–306.

Iordanova, Dina. "Indian Cinema's Global Reach." *South Asian Popular Culture* 4, no. 2 (2006): 113–40.

Ivory, James. "Foreword." In *The Selected Poetry of Pier Paolo Pasolini: A Bilingual Edition.* Chicago: University of Chicago Press, 2014.

Iyer, Usha. "Bringing *Bharatanatyam* to Bombay Cinema: Mapping Tamil-Hindi Film Industry Traffic through Vyjayanthimala's Dancing Body." In *Industrial Networks and Cinemas of India: Shooting Stars, Shifting Geographies and Multiplying Media*, edited by Monika Mehta and Madhuja Mukherjee, 77–91. London: Taylor & Francis, 2020.

——. "Dance Musicalization: Proposing a Choreomusicological Approach to Hindi Film Song-and-Dance Sequences." *South Asian Popular Culture* 15, no. 2–3 (September 2, 2017): 123–38.

——. *Dancing Women: Choreographing Corporeal Histories of Hindi Cinema*. Oxford: Oxford University Press, 2020.

Jaaware, Aniket. *Practicing Caste: On Touching and Not Touching*. New York: Fordham University Press, 2018.

Jaikumar, Priya. *Cinema at the End of Empire: A Politics of Transition in Britain and India*. Durham, NC: Duke University Press, 2006.

Jha, Priya. "Lyrical Nationalism: Gender, Friendship, and Excess in 1970s Hindi Cinema." *Velvet Light Trap* 51, no. 1 (2003): 43–53.

Jhingan, Shikha. "Lata Mangeshkar's Voice in the Age of Cassette Reproduction." *BioScope: South Asian Screen Studies* 4, no. 2 (2013): 97–114.

Jian, Chen, Martin Klimke, Masha Kirasirova, Mary Nolan, Marilyn Young, and Joanna Waley-Cohen, eds. *The Routledge Handbook of the Global Sixties: Between Protest and Nation-Building*. London: Routledge, 2018.

Joseph, Jenson. "Just a Buffalo, or Not?: A Nuanced Take on Lijo Jose Pellissery's *Jallikattu*." *Film Companion* (blog), November 20, 2019. https://www.filmcompanion.in/features /malayalam-features/just-a-buffalo-or-not-a-nuanced-take-on-lijo-jose-pellisserys -jallikattu/.

Kabir. *One Hundred Poems of Kabir*. Translated by Rabindranath Tagore. Hyderabad: Orient Blackswan, 2004.

Kabir, Ananya Jahanara. *Territory of Desire: Representing the Valley of Kashmir*. Minneapolis: University of Minnesota Press, 2009.

Kapoor, Ranjit. *Chintu Ji*. Eros, 2009.

——. "The Making of *Chintu Ji*." *Chintu Ji* DVD. Eros, 2009.

Kapse (formerly), Anupama Prabhala. "Afterword: The Long Arabesque: Economies of Affect between South Asia and the Middle East." *Film History* 32, no. 3 (2020): 241–54.

Kapur, Jyotsna. "Love in the Midst of Fascism: Gender and Sexuality in the Contemporary Indian Documentary." *Visual Anthropology* 19, no. 3–4 (September 1, 2006): 335–46.

Katulkar, Ratnesh. "Critical Analysis of Indian Historians' Writings on Buddhism." *Journal of International Buddhist Studies* 7, no. 1 (June 2016): 1–14.

Kaur, Raminder. "Bertrand Russell in Bollyworld: Film, the Cold War, and a Postmortem on Peace." In *India and the Cold War*, edited by Manu Bhagavan. Chapel Hill: University of North Carolina Press, 2019.

K. A. V. "From Madras with Love." *Film World*, May 1978.

Kaviraj, Sudipta. "Reading a Song of the City." In *City Flicks: Indian Cinema and the Urban Experience*, edited by Preben Kaarsholm, 55–70. Denmark: Roskilde University, 2002.

Kelkar, S. K. "You Share Your Birthday with—Satyajit Ray." *Illustrated Weekly of India*, April 29, 1979.

Keller, Sarah. *Anxious Cinephilia: Pleasure and Peril at the Movies*. New York: Columbia University Press, 2020.

Keune, Jon. *Shared Devotion, Shared Food: Equality and the Bhakti-Caste Question in Western India*. Oxford: Oxford University Press, 2021.

Khanna, Harish. "Indian Film Abroad: Search for New Horizons." *Foreign Trade of India: Accent on Indian Cinema* (1970): 30–36.

Khanna, Neetu. *The Visceral Logics of Decolonization*. Durham, NC: Duke University Press Books, 2020.

Khubchandani, Kareem. *Ishtyle: Accenting Gay Indian Nightlife*. Ann Arbor: University of Michigan Press, 2020.

Krishnan, Hari. *Celluloid Classicism: Early Tamil Cinema and the Making of Modern Bharatanatyam*. Middletown, CT: Wesleyan University Press, 2019.

Kumar, Aishwary. "Apotheosis of the Unequal: Gandhi's Harijan." In *Radical Equality: Ambedkar, Gandhi, and the Risk of Democracy*, 165–218. Stanford, CA: Stanford University Press, 2015.

Kumar, Dilip. *Dilip Kumar: The Substance and the Shadow*. Delhi: Hay House, 2014.

Kumar, Jainendra. *Premchand: A Life in Letters*. Translated by Sunita Jain. Agra: Y. K. Publishers, 1993.

Lamster, Mark. *Architecture and Film*. New York: Princeton Architectural Press, 2000.

Larkin, Brian. "Indian Films and Nigerian Lovers: Media and the Creation of Parallel Modernities." *Africa: Journal of the International African Institute* 67, no. 3 (1997): 406–40.

———. "Itineraries of Indian Cinema: African Videos, Bollywood, and Global Media." In *The Bollywood Reader*, edited by Rajinder Dudrah and Jigna Desai, 216–28. Maidenhead, Berkshire, UK: McGraw-Hill Education, Open University Press, 2008.

Lavezzoli, Peter. *The Dawn of Indian Music in the West*. London: Bloomsbury Academic, 2006.

Limbrick, Peter. *Arab Modernism as World Cinema: The Films of Moumen Smihi*. Oakland: University of California Press, 2020.

Lutgendorf, Philip. "*Padosan*." Indian Cinema: Notes on Indian Popular Cinema. N.d. https://indiancinema.sites.uiowa.edu/padosan.

Maasri, Zeina. *Cosmopolitan Radicalism: The Visual Politics of Beirut's Global Sixties*. London: Cambridge University Press, 2020.

Makdisi, Saree. "'Postcolonial' Literature in a Neocolonial World: Modern Arabic Culture and the End of Modernity." *Boundary 2* 22, no. 1 (1995): 85–115.

Mahmood, Hameeduddin. *The Kaleidoscope of Indian Cinema*. New Delhi: Affiliated East-West Press, 1974.

Majumdar, Neepa. "The Embodied Voice: Song Sequences and Stardom in Popular Hindi Cinema." In *Soundtrack Available: Essays on Film and Popular Culture*, edited by Pamela Robertson Wojcik and Arthur Knight, 161–81. Durham, NC: Duke University Press, 2001.

———. "Pather Panchali: From Neo-Realism to Melodrama." In *Film Analysis: A Norton Reader*, edited by Jeffrey Geiger and R. L. Rutsky, 510–27. New York: Norton, 2013.

———. *Wanted Cultured Ladies Only!: Female Stardom and Cinema in India, 1930s–1950s*. Urbana: University of Illinois Press, 2009.

Majumdar, Rochona. "Art Cinema: The Indian Career of a Global Category." *Critical Inquiry* 42, no. 3 (March 1, 2016): 580–610.

———. "Debating Radical Cinema: A History of the Film Society Movement in India." *Modern Asian Studies* 46, no. 3 (2012): 731–67.

———. *Marriage and Modernity: Family Values in Colonial Bengal*. Durham, NC: Duke University Press, 2009.

Malik, Amita. "The Indian Cinema Looks Forward in the Seventies: Rise of the Regions." *Foreign Trade of India: Accent on Indian Cinema* (1970): 43–47.

Manuel, Peter. *Thumri in Historical and Stylistic Perspectives*. South Asia Books, 1990.

Marwick, Arthur. *The Sixties: Cultural Revolution in Britain, France, Italy, and the United States, c.1958–c.1974*. Oxford: Oxford University Press, 1998.

Mathur, Yashika. "Rajesh Khanna Was a Poor Actor: Naseeruddin." *Hindustan Times*, July 26, 2014, sec. HT City.

Matringe, Denis. "Krsnaite and Nath Elements in the Poetry of the Eighteenth-Century Panjabi Sufi Bullhe Sah." In *Devotional Literature in South Asia: Current Research, 1985–1988*, edited by R. S. McGregor, 190–208. Cambridge: Cambridge University Press, 1992.

Mazumdar, Ranjani. "Aviation, Tourism and Dreaming in 1960s Bombay Cinema." *BioScope: South Asian Screen Studies* 2, no. 2 (July 1, 2011): 129–55.

———. *Bombay Cinema: An Archive of the City*. Minneapolis: University of Minnesota Press, 2007.

———. "Gangland Bombay." In *Bombay Cinema: An Archive of the City*, 149–96. Minneapolis: University of Minnesota Press, 2007.

Mazzarella, William. *Censorium: Cinema and the Open Edge of Mass Publicity*. Durham, NC: Duke University Press, 2013.

McGarr, Paul M. *The Cold War in South Asia: Britain, the United States and the Indian Subcontinent, 1945–1965*. Cambridge: Cambridge University Press, 2013.

McHugh, Kathleen, and Vivian Sobchack. "Introduction." *Signs: Journal of Women in Culture and Society*, special issue, "Recent Approaches to Film Feminisms," 30, no. 1 (September 1, 2004): 1205–7.

Meftahi, Ida. *Gender and Dance in Modern Iran: Biopolitics on Stage*. London: Routledge, 2017.

Mehta, Monika. *Censorship and Sexuality in Bombay Cinema*. Austin: University of Texas Press, 2011.

Mehta, Monika, and Madhuja Mukherjee. "Introduction: Detouring Networks." In *Industrial Networks and Cinemas of India: Shooting Stars, Shifting Geographies and Multiplying Media*, 1–17. London: Taylor & Francis, 2020.

Meiyappan, A. V. "Statement of Events as They Happened." *The Times of India (1861-Current)*, March 10, 1968.

"Meri Pyari Bindu (Remix)." *Padosan*. YouTube. http://www.youtube.com/watch?v=LKG Kaso22hc.

Merziger, Patrick. "Americanised, Europeanised or Nationalised? The Film Industry in Europe under the Influence of Hollywood, 1927–1968." *European Review of History: Revue Européenne d'histoire* 20, no. 5 (October 1, 2013): 793–813.

Metz, Christian. *The Imaginary Signifier: Psychoanalysis and the Cinema*. Bloomington: Indiana University Press, 1986.

Milani, Farzaneh. "Through Her Eyes: An Interview with Fakhri Fay Vaziri." *Film History: An International Journal* 32, no. 3 (2020): 170–83.

Mini, Darshana Sreedhar. "Transnational Journeys of Malayalam Soft-Porn: Obscenity, Censorship and Mediations of Desire." Doctoral thesis, University of Southern California, 2020.

Mir, Ali. "Lyrically Speaking: Hindi Film Songs and the Progressive Aesthetic." In *Indian Literature and Popular Cinema: Recasting Classics*, edited by Heidi Rika Maria Pauwels, 205–19. London: Routledge, 2007.

Mir, Ali Husain, and Raza Mir. "Progressive Poetry and Film Lyrics." In *Anthems of Resistance*, 111–34. New Delhi: RST IndiaInk Publishing, 2006.

Mir, Mustansir. "Teachings of Two Punjabi Sufi Poets." In *Religions of India in Practice*, edited by Donald S. Lopez, 518–29. Princeton, NJ: Princeton University Press, 1995.

Mir, Raza, and Ali Husain Mir. *Anthems of Resistance: A Celebration of Progressive Urdu Poetry*. New Delhi: RST IndiaInk Publishing, 2006.

Mitchell, W. J. T. "Ekphrasis and the Other." In *Picture Theory: Essays on Verbal and Visual Representation*, 151–81. Chicago: University of Chicago Press, 1994.

Mitra, Durba. *Indian Sex Life: Sexuality and the Colonial Origins of Modern Social Thought*. Princeton, NJ: Princeton University Press, 2020.

———. "'Surplus Woman': Female Sexuality and the Concept of Endogamy." *Journal of Asian Studies* 80, no. 1 (2021): 3–26.

Mokkil, Navaneetha. *Unruly Figures: Queerness, Sex Work, and the Politics of Sexuality in Kerala*. Seattle: University of Washington Press, 2019.

Mooallem, Stephen. "The 1940s." *Harper's Bazaar*, April 2017.

Mossaki, Nodar, and Lana Ravandi-Fadai. "A Guarded Courtship: Soviet Cultural Diplomacy in Iran from the Late 1940s to the 1960s." *Iranian Studies* 51, no. 3 (May 4, 2018): 427–54.

Mukherjee, Debashree. *Bombay Hustle: Making Movies in a Colonial City*. New York: Columbia University Press, 2020.

———. "A Specter Haunts Bombay: Censored Itineraries of a Lost Communistic Film." *Film History* 31, no. 4 (2019): 30–60.

———. "Tracking Utopias: Technology, Labour and Secularism in Bombay Cinema (1930s–1940s)." In *Media and Utopia*, edited by Arvind Rajagopalan and Anupama Rao, 81–102. London: Routledge, 2017.

Mukherjee, Madhuja. "Arriving at Bombay: Bimal Roy, Transits, Transitions, and Cinema of Intersection." In *Industrial Networks and Cinemas of India: Shooting Stars, Shifting Geographies and Multiplying Media*, edited by Monika Mehta and Madhuja Mukherjee, 108–23. London: Taylor & Francis, 2020.

Mukherjee, Silpa. "Behind the Green Door: Unpacking the Item Number and Its Ecology." *BioScope: South Asian Screen Studies* 9, no. 2 (December 1, 2018): 208–32.

Mulvey, Laura. "Visual Pleasure and Narrative Cinema." *Screen* 16, no. 3 (Autumn 1975): 6–18.

Naficy, Hamid. "Theorizing 'Third-World' Film Spectatorship." *Wide Angle* 18, no. 4 (1996): 3–26.

Nagib, Lúcia. *World Cinema and the Ethics of Realism*. New York: Continuum, 2011.

Nagib, Lúcia, Chris Perriam, and Rajinder Dudrah, eds. *Theorizing World Cinema*. London: I. B. Tauris, 2011.

Nagwekar, Rutuja. "Birthday Special: Let's Know the Saga of 'Mumtaz.'" *The Live Mirror* (blog), July 31, 2018. https://www.thelivemirror.com/birthday-special-lets-know-saga-mumtaz -tagged-b-grade-actress/.

New York Conservatory for Dramatic Arts. "Acting for the Comedy Genre—Tips on Becoming an Actor or Actress in Comedy." Accessed May 21, 2011. http://www.sft.edu/tips /acting-for-the-comedy-genre.html.

Nikitin, Afanasiĭ Nikitich, Dmitriĭ Nikolaevich Butorin (illus.), and V. M. Nemtinov (illus.). *Khozhenie Za Tri Moria Afanasiia Nikitina 1466–1472 Gg*. Translated by Nikolaĭ Sergeev- ich Chaev. Moscow: State Publishing House of Geographical Literature, 1960.

Nima, Bigloo. *Googoosh Maste Mastam Kon—Homaye Saadat Soundtrack, 1350*. YouTube. Accessed June 20, 2019. https://www.youtube.com/watch?v=WLDunqmXf3w.

Nnaemeka, Tony, E. E. UviEghara, and Didi Uyo. *Philosophy and Dimensions of National Communication Policy*. Lagos: Centre for Black and African Arts and Civilisation, 1989.

Nornes, Markus. *Cinema Babel: Translating Global Cinema*. Minneapolis: University of Minnesota Press, 2007.

Nowell-Smith, Geoffrey. *The Oxford History of World Cinema*. Oxford: Oxford University Press, 1996.

"Official Selection 1958: In Competition—Festival de Cannes 2014 (International Film Festival)." Accessed March 15, 2014. http://org-www.festival-cannes.com/ar/archives/1958 /inCompetition.html.

Omvedt, Gail. "Hinduism and Politics." *Economic and Political Weekly* 25, no. 14 (1990): 723–29.

———. *Seeking Begumpura: The Social Vision of Anticaste Intellectuals*. New Delhi: Navayana, 2009.

"One Star Less in Madras." *Forum: The Indian Monthly Magazine*, April–May 1961.

Orsini, Francesca, ed. *Love in South Asia: A Cultural History*. Cambridge: Cambridge University Press, 2006.

Oruc, Firat. "Petrocolonial Circulations and Cinema's Arrival in the Gulf." *Film History: An International Journal* 32, no. 3 (2020): 10–42.

Oukaderova, Lida. *The Cinema of the Soviet Thaw: Space, Materiality, Movement*. Bloomington: Indiana University Press, 2017.

Our Legal Correspondent. "Special Tax Leviable: Sale of Celluloid Bangles." *Times of India*. May 12, 1962.

Our Special Correspondent. "100 Movies Fetch Rs. 17 Lakhs at Film Market." *Times of India*. January 19, 1978.

Paasonen, Susanna, Feona Attwood, Alan McKee, John Mercer, and Clarissa Smith. *Objectification: On the Difference between Sex and Sexism*. London: Routledge, 2020.

Patel, Geeta. *Lyrical Movements, Historical Hauntings: On Gender, Colonialism, and Desire in Miraji's Urdu Poetry*. Stanford, CA: Stanford University Press, 2002.

Patel, Raman M. "Export Potential of Plastics." *Foreign Trade of India* 23 (1965): 46–48.

Patel, Sujata. "Construction and Reconstruction of Woman in Gandhi." In *Ideals, Images, and Real Lives: Women in Literature and History*, edited by Alice Thorner and Maithreyi Krishna Raj, 288–321. New Delhi: Orient Blackswan, 2000.

Partovi, Pedram. "Popular Iranian Cinema before the Revolution." Recorded talk and transcript. Library of Congress, 2018. https://www.loc.gov/item/webcast-8331/.

Patil, S. K. *Report of the Film Enquiry Committee (1951)*. New Delhi: Government of India Press, 1951. http://archive.org/details/in.ernet.dli.2015.51593.

Pillai, Swarnavel Eswaran. *Madras Studios: Narrative, Genre, and Ideology in Tamil Cinema*. London: SAGE Publications, 2015.

Prakash, Gyan. *Emergency Chronicles*. Princeton, NJ: Princeton University Press, 2019.

———, ed. *Noir Urbanisms: Dystopic Images of the Modern City*. Princeton, NJ: Princeton University Press, 2010.

Prakash, Gyan, and Kevin Michael Kruse. *The Spaces of the Modern City: Imaginaries, Politics, and Everyday Life*. Princeton, NJ: Princeton University Press, 2008.

Prasad, M. Madhava. *Cine-Politics: Film Stars and Political Existence in South India*. New Delhi: Orient Blackswan, 2013.

———. *Ideology of the Hindi Film: A Historical Construction*. New York: Oxford University Press, USA, 2001.

Prashad, Vijay. *The Darker Nations: A People's History of the Third World*. Reprint edition. New York: New Press, 2008.

Prateek. "Inward Bound: Self-Referentiality in Bombay Cinema." In *Salaam Bollywood: Representations and Interpretations*, edited by Vikrant Kishore, Amit Sarwal, and Parichay Patra, 80–90. New Delhi: Routledge India, 2016.

Premchand, Munshi. "Adab Ki Gharaz-o-Gayat (The Purpose of Literature)." In *Manazmini-i-Premchand (Essays of Premchand)*, 234–53. Aligarh: University Publishers, 1960.

Pronin, V. M., and K. A. Abbas, dirs. परदेसी—*Pardesi*. Main cast: Prithviraj Kapoor, Balraj Sahni, Nargis, Padmini. SEPL Vintage. YouTube. Accessed August 9, 2021. https://www.youtube.com/watch?v=QBFAmFC4D7s.

Punathambekar, Aswin. "Ameen Sayani and Radio Ceylon: Notes towards a History of Broadcasting and Bombay Cinema." *BioScope: South Asian Screen Studies* 1, no. 2 (July 1, 2010): 189–97.

———. *From Bombay to Bollywood: The Making of a Global Media Industry*. New York: New York University Press, 2013.

Punathambekar, Aswin, and Sriram Mohan. "A Sound Bridge: Listening for the Political in a Digital Age." *International Journal of Communication* 11 (October 27, 2017): 20.

Putcha, Rumya S. "The Mythical Courtesan: Womanhood and Dance in Transnational India." *Meridians* 20, no. 1 (April 1, 2021): 127–50.

Quraishi, Uzma. *Redefining the Immigrant South: Indian and Pakistani Immigration to Houston during the Cold War*. Chapel Hill: University of North Carolina Press, 2020.

Radhakrishnan, Ratheesh. "The 'Worlds' of the Region." *Positions: Asia Critique* 24, no. 3 (August 1, 2016): 693–719.

Rai, Swapnil. "From Bombay Talkies to Khote Productions: Female Star Switching Power in Bollywood Production Culture." *Feminist Media Studies*, January 9, 2020, 1–15.

Raipuri, Akhtar Husain. "Literature and Life." Translated by Adeem Suhail. *The Annual of Urdu Studies* 25 (2010): 123–30.

Rajadhyaksha, Ashish. "The 'Bollywoodisation' of the Indian Cinema: Cultural Nationalism in a Global Arena.'" In *City Flicks: Indian Cinema and the Urban Experience*, edited by Preben Kaarsholm, 113–39. Chicago: Seagull Books, 2006.

———. *Indian Cinema in the Time of Celluloid: From Bollywood to the Emergency*. Bloomington: Indiana University Press, 2009.

Rajagopal, Arvind. *Politics after Television: Hindu Nationalism and the Reshaping of the Public in India*. Cambridge: Cambridge University Press, 2001.

Rajagopalan, Sudha. "Emblematic of the Thaw." *South Asian Popular Culture* 4, no. 2 (2006): 83–100.

———. *Indian Films in Soviet Cinemas: The Culture of Movie-Going After Stalin*. Bloomington: Indiana University Press, 2008.

Ramachandran, Ayesha. *The Worldmakers: Global Imagining in Early Modern Europe*. Chicago: University of Chicago Press, 2015.

Ramachandran, T. M. "Editor's Note." *Foreign Trade of India: Accent on Indian Cinema* (1970).

———. "Indian Films in Non-European Countries." *Foreign Trade of India: Accent on Indian Cinema* (1970): 71–74.

Rao, Pallavi. "Soch Aur Shauch: Reading Brahminism and Patriarchy in Toilet: Ek Prem Katha." *Studies in South Asian Film & Media* 9, no. 2 (January 1, 2019): 79–96.

Ray, Satyajit. "Foreword." *Film World*, October 1964.

Richards, Rashna Wadia. *Cinematic Flashes: Cinephilia and Classical Hollywood*. Bloomington: Indiana University Press, 2012.

Romer, Jean-Claude, F. Vidal, and Jean-Louis G. Siboun. *40ème: Cannes 1946–1986: Festival International du film*. Montreuil, France: Media-Planning, 1987.

Roshan, Rakesh. *Kaho Naa Pyaar Hai Bollywood DVD*. Eros Entertainment, 2000.

Rotha, Paul. *The Film Till Now: A Survey of World Cinema*. London: Vision Press, 1949.

———. *Movie Parade: A Pictorial Survey of the Cinema*. London: Studio Publications, 1936.

Rotha, Paul, and Roger Manvell. *Movie Parade, 1888–1949: A Pictorial Survey of World Cinema*. London: Studio Publications, 1950.

Salam, Ziya Us. *Housefull: The Golden Years of Hindi Cinema*. Noida, India: Om Books International, 2012.

Salazkina, Masha. *In Excess*. Chicago: University of Chicago Press, 2009.

———. "Soviet-Indian Coproductions: Alibaba as Political Allegory." *Cinema Journal* 49, no. 4 (Summer 2010): 71–89.

"Sales Tax on Plastic Bangles Must Go." *Times of India*. August 24, 1976.

Sardar, Ziauddin. "Dilip Kumar Made Me Do It." In *The Secret Politics of Our Desires: Innocence, Culpability, and Indian Popular Cinema*, edited by Ashis Nandy, 19–91. New York: St. Martin's Press, 1998.

Sarkar, Bhaskar. "Metafiguring Bollywood: Brecht after *Om Shanti Om*." In *Figurations in Indian Film*, edited by Meheli Sen and Anustup Basu, 205–35. London: Palgrave Macmillan UK, 2013.

————. *Mourning the Nation: Indian Cinema in the Wake of Partition.* Durham, NC: Duke University Press, 2009.

————. "Plasticity and the Global." *Framework: The Journal of Cinema and Media* 56, no. 2 (September 29, 2015): 451–71.

"Save Foreign Exchange." *Times of India.* December 2, 1962.

Sawhney, Rashmi. "An Evening on Mars, Love on the Moon: 1960s Science Fiction Films from Bombay." *Studies in South Asian Film & Media* 6, no. 2 (October 2015): 121–46.

Scroll Staff. "Sonu Nigam Grumbles about 'Forced Religiousness' after Muslim Call to Prayer Wakes Him Up." *Scroll.In,* April 17, 2017. https://scroll.in/latest/834816/sonu-nigam -grumbles-about-forced-religiousness-after-muslim-call-to-prayer-wakes-him-up.

Selznick, Brian. *The Invention of Hugo Cabret.* New York: Scholastic Press, 2007.

Sengupta, Rakesh. "Towards a Decolonial Media Archaeology: The Absent Archive of Screenwriting History and the Obsolete Munshi." *Theory, Culture & Society,* July 6, 2020, 1–24.

————. "Writing from the Margins of Media: Screenwriting Practice and Discourse during the First Indian Talkies." *BioScope: South Asian Screen Studies* 9, no. 2 (December 1, 2018): 117–36.

Shackle, Christopher, and Rupert Snell. "Premchand: Urdu Hindi Aur Hindustani." In *Hindi and Urdu Since 1800: A Common Reader,* 141–44. London: School of Oriental and African Studies, University of London, 1990.

Shailendra. *Andara kī āga.* Edited by Ramā Bhāratī. Nayī Dillī: Rājakamala Prakāśana, 2013.

Shambu, Girish. *The New Cinephilia.* Los Angeles: Caboose, 2014.

Shaw, Denis J. B. "Mastering Nature through Science: Soviet Geographers and the Great Stalin Plan for the Transformation of Nature, 1948–53." *Slavonic and East European Review* 93, no. 1 (2015): 120–46.

Shaw, Tony, and Denise J. Youngblood. *Cinematic Cold War: The American and Soviet Struggle for Hearts and Minds.* Lawrence: University Press of Kansas, 2010.

Siddique, Salma. *Evacuee Cinema: Bombay and Lahore in Partition Transit, 1940–1960.* Cambridge: Cambridge University Press, 2022.

Siefert, Marsha. "Image/Music/Voice: Song Dubbing in Hollywood Musicals." *Journal of Communication* 45, no. 2 (1995): 57–59.

Singh, J. P. "A Subaltern Performance: Circulations of Gender, Islam, and Nation in India's Song of Defiance." *Arts and International Affairs* 1, no. 1 (2016). https://theartsjournal.net /2016/03/13/singh/.

Singh, Ranbir, and Anupama Arya. "Nehru's Strategy of National Integration." *Indian Journal of Political Science* 67, no. 4 (2006): 919–26.

Sippy, N. C. "More Noisy than Comic: 'Padosan.'" *Times of India.* January 12, 1969.

Sontag, Susan. "The Decay of Cinema." *New York Times on the Web,* February 25, 1996. http://partners.nytimes.com/books/00/03/12/specials/sontag-cinema.html.

Stam, Robert. *World Literature, Transnational Cinema, and Global Media: Towards a Transartistic Commons.* London: Routledge, 2019.

Stringer, Julian. "Global Cities and the International Film Festival Economy." In *Cinema and the City,* edited by Mark Shiel and Tony Fitzmaurice, 134–44. London: Blackwell, 2001.

"Studio Owners—Producers: S. S. Vasan." *Film World,* October 1964.

Sundar, Pavitra. "Meri Awaaz Suno: Women, Vocality, and Nation in Hindi Cinema." *Meridians: Feminism, Race, Transnationalism* 8, no. 1 (2007): 144–79.

———. "Usha Uthup and Her Husky, Heavy Voice." In *Indian Sound Cultures, Indian Sound Citizenship*, edited by Laura Brueck, Jacob Smith, and Neil Verma, 115–51. Ann Arbor: University of Michigan Press, 2020.

Sunya, Samhita. "On Location: Tracking Secret Agents and Films, between Bombay and Beirut." *Film History* 32, no. 3 (2020): 105–40.

Tagore, Rabindranath. *The English Writings of Rabindranath Tagore: Poems*. New Delhi: Sahitya Akademi, 2004.

Takulia, H. S. "Winds of Change: To the Editor, Times of India." *Times of India*. July 5, 1971.

Talwalker, Clare. "Shivaji's Army and Other 'Natives' in Bombay." *Comparative Studies of South Asia, Africa and the Middle East* 16, no. 2 (August 1, 1996): 114–22.

"The Tamil Film." *Film World*, October 1964.

Teo, Stephen. "Malay Cinema's Legacy of Cultural Materialism: P. Ramlee as Historical Mentor." In *Singapore Cinema: New Perspectives*, edited by Liew Kai Khiun and Stephen Teo. London: Taylor & Francis, 2016.

"Thackeray Wants Panel to Cure Film Industry's Ills." *The Times of India (1861-Current)*, December 14, 1970.

The M. P. Kolahal Nityantran Adhiniyam, 1985, M.P. Act No. 1 of 1986, Bare Acts Live, http://www.bareactslive.com/MP/MP359.HTM.

Thomas, Rosie. *Bombay before Bollywood: Film City Fantasies*. Albany: State University of New York Press, 2015.

Thompson, Emily. *The Soundscape of Modernity: Architectural Acoustics and the Culture of Listening in America, 1900–1933*. Cambridge, MA: The MIT Press, 2004.

Thompson, Kristin. "The Concept of Cinematic Excess." *Ciné-Tracts* 1, no. 2 (1977): 54–64.

———. *Exporting Entertainment: America in the World Film Market, 1907–34*. London: British Film Institute, 1985.

Thussu, Daya Kishan. *Communicating India's Soft Power: Buddha to Bollywood*. New York: Palgrave Macmillan, 2013.

Times of India News Service. "Shah Explains Film Industry Crisis." *Times of India (1861-Current)*, March 29, 1968.

"Unfriendly." *Times of India*, October 11, 1976.

U.N.I. "Racket in 'Import' of Thriller Films." *Times of India*, March 3, 1975.

Valck, Marijke de. *Film Festivals: From European Geopolitics to Global Cinephilia*. Amsterdam: Amsterdam University Press, 2007.

Valck, Marijke de, and Malte Hagener. *Cinephilia: Movies, Love and Memory*. Amsterdam: Amsterdam University Press, 2005.

Van Fleit Hang, Krista. "'The Law Has No Conscience': The Cultural Construction of Justice and the Reception of Awara in China." *Asian Cinema* 24, no. 2 (October 1, 2013): 141–59.

Vasudevan, Ravi. *The Melodramatic Public: Film Form and Spectatorship in Indian Cinema*. New York: Palgrave Macmillan US, 2011.

———. "'You Cannot Live in Society—and Ignore It': Nationhood and Female Modernity in Andaz." *Contributions to Indian Sociology* 29, no. 1–2 (January 1, 1995): 83–108.

Vasunia, Phiroze. "Sikandar and the History of India." In *The Classics and Colonial India*, 92–116. Oxford: Oxford University Press, 2013.

Wadali Brothers. *Wadali Brothers - Yaad Piya Ki . . .* Times Music, 2007. LP.

Wakankar, Milind. "The Question of a Prehistory." *Interventions* 10, no. 3 (2008): 285–302.

———. *Subalternity and Religion: The Prehistory of Dalit Empowerment in South Asia*. London: Taylor & Francis, 2010.

Wani, Aarti. *Fantasy of Modernity: Romantic Love in Bombay Cinema of the 1950s.* Cambridge: Cambridge University Press, 2016.

"Weekly Notes." *Economic Weekly,* May 2, 1959: 596

Weidman, Amanda J. *Singing the Classical, Voicing the Modern: The Postcolonial Politics of Music in South India.* Calcutta: Seagull Books, 2007.

"Where Smuggling Is King." *Times of India.* August 18, 1974.

Willeman, Paul. "Through the Glass Darkly: Cinephilia Reconsidered." In *Looks and Frictions: Essays in Cultural Studies and Film Theory.* London: British Film Institute, 1994.

Williams, Linda. "Film Bodies: Gender, Genre, and Excess." *Film Quarterly* 44, no. 4 (1991): 2–13.

Yampolsky, Mikhail, and Larry P. Joseph. "Voice Devoured: Artaud and Borges on Dubbing." *October* 64 (Spring, 1993): 57–77.

Yengde, Suraj. "Dalit Cinema." *South Asia: Journal of South Asian Studies* 41, no. 3 (July 3, 2018): 503–18.

Zaveri, Hanif. *Mehmood—A Man of Many Moods.* Mumbai: Popular Prakashan, 2005.

Zhang, Zhen. "Transnational Melodrama, Wenyi, and the Orphan Imagination." In *Melodrama Unbound: Across History, Media, and National Cultures,* edited by Christine Gledhill and Linda Williams, 83–98. New York: Columbia University Press, 2018.

ترانه هندی از دین در فر در فیلم همای سعادت (Hindi song by Fardin in *Homaaye Sa'adat*). YouTube. http://www.youtube.com/watch?v=Mmpk2qIgmiI&feature=youtube_gdata_player.

INDEX

Founded in 1893,
UNIVERSITY OF CALIFORNIA PRESS
publishes bold, progressive books and journals
on topics in the arts, humanities, social sciences,
and natural sciences—with a focus on social
justice issues—that inspire thought and action
among readers worldwide.

The UC PRESS FOUNDATION
raises funds to uphold the press's vital role
as an independent, nonprofit publisher, and
receives philanthropic support from a wide
range of individuals and institutions—and from
committed readers like you. To learn more, visit
ucpress.edu/supportus.

Printed in the USA
CPSIA information can be obtained
at www.ICGtesting.com
JSHW010721081223
53473JS00004B/28

9 780520 379534